Painting and Presence

Painting and Presence

Why Paintings Matter

ANTHONY RUDD

OXFORD
UNIVERSITY PRESS

Great Clarendon Street, Oxford, OX2 6DP,
United Kingdom

Oxford University Press is a department of the University of Oxford.
It furthers the University's objective of excellence in research, scholarship,
and education by publishing worldwide. Oxford is a registered trade mark of
Oxford University Press in the UK and in certain other countries

Published in the United States of America by Oxford University Press
198 Madison Avenue, New York, NY 10016, United States of America

British Library Cataloguing in Publication Data
Data available

Library of Congress Control Number: 2022933692

ISBN 978-0-19-285628-9

DOI: 10.1093/oso/9780192856289.001.0001

Printed and bound by
CPI Group (UK) Ltd, Croydon, CR0 4YY

To Jeanine, with my love.
And to the memory of my parents, who both loved painting.

Contents

Preface and Acknowledgments

This book is an exploration of the value of paintings and, therefore, of the value of painting as an art form, an attempt to think about why paintings should matter to us. I have called it an 'exploration', as I wrote it in an exploratory spirit, as a continuing dialogue with myself, in the course of which I also entered into dialogue with a range of philosophers, artists, critics, and others from different times and places. There are, of course, many other writers and artists I could have brought into these conversations, and more that could have been said about all the topics I discuss. My aim has been to stimulate readers to take up the dialogue for themselves rather than to present anything that would claim to be a complete account. (A conversation is necessarily open-ended in a way that a deductive proof is not.) My own thoughts about these matters have been helped by the discussions that followed my presentation of some drafts of parts of this book at various colloquia, as well as by other conversations. My thanks in particular to Elanor Taylor, Joseph Kupfer, Sarah Buss, Kendall Walton, Laura Engel, David Davies, Gary Iseminger, Paul Coates, John Lippitt, Steven DeLay, Tony Aumann, John Cottingham, Claire Carlisle, and Douglas Hedley. I am particularly appreciative of my colleagues in the Philosophy Department at St Olaf College for their supportive interest, especially Charles Taliaferro, whose recent work on aesthetics and religion has many points of connection with my project in this work. My particular thanks to Matt Vinton, for preparing the index. My greatest debt, as ever, is to my wife, colleague, constant interlocutor, and companion on many gallery visits, Jeanine Grenberg. I am also grateful to my father: discovering some of his old paints and brushes after his death was what stimulated me to take up painting, which in turn stimulated me to think philosophically about what I was trying to do, and what better painters were succeeding in doing. I hope he would have enjoyed this book.

I am grateful to the publishers of the relevant journals for permission to republish some material that first appeared in the following articles, and to which those publishers retain the copyright:

'Why Paintings Matter: Some Phenomenological Approaches', *Journal of Aesthetics and Phenomenology* 4/1 (2017): 1–14. published by Taylor and Francis. doi: 10.1080/20539320.2017.1319628.

'Understanding Paintings: The Icon as a Paradigm', *Religion and the Arts* 22/5 (2018): 598–621, published by Brill. doi: 10.1163/15685292-02205002.

'On Painting and Its Philosophical Significance: Merleau-Ponty and Maritain', *International Philosophical Quarterly* 59/2 (2019): 137–54, published by the Philosophy Documentation Center. doi: 10.5840/ipq2019311129.

I haven't included any illustrations in this book, though I refer to quite a variety of particular paintings. One advantage of the internet age is that images of a vast number of paintings are available at a click, and I hope readers will seek them out and check my discussions of particular paintings against them.

Introduction

This book is a philosophical inquiry into the value of paintings—why they matter to us, or rather why (or whether) they *should* matter to us.[1] It is, therefore, a normative inquiry, not just an exercise in descriptive psychology. In this Introduction I will briefly explain the nature of the question I am asking, describe my approach to answering it, and give a brief overview of the structure of my argument.

I

One possible way to think about why we should value paintings would be to take that question as a special case of the more general question of why we should value art—where 'art' is taken to include music, literature, etc. as well as the whole range of the visual arts—and start by trying to answer that. However, this is not the route I shall be taking. The question 'Why should we value art?' is so broad that it threatens not only to become unmanageable, but also to lead us away from attending to what is specific—and specifically interesting and valuable—about the various different forms of art. Moreover, trying to think about the value of art in general inevitably raises the prior question 'What *is* art?' This question has occupied much of philosophical aesthetics and is regularly raised in the wider culture each time some curious new installation wins the Turner Prize or whatever ('Is *that* art?'), but I suspect it is unanswerable. The attempt to define a controversial notion has often produced good philosophy en route but has rarely, if ever, culminated in the achievement of a satisfactory definition of the concept at issue. And although much interesting work in aesthetics has been stimulated by the question 'What is art?', I fear that the concept is, or at least has become, so vague and indeterminate that any answers to it will be either so broad as to be

[1] The primary question is 'Why do paintings matter?' not 'Why does painting (the activity) matter?' One might commend the activity of painting for lots of reasons—as a pleasant pastime, because it encourages one to look closely at the world around one, etc. But my concern is with why we should value paintings; the activity of painting, from this perspective, is primarily of value because it produces objects that are of value (paintings). One can, of course, also use 'painting' to refer not to the activity but to the art form (painting, as distinct from, e.g., music or literature). So I will sometimes pose my question as 'Why does painting matter?', referring to the art form. (I hope the context will always make my meaning clear enough.) And when I refer to the 'value' of paintings in what follows, I will always be talking about their intrinsic worth, what it is about them that we should care about, not about the monetary 'value' that might get attached to them.

Painting and Presence: Why Paintings Matter. Anthony Rudd, Oxford University Press. © Anthony Rudd 2022.
DOI: 10.1093/oso/9780192856289.003.0001

unhelpfully vague and indeterminate themselves or else too narrow to avoid numerous counterexamples.

One virtue of concentrating on painting, by contrast, is that we do at least have a rough intuitive idea of what a painting is. I'm not saying our idea is anything *more* than rough and intuitive, and there are still controversial borderline cases. I will not be attempting a *definition* even of painting, but I do think there are enough paradigm cases of the sorts of things we call paintings, and they have enough commonality, to give us an adequate grasp of the notion of a painting for current purposes. It is also worth noting that not only is the concept of painting obviously narrower in some respects than that of art, but it is also in some (other) respects broader. That is, the current concept of art is a fairly recent and specifically Western invention; there are many objects that are indisputably paintings that would not have been understood by their creators or initial audiences as 'artworks' but rather as, for example, devotional artefacts. One advantage of considering the concept of painting rather than that of art is that it can help us avoid questionable assumptions that may come from thinking of a painting as essentially a 'work of art' in the modern Western sense (however vague that sense may be). Having said that, it would, of course, be silly to deny that there are important similarities between painting and what we think of as the other arts. Much of what I say about the value of painting will, I think, be applicable to sculpture; some of it will apply to other visual arts; and some of it may apply also to the non-visual arts. So I will feel free at various points to consider and make use of discussions of sculpture, or of the visual arts, or even of 'art' generally. I should also note that, although I do not provide a general theory of 'art', I do discuss at some length one topic in the field of aesthetics apart from that of painting. For reasons which will, I hope, become clear as I proceed, my theory of why paintings matter cannot be completed without considering why our aesthetic appreciation of the natural world matters. So in Chapters Eight and Nine I will try to show that at least some main aspects of my theory of painting can be applied in thinking about the aesthetics of the natural environment. But even this discussion makes no attempt at completeness and exists for the sake of rounding out my account of the value of painting.

Within the field of painting, though, my account is intended to have a very broad scope; I want it to apply across different times and across different cultures. I don't deny that there are *many* good answers that might be given to the question of what value paintings have, some of which may be specific to a particular culture, a particular tradition. Some are certainly specific to some kinds of painting and not others. We might appreciate a Bruegel for its lively storytelling, without supposing that all paintings ought to tell stories or disparaging, say, a Rothko for failing to do so. But I do believe that, beyond these specifics, there is something universal about what we respond to in (good) visual art and particularly in painting, a value that can be found, universally, in (good) painting

as such.[2] I have no a priori proof of this; call it either a statement of faith or a working hypothesis. My aim is, by considering some particular kinds and traditions of painting, and associated traditions of theorizing about what those kinds of painting are trying to do, to bring some universal structures to light. Of course, there can be no question in a book of this kind of attempting a survey of painting from all places and times, even if I had the competence to do so. I have, however, tried to range reasonably widely in the kinds of both painting and theorizing about painting that I consider, from Eastern Orthodox icon painting to classical Chinese landscapes to the high modernist art of late nineteenth-/early twentieth-century Europe—together with contemporaneous theorizing about all these traditions. No doubt this choice of examples reflects, to some extent, my personal tastes and interests; it certainly reflects my own cultural/historical perspective as a 'Westerner' writing in the early twenty-first century. But none of us has a 'view from nowhere'; we are all always culturally, historically—and personally—situated in a wide variety of ways. This does not, I think, condemn us to relativism or make it impossible for us to find genuine cross-cultural and cross-historical universals. But they will only show up to us from the different particular perspectives that we inhabit. Since I cannot claim to have any a priori method that can ensure that I will find the universal values I am looking for, the only way in which an account such as the one I will be offering can be validated is to ask my readers to work with it and see whether they find it illuminating, to consider whether my account makes sense of their experience of paintings and why they matter to them. But although I cannot guarantee in advance that a universal answer to the question why painting matters can be given, I can also see no reason to rule the possibility out in advance.

My account is intended to be applicable both to different places and to different times. Much (Western) art history has rightly been criticized for a Eurocentric bias, as if the history of art was basically the history of Western art;[3] but it has also often offered teleological readings of the history of art (even within just the Western tradition) which downplay the achievements of one time in relation to

[2] It may be wondered whether I am trying to understand what is valuable about paintings generally, or what is valuable specifically about good or great paintings. I don't see these as separate questions. Obviously, we do value different paintings more or less; some we may positively *dis*value. I will mostly start from considering our experience of good paintings—ones we rightly appreciate, admire, are moved by, etc. In reflecting on what we do appreciate about them, we can understand what it is we appreciate, though in a lesser degree, about less good painting—and what is lacking in paintings that are downright bad. Of course, this is complicated. (I think some paintings are definitely better or worse than others, but that doesn't mean that we can arrange them all on a tidy quantitative scale, and one painting may be better in some ways than another but worse in other ways.)

[3] For instance, Gombrich's classic *The Story of Art* (Gombrich 1978) has (after a couple of introductory chapters on 'primitive' art) only one further chapter on non-Western art (10 pages out of a total of 490). Gombrich's book is wonderful and fully deserves its classic status; the only problem with it is that its title should have been *The Story of Western Art* (or *The Story of Western Art with Some Brief Comparative Notes on Other Traditions*).

those of other, more favoured times. Vasari saw the history of painting reach its culmination in the achieved perspective technique and (idealized) naturalistic depiction of the High Renaissance, and he admires earlier painters mainly for their contributions to the development of those techniques. Their works were impressive for their time, but for us they are to be admired mainly as steps on the way to the achieved perfection of Leonardo, Michelangelo, and Raphael.[4] Four centuries later, Clement Greenberg argued that the defining characteristic of painting was its presentation of two-dimensional arrays of colour and line and that, through the history of modernism from the late nineteenth century on, it had finally come—in Greenberg's own time and place, mid-twentieth-century New York—to eschew representationalism and fully embrace this painterly essence.[5] And although postmodernism has been influentially characterized as a scepticism about such grand narratives,[6] the very term implies just such a narrative—one that has been enthusiastically fleshed out by many postmodern theorists. According to *this* story, we have now passed through and beyond Greenberg's modernism, so that not only representation, but also notions such as meaning, presence, and artistic greatness have been exploded or undermined, rendering the kind of high modernist art Greenberg admired an impossibility for those attuned to the zeitgeist. There are, of course, also reverse teleologies, narratives of decline. Arthur Pontynen, for instance, argues that from the Renaissance—even the later Middle Ages—onwards, art has been falling away from the classical ideals that are proper to it and that this decline has merely accelerated through modernism and postmodernism.[7]

I should say that I have no knock-down, in-principle argument against teleological theories of art in general or painting in particular, but I do find them highly implausible. What motivated me to embark on this project was the desire to understand my own experience of paintings as gripping, fascinating, revelatory;[8] and I find many different paintings, from different ages and from different cultures equally powerful and moving. And I can't arrange the art I admire into any tidy teleological scheme. Of course, there *is* what one might call localized teleology in the history of art; one can certainly trace the development of particular techniques or the ways in which painters responded to changing social and historical circumstances. But I can see no reason to think that the history of art shows us any overall trajectory in terms of aesthetic worth, though there are certainly *localized, particular,* true narratives of increasing achievement or decline.[9] It is, therefore, I think, dangerously misleading to look at art from the

[4] See Vasari 1991. [5] See in particular Greenberg 1988 and 1995. [6] See Lyotard 1984.

[7] See Pontynen 2017.

[8] Obviously, I hope I have been able to do so in a way that is helpful to others who want to understand their experiences of that kind. A reader who has never had any such experiences will, I'm afraid, not be likely to get much out of this book.

[9] For example, the development of eighteenth-century British painting towards the achievements of Constable and Turner, and its decline from this high point during the nineteenth century.

perspective of one moment in its history and see everything else as either leading up to or declining from that point. (It is perhaps most dangerous when that moment is *now*.) Of course, these teleological schemes are often motivated less by an interest in history per se and more by a concern with advocacy; they are concerned to point the way forward for contemporary artists.[10] I take it to be obvious that we (rightly) admire the art of the past—from many different cultures, from many different eras—and that we admire it for itself, not just because we can see it with hindsight as a step on the way to something else.[11] We also (rightly) admire it whether or not its style is one that can plausibly be taken up and continued by contemporary artists or directly influence them. I have no advice to offer contemporary artists and no speculations about where art should go from here, or whether indeed art (or painting specifically) is now dead (a thing of the past). But even if it is, we have over the centuries and up till today, accumulated a lot of artworks (paintings in particular) which we rightly continue to admire; and it is this admiration that I want to understand.

Although my concern to find a universal answer to the question of why paintings matter may make this project fairly ambitious in a way, it might still seem, philosophically speaking, a rather limited one (whether that is for better or for worse). Aesthetics is usually considered a rather marginal and optional part of philosophy generally, and the philosophy of painting is just one corner of aesthetics. But I think Merleau-Ponty was right when he said that 'Every theory of painting is a metaphysics',[12] and I will be arguing that an adequate understanding of the value of painting has implications for our understanding of value in general and its metaphysical foundations. One of the morals of the story I will be telling is that one cannot understand why paintings might matter without a broader understanding of why, or in what sense, *anything* might matter. So this exploration of the significance of painting opens out into broad fields of value theory and metaphysics. (Part Three of the book is largely concerned with these topics.) In this sense, the book indeed has a philosophically rather ambitious scope (again, whether that is for better or for worse). And this conviction that the value of painting can only be understood in the context of the wider metaphysics of value underlies this book's concern with the relation of art and religion. It is not, I will be arguing, an unimportant or merely contingent fact that so much painting (and visual art generally) was, historically, religious in character. I do take seriously H.-G. Gadamer's striking (and to some, no doubt, shocking) claim

[10] Bell 2017: 168 notes that 'Greenberg's grand historical scheme, like others before it, swung between description—this is the direction painters just happen to have taken—and prescription—this is the direction that any painter who is serious about art must from now onwards take.' I suspect that the prescriptive element has almost always been what has chiefly driven such accounts.

[11] Of course, there's nothing wrong with being interested in it for its place in history (art history or history more generally); but if the work is any good, then its historical significance doesn't exhaust our interest in it.

[12] Merleau-Ponty 1996b: 132.

that 'Only the religious picture displays the full ontological power of the picture ... the religious picture has an exemplary significance.'[13] I think this gives us an important clue for how to think about the value of painting, and I do follow its suggestion that there are important things that we can learn about painting generally from considering specifically religious painting. Whether this means that all painting has (intentionally or otherwise) some sort of religious significance or simply that there is a helpful *analogy* between religious painting and painting generally will be a central issue for this book.

II

In this section I will briefly describe my methodology. Discussions of methodology usually tend to be rather unexciting, but I think it may be useful to set out explicitly the kind of approach I will take in pursuing this inquiry and to make clear the philosophical tradition in which it largely stands. I think the best way to explicate the value of paintings is to start with our first-person experience of the value of paintings, of looking at paintings and finding them *worth looking at*—being moved by them, fascinated by them, charmed by them, and challenged by them.[14] In other words, it is a *phenomenological* inquiry—which is simply to say, an inquiry into what it is like, from a first-person point of view, to experience paintings as mattering, as being of value. Moreover, as a normative inquiry, it doesn't just take that experience as a datum which we might then try to explain in objective causal terms, appealing to psychology or sociology. Rather, it sticks with that experience and tries to see what it is about those paintings that becomes apparent to us when we experience them in that way—as mattering.

It might be thought that there is a tension between this first-person experiential approach and my stated concern to reach conclusions about essential, universal structures. One reason for thinking this might be the assumption that to report on first-person experience is simply to describe what is going on in one's own mind, and, in particular, that emotional responses such as I have mentioned above can only be purely personal, subjective feelings. So one might ask how universal conclusions can be drawn from one person's experience. How can I argue from what matters *to me* about painting to what matters about painting as such? But one might also ask how universal conclusions can be drawn even *within* one person's experience. There are a great many paintings in the world, and no one has seen more than a small sample of them. So even if all the paintings I have

[13] Gadamer 2004: 137.

[14] Of course, someone might find a painting worth looking at without that sort of emotional involvement, perhaps because he or she might get some useful information from the painting. But that (as I will explain in Chapter One) is not the sort of valuing I am concerned with.

seen and appreciated have a common feature (A) which seems to be what makes them matter, how can I generalize from such a small sample and claim that A is what makes *all* paintings have value—or even just value for me? Might not the next painting I see appeal to me for some quite different reason (B)? (This is just an application of the old philosophical problem of induction—Hume's problem—to this case.)

In response to these issues I should note that my approach is not merely phenomenological (first-personal) but Phenomenological—that is, it follows, broadly speaking, the understanding of the significance of such first-personal inquiry characteristic of the self-conscious philosophical movement known as Phenomenology, founded by Edmund Husserl in early twentieth-century Germany and still flourishing today. What Phenomenology attempts is not a kind of inductive hypothesis formation, but an 'intuition of essences'. This approach attempts to discover, through careful attention to some particular experiences, essential features of experience and/or the objects of experience. It claims that 'We can intuit, or make present to ourselves, not only individuals with their features, but also the essences that things have.'[15] It is important to note that 'intuition' here simply means attending carefully to something so as to note what it really is. It does not refer to the exercise of a mysterious sixth sense: 'the idea is not that we, by mere gazing passively at the object, can obtain infallible insights into its invariant structure.'[16] Rather, we actively reflect on what is essential to its being what it is or having the effect that it does. This may involve 'eidetic variation', whereby we imaginatively alter the features that something has in order to see what it can and cannot lose without losing its identity. For instance, 'We can see not only that material objects interact causally with their surroundings, but that they must do so; without the possibility of such interaction a material object would not be what it is.'[17] Clearly, this cannot be a matter of discovering that *this* material object can causally interact, and so can that one, and so can *that* one, and then concluding that maybe they all can. Such an inductive procedure could never reach the certainty that we do have about that universal claim.

For an example that is slightly closer to the subject matter of this book, consider the value of persons. If I say that all persons have absolute value, this is not because I have considered *this* person and discovered that, as a matter of fact, she has absolute value, and then considered *that* person and concluded that so does he, and then, after a bit, formed a tentative inductive hypothesis that maybe all persons have absolute value. Rather, one experiences in each instance that human beings as such have absolute value.[18] There is at least some similarity in our

[15] Sokolowski 2000: 177. [16] Gallagher and Zahavi 2012: 30.
[17] Sokolowski 2000: 177.
[18] See Grenberg 2013 for an argument that Kant's ethics of respect for persons is not, as often supposed, based on purely formal considerations, but on an appeal to experience—however, phenomenological, *not* 'empirical' experience. For this crucial distinction, see pp. 16–17, 40–6.

thinking about the value of paintings. In experiencing this painting as valuable, moving, or enthralling, I get a sense of what it is that matters about painting generally. I might then try to think of a painting that is in a very different style, from a very different time and place, but which I also respond to positively as having value, as mattering. There will no doubt be very different things about the two paintings that I value—maybe the vibrant colours and bold, simplified shapes of the one and the intricately detailed monochrome drawing of the other. But is there some commonality between the ways in which I respond to them as paintings, a response to something they are both doing, albeit in their very different ways, that is distinctive, and different in kind from the ways in which I might respond, say, to a piece of music or a poem? If it seems there is, then I am starting to get an understanding of what is essential to paintings, or of why paintings matter.

This phenomenological method does make some metaphysical assumptions.[19] In particular, it assumes that essential, universal structures are there to be found—in our experience and in the objects of our experience.[20] This can be and has been challenged.[21] But that claim is not a dogmatic one. Phenomenology starts with the assumption that there are (or even just that there may be) such structures to be found, and justifies that assumption by uncovering them in experience. There is a circularity here, but it will only seem vicious to those who insist on a strict epistemological foundationalism as the only possible alternative to scepticism. However, even if we set aside radical scepticism about whether there are essential structures to be found at all, one may still be sceptical about particular claims to have found them, and such more limited scepticism will sometimes, of course, be justified. The Phenomenological procedure makes no claim to be infallible. It's easy to mistake what one personally finds striking about something for an essential structure of that kind of thing. This is what can make it seem plausible to claim that phenomenological investigation can only give a sense of how things seem to me, not how they really are (the first worry I mentioned above). But first-personal experience is not just an introspective report on the contents of my mind; it is my window onto the world beyond me. (One of the central claims of Phenomenology is that conscious experience is *intentional*—which is to say,

[19] If Husserl, the founder of Phenomenology, thought he was creating a 'rigorous science' so pure as to be without presuppositions, he was mistaken. But few of his followers have held to such ambitions.

[20] Whether Phenomenology is about the essential structure of our experience (and therefore of external objects only as they appear in our experience) or about the essential structures of things themselves has been a major bone of contention within Phenomenology. I do take Phenomenology in a broadly realist sense, while trying to avoid too naive a realism. This issue will be discussed at various points in what follows.

[21] For example, by those I would call radical postmodern nominalists (such as Foucault and Deleuze—also Derrida, as he has been widely, though perhaps not most accurately interpreted) for whom all apparently essential structures are contingent human projections—or maybe not even *human* projections, but the passing configurations of autonomous sign systems.

directed towards an object; experience is always *of* something.[22]) That I experience material objects as such as necessarily open to causal interactions with one another is not just a quirk of my personal psychology; it is a genuine insight into how things are in the world. And so, I would claim, is my experiencing persons as such as having absolute value. But here, of course, there is a real possibility of disagreement, as there is not in the material object case. Someone may experience persons as worthless or a particular group of people as having less worth than others. And I am committed to claiming not just that the sociopath or the racist is making an intellectual mistake but that his or her experience is itself delusive, a result of failing to attend carefully, or in the right way—a failure to really *look* at persons and see them for what they really are.

So experientially based claims about essences can be questioned and corrected. In its quest for universals, 'Phenomenology aims to disclose structures that are intersubjectively accessible and its analyses are consequently open for corrections and control by any (phenomenologically attuned) subject.'[23] In controversial cases, particularly those including issues of value, it is important not simply to stick with how things seem to oneself, even after a genuinely careful consideration. Hence, it has been important to me to collect testimonies—from critics and appreciators of art, from artists themselves, and from theorists who were contemporary with the art they described, as well as from art historians—about how they experienced paintings, what they took those paintings to be doing, and what they supposed to be valuable about those paintings. And that is also why it is important to consider a range of relevant examples of different styles and from different times and places. My aim is not to add further instances to an inductive argument, but to see whether the same essential structures do reveal themselves in all of these different kinds of case. And this is why, although my overall methodology is first-personal, this book contains a lot of historical material. The point is not historical scholarship for its own sake—although I make grateful use of such scholarship—but to make accessible a broad range of relevant first-personal experience.

My inquiry can properly be characterized, then, as a phenomenological one, and I do make significant use of work by philosophers in the specifically Phenomenological tradition, particularly Merleau-Ponty. So this book could be considered, albeit in a broad sense, an essay in Phenomenological aesthetics. I try to avoid unnecessary technicalities, though, and I proceed through dialogue with philosophers from a number of different theoretical traditions—and also with art historians and theorists and artists themselves. A huge amount has been written

[22] See, e.g., Sokolowski 2000: ch. 1; Gallagher and Zahavi 2012: ch. 6. The object of experience in question need not necessarily be something wholly mind—independent; it could be, e.g., a dream image. But even in a dream, one can distinguish between the dream experience and the dream object.
[23] Gallagher and Zahavi 2012: 28.

on all the topics I am dealing with from a wide variety of perspectives, and even in a deliberately wide-ranging book like this, it hasn't been possible to engage with more than a small fraction of potentially relevant material. I have deliberately avoided getting drawn into detailed critical discussions of alternative approaches in order to focus on developing my own positive argument. So, for instance, I note only briefly and/or tangentially some other traditions of thinking about art within 'Continental philosophy' (e.g. Hegelian-Marxist and postmodernist approaches). I do spend rather more time engaging with discussions in analytical philosophy of art. And at least some of the themes I am concerned with here could indeed have been developed through detailed consideration of debates in analytic philosophy (e.g. about art and truth, or the intrinsic vs instrumental values of art). Still, I have chosen to proceed for the most part Phenomenologically and with only sporadic attention to those analytic discussions. A comparative study of Phenomenological and analytical aesthetics would be a very interesting project and would, I think, disclose some important commonalities as well as differences, but that is not what this book is primarily attempting.

My basic thesis is much older than either Phenomenological or analytical philosophy, though. (I use Phenomenology as a method to help with explicating insights that are much older than Husserl and his school.) To put it in a nutshell, my claim is that painting matters because it is or can be truthful, that—apart from all the many particular reasons why we might value some particular paintings— good paintings in general are of value because they disclose essential aspects of reality. (This is why, as I noted above, painting has a metaphysical significance.) That this claim is not original is a merit. (If it was original, that would be a serious objection to it, for there would be something quite comically hubristic about my claiming to have discovered for the first time what makes paintings valuable.) This disclosive theory of painting has been eloquently articulated by a number of twentieth-century philosophers,[24] but, as I will try to show, the basic idea goes back at least to the Neoplatonic tradition of theorizing about art in the West, and it was also generally accepted in classical Chinese art criticism. It is implicit, I believe, in religious painting (and religious visual art generally) and was often made explicit in theological theorizing about art. So I think the correct basic answer to the question of why painting matters has been around for a long time and has been known about in many different cultural contexts. My aim in this book has been to articulate it clearly so as to make it seem accessible and, I hope, plausible to contemporary readers. But of course, although the basic idea is an ancient one, my particular version of it will have a variety of more specific bells and whistles, for which I can take rather more credit (or blame).

[24] Apart from Merleau-Ponty, my greatest intellectual debts are to Jacques Maritain and Iris Murdoch.

III

It might be helpful to the reader to have a brief overview of my line of argument. The book is divided into three parts. In Part One I raise the problem of the value of painting and sketch out the general approach to it that I will take. I find it useful to start from a critique of the arts in general (but applied to painting in particular) that goes back to Plato and which suggests that in fact the arts *don't* have positive value. My concern is not with the details or historical context of Plato's arguments in *Republic*, book 10, but with the central and enduring challenge that they raise, namely that painting (art generally) does not lead us to the True and the Good, and may take us away from them. (Modern version of these criticisms can be seen, for instance, in contemporary discussions which assume that only science can get us to the truth and that art is merely entertainment or decoration, and in recent political critiques of the arts.) My project is to see if this Platonic Objection can be answered in its own terms, by showing that painting is good because it does lead us to truth. (In broad outlines, I follow Iris Murdoch's response to the Platonic Objection, though her specific concern is more with literature than with painting. In a sense the book could be said to develop a broadly Murdochian account of painting.) I trace the history of the idea that painting (or the arts generally) can provide us with significant truth up to some contemporary Phenomenological discussions and argue that the kind of truth that paintings make available to us must be non-discursive; it cannot be adequately paraphrased in any non-visual medium. Knowledge of such truth is, therefore, a kind of knowledge by acquaintance.

The theory of painting is set out in detail in Part Two, where I develop a fuller account of the kind of knowledge by acquaintance that painting provides. I take up the term 'presence' which has been used by various art critics and theorists to indicate a particularly intense or charged way in which we can experience artworks as communicating with us. Paintings make themselves present to us, but in so doing they also make something else—their subject matter—present to us in a way that discursive representations cannot. (I argue that this is true in a sense even of abstract or 'non-representational' paintings.) In developing this understanding of paintings as revelatory or disclosive, I follow the claim by Gadamer mentioned above that religious painting is 'exemplary' for painting in general in that it makes clear that the painting doesn't just mimetically represent its subject matter, but is in 'ontological communion' with it. Following this lead, I consider the theology of the Eastern Orthodox icon, which is understood not as providing a naturalistic likeness of a saint, but as bringing the devout viewer into the presence of sanctity. I also note parallels in other traditions—in Hindu religious sculpture, but also in the apparently more secular tradition of classical Chinese landscape painting. There too the aim of the painting is not simply representation, but to bring the viewer into communion with a normatively significant order, the elements of which are not so much depicted as evoked in their essence.

Is this traditional religious-metaphysical understanding of painting relevant to modern secular art, though? I argue that it is, through a close reading of Merleau-Ponty's essays on painting, especially 'Eye and Mind'. I try to show that Merleau-Ponty articulates there a view of art as disclosive, as revelatory of the essence of things. What painting shows us (e.g. what Cézanne shows us of Mont Sainte-Victoire) goes beyond and is irreducible to any discursive knowledge (e.g. from geology). I go on to argue that this disclosive view of painting, which focuses on the relation of painting to its subject matter, needs to be supplemented by considering the sense in which painting is expressive—both of a painter's subjectivity and of the wider culture to which the painter belongs. Painting never makes things present to us absolutely, but only as they resonate with and thus find expression through a particular sensibility. I also emphasize what we might call the truth in formalism—that the way in which a painting discloses and expresses whatever it does is done only in and through the visual presentation of formal elements. Throughout I make a point of attending to statements by artists—including Matisse, Kandinsky, Klee, and Hepworth—as well as philosophers of art, and considering examples of particular paintings.

Part Three is concerned to explicate and defend the metaphysical implications of this theory of painting. I argue that the essentialism and the idea of non-discursive knowledge which it involves are philosophically defensible and not particularly extravagant. However, if it is to explain the *value* of painting, the theory needs to explain not only the connection of painting to the True, but also to the Good; it must explain, that is, why the particular kind of knowledge by acquaintance that painting provides is good to have. I argue that it can only do this if what painting discloses—the essences of things, the order of nature—is itself good. But this is, in fact, what we experience, not only indirectly through painting, but directly in the aesthetic appreciation of nature itself. To experience nature aesthetically is to experience it as being valuable, as having an ontological goodness—however problematic it may be to relate this to a notion of *moral* goodness. So—as seems right if we are to answer Plato's critique—the Beautiful (i.e. positive aesthetic value), the True, and the Good must all come together. Painting cannot be of value unless it is a response to the real value of the broader order of things. So an adequate account of the value of painting—and of the aesthetic appreciation of nature—requires us to repudiate the modern picture of a 'disenchanted' value-free world. In the final chapters I consider whether or in what way this 're-enchantment of the world' can be considered to be religious in character. In so far as it can, then the icon is exemplary for painting in general not only in a weak sense (there is a structural parallel between the way an icon makes a saint present and the way in which any painting makes its subject matter present) but also in a stronger sense—that what all painting discloses is, in a sense, something sacred and that painting itself, therefore, is a sacred, even a quasi-sacramental act.

PART ONE

Chapter One
Do Paintings Matter?
The Platonic Challenge

Why do we value paintings? We hang paintings on our walls; some that are deemed especially worthy are placed in museums and galleries, and large numbers of people go to those institutions to look at the paintings they contain. Some paintings are sold for stupefying sums of money. Educators try to encourage young people to appreciate paintings. Some people, of course, give the paintings they see only a casual glance or treat them as decorative backgrounds, or stop by the *Mona Lisa* just long enough to take a selfie; but others will spend a considerable amount of time looking intently at a single painting and find it very worthwhile to do so. And some, of course, find it worthwhile to create paintings and may find the activity of painting very satisfying, even if the results are fairly mediocre. We should perhaps be more surprised at these things than we usually are.

I

So why do we value paintings? Perhaps there is no one answer. And perhaps part or even all of the answer is a debunking one. Our culture tells us that the *Mona Lisa* is an important painting (or an important cultural object), and so we go and take selfies in front of it to show that we've been there. But—even when the debunking explanations are fleshed out a bit more—it seems implausible to suggest that that sort of thing is *all* there is to the appreciation of painting. Certainly, what we appreciate and how we do so are culturally conditioned in all sorts of ways, and certainly people can be pressured into feeling that they ought to give a nod of approval to culturally significant objects. But it doesn't follow from that that all art appreciation is just cultural conformity or that it is just arbitrary that we treat *painting* specifically as a culturally significant practice (as though we might equally well treat any practice in that way). It is certainly and importantly true that the way paintings are treated in modern Western culture (our hanging them in dedicated galleries, etc.) is far from being a historical or cultural universal and that, indeed, the concepts of 'art' and of 'the aesthetic' are relatively recent ones. But people have been making decorative patterns and/or representations—object which exceed the strictly utilitarian and which are intended to appeal to, please, or engage the senses—since there has been what we can recognize as

Painting and Presence: Why Paintings Matter. Anthony Rudd, Oxford University Press. © Anthony Rudd 2022.
DOI: 10.1093/oso/9780192856289.003.0002

human culture (the Lascaux caves); and such making has, I think, gone on in every culture we know of. Painting, specifically—at least in the broad sense of making two-dimensional images that suggest three-dimensional objects[1] (and setting aside for now issues concerning abstract art)—is, if not universal, at least very widespread in space and time. And as Paul Crowther notes, 'It is true that the concept of the "aesthetic" is a modern western one, but it is, in large part, derivative from the more universally distributed concept of *beauty*—in the sense of that whose visual appearance is found fascinating in its own right.'[2]

It seems fair to say that—across cultures—much, and probably most, of what we now classify as visual 'art' and put in museums, originally existed in and was created for a religious context. This is obviously true of European painting before the High Renaissance. Only since then has painting been seen in the West as something to be valued 'aesthetically', simply for its own significance—and only since then has the painter in the West been regarded as a culturally significant, creative figure, rather than simply as an artisan. (It should be noted, though, that these transitions had been made centuries earlier in China, by Tang dynasty (607–918 CE) times at the latest.) But what we should be struck by is that all these different cultures whose religious artefacts now get classified as art had felt it religiously important to make and contemplate objects which had an 'aesthetic' appeal in the literal sense—that is, which struck, engaged, attracted the senses (especially for our purposes, vision). One might indeed argue about whether religious objects were really aesthetic all along (people who contemplated them were satisfying aesthetic needs while they believed they were satisfying religious ones) or whether, even now, 'aesthetic' objects are really religious ones (and that people who contemplate them are satisfying religious needs while they believe they are satisfying aesthetic ones). Perhaps this antithesis is too sharp or isn't formulated quite correctly, but the relation of art and religion is an issue which is inescapable for anyone who takes the history of art seriously, and I will be returning to it. In any case, even if the concept of 'art' in the modern West is relatively new and local, people have felt it important to make and to contemplate visually engaging images down the ages and across very different cultures—and this is something that is worth trying to understand.

And yet the value of painting—why it matters to us—seems to be an underexplored topic. Crowther complains, with considerable justice, that philosophical discussions of art tend either to post-structuralist reductionism (which focuses with debunking intent on the hidden sociopolitical agendas expressed by artworks) or to the explication of aesthetic concepts with which

[1] Please note that I am presenting this as a rough general characterization and not as a watertight definition.

[2] Crowther 2009: 16. I will have more to say about this formulation below. Obviously, as it stands, it is a definition of visual beauty, rather than beauty per se. It could be modified easily enough to cover, say, musical beauty; mathematical beauty would be more complex.

analytic aestheticians are mostly concerned but which often doesn't encourage the question of why artworks *matter*.[3] And where philosophical theories of art do try to give accounts of the value art has, they often tend to intellectualize in a way that seems to leave something crucial missing. In this connection it is interesting to note a very revealing remark by Arthur Danto, whose theory of art was largely shaped by his reflections on recent minimalist and conceptual art, and who saw art as a form of para-philosophical inquiry:

> I think living in New York in the mid-to-late twentieth century has been to live in a philosopher's wonderland, for the artworld threw up example after example of the most astonishingly conceptual sort...But I am...a lover of fine painting and I cannot claim that I love the art that has occasioned my philosophy with anything like the intensity or in anything like the same way in which, for example, I adore the Dutch masters. Aesthetically, I suppose, I might be willing to trade it all for Giorgione's *La Tempesta*. But, unlike the law, good philosophy is generated by hard cases. And good philosophy of art by monochrome red squares and *Brillo Boxes*.[4]

Danto's own work shows that interesting philosophy of art can be generated by the works that even Danto cannot really love. What *I* am trying to understand, though, is the aesthetic value that the Giorgiones and the Dutch masters (and many other paintings—and not just Western ones from the Renaissance-and-after canon) have; what it is about them that Danto (rightly) responds to with *love*. And I am convinced that this cannot be a side issue but must be central to understanding why we should value those paintings.

As for art history, much of it encourages its students to adopt a detached, unemotional stance, to learn about points of technique, historical context, how to decipher symbolism, and so forth. This is often very interesting, but something more immediate, more visceral, about our response to paintings may get overlooked by this approach—or may even be inhibited by it. One distinguished art historian who thinks this is the case is James Elkins. He describes the intense effect that seeing Bellini's *The Ecstasy of St Francis* in the Frick Collection in New York had on him as a teenager:

> I loved...the diffusion of sacredness, the rapt attention Bellini had paid to every detail...*The Ecstasy of St. Francis* is an entire world where every twig and thorn has its measure of holiness...I was transfixed by a world where every ordinary object glinted in a half-sacred light.[5]

[3] See Crowther 2009: 1–2. [4] Danto 1993: 198. [5] Elkins 2001: 82, 83, 84.

But, he goes on, 'that was then and this is now. Now I feel almost nothing for the picture...I put the blame for this squarely at the feet of art history.' His attraction to the Bellini was 'one of the reasons I eventually went on to study Renaissance art. Yet each time I learned something new, I lost a little of what I had felt before.'[6] I don't want to believe that learning all the very interesting things that art history has to tell us about paintings must *necessarily* inhibit or undermine our deep emotional response to them. But scholarly art historians often don't exactly seem to encourage such responses—as Elkins laments at various points in the deeply interesting book from which I have just quoted, and to which I shall return.

Where art history and theory are not focusing on technical and contextual issues, they often seem primarily concerned with sociology and social history, with what the painting can tell us about the society in which it was created and appreciated. (And much of this work is done in a debunking spirit—setting out to expose the bourgeois, patriarchal, etc. ideological subtext of the picture.) All of which is certainly legitimate in principle and may be more or less well done in practice, but it does not encourage—it may even actively discourage—the intense personal experience of the painting as beautiful, wonderful, terrifying, consoling, absorbing: as speaking to us, making demands on us. And yet the fact that paintings can evoke such kinds of response is surely a major part of the reason why we have paintings at all, why we have galleries, or why art history is taught. This inquiry will be an attempt to think about the ways in which we experience paintings as mattering to us in this emotionally intense, personal way.[7] Its approach will be neither psychological nor sociological—that is, it won't be developing empirical hypotheses about why certain people in certain cultural contexts may have experienced paintings in certain ways. It will, rather (as I mentioned in the Introduction) be phenomenological—that is, it will attempt to enter from a first-person point of view into the experience of paintings as mattering, as having value, as affording experiences that in some way enrich us (perhaps by deeply disturbing or challenging us). And (as I also mentioned in the Introduction) I think that reflecting on why pictures are of value to us is not a purely self-contained inquiry within the philosophy of art but can tell us important things about who we are, what our way of being in the world is, and what value is.

[6] Elkins 2001: 84–5.

[7] An assumption I am making throughout is that the emotions are, or can be, cognitive. They are not purely subjective discharges of intellectually irrelevant feeling but are ways of apprehending the world that can be assessed as appropriate (or inappropriate) to the objects or events that occasioned them. And indeed, some things can only adequately reveal themselves through a certain emotional response. (If you didn't respond to this act of cruelty with horror and pity, then you didn't understand what it was.) That an emotional reaction may be a way of knowing something has been extensively and effectively argued in recent philosophy; see, e.g., Goldie 2000; Nussbaum 2003; Furtak 2018.

II

In considering what the value of painting might be, it is useful to have to respond to the suggestion that it might not have any. So I will start with the first great challenge in the Western philosophical tradition to the value of the arts generally—that presented by Plato in book 10 of the *Republic*, which remains, I think, of much more than just historical interest. Plato's main target was epic and dramatic poetry, but his critique is of *mimesis*—imitation—generally, and he approaches poetry through an explicit consideration of painting. In books 2 and 3 of the *Republic* Plato had Socrates propose that the education of the guardians in the ideal city should include mimetic poetry, but, because we are shaped by what we imitate, the poetry in question should be strictly censored so as to ensure that it had good rather than corrupting effects.[8] In book 10, however, he claims that the arrangements for the ideal city should involve banning imitative poetry altogether.[9] He goes on to give a metaphysical argument against *mimesis*, taking painting as an example. The painter merely imitates, produces a copy of, a physical thing (and actually a copy of the thing only as it appears from a particular perspective, in a certain light, and so on). Moreover, that physical thing is itself merely an imitation or copy of its Form. For Plato, the Forms are timeless, immaterial essences. The particular physical things we see around us are what they are because they imitate or 'participate in' the Forms, but they always fall short of them. So Socrates criticizes representational art because it copies physical things which are themselves already imperfect copies of the Forms. Forms are what we should be looking for if we want real knowledge, but they are objects of thought, not of sense perception, and can therefore only be accessed through reason, not through visual representations. Imitation thus takes us further away from reality rather than closer to it.

Although Socrates sees painting as trivial, he doesn't suggest banning it. Mimetic poetry—and he has in mind mainly Homer and the works of the tragedians—*should* be banned, as it is not only trivial but corrupting. It seduces us by its charms (of which Plato was vividly aware) into false beliefs—about the gods, about what is really good or evil—and into adopting false attitudes. The poet, like the rhetorician or the sophist, manipulates us by playing on our emotions, rather than encouraging us to think hard about what is really true and good. But although Plato doesn't explicitly do so himself, we can certainly see how this part of his critique could also be extended to painting. Vivid images, like cleverly chosen phrases, can seduce and mislead. For instance, someone seeing a

[8] Plato, *Republic* 377a–402a.

[9] Plato, *Republic* 595a. This still leaves 'hymns to the gods and eulogies of good people' (607a: Plato 2004: 311).

painting of Zeus (or the Christian God) might be tempted into thinking that Zeus (God) really is a spatially limited, human-like being.

It is important to see that Plato's arguments are not just of historical interest; in fact he gives us the prototypes for two kinds of argument against art (or against the idea of art having a deep value) which are both still very much current, even amongst people who are far from being Platonists in their general outlook. The first could be described as 'rational' or even 'scientific'. Its contemporary proponents may have no objection to painting (or to the arts in general) as entertainment or relaxation, but they would claim that from the point of view of the search for truth, art is trivial; it just entertains, rather than giving us insight into how things really are. One can make this case even if one doesn't believe in Plato's Forms or anything like them. Indeed this sort of view is mostly taken these days by scientific naturalists, who would contrast the superficial appearances that art presents with the deep structures that science investigates. Science is the road to truth; art is merely subjective.[10] The second kind of argument is moral and/or political— the arts may make us delight in bad things and can corrupt their viewers. Again, arguments of this kind are still very much current. People are sexually aroused by pornography and men (in particular) may be led by pornographic images to look on women (in particular) as mere sexual objects. A vivid propaganda image may influence people to adopt simplistic and malign political attitudes, and it may exercise far more persuasive power than any amount of rational argumentation. And even if the vivid images actually influence people to vote in the way that the rational arguments would point to, a healthy society is surely one where people vote the right way for the right reasons, not because they have been manipulated to do so. Of course, a critique of, for example, pornographic or politically manipulative imagery need not generalize into a critique of the arts as such. (Nor need a defender of the arts reject these more specific criticisms.) But other political critiques of painting, or the arts generally, have claimed that beautiful images—even when they are not overly pornographic or manipulative—may narcotize people, distract them from the ugly realities of injustice and oppression, and insidiously inculcate ruling ideologies. Of course, even these arguments needn't claim that *all* art *necessarily* does this. But they do articulate a sense that art is dangerous, very liable to lead us astray and probably needs to be kept on a tight political leash to prevent it from so doing.[11]

These two main kinds of argument—'scientific' and 'political'—are, of course, separable. One can think that the arts are trivial—at any rate, that they have nothing to do with truth—but also consider them harmless or, indeed, for the

[10] See, e.g., the chemist Peter Atkins (1995: 123): 'Although poets may aspire to understanding, their talents are more akin to entertaining self-deception...While poetry titillates and theology obfuscates, science liberates.'

[11] See Walter Benjamin's (2002: 122) notorious claim that, since fascism has aestheticized politics, communism responds by politicizing art.

most part pleasant or even necessary as entertainment or relaxation. On the other hand, someone who maintained the second, ethico-political, critique might allow that art *could in principle* reveal truth, but would be more impressed by its ability to take us away from it. But the two arguments are, nevertheless, closely connected; in their most common forms, they both claim that paintings merely give us pleasing surface appearances which may seduce us away from what is in fact True or Good or Just. How, then, might the challenge of these 'Platonic' arguments be met? I will continue to call the arguments 'Platonic' in scare quotes, since, as I've noted above, many of those who make criticisms of these kinds now are far from being Platonists in general and also because—as I will argue below—Platonists can (and often have) ultimately rejected those criticisms. (This may perhaps even be true of Plato himself.) In considering how the significance of painting can be defended against these arguments, much of what I will say will plausibly generalize to the other arts as well; and I will consider and draw on some accounts and defences of art in general, which will need to be particularized to apply specifically to painting. I will, however, try to stay focused on the value of painting specifically and keep my references to the other arts incidental.

III

One option, of course, is to simply give in to the 'Platonic' criticisms. This would mean taking painting to be a practice which gives pleasure to a lot of people, without thinking that it does anything more profound than just that. It's simply a form of entertainment or decoration; we can enjoy what we happen to like of it, while also (depending on how seriously we take the second kind of argument) deploring (or perhaps even censoring) images which we take to have corrupting effects. On this sort of approach, if we ask, 'Why does painting matter to us?', the inquiry will be a merely empirical one—descriptive, rather than normative. It will note that, under certain circumstances, certain visual arrays are pleasing to people (or to most, or to some people). Causal explanations may be sought for this, appealing perhaps to sociological factors, or perhaps to neurological structures, or to speculations about what might have proved evolutionarily advantageous to our ancestors.[12] But in the end, it will be a matter of brute fact: we do, in fact, respond with pleasure or interest when stimulated in certain ways. Such

[12] I should say that I have no objection to neurological or evolutionary investigations into our aesthetic sensibilities per se, and such investigations need not be tied to a reductionist agenda. What I do object to is taking what we can glean from these sciences as giving us the whole story about aesthetic experience. Analogously, one can legitimately inquire into the neurological structures underlying our mathematical capacities, and into the evolutionary development of those capacities, but these inquiries cannot be taken as 'explaining' mathematical truth, let alone debunking it or showing to be a projection of the human brain.

approaches are reductionist—on these views paintings don't *actually* have value; they don't *really* matter; they just stimulate pleasant feelings in us.[13] (Or we might say that they do matter *to us*, but only instrumentally, because we happen to like having such feelings stimulated.) Such a reductionist, subjectivist approach to art would seems to undermine the possibility of serious disagreement about artworks; if this gives you pleasant feelings but fails to do so for me, what more is there to be said? Neither of us can be right or wrong, on this view, to feel what we do.

Some philosophers have, of course, tried to give subjectivist views of art which nonetheless allow for there being better or worse judgements about artworks (Hume being the influential pioneer of such moderated subjectivism[14]). But I fear that even the most sophisticated subjectivism would still fail to account properly for what is present in our experience of (good) paintings: the sense that their appreciation is an activity of real value, because it brings us into contact with something that really has meaning and worth in itself. The crucial point at stake is that the awe, wonder, delight—even fear—that I might feel while looking intently at a Bellini or a Rothko is *intentional*;[15] it is an experience of the painting itself as awe-inspiring, wonder-ful. I do think that evaluative realism—the sense that what we are experiencing is itself of value—is present in our aesthetic experiences; it is not just a later rationalization. It is true that this is not by itself a decisive argument against subjectivism; some experiences are illusory, however painful it may be for those who have inhabited them to recognize that. I do think, though, that we should stick with the experiences and take them seriously, unless we are really compelled by decisive argument to turn against them. (Experience is innocent till proved guilty.) But although I find subjectivist accounts dissatisfying, I shan't try to argue against them directly here. My project is, rather, to see whether I can develop a plausible alternative to such accounts of painting, one that is guided by our experience of paintings as having real value, rather than trying to debunk it.

Although I am looking for a non-subjectivist theory of art, it needn't be thought that the only alternative to subjectivism must be a kind of radical objectivism which would claim that what is of value in paintings is an entirely mind-independent property which they have, one that has nothing to do with our particular forms of sensibility and experience. Such an account might itself seem rather implausible. We are, after all, talking about *aesthetic* value—the value of

[13] Though such reductive accounts are popular today, they certainly aren't new. Spinoza (1992: Appendix to Part One, 61) gives a ruthlessly debunking account of aesthetic value generally: 'if the motion communicated to our nervous system by objects presented through our eyes is conducive to our feeling of well-being, the objects which are its cause are said to be beautiful, while the objects that provoke a contrary motion are called ugly'.

[14] See Hume 1996.

[15] 'Intentional' in the technical Phenomenological sense, explained in the Introduction, meaning a mental state's being directed to or about an object, not necessarily having to do with intentions in the everyday sense.

things as they look to us as beings with the particular visual senses that we have. Many recent philosophers have indeed tried to find some sort of middle way between objectivism and subjectivism. For instance, Malcolm Budd gives an account according to which a work of art is valuable because it offers someone who appreciates it with understanding an experience that is intrinsically valuable.[16] The value of the work derives from the value of the experience it affords. However, Budd insists that the experience in question is irreducibly intentional (and particular): 'it does not have a nature specifiable independently of the nature of the work'.[17] So the painting cannot be regarded as a mere means to the end of giving me a pleasant feeling, since the 'end' itself can't be characterized except by reference to the 'means'. A similar view is neatly expressed by A. H. Goldman, who says, 'The object itself is valuable for providing experience that could only be an experience of that object.'[18] Budd and theorists who share his approach also hold that experiences of artworks are not intrinsically valuable just because they feel good to the experiencer. If I respond with rapture to something kitschy or overly sentimental, then the positive intensity of my experience merely shows my poor taste. My judgement that an experience is intrinsically valuable is justified only if, as Budd says, 'there is good reason to find it intrinsically rewarding'.[19]

There seems, however, to be a circularity in accounts of this kind: the work is valuable because the experience is, but the experience is what it is (and therefore has the value it does) because of the work of which it is an experience. But in that case, doesn't the value of the experience derive from the work, rather than vice versa? If it does, though, it would be the work that is intrinsically valuable, and the value of the experience would be parasitic on that of the work. That is also, on the face of it, suggested by Budd's claim that judgements about the intrinsic worth of experiences are rational and defeasible. For if the value of an experience is not to be assessed either subjectively (how good it feels) or instrumentally (we are talking about *intrinsic* value here), it seems that its rational assessment could only be based on whether the artwork in question *merited* being experienced as valuable. So the experience can be rationally assessed only via a rational assessment of the work itself. The conclusion we seem led to is that it is good to experience artworks because *they* are good; it's not that they are good because it is good to have the experience of them.

It seems, then, that the logic of Budd's position points in a more realist direction than at first appears. However, he continues to insist that our aesthetic judgements remain 'anthropocentric' (that is, there is no reason to think that beings who lacked specific features of human sensibility would find their experiences of our artworks valuable).[20] And it is hard to deny that there is something plausible

[16] See Budd 1996: 4–5. [17] Budd 1996: 4.

[18] Goldman 2006: 339. See also Iseminger 2004. [19] Budd 1996: 40.

[20] See Budd 1996: 39–40.

about this claim. The properties we appreciate paintings for are, after all, *aesthetic* properties—that is, they appeal to the senses. But this would seem to restrict their appreciation to beings which have sensory faculties like ours. The point can be made even within humanity: blind people cannot experience paintings, and those who have purely monochromatic vision (a subgroup of those often misleadingly called 'colour-blind') will have a drastically reduced ability to appreciate many paintings (Chinese ink-on-silk landscapes would mostly be fine; Titian and Matisse would not). If one imagines a whole planet of rational beings with radically different visual senses from ours, we might have to agree that they would have no reason to value human paintings. Does that mean that they would be missing out on something that really was of value? If only they could see the Matisses the way we can! Or would it simply mean that the value of a Matisse is only a value for those who have (normal) human colour perception?

One is tempted to put the question in these terms: would a painting still be valuable even if there was no one who did or, more strongly, no one who even *could* appreciate it? But perhaps that isn't the best way to put the question about the value of artworks. They are, after all, human artefacts, created to be experienced by human beings. If they are valuable, it may be because they do something for us and they wouldn't have value without us (or beings sufficiently like us). And yet we may indeed find real value in them. G. E. Moore had a thought experiment in which he imagined an intensely beautiful planet which no sentient being would ever experience or know of.[21] He thought it obvious that a universe containing that planet would be of greater value than a universe without it. Others have disagreed. But one could question whether the reality of aesthetic (or other kinds of) value should be construed in terms of its 'mind-independent existence'. After all, we, with our minds, are parts of reality, so to assume that something is real only if it is mind-independent is perhaps dubious. Maybe beauty exists neither just in our minds nor simply 'out there' in the world but has an existence somehow between us and the world? John McDowell has argued both that secondary qualities such as colour have something like this ontological status *and* that there is a plausible analogy in this respect between secondary qualities and both aesthetic and moral value.[22] He thinks this gives us reason to question the idea that 'it is compulsory to accept the equation of the world (what is real or factual) with what is objective' in the sense of 'fully describable in terms of properties that can be understood without essential reference to their effects on sentient beings'.[23] And there is a further connection one can make here. Berkeley argued that we could not distinguish between the warmth and then heat that we feel in a fire when we

[21] See Moore 1962: 83–4. What Moore really intends—certainly what he needs in the context for his argument against Sidgwick—is that no being at all that was capable of appreciating the beauty of the planet would ever experience it.

[22] See McDowell 1998a, 1998b. [23] McDowell 1998a: 116, 114.

approach it and the pleasure and then pain that we feel 'in ourselves' as we do so.[24] Similarly, I'm not sure we can distinguish clearly between the colours we see in, say, Matisse's *Music*, and the beauty we experience them as having. The valuational qualities we experience in things may be as real as their secondary qualities.

It might still be felt that this would be a second-rate kind of reality—that beauty and colour would still both be subjective compared with the robust, mind-independent reality of primary qualities. But here we should note the argument that has been made by philosophers from Berkeley to Dummett, that it is impossible to make sense of the idea of a world 'in itself' possessing *only* primary qualities. Dummett notes that:

> Science progressively seeks descriptions in terms that do not depend, for their meaning, upon human modes of experience or upon the position of human beings in the universe…When our descriptions have been completely purified, however, all that we are and can be left with are abstract mathematical models… [For scientific purposes] this is completely satisfactory, but what has happened to our ambition to know what things are like in themselves? It is not merely incredible that what there is in itself is a skeletal abstract structure: it does not as much as make sense to say that.[25]

We are obviously getting into deep metaphysical waters here. We will need to dip our toes back into them eventually. I mention these issues now (and clearly I have done nothing more than indicate how a line of argument might be developed) only to try and loosen the grip of the very powerful metaphysical picture which suggests that the more mind-independent something is, the more real that makes it—a picture which can make it hard to think well about the sense in which aesthetic (and other) values may be real. The main part of this book will be devoted to a phenomenological explication of the ways in which paintings do show up as valuable to us in our experience. That account will be realist about their value (it will be explicating the evaluative realism that I have said is present in our experience of paintings) without necessarily committing itself to objectivism in McDowell's sense. I will then return to the question of the metaphysical status of aesthetic value explicitly at the end of the book, in Chapter Ten.

My project is, then, to answer the 'Platonic' objections to painting, to find, through a phenomenological investigation, an adequate *normative* (rather than merely descriptive or debunking) answer to the question 'Why do we value paintings?' One possibility, though, which should be noted at the outset, is that there is no one general answer to be had and that it is a mistake to look for such

[24] Berkeley 1998: 64.
[25] Dummett 2006: 94–5. This point is also insisted on by Galen Strawson in his argument for a kind of panpsychism; see, e.g., Strawson 2008: 57–60.

a thing. Instead, we should ask, 'Why is *this* painting of value? What is valuable about *that* one?' It is important to note that this is not a form of scepticism or subjectivism about paintings really having value, but it is sceptical about the project of attempting to provide an overarching philosophical theory which would explain that value. Rather, it suggests, we should stick to first-order art criticism and focus on particulars.[26] It would, of course, be very implausible to suggest that there are no interesting commonalities to be found in the ways in which we assess different paintings. First-order art criticism itself is constantly comparing paintings, noting the development and maturing, or perhaps the decline, of one artist's style, or the way one painter was influenced by a predecessor, or broke away from that influence, etc. And if we judge that one painting is better than another or—more specifically—that its colours are more vibrant, that it is more harmoniously structured, or more expressive, etc. than another, we are then appealing to common criteria. Of course, criteria for artistic excellence are multiple and cannot be applied mechanically; and perhaps in some cases it is precisely the lack of harmonious structure that we may appreciate.[27] Moreover, if I am struck by, say, the solemn, yet serene quality of Piero della Francesca's *Baptism of Christ*, it is not as though the painting gives me a dose of some universal quality which I might also get from looking at, maybe, a Cézanne landscape. What I appreciate in the Piero is its particular way of being serene, and other works might leave me cold, even though I can recognize that they could correctly be described as serene.

The particularist is right, then, to remind us that individual paintings need to be attended to in their own right; they are not indifferent means of conveying some general content. And of course, different paintings, and different kinds of painting, affect us in different ways, and we may appreciate them for different reasons. As I noted in the Introduction, the qualities we value in a Bruegel and in a Rothko may be quite different. So I can, *up to a point*, agree with Domenic Lopes when he says:

> Paintings describe scenes, delight the senses, express emotions, communicate ideas, and allude either to other artworks or to common experience. There is no single reason for which we value all paintings and only paintings as aesthetic objects. A reason to value one painting may not be a reason to value all, and it may be a reason to value something that is not a painting at all.[28]

[26] Such a view is obviously Wittgensteinian in general inspiration, and one can see some of the remarks in Wittgenstein's 'Lectures on Aesthetics' (Wittgenstein 1967) as pointing in this direction.

[27] It is, however, harder to find an example of this than I had at first supposed it would be. Even a depiction of a chaotic scene, such as Tintoretto's *Massacre of the Innocents* (in the Scuola Grande di San Rocco in Venice) has its own structure and even its own kind of harmony. So, indeed, do Jackson Pollock's drip paintings. Perhaps we should say that what harmonious structure involves may be very different as between different paintings.

[28] Lopes 2001: 501.

But although it's true (to take up Lopes's last point) that I may appreciate Bruegel's lively storytelling and also that of my verbally dexterous raconteur friend, it still matters that I am appreciating Bruegel's ability not just to tell stories, but to do so through the medium of painting. And if I enjoy two paintings, although I may enjoy very different things about them, I still think it is right to say that my appreciation of them has something in common that is quite different from my appreciation of, say, a piece of music or the taste of my breakfast cereal. Why shouldn't we try to understand what that commonality is? The particularist critique, however, can be helpful in reminding us of the sort of commonality we should be looking for. Lopes is right that different paintings have very different qualities, and I think we rightly value many very different paintings of very different kinds. So if there is a common feature which we value in them, it cannot be one of those features which differentiate one type of painting from another.

We should not, then, be engaging in a Procrustean effort to insist that all good painting must resemble one particular kind of good painting. However, we can still ask such questions as 'What it is that makes Bruegel's storytelling paintings come alive, while other narrative-packed genre works do not?' and 'What makes Rothko's colour fields so powerful while other colour-field abstracts may be merely dull?' The common feature I am searching for, then, cannot simply be one more characteristic on the same level as, for example, harmonious formal structure or representational accuracy; it must be, rather, that which is present in good paintings of any kind (present in a greater degree the greater the painting) and which makes us *care* about this one's representational accuracy or that one's harmonious structure, when we don't (or don't care as much) about the representational accuracy or harmonious structure which we may agree exists in more mediocre works. Whether there is any one thing of this sort cannot be demonstrated a priori. Perhaps the quest for it will turn out to be futile, but that is a judgement we can only reasonably come to after having attempted it. As with subjectivism, I do not claim to have a knock-down argument for the falsity of particularism, but—as with subjectivism—I think it is a position that we should only fall back on if we are forced to. My project is to see whether a positive, informative, and general answer to the question why paintings matter is possible. But we should certainly bear in mind as we proceed the dangers of hasty generalization and the risks of basing a philosophical theory on features that are specific to one or two of a philosopher's favourite paintings or artists.

IV

Socrates in *Republic* book 10 does say that he would be glad to hear a convincing defence of poetry, but he insists that it would have to show that poetry—and by extension art generally—'not only gives pleasure but also benefit...to human

life.'[29] Since his argument was that art tended to lead us away from the True and the Good, it seems that the most direct way to answer him would be to show that art—painting in particular—can be of 'benefit' to us by actually leading us towards the True and the Good. This is indeed the line of inquiry I will be following in this book, but what does it involve? One might start with the idea that a painting serves the Good and is thus itself of value if it conveys a (good) moral (and/or political) message. But many of the paintings that are most admired don't seem to have any obvious moral or political message at all, and many of those that do are of very little artistic merit. Didactic or explicitly political art can sometimes be aesthetically powerful, but didacticism more often seems to work against artistic merit. One could, of course, simply define good art as that which didactically serves a good moral or political cause, but that would be to give up on my project, which is to understand why we rightly value *many* kinds of paintings (most of which are not explicitly didactic). So if painting is to be valued because it serves the Good, we will need to find a subtler way of understanding how it might do that than simple didacticism.

What about Truth? Perhaps the simplest way in which one might think of a painting as conveying the truth would be through representational accuracy. So perhaps we should value paintings because, or in so far as, they depict things as they really are? But, of course, there are also numerous problems with that proposal. Firstly, there are excellent paintings which are not representational at all; secondly, even among those paintings which do have a recognizable subject matter, the best ones are not necessarily those which represent their subjects in the most literal or accurate fashion; and thirdly, there are many paintings which are representationally accurate but which seem to have little or no artistic merit. So literal representational fidelity is neither necessary nor sufficient for a painting to have value (which is not to say that it is never part of what we might admire a painting for). This does not rule out the idea that we might value paintings for their truthfulness, but if we do, we would need to think of their truthfulness as more than just representational accuracy. (That, of course, was precisely what Plato condemned as trivial or misleading.) Perhaps one way to start thinking about this would be to suggest that we value them not just for accurately rendering any arbitrary object, but because we can learn from them about things that are of some significance or interest to us, such as, for instance, when the paintings produced by a certain society are used by historians or social scientists as evidence for what the society was like. This might range from simple factual information—a painting may show us what sorts of clothes people wore (and how they differed according to gender, class, etc.) or what their buildings looked like—to much subtler kinds of understanding, such as when the style or the typical subject

[29] Plato, *Republic* 607d (Plato 2004: 312).

matter of a culture's paintings is taken to tell us something about the mindset, the typical concerns and values of that culture, or the tensions within it.[30]

These are certainly legitimate reasons why someone interested in a particular society might take an interest in some paintings. But it doesn't seem to get us far towards understanding why paintings generally might be of value to people generally (as opposed to those with special interests in a particular culture). It would seem in the former sorts of case (where the painting is being used as a source of empirical information) that the painting is being used in a purely instrumental way, rather than being valued intrinsically;[31] and it is significant that the quality of the painting (beyond a basic level of technical proficiency) is of no concern to a historian who is simply concerned with, for example, understanding the social significance of changing styles of clothing. A painting may be a useful information source while having little artistic merit. And even in the more complex sort of case, where a painting is valued as an expression or illustration of the typical mindset of a society, this is entirely compatible with its being quite mediocre as a painting. One might indeed argue that mediocre art is *better* as evidence of a general social outlook than the work of a genius, which might tend to express something atypical or at least something that goes beyond the usual social mindset. Of course, the point might be that what the genius does is to express something about his or her society and culture that goes deeper; that exposes something below the level of ordinary social consciousness. This is roughly the Hegelian (and sophisticated-Marxist) theory: great art doesn't just manifest the superficial self-image of a culture by showing what it thinks of itself; it makes manifest its social subconscious, its deeper motivations, fears, and tensions.[32] Plenty of important critical work has been done along these lines, but the worry remains that, even at this sophisticated level, we are still using paintings as clues (one kind among many others) to the zeitgeist or to the mindset of the culture. The artwork is still being used as a tool of social-scientific research, rather than being valued in itself. Of course, using art to understand the society that produces it is an entirely legitimate and indeed important enterprise. I don't however, think it can, by itself, give an adequate account of the value of painting.[33]

[30] See, e.g., Scharma 1991.

[31] One can get into complex debates when one tries to give a precise explication of this distinction, but I think the basic idea of it is clear enough to make the points I want to make with it in this context.

[32] See, e.g., T. J. Clark's account (Clark 1999: ch. 2) of Manet's *Olympia* as making blatantly explicit the dominance of capitalist exchange value in mid-nineteenth-century Paris—something that its audience would have preferred not to be reminded of quite so directly. See also Robert Pippin's discussion (Pippin 2014: 68–78) of Clark's account.

[33] Pippin (2014: 72) is well aware of the problem: 'the worry about any such sociohistorical account is reductionism, not doing justice to the art as art'. Whether any Hegelian, Marxist, or in general historicist account can really avoid that problem while remaining recognizably Hegelian, Marxist, etc. is the crucial question. For all the sophistication of his discussion, Pippin does not persuade me that it can.

If the value of painting is connected to its promotion of the Good and/or the True, that connection will have to be understood in subtler ways than those just discussed. I will start in Chapter Two to discuss the sense in which I think the value of painting really is connected to Goodness and Truth. But one might also choose to challenge Socrates' sense of what a successful justification of art should consist in. Perhaps the beauty of a painting is its own justification, even if it has no connection with either truth or goodness. Or perhaps painting has, or need have, no connection with beauty either, but can be celebrated as a pure, autonomous activity, a playful celebration of visual possibility. Or *some* painting (or visual art generally) might be seen as worthwhile precisely because it subverts, ironizes, or undermines those portentous, suffocating old norms of Goodness, Truth or Beauty. These moves would still however be *justifications* of art (or of some art)—they posit beauty, playfulness or subversion as Good Things. Art is seen as worthwhile, as being good for us in some way (where 'good' is taken in the broadest sense as the most general evaluative predicate) even if it isn't good in a narrower sense (morally good). And if art is taken to convey the insight that there is no ultimate Truth, but, rather, an indefinite plurality of different possible ways of seeing, that itself is still being taken as something important that art enables us to know: the truth that there is no Truth. In other words, it seems that these responses don't really escape from the framework of standards that Plato sets for a successful defence of art. They may give, or presuppose, accounts of human flourishing (as involving play, subversion, or pure aesthetic appreciation) or of philosophical insight (as involving scepticism and relativism) which Plato himself would have repudiated, but they are still claiming that art is of value because it contributes to human flourishing and provides us with philosophically significant insight.

I do want to pause, though, with the suggestion that painting is justified not by conveying truth or promoting moral goodness, but by its beauty. This might, after all, seem the obvious answer to the question of why we value art, why it matters to us. We value (good) paintings because they are beautiful. Isn't it as simple as that? As I have just noted, this wouldn't be breaking out of Socrates' framework altogether, but can't we answer him simply by saying that the appreciation of art is 'beneficial' to us, in a broad sense, because (good) art is beautiful and the appreciation of beauty is an important part of what a good, flourishing, full life is? (Socrates, indeed, would be the last person to disagree with *that*.[34]) That we are 'benefited' by being able to appreciate the visual beauty of a painting does not mean that its value for us is merely instrumental (as it seemed the value of merely didactic or informational painting was); in attending to its beauty, we are not using it as a means to an end, but are 'benefited' precisely though appreciating

[34] See Plato's *Symposium* and *Phaedrus*. Of course, he would need to be persuaded that the beauty of *paintings* was significant, but, as I note at the beginning of Chapter Two, later Platonists found plausible enough reasons in their own terms for thinking that it was.

what it intrinsically is. Of course, there are lots of beautiful things other than paintings which we also value for their beauty, so a proper account of the value of paintings specifically will need to say why we value *these* beautiful objects in the ways we do. But that they are beautiful seems at least an intuitively clear starting point for an account of the value of paintings.

One simple and obvious problem with this suggestion, though, is that not all paintings *are* beautiful and, more to the point, that not all great paintings are beautiful (the non-beautiful ones aren't simply the ineptly executed ones). Consider, for example, Grünewald's *Crucifixion*, Artemisia Gentileschi's versions of *Judith and Holofernes*, or Goya's *Saturn Devouring His Son*. Or—rather different examples—consider Picasso's *Demoiselles d'Avignon* or Francis Bacon's screaming popes. These are all great paintings, but their greatness doesn't seem to have to do with their being *beautiful*. Of course, it would be fallacious to argue from the existence of such counterexamples that paintings are *never* beautiful or that their beauty is never the reason why we value them. These are masses of very beautiful paintings which we value as such. But the examples do seem to show that beauty is only *one* reason why we might value a painting—and this again raises the possibility of a radical pluralism, that we might value different paintings for utterly different reasons.

One might resist this conclusion by arguing that, despite what we might at first think, we do value paintings like the ones I have just mentioned for their beauty. However horrific their subject matter, it might be said, for example, that we respond to the beauty of their formal properties, their finely structured composition, or their well-balanced and sumptuous colour. There may be something in this—as Iris Murdoch notes, there is a strong tendency for art to make even the horrific seem pleasing: 'Art cannot help changing what it professes to display into something different. It magically charms reality, nature, into a formal semblance…art cannot help, whatever its subject, beautifying and consoling. Goya's "horrors of war" are terrifying but beautiful.'[35] But if this is really the case (Murdoch herself goes back and forth about whether this is always or inevitably so), then we would have to conclude that all these works are in some sense failures, that there is something dishonest about them—they seduce us into taking pleasure in what should horrify us. If this is so, it would reinforce rather than answer, the 'Platonic' critique. It might be responded that we don't actually enjoy the horrors Goya depicts because he depicts them so beautifully, but we enjoy the merely formal properties of his works and ignore the notional subject matter. But I think it would be very implausible to suggest that, as a matter of psychological fact, we can often do that—or do it at all. It is also implausible, more generally, to take a pure formalist stance and argue that the greatness of

[35] Murdoch 1993: 122.

great representational paintings has nothing to do with what makes them representational, that their beauty lies wholly in their significant form, which we have to abstract from their irrelevant representational properties. (But this is an important issue, to which I shall be returning.) And, in any case, this sort of formalist defence of the claim that we appreciate great paintings for their beauty doesn't work for great paintings in which (irrespective of the subject matter) the formal properties themselves are harsh, jarring, or discordant (as in *Demoiselles d'Avignon*).

A better response to the problem of great but non-beautiful art is to ask, again, what we mean by 'beauty'. I have raised the problem by relying on a simple intuitive sense that Grünewald's *Crucifixion* is not beautiful but that, for example, Raphael's *Madonna with the Goldfinch* is. But we might want to distinguish between this rather narrow sense of beauty and a broader sense. I have already quoted above Paul Crowther's definition of beauty as 'that whose visual appearance is found fascinating in its own right.'[36] In this sense, then, all the paintings I mentioned above do indeed count as beautiful. They fascinate us, strike us, draw us in, and do so simply in virtue of the way they look. We can we can bring out the point Crowther is getting at here by comparing his definition of beauty with the classic one provided by Aquinas—'that which pleases when seen.'[37] The two are, of course, very similar, but the distinction between 'pleases' (*placet*) and 'is found fascinating' marks the distinction between 'narrow' and 'broad' senses of beauty. The latter is just the most general term of aesthetic commendation; the former is a subclass of what is beautiful in the broader sense. (Other subclasses would be—most obviously—the sublime; also the handsome, the pretty, etc.) Now, it might indeed seem plausible to say that what we value about great art when we value it intrinsically (so not just for its historical significance, etc.) is that it is beautiful in the broad sense. Shifting to that sense does, I think, deal with the kinds of counterexample that I have been considering.[38]

It might be argued that this move still fails to deal with another possible set of counterexamples: artworks that are not 'beautiful' even in the broad sense, that are (deliberately) made or selected to be lacking in visual interest or fascination. We might think of Duchamp's *Fountain*, Warhol's *Brillo Boxes*, Carl Andre's bricks, etc. or various kinds of minimalism, *arte povera*, etc. But such works are not counterexamples to my thesis, for I am not proposing (broad-sense) beauty as a necessary condition for something being a significant artwork. I am, rather, suggesting that it is necessary for a painting to be good qua painting. That is a quite different claim. A counterexample to *that* would have to be a painting that was not in any way visually striking or interesting, etc., but which was nevertheless

[36] Crowther 2009: 16. [37] '*id quod visum placet*': *Summa Theologiae*, I: 5.4 ad 1.
[38] The widespread disparagement of the idea that beauty should be the aim of art in twentieth-century art criticism did, of course, depend on taking 'beauty' only in the narrow sense.

an artistically good (not just technically competent) painting. And I am happy to deny that there can be any such thing. Indeed, that there cannot seems to me to be an analytic truth. Of course, a painting that lacks aesthetic merit (broad-sense beauty) may still be significant in a variety of ways—for its historical interest or whatever—and it may even be the case that a bad painting can still be a significant artwork. (If a urinal can be a significant artwork, why not a bad painting?[39]) Since I am deliberately avoiding the question 'What is art?' (or 'What is an artwork?') in this book, I do not need to take a stand on this.

It is tempting, then, to say that what makes a painting good qua painting just is the visually fasciting way it appears. It might seem that saying this would commit us to the controversial thesis of 'aesthetic empiricism' according to which the only features of a painting (or artwork generally) that are relevant to its aesthetic evaluation are directly perceptible ones. It's just the way it looks that matters, even if you know or care nothing about the social world in which it was produced, who it is supposed to be a picture of, etc.[40] Controversial though it is, there is certainly something attractive about this idea. Paintings, after all, are created to be looked at: in a gallery, surely one does better to look closely at the paintings, rather than spend one's time perusing the placards next to them or reading a guidebook. However, a variety of arguments have been deployed against aesthetic empiricism. These include reference to fakes (a real Vermeer is a better painting than a forgery, even if you can't tell the difference visually); to indiscernibles;[41] and to various kinds of minimalist or conceptual Art which need to be understood not just in terms of their appearance, but in terms of the point they are making, the art-historical context on which they are commenting, etc. I'm not sure these cases make a strong argument against aesthetic empiricism; at any rate, to rely on them seems somewhat question-begging. An aesthetic empiricist could plausibly enough reply that a truly indistinguishable fake *is* of equal aesthetic merit to its original (though we might value the original for its *historical* importance, as we might value the original handwritten manuscript of a novel). And it doesn't seem unreasonable to say that many minimalist works lack significant *aesthetic* value while conceding that they may make interesting conceptual points, etc. Indeed, as we have seen, Danto agrees that his *Brillo Boxes* and red squares are not of great visual appeal, despite their 'astonishingly conceptual' interest. And since he goes on to say that, *aesthetically* speaking, he

[39] Actually I don't think Duchamp's urinal was or is itself a significant artwork. His *act of exhibiting it* was a significant event, or art-historical gesture, or something of the kind. Exhibiting a bad painting (doing so consciously, deliberately, that is) might perhaps be a significant artistic gesture in some circumstances, and some artists have indeed tried to make such gestures. On this phenomenon, see Bowman 2018.

[40] For a vigorous critique of aesthetic empiricism, see Davies 2004: ch. 2; for a partial defence, see Lamarque 2010: ch. 6.

[41] See Danto 1981: 1–2 for a discussion of several imagined paintings, all visually identical, each being a red square, but each with a quite different contextual meaning.

might trade them all for a Giorgione, it may be that he is not really disagreeing with the aesthetic empiricists at all about what makes for *aesthetic* value.

I think a more powerful argument against aesthetic empiricism is to note the importance in appreciating paintings of being able to understand their subject matter or symbolism (it matters to know that this is not just a picture of a woman but of the Madonna or of Venus). Relatedly, Kendall Walton has argued that one cannot appreciate an artwork without knowing the relevant categories into which it falls. It would be pointless trying to appreciate a cubist painting as though it were an Impressionist one, for instance, or vice versa; one needs to know how to appreciate it *as* a cubist, and one cannot do that just by looking at it, without some background knowledge.[42] A defender of aesthetic empiricism could, of course, respond that paintings can have all sorts of interest and value in addition to their strictly aesthetic ones and argue that although it's useful or interesting to know background information about a painting, that does not enhances our strictly *aesthetic* appreciation of it. However, a defence along these lines runs into the problem that it is hard to maintain a very strict distinction between the purely aesthetic properties of a painting and all the rest; in attempting to do so consistently, one would ultimately be forced into a very implausibly narrow kind of formalism. So a strict aesthetic empiricism probably is untenable.

Does this mean that we have to drop the idea that the value of a painting (qua painting rather than, say, qua historical information source) lies essentially in its visual appearance, the way it looks? I don't think so. We can hold on to something of the spirit of aesthetic empiricism, even if we can't stick to the letter. We can agree that background information—about subject matter, style, symbolism, historical context, etc.—may indeed be helpful for aesthetic appreciation and evaluation, but it is helpful because it enables us to properly appreciate the visually apparent features of the painting for what they are. Its role is an ancillary one. What is 'visually apparent' in this sense may take close, active, and informed looking to properly see. It is important to remember that perceptual experience is *never* a purely passive process: when I look at *anything*, the background knowledge or assumptions that I bring with me (as well as my particular interests, desires, etc.) contribute to how I experience it; and sometimes quite specialized knowledge may be necessary if I am to appreciate it fully for what it is (e.g. a physicist looking into a cloud chamber and seeing the movements of particles, rather than a confusing blur). And of course, this is true of paintings: looking at a painting is an active, interpretative experience, not a purely passive one.[43] But the background knowledge we bring to paintings serves the purpose of allowing us to

[42] See Walton 1970.

[43] So I think that rescuing what is right about aesthetic empiricism requires us to reject the 'Myth of the Given' associated with classical empiricist philosophy in general. But I will have more to say about this later, in Chapter Seven.

properly appreciate what is fascinating about their visual appearance, to dwell with it. By contrast, the physicist—at least qua physicist—is looking into the cloud chamber simply to get information, not to appreciate the patterns aesthetically.

However, even if one does want to say, in the spirit of this chastened aesthetic empiricism, that the value of a painting (its intrinsic value, that is) resides in its visually fascinating appearance, one would need to say a bit more about what this visual fascination consists in; given what I have said above about formalism, it seems it would have to involve more than merely formal properties. But, most fundamentally, for the argument that painting is *of value* because it is beautiful (visually fascinating) to work, it needs to be shown that what is visually fascinating is of value; that to experience this broad-sense beauty does indeed make our lives richer, more fulfilled. To experience something that is visually pleasing or fascinating is, of course, pleasing or fascinating, but is this really enough to make it of significant value, to explain why it can matter to us, or why we might think it *should* matter? Lots of arrays of colours, shapes, and lines may be visually pleasing or fascinating to us, but why do we experience a good painting as mattering in a way that, say, a well-designed wallpaper does not? What is the difference between visual art and mere decoration?[44] (Of course, I am not denying that we may rightly value a painting for its decorative qualities, as we might for the moral lesson or historical information we might get from it. But at least in the case of good paintings, there seems to be more to it than that.) We do also enjoy a lot of representational images and find fascination in them. But, to recall the Platonic Objection, pornography, political propaganda, and commercial advertising are all intended to fascinate visually. So what distinguishes their visually fascinating qualities from those of good representational paintings?

In responding to these questions, I want to start from a distinction that Ruskin drew, between what he called *aesthesis* and *theoria*. According to Peter Fuller, he described the former 'as "mere sensual perception of the outward qualities and necessary effects of bodies"... the latter as the response to beauty of one's whole moral being.'[45] In a similar way Ananda Coomaraswamy notes that almost all cultures outside the modern West 'have called their theory of art or expression a "rhetoric" and have thought of art as a kind of knowledge [whereas] we have invented an "aesthetic" and think of art as a kind of feeling.'[46] Both thinkers are insisting that what matters in beauty—and in art in so far as it aims at beauty—must be more than merely 'aesthetic', more than merely being pleased or even fascinated by surface appearances. I have just distinguished between 'narrow' and 'broad' senses of beauty; we might describe Ruskin and Coomaraswamy as attempting to distinguish between a 'deep' and a 'shallow' sense of beauty. And if

[44] I am not suggesting that the distinction is absolute, hard and fast, or unblurred, but it doesn't need to be to be real.

[45] Fuller 1988: 45. [46] Coomaraswamy 2005: 27.

this 'deep' beauty is something to be both *known* and responded to with one's 'whole moral being', then we are aligning it with the True and the Good, as Plato would wish. On this view, beauty (in the sense of what is apprehended and responded to in *theoria* rather than *aesthesis*) is not a self-standing value, independent of truth and goodness, but, we might say at a first attempt, the way in which truth and goodness show up to us.

Still, the beauty of a painting (as distinct from that of, say, a mathematical proof) must surely still be 'aesthetic' in a literal sense: it is apprehended by the senses and makes its appeal to them. If paintings are of value for their truth and goodness, then (to avoid the problems I noted with the simple didactic and informational accounts), this must be a kind of truth and goodness that is essentially manifested through their sensory visual beauty. So we need to make sense of the idea of a beauty that is essentially sensory (visual) without simply reducing it to the experience of subjectively pleasing (even in the broad sense of fascinating, perhaps *piquant*) sensations. We need, that is, to show that our experience of paintings can have the characteristics of *theoria*, rather than merely of *aesthesis*, while still remaining literally aesthetic—sensory, visual.

I argued above that the first, simple attempts to explain the value of painting in terms of its connection to the Good and the True (its usefulness for teaching moral lessons or as an information source) failed because there seems to be no essential connection between these things and painterly excellence. But the attempt to explain the value of painting in terms of its (broad but shallow sense) beauty (simply its visual fascination) also seemed problematic, since beauty in that sense simply doesn't seem important enough to explain how we can be deeply moved by paintings or think of them as mattering deeply. So I want to suggest, then, at least as a plausible avenue for exploration, that if the value of a (good) painting consists in its beauty, then this must be beauty in the 'deep' sense—the sense of its conveying something of significance or meaning, not just providing titillating visual sensations. 'Deep' beauty is visually fascinating *because* it reveals to us what is significant. But at the same time, if the value of a (good) painting does have to do with its connection to goodness and truth, this connection must be one that is essentially made through its beauty. The significance it reveals is essentially accomplished through its visual beauty.

To follow up the idea that the value of paintings lies in their deep-sense beauty, we need, then, to explain how the experience of the visually fascinating might plausibly connect with the goodness and truth. I will start from the notion that painting can be truthful. For the reasons given above, this must mean more than just conveying empirical information. So if the truthfulness of paintings is what makes them matter, then this must be some sort of essential truth, not just empirical information, something that matters to everyone, not just, for example, to a social historian who happens to be interested in changing styles of dress in seventeenth-century Holland. We need, in fact, something of at least the same

broad kind as Clive Bell's 'Metaphysical Hypothesis', according to which painting, whatever its subject matter, makes us aware, through attention to pure form, of 'the God in everything, of the universal in the particular, of the all-pervading rhythm ... that which lies behind the appearance of all things.'[47] I'm not suggesting that Bell's hypothesis is adequate as it stands (and I have already expressed scepticism about the strict formalism that he advocated) but it does indicate the *sort* of truthfulness we would need to find in painting if its truthfulness is to explain its value. It needs to be essential—if you like, 'metaphysical'—truth, and it needs to be conveyed by (good) painting as such, whatever its specific subject matter or style. But how can *painting* convey such metaphysical truth? What, if any connection can there be between visual fascination and insight into reality? If we could answer this question, though, and make a connection between beauty and truth, this would also show us at least one way in which we could connect beauty and goodness. For if truth is good and if beauty can be a form of truth, then beauty is good. Of course, for Plato and for later Platonism, Beauty, Truth, and Goodness do all go together, even though for Plato himself art falls outside that charmed circle.[48] But can they still be plausibly connected today? This is the question I will turn to in Chapter Two.

[47] Bell 1914: 69–70. [48] Or the Plato of *Republic* book 10 taken at face value.

Chapter Two
Truth (and Goodness) in Painting

At the end of Chapter One I mentioned the idea that painting can make us aware of 'essential' or 'metaphysical' truths, and I want to explore that idea in this chapter. If it is right, it would, of course, constitute a direct answer to Plato's critique. The idea that there is deep truth to be found in painting has been taken up—though in some very different ways—by a number of recent thinkers. I will come to some of these shortly. But it is worth noting that it is an old idea—and very interesting to see that we can find hints of it even in Plato himself, as well as fully worked-out versions of it in some of his followers. So I will start with what one might call the Platonic answer to the Platonic challenge.

I

Socrates' argument for the triviality of painting (its being three steps removed from the truth of the Forms) depends on what might seem to be a crudely mimetic 'copy' theory of what painting tries to do. But Socrates himself had already shown a more complex and sophisticated understanding of what painting aims at earlier in the *Republic* itself. At one point he asks 'Do you think, then, that someone would be any less a good painter if he painted a model of what the most beautiful human being would be like ... but could not demonstrate that such a man could actually exist?'[1] Clearly this painter is depicting an ideal, not copying an empirical reality. A little later Socrates uses painting as an analogy for what the philosophical framers of a good constitution should do:

> there is no way a city can ever find happiness unless its plan is drawn by painters who use the divine model ... they would look often in each direction: on the one hand to what in its nature is just, beautiful, temperate and all the rest [i.e. Forms] and on the other towards what they are trying to put into human beings, mixing and blending pursuits to produce a human likeness based on the one that Homer too called the divine and godly ... they would erase one thing, I suppose, and draw in another, until they had made people's characters as dear to the gods as possible.[2]

[1] Plato, *Republic* 472d (Plato 2004: 165). See also 484c–d.
[2] Plato, *Republic* 500e, 501b–c (Plato 2004: 195).

Painting and Presence: Why Paintings Matter. Anthony Rudd, Oxford University Press. © Anthony Rudd 2022.
DOI: 10.1093/oso/9780192856289.003.0003

Adeimantus, Socrates' interlocutor at this point, then comments, 'The drawing would be most beautiful that way.'[3] Paul Crowther comments that this passage shows that Plato realized that good painting involves more than a facile imitation of appearances and requires, rather, a 'selective intervention on the appearances it deals with. It involves idealization.'[4] And an idealization, we might note, that is based on a knowledge of the Forms. I would like to think that this suggests that Plato's own intention in book 10 (and indeed, that of Socrates, qua character in the *Republic*) was provocation—a challenge to the reader to think what painting would need to be to escape his condemnation of mere mimesis. However that may be, the subsequent Platonic tradition took seriously the idea that the visual arts involve not mimesis but idealization, based on a vision of the Forms. Plotinus takes sculpture as an example:

> Suppose two blocks of stone lying side by side: one is unpatterned, quite untouched by art; the other has been minutely wrought by the craftsman's hands into some statue of God or man...the stone thus brought under the artist's hand to the beauty of form is beautiful not as stone—for so the crude block would be as pleasant—but in virtue of the Form or Idea introduced by the art. [Thus the arts] give no bare reproduction of the thing seen, but go back to the Reality-Principles from which Nature itself derives and furthermore...much of their work is all their own; they are beholders of beauty and add where nature is lacking.[5]

Here we have a clearly worked-out defence of art against the 'Platonic' criticisms that is itself Platonic. The artist doesn't simply try to imitate the way a particular thing appears, but to portray that individual so as to show it as expressing the ideal Forms—and doing so more fully and clearly than we can see in everyday experience of our imperfect world. It does not, of course, mean that the artist turns away from the natural, sensible world altogether in order to directly depict the Forms, for they are not literally depictable. Rather, the Platonic tradition regards the sensible world as participating in the Forms or imitating them (as though it was itself an artist striving to model itself on the Forms), so that to see the visible things around one is to see in them intimations of the Forms. This for Plato is most clearly and directly the case when we see something (or someone) beautiful.[6] The lover loves and desires the beautiful beloved but also, beyond the particular beloved, is drawn to the Form of beauty.[7] Plato doesn't explicitly think of the lover, the person struck by beauty, as an artist, but he does say that the lover

[3] Plato, *Republic* 501c (Plato 2004: 195). [4] Crowther 2016: 12.
[5] Plotinus, *Enneads* V.8.1 (Plotinus 1991: 410). [6] See Plato, *Phaedrus* 249e–251a.
[7] I don't think Plato's account need be taken to imply that the particular beloved gets left behind or jettisoned as the lover continues up the ladder towards Beauty itself, but this isn't a point we need to go into here.

is drawn by his (or her[8]) love of beauty to create beautiful things.[9] He seems to be thinking mainly of immaterial things—laws, theories—but it is not too much of a stretch to make Plotinus' move to understanding the artist as someone who responds to his or her experience of beauty in the sensible world by using elements of it to create or shape objects so that they will embody or express the Forms more fully or clearly. And the more fully something embodies or manifests or participates in the relevant Forms, the truer, better, and more beautiful it is, and the more it 'reminds' us of the Forms themselves. So art indeed be a way of leading the mind to Truth, Goodness, and Beauty.

One might still worry that this kind of Platonistic aesthetic justifies the arts, but only instrumentally, that it sees them as useful (even perhaps necessary) for the spiritual life, rather than valuable in themselves. They are ladders by which we ascend from the sensible world to the Forms (or beyond) but can then kick away. According to Douglas Hedley, images 'are left behind in the final stage of Plotinus' ascent of the mind, but only at the very last stage.'[10] But he goes on to note that even Plotinus' 'final stage'—the visionary union of the soul with the One, which transcends the Forms themselves—is in a way closer to the state of rapt aesthetic attention to an image than it is to a process of discursive reasoning. According to Plotinus:

> The wise men of Egypt…when they wished to signify something wisely, did not use the forms of letters which follow the order of words and propositions…but by drawing images and inscribing in their temples one particular image of each particular thing, they manifested the non-discursiveness of the intelligible world.[11]

Hedley comments, 'Plotinus prioritizes vision over discursive reflection; the immediacy of sight over the mediated.'[12] But despite the substantial 'aesthetic' element in Plotinus' philosophy, his ultimate goal is an inner contemplative vision to which the sensuous aesthetic vision of an image is merely an analogy. However, a Platonist of a less ascetic kind than Plotinus might reasonably find it intrinsically valuable not only to contemplate the Forms, or the One, or God but also to contemplate the visible world as the expression, emanation, or creation of the Forms, the One or God.[13] For Hedley himself, 'The physical cosmos is the mirror of the Divine; a theophany. This world is a luminous array of images reflecting

[8] Plato's account of love is of course very male-centred; but the main account of love and beauty in the *Symposium* is, nevertheless, given by a woman, Diotima. I take this to be a pretty clear indication that Plato takes the ascent to be open to both sexes—as is also made clear in the *Republic*, where women can be philosophers (and therefore rulers) and where the true philosopher is the one who ascends to knowledge of the Forms.

[9] Plato, *Symposium* 209 a–b. [10] Hedely 2016: 22.

[11] Plotinus, *Enneads*, V.8.6, quoted in Hedley 2016: 23–4. [12] Hedley 2016: 24.

[13] I'm obviously trying to keep the Platonist's metaphysical options as open as possible here!

(although often enigmatically) the perfect being of the Divine.'[14] The logic of the Platonic ascent itself does not compel one to leave the lower stages behind; indeed, it seems plausible to say that one understands the higher world better when one recognizes that it expresses itself in the visible world and celebrates that expression. It does seem, then, that a Platonist can reasonably see the appreciation of visual beauty in nature, and its celebration in the making and appreciating of art, as intrinsic and enduring goods, not just as pedagogical steps leading beyond the visible.

These Platonic and Neoplatonic theories had a great influence on medieval aesthetics—in the West largely through the mediation of Augustine, for whom God was the pure Beauty, the reflections of which we see in the beautiful things of the world.[15] And, as we shall see, in the Greek Orthodox East, Platonism (as mediated through the Greek Church Fathers) provided the theoretical underpinning for the practice of iconography and the veneration of icons. The Platonic theories were revived—now with access to the original Platonic and Plotinian texts—by the Florentine Neoplatonists of the early Renaissance, who themselves greatly influenced both the theory and the practice of later Renaissance visual art. The influence of this Platonic art theory declined, however, with the development of modernity, when the scientific/technological 'disenchantment' of nature set in, and the natural world was no longer seen as a meaningful—and therefore beautiful—order. As Steven Crowell puts it, 'With its vision of a disenchanted nature, modern thought began to undermine traditional foundations of the philosophical inquiry into beauty.'[16] Hence, we see the rise of sensibility theories with their subjectivist understanding of beauty—even if, like Hume's, they aspire to a de facto universality.

Though eclipsed, the Platonic theory of art never wholly disappeared. It remained influential in eighteenth-century Germany,[17] where it provided the background for German idealist aesthetics, which in some ways continued the Platonic tradition while breaking from it in others. And Schopenhauer, a little later, explicitly returned aesthetic theory to its Platonic roots; in his wonderful image, the true artist is someone who 'understands nature's half-spoken words'[18]—who idealizes, so as to show objects expressing their essences with a clarity and completeness that is not found in nature itself. But for most thinkers the Platonic metaphysics underpinning the traditional account of art was not a live option.[19] A new account of the meaning and value of art seemed to be needed, one that was neither metaphysical in the traditional way nor merely subjective,

[14] Hedley 2016: 139. [15] See, e.g., Augustine, *Confessions* X, vi (Augustine 1998: 183–4).
[16] Crowell 2011: 33. [17] See Beiser 2009.
[18] Schopenhauer 1969: i, 222.
[19] Of course, Schopenhauer, though a fairly strict Platonist in his aesthetic theory, is certainly not in his philosophy as a whole—and commentators have not always found his appeal to Platonic Forms obviously consistent with his overall philosophy of the will.

and Kant obligingly provided one. He officially rejected the old Platonic association of aesthetic experience with truth. However, his cautious suggestion that the experience of beauty at least gives us an intimation of how nature and freedom could be reconciled inspired subsequent German Romantics and idealists. As Robert Pippin notes, they took from Kant (or Kant as they read him) the notion that 'aesthetic intelligibility', although 'affective and largely sensible', was 'uniquely determinate and not merely a reactive response'. It was, rather, a 'mode of awareness [that] was in some even if in a quite cognitively unusual and difficult to categorize sense, *revelatory* in a still deeply important way'.[20]

Inspired by these thoughts, Kant's successors did indeed re-establish the connection between art and (significant, metaphysical) truth. For Hegel the 'highest task' of art is to become—along with religion and philosophy—'a mode of revealing to consciousness and bringing to utterance, the Divine Nature, the deepest interests of humanity and the most comprehensive truths of the mind'.[21] What is specifically characteristic of art is that it does so by representing 'even the highest ideas *in sensuous forms*'.[22] But, Hegel continues, 'Only a certain circle and grade of truth is capable of being represented in the medium of art'.[23] Plotinus would, of course, agree that art can only take us so far towards the ultimate truth, but Hegel gives this idea a historical twist: sculpture *could* fully express the limited degree of truth that was present in the ancient Greek understanding of the gods, but Christianity and 'the spirit of our modern world' have given us a 'deeper form of truth', which 'is no longer so closely akin and so friendly to sense as to be adequately embraced and expressed through that medium'. As a result, for the 'reflective culture of our life of today', 'art no longer affords that satisfaction of spiritual wants which earlier epochs and peoples have sought therein';[24] and so 'art is, and remains for us, on the side of its highest destiny, a thing of the past'.[25]

Hegel, then, re-establishes the connection between art and truth; for him profound metaphysical truths can be expressed through particular, sensuous appearances. It is, indeed, an essential theme of Hegel's thought as a whole that mind, spirit, thought (*Geist*) only ever exists within some kind of expressive embodiment: 'An appearance or show...is essential to existence. Truth could not be did it not appear'.[26] But on the other hand, Hegel celebrates the power of abstract thought to rescue spirit in its universality from its particular expressions:

> even if artistic works are not abstract thought and notion, but...an alienation from itself towards the sensuous, still, the power of the thinking spirit (mind) lies herein, *not merely* to grasp *itself only* in its peculiar form of the self-conscious spirit (mind), but just as much to recognize itself in its alienation in the shape of

[20] Pippin 2014: 10. [21] Hegel 1993: 9. [22] Hegel 1993: 9. [23] Hegel 1993: 11.
[24] Hegel 1993: 12. [25] Hegel 1993: 13. [26] Hegel 1993: 10.

feeling and the sensuous, in its other form, by transmuting the metamorphosed thought back into definite thoughts, and so restoring it to itself.[27]

Modern Hegelians, like Robert Pippin, have noted this tension. Pippin argues that, as essentially embodied minds, we never get beyond the need for a sensuous, particular presentation of truth, that although the form of art that we need in modernity to express essential truths about ourselves may change radically, we will never leave behind the need for art of some kind.[28] However, Hegel's 'official' doctrine is that the truths that art can present in sensuous form are not the highest truths (or the highest forms of truth) and that truth can now be presented more adequately in conceptual form, so that art ceases to be strictly necessary for us. So Hegel in a way defends the arts against Plato—they were certainly needed to express truth in Plato's own time—but in a way that makes art ultimately dispensable. Now, for us, although art can still express truths, we have better ways of doing so.

II

One contemporary philosopher who is keen to respond to Hegel's challenge is Steven Crowell. In his promisingly titled essay, 'Phenomenology and Aesthetics: Or, Why Art Matters' he argues that art can indeed convey deep philosophical insights and suggests that a Phenomenological account promises to 'circumvent Hegel's verdict by freeing art from its subordination to "the concept" without severing its connection to truth'.[29] So, for instance, he argues that a minimalist sculpture—his example is Donald Judd's *Untitled (Large Stack)* of 1991—can visually present certain Phenomenological insights into the nature of perception.[30] But, he admits, here Hegel's question imposes itself once more: even if art is indeed a mode of truth, isn't such truth only a poor substitute for conceptual thought? In our case, it might seem that Judd's work merely illustrates an account of vision that is more adequately represented in Husserl's conceptual description. Why then should art *itself* matter to us?[31]

Crowell argues that Hegel's challenge here can only be met, artistic truth can only matter *deeply*, if the truth that a painting conveys qua artwork (rather than qua schematic information source or illustration of pre-existing thesis) is such

[27] Hegel 1993: 15.

[28] See Pippin 2014: 43–7. What Pippin says about our 'amphibian' nature as particular, finite embodied beings, but capable of thinking universally and imagining worlds beyond our own seems to me quite correct but hard to reconcile with his supposedly anti-essentialist historicism. He is aware of the problem, but doesn't do anything very convincing (to my mind) to resolve it (see 46, 91–2, 141).

[29] Crowell 2011: 34. [30] For the details of this analysis, see Crowell 2011: 38–41.

[31] Crowell 2011: 41.

that it is *only* apprehensible as the artwork presents it. So what matters is not just the content but the mode in which the content is presented. Art can convey truth, but it isn't just a means of delivering a content (perhaps in a particularly appealing or accessible way) that could exist apart from its medium or vehicle. This is sometimes known as the 'no paraphrase' thesis.[32] My concern, of course, is with whether *paintings* specifically can convey non-paraphrasable truths. If they can— and if those truths are important ones—then paintings matter because they can present us with important truths that would otherwise be inaccessible. In the later part of his essay Crowell claims that the still lifes of the Italian painter Giorgio Morandi do just that. He claims that they show the 'thinghood' of the simple everyday artefacts—jugs, bottles—that they depict, something which, he argues, escapes Heidegger's analysis of the being of 'ready-to-hand' objects as tools or equipment—that is, things seen as significant because we can use them in various ways.[33] It even escapes the more expansive analyses in Heidegger's later work, where he does try to get beyond the analysis of things as equipment. But even in this later work, Crowell argues, 'What Heidegger has not yet managed to illuminate is what might be called the "indifference" of *mere* things.'[34] This 'indifference' seems to be the sheer unintelligible materiality—the 'silence'—of the objects, their existence beyond any use or meaning they may have to us. And this, in Crowell's view, is what is made manifest in Morandi's paintings of everyday objects.

One might think that Crowell takes Morandi's showing of the 'silence' and 'indifference' of things to reveal them as meaningless. But, on the contrary, he argues that Morandi shows that things are *not* left merely absurd and meaningless when the significance that we attribute to them, relative to us, is stripped away:

> For while it is true that implements 'divorced from use' do fall silent, falling silent does not signify absurdity, the meaninglessness of what is thus silenced, as it must appear to a thought that identifies meaning exclusively with what can be captured in conceptual form. Falling silent is neither the absence of speech nor the impossibility of speech, but rather a mode of speaking…predicable only of something capable of speech. If thinghood is thus intelligible only as the falling silent of the implement, we can understand something of why art matters, for, without the work's way of letting this falling silent happen, such an experience must remain silent, unexpressed.[35]

[32] This is most often discussed in relation to poetry: see Kivy 1997, where Kivy criticizes the thesis that a poem cannot be adequately paraphrased. Lamarque (2009: 398–420) defends the thesis against Kivy.

[33] See Heidegger 1962: div. 1, chs. 2 and 3.

[34] Crowell 2011: 45. Crowell refers to Heidegger's essays 'The Origin of the Work of Art' (Heidegger 1971a) and 'The Thing' (Heidegger 1971b).

[35] Crowell 2011: 50.

TRUTH (AND GOODNESS) IN PAINTING 45

One might object at this point that Crowell, if he has succeeded, has just explained in words the metaphysical significance which Morandi indicated in his paintings—and has thus undermined his own non-paraphrasability thesis. But I think Crowell's point is that although we can verbally express what paintings indicate in very broad and schematic terms, we cannot really understand and appreciate it deeply except by experiencing the painting itself. The notion that there is knowledge of this non- or only partially discursive kind—knowledge by acquaintance—is both familiar and plausible. This applies to simple sensory states—it seems right to say that we can only know what, for example, cerulean blue looks like or how a lemon tastes by having those experiences.[36] It is important to note, though, that non–discursive does not necessarily mean non-conceptual. If our sensory experience is itself always conceptually informed, as I believe it is, then the irreducibly experiential is not non-conceptual, at least not in the sense that philosophers have often given that term. To see something as cerulean blue is to see it *as* a colour, as not-red, not-yellow, not-cobalt, etc.; it is not a pure, wordless, sensory rapture. But, in accepting this point, one needn't, and shouldn't, rebound so far from the 'Myth of the Given' as to fall into some kind of structuralism (or one of its analytic equivalents) in which the actual sensory experience drops out altogether. Seeing the colour or tasting the lemon really does give one something new, something that exceeds any verbal description.[37]

The point can be made more clearly, perhaps, by expanding the notion of knowledge by acquaintance beyond the simple sensory examples given above. What it is like to fall in love? What it is like to know one has a terminal illness? What it is like to suffer a certain kind of political oppression? What makes these instances particularly interesting for our purposes is that someone who has not directly experienced them will still be likely to have *some* verbally expressible knowledge of what they would be like. Furthermore, such a person may deepen his or her knowledge considerably through reading literary works of art that depict those states, even if he or she still hasn't experienced them personally. Of course, literature is not a substitute for life; it may deepen our intimations of 'what it's like', but the experience itself remains distinct from even the most sensitive evocation of it. It should, however, be noted that, although the knowledge that literature may give us is obviously presented verbally, there is good reason to think that the wisdom conveyed by a great novel is itself not paraphrasable—not reducible to a philosophical summary of ethical truths, say.[38] You cannot

[36] These sorts of examples are what Russell primarily had in mind when he introduced the notion of knowledge by acquaintance; they are also, of course, the kinds of things talked about by philosophers of mind in their—not always very helpful—arguments about 'qualia'. For Russell's notion, see Russell 2008 and 1997: ch. 5. (It should be said that Russell did at this point allow that we may have acquaintance with entities other than sense data—universals and, possibly, our selves.)

[37] I will say more about this important but highly contentious issue in Chapter Seven.

[38] On this irreducibility of literary insights, see Nussbaum 1992.

adequately represent what *Middlemarch* or *The Brothers Karamazov* has to say in a list of general propositions. These examples are only analogies to what paintings may show us,[39] but they may help to support the idea that there is important non-discursive knowledge to be had. And it does seem plausible to say that this is what painting gives us. However subtle, eloquent, or inventive a verbal description of a painting may be, it is not a substitute for seeing it. Again, the point is not to invoke some dubious notion of pure, non-linguistic experience. I am always seeing the painting at least, minimally *as* a painting, maybe as a Rothko or a Raphael, as a Madonna and Child, or as a classical Chinese mountainous landscape. But that my experience is linguistically shaped and mediated does not mean that it can be reduced to a purely verbal level. I need the sensuous immediacy of actually seeing the painting.

So I think Crowell is onto something important. It's not clear that he is really providing an *objection* to Heidegger. Indeed, Crowell quotes Heidegger as saying that because 'we never know thingness directly, and if we know it at all, then only vaguely', we 'require the work of art' to reveal it.[40] So Heidegger and Crowell seem to agree that there are insights that art can express more fully or adequately than philosophy, that Morandi takes over where Heidegger leaves off, so to speak. This thesis could only be further justified by looking at Morandi's works (and at other paintings) and letting them speak to us. But it would in principle provide an answer to at least part of Plato's critique. Painting matters because it doesn't just imitate surface appearances, but intimates deep truths that are available in no other way. Of course, if the Platonic critique assumes that truth must necessarily be fully expressible in discursive terms, then Crowell's response would not so much give it a 'straight' answer in its own terms but would, rather, challenge the 'Platonist's' views about the nature of truth.[41] But that would only make it all the more interesting.

III

Promising though Crowell's account is, I see two major problems with it. The first can be raised by noting that Crowell confines himself to a few examples (Morandi and minimalism). Are these *just* examples, and is he claiming that *all* painting conveys significant metaphysical truth? If so, there would be something about the very act of painting itself, or of its products, that was metaphysically significant.

[39] However, a work like Goya's *Third of May, 1808* may bring home the horrors of political oppression with particular vividness

[40] Heidegger 1971a: 70, quoted in Crowell 2011: 45.

[41] I put 'Platonist's' in scare quotes in part because I don't think Plato himself held the view that all truth is verbally, rationally articulable. But nothing hinges on this exegetical question for current purposes.

And it might not be implausible to think that paintings (generally) do present objects to us in a way that detaches them from their usual contexts of practical use and thus allows us to see them—their silent 'thingness'—as such. (This would be a recognizably Kantian thesis.) However, Crowell seems to think that there is something very specific about the way *Morandi* paints that gets across to us the 'silence' of thinghood, a style or manner that is certainly not universal.[42] So is Crowell saying only that painting *can* convey deep truths—and that Morandi (and maybe a few others) has succeeded in using the medium to do so? It might seem that this should lead us to conclude that Morandi is a greater artist than, say, Picasso, or Tintoretto, or Duccio (to pick a few names almost at random), assuming that they don't convey these deep truths. But I think it's pretty obvious that he isn't. Morandi is usually thought of as an interesting but relatively minor artist.[43] But if this is so, if Morandi does convey a deep philosophical insight, while remaining a minor artist, then the ability of painting to convey deep ontological truth cannot be the sole or even the most important source of its value. It might be said that other—greater—artists than Morandi are also—and more—important because they convey other deep truths. But in that case does their greatness relative to Morandi consist in the fact that the truths they convey are more important? And how would we asses such a claim?

Even when a philosopher picks an artist of intuitively greater stature than Morandi as having a privileged status as the purveyor of deep ontological insight, the essential problem seems to remain. Merleau-Ponty, for instance, gives Cézanne an exemplary status as one who discloses the pre-objective being of things—the world as we experience it prior to our adoption of a detached, intellectualizing stance.[44] And in his late essay 'Eye and Mind' he argues that there is a close connection between the 'perfecting' of perspective painting in the Renaissance and the philosophy of the detached spectator observing a mathematicized scientific world which found its classical expression in Descartes.[45] (Merleau-Ponty pays particular attention to Descartes's optics in this connection.) By contrast, he sees classic modernist art—he now mentions Klee and Matisse as well as Cézanne—as intuitively expressing a deeper philosophical understanding, one that takes us closer to the participative immediacy of our being-in-the-world. (Hence his claim that 'The entire history of painting in the modern period…has a metaphysical significance.'[46]) On this view, it seems (although Merleau-Ponty doesn't say so outright) that High Renaissance art was

[42] See Crowell 2011: 48–9 for a comparison of Morandi's still lifes with those by Chardin and Willem Kalf.

[43] I should say that I admire Morandi and am not trying to denigrate him. But it seems clear to me that his achievement is not on the same level as that of, say, Picasso or Matisse.

[44] See the various references to Cézanne in Merleau-Ponty 2013 and 1996a.

[45] Merleau-Ponty 1996b: 130–39. I don't think Merleau-Ponty is making a claim about direct lines of influence here, but rather noting a commonality of attitude or spirit.

[46] Merleau-Ponty 1996b: 139.

expressive of a sort of philosophical error—all the more dangerous, perhaps, as it presented it in such a seductive form. Now, on the face of it, if we take ontological truthfulness as a (or the) reason 'why art matters', then a more truthful painter is a greater one. Does this mean that Cézanne was a greater artist than, say, Raphael? The claim doesn't seem absurd in the way a similar claim about Morandi would be. But we may feel that, at this level of achievement, it makes little sense to try and rank artists. And it is hard to feel entirely comfortable with the judgement that Raphael was making some kind of a *mistake*. It seems Merleau-Ponty faces a dilemma here. If—as he appears to be—he is trying to give a general account of the essence of painting as the expression of our being-in-the-world, then he seems committed to saying that all the great High Renaissance (and many subsequent) masters were just failures. But this would be the sort of implausibly Procrustean account that I agreed with the particularists in rejecting. However, if Merleau-Ponty says that the Renaissance masters were simply trying to do *something else*, something which we can admire them for doing as much as we can admire Cézanne for doing what he did, then it would seem that he has given up on the project of giving a *general* account of painting or why it matters. But this would be a surrender to particularism, whereas I am trying to find some alternative to both particularism and Procrusteanism.

If we want to avoid picking out some particular artists as being more metaphysically insightful than others, one option would be to claim that *all* painting as such has a metaphysical significance. Another Phenomenological philosopher, Paul Crowther, has developed an account of this kind. Like Crowell, he argues that painting (the visual arts generally) matter to us because they convey important truths. For him these have to do with the basic structures of our being-in-the-world. (In the broad outline of his project, though certainly not in the details, he is following Merleau-Ponty.) He claims that 'In the visual artwork, features that are basic to the reciprocity of subject and object of experience *are made to exist in a heightened and enduring form*.'[47] So, for example, the 'aesthetic unity' of a work—an inherence of parts in a whole which can only be understood through perceiving it, not discursively—is said to model 'the human perceptual situation *per se*' in that the work is created by an artist (and thus depends on the subject) but also reciprocally effects both its creator and other spectators. Such works 'directly exemplify the reciprocal interaction of body and world'.[48] Again, a visual artwork is necessarily spatial, but not temporal (in the way a piece of music or a novel is). It is all present at once, and its aspects can be taken in in any order. Thus it 'exemplifies this fullness and plenitude of spatial being'.[49] Crowther has much more of this kind to say, much of it very interesting. But what I want to note here is that on his account, what is ontologically revealing

[47] Crowther 2009: 5. [48] Crowther 2009: 25.
[49] Crowther 2009: 26.

about paintings turns out to be very general features which are shared by all paintings as such. His account does not, then, privilege specific painters as more metaphysically insightful than others and so it avoids the problems that I have noted with Merleau-Ponty's and Crowell's accounts. But as a result, Crowther faces the opposite problem, that he fails to explain aesthetic merit. Why does *good* painting matter to us, if even mediocre work still exemplifies all these ontological structures? (Indeed, artefacts of any kind and even natural objects exemplify some of them). A possible response to this objection is suggested by a later work by Crowther, where he notes that a painting makes perceptible the process of its making, how 'all the individually contingent moments of deliberation and gesture that were involved in making the picture are transformed into necessity once the work is completed'.[50] But, he continues, 'in non-artistic painting, these factors are overlooked in favour of the informational function that the image serves. In artistic painting, on the other hand, we attend to the work as a completed whole', so that we are aware of it as manifesting the process of its creation.[51] But a utilitarian artefact (especially a hand-made rather than a mass-produced one) may wear the process of its production on its sleeve, as it were; and an artwork that draws attention to the process of its own creation may still be of little or no artistic merit or value.

The worry one has with Merleau-Ponty and Crowell is that they take their metaphysical views (arrived at independently) and use them as a basis for ranking artists. The worry one has with Crowther is that his account of what matters in painting doesn't correlate with *any* plausible ranking of the merits of artists. It would be preferable if we could find a way of understanding art as expressing truth which correlated the amount of truth we think is expressed with our intuitive judgements about the greatness of painters and which did not, therefore, leave us having either to deny or diminish the value of intuitively great art because it doesn't seem to align with our philosophical theories or to exaggerate the merits of mediocre work that does express what we think philosophically insightful. One philosopher who suggests a way to do this—although he does himself very explicitly take a particular painter to have reached a higher level of philosophical insight than others—is Michel Henry. In his book on Kandinsky, Henry argues that all painting is in its essence non-representational: it seeks not to copy appearances but to express or evoke the pathos of 'Life', which he takes as ontologically prior to the 'World' of scientifically articulated objectivity.[52] (There is something of Merleau-Ponty about this, but also something of Schopenhauer's distinction between the world as Will and as Representation.[53]) Setting aside the details of Henry's metaphysics, his claim is that representational art was

[50] Crowther 2016: 148. [51] Crowther 2016: 148.
[52] Henry 2009: 3–10, 16–19, 120.
[53] Henry (2009: 113–18) acknowledges this connection with Schopenhauer.

always essentially concerned with the expression of Life but was inhibited by its need to also represent appearances[54] (though he thinks that traditional, stylized religious art was less inhibited in that respect than post-Renaissance naturalism[55]). Modernism tried to free painting from representation, but in fact the whole avant-garde movement from Cézanne through to cubism and beyond to Mondrian and Malevich was simply catching up with the post-Galilean mathematization of nature by the physical sciences, reducing it to geometrical forms. But this art is still ultimately representational, even though what it represents is the basic structural elements of the external world.[56] Kandinsky, by contrast, pioneered an art that is radically non-representational, that does not *represent* Life but, through the emotionally significant intensity, placement, and juxtaposition of colour, *expresses* Life or immerses the viewer in it.[57]

Whatever we may think of these specific claims, what I want to take note of here is that Henry is arguing both that painting in general is able to express (not just state) deep metaphysical truths (through the expressive use of colour in particular) *and* that only Kandinsky succeeded in fully realizing this possibility, freeing painting from other, less philosophically significant tasks to focus on this alone.[58] Setting aside the specific claims he makes for Kandinsky, I think Henry does suggest at least the most plausible *form* that a solution to this problem should take: what is of value in painting is something that exists in some degree in all painting, but it is taken to a higher level, the better the painting is. Where Henry does still go wrong, I think, is in supposing that only a certain kind of painting can have in full purity what gives painting in general its value. My approach is much more pluralistic. I think we intuitively (and rightly) judge many kinds and styles of painting to have value, and the best instances of them to have great value. If this value lies in their expressing truth, then the truth in question must be expressible in many ways—in Rublev, in Raphael, and in Rothko; in Mondrian as well as Kandinsky; and in the landscapes of Dong Yuan as well as those of Constable. To explain what sorts of truths they might all convey, and to explain how such different visions may all be truthful, will obviously be a considerable task. What I have said so far does not answer the problem I raised for Crowell but only sets out what form I think the answer should take. The detailed account that I will give in Part Two of the book will try to put some flesh on these bare bones.

[54] Henry 2009: 31. [55] Henry 2009: 128. [56] Henry 2009: 13–15.
[57] Henry 2009: 16–19, 21.
[58] This does still allow for the possibility that, even though Kandinsky was the first to devote him-self to this task in its purity, other artists might have created works which, while still 'impure,' were, nonetheless, more expressive of Life than Kandinsky's 'pure' ones. Henry clearly doesn't think this is the case, but the possibility should be noted.

IV

The second major problem that I find with Crowell's account of why art matters is that is that he doesn't make it clear *why* the truth that he thinks Morandi shows us itself matters. Why, even if paintings do show us truth, does that make them valuable? Crowell starts his essay (as I started this chapter) by discussing the Neoplatonic grounding of traditional aesthetics according to which art is a response to beauty, which is thought of as a quality present in the natural world around us and deriving from a metaphysical source—the Form of Beauty, or God. But, as I noted above, Crowell thinks that this understanding of the relation of beauty to art dropped out of our thinking with the onset of modernity and the scientific/technological 'disenchantment' of nature. He claims that this need not prevent us from seeing art as revelatory of truth. But he doesn't really address the question of why, if the truth about reality is that it lacks inherent meaning and value, it would be valuable for us to come to know that. And this means that, even if one accepts everything he does say, Crowell hasn't really answered the question he started with: why does art matter? The question of the value of truth, if it is detached from its Platonic and medieval stablemates, Goodness and Beauty, was raised by Nietzsche,[59] but it has not, I think, been taken seriously enough by most subsequent thinkers (even, or especially, not by Nietzsche's postmodern would-be disciples). Gerald Manley Hopkins writes of the natural world as expressive of the grandeur of God: 'There lives the dearest freshness deep down things',[60] although this is usually veiled from us by our exploitative, utilitarian attitude to the natural world. Many thinkers have taken the arts—including painting—to be able to restore this sense of 'dearest freshness' to us—to show us a deep truth about things which is beautiful because it reveals their goodness. But if these dimensions of beauty and goodness are lost, why isn't the value of showing the deep truth about things lost with them? The issue is raised vividly by Francis Bacon (the painter, not the philosopher), who says:

> I think that man now realises that he is an accident, that he is a completely futile being... when Velasquez was painting, even when Rembrandt was painting...they were still... conditioned by certain types of religious possibilities, which man now, you could say, has had completely cancelled out for him. You see, all art has now become completely a game by which man distracts himself; and you may say it has always been like that, but now it's entirely a game.[61]

[59] See, esp., Nietzsche: 1996: Essay Three.
[60] Hopkins, 'God's Grandeur' (in Hopkins, 1998, 114) line 10.
[61] Sylvester 2007.

I find 'game' a strange word to describe Bacon's own work, which seems to express a despairing sense of the 'futility' of human existence which itself only makes sense in implicit contrast to the background of a rejected religious or metaphysical outlook. But in a radically disenchanted world, art may serve distract us from the futility of our existence as Nietzsche sometimes supposed ('We have art so we do not perish from the truth.'[62]); or it may try (as Bacon's work seems to) to compel a recognition of that futility. But why, in a meaningless world, would it even be meaningful, of value, to make us aware of that meaninglessness? In such a world, can the truth-revealing nature of art be a reason for valuing it? Crowell is actually rather ambivalent about this. Although he initially seems to take the disenchantment of the world for granted, he does, as we have seen, insist that the 'silence' of things is not equivalent to their 'absurdity'. He even alludes in this connection to 'a silence between lovers'[63] (which we might think of as a connection that reaches 'deeper than words'). This seems to hint that Morandi's re-expressing of the non-human reality of things might be a first step *away* from the scientific/technological disenchantment of the world.[64] But, as it stands, it is only a hint.

It will, then, be important for an account which places the value of art in its capacity to reveal truth to explain why such revealing is itself of value. And it is hard to see how it can do that if there is no value in the world, the truth of which art could reveal to us. It may seem that it can be valuable to know truths, even if those truths are themselves about value-free facts. But this would be instrumental value: I need to know how things are so I can act advantageously. But this pragmatic defence of the value of truth (or, rather, the value of having enough truth or approximate-enough truth to allow us to act effectively) hardly seems relevant for our purposes. If art makes truths accessible to us, they are not practical truths of this kind; and even if they were, this would amount only to an instrumental, rather than an intrinsic justification of the value of art. It might seem obvious that a realist account of the value of art such as I am aiming to give here must be based on a wider evaluative realism. (It would seem strange to think of art as the *only* thing that has value in the world.) However, in ethics, various forms of constructivism have been presented as alternatives to both ethical realism and mere subjectivism.[65] Perhaps, similarly, we can think of aesthetic value as something we create, but in a way that is not merely arbitrary and which has a genuine authority over us? I think that ethical constructivism does, in fact, fail to provide any justification for morality[66] and that constructivism is even less

[62] Nietzsche 1968: bk 3, sect. 822. [63] Crowell 2011: 50.

[64] And see Crowell 2011: 50–1, n. 2, where he recognizes that some 'environmental philosophers' have drawn on Merleau-Ponty in search of a 'renewed philosophy of *natural* beauty'. This is an issue I shall return to in Chapters Eight and Nine.

[65] See, e.g., Rawls 1980; Korsgaard 1996; Street 2012.

[66] I criticize Korsgaard's version of constructivism in Rudd 2012: ch. 5.

plausible in aesthetics. But in any case, it is hard to see how a constructivist aesthetics, even if it did have some plausibility, could help to support an account of the value of art which made its *truth-revealing* capacity central to its value. For the whole point of constructivist accounts is that they sever the value of art/ethics from any question of its revealing how things are outside us. And what I am concerned with here is what it would take to make a truth-based account work.

One modern philosopher who gives a truth-based account of the value of art which does explicitly connect truth to goodness and beauty is Iris Murdoch. And it is significant that Murdoch is deeply influenced by Plato, though she is somewhat sceptical about the metaphysical commitments of traditional Platonism and gives a rather different account of the value of art from the traditional Neoplatonic one. As a modern attempt to meet the 'Platonic' critique of art, using materials largely derived from Plato but without necessarily embracing a full-blown Platonic metaphysics, Murdoch's account is very relevant for our current purposes. Her aesthetics is, indeed, best seen as a response to Socrates' critique of art in *Republic* book 10—a challenge which she takes very seriously. For Murdoch the two aspects of the 'Platonic' critique that I distinguished (art isn't true and art isn't good) fit closely together, since she sees morality itself as bound up with truthful perception. We don't act well because we don't see well—that is, we fail to perceive what is really going on around us and the moral demands it makes upon us. And this is because we are busy wrapping ourselves up in a in a blanket of consoling, pleasing—or piquantly interesting—fantasy, rather than being willing to face the ethical demands that a clear and honest view of the world would make manifest: 'The chief enemy of excellence in morality (and also in art) is personal fantasy: the tissue of self-aggrandizing and consoling wishes and dreams which prevents one from seeing what is there outside one.'[67] And she is intensely conscious that bad art—and sometimes, she worries, even good art—can merely reinforce this tendency to self-indulgent fantasy: 'The bad artist (who resides in all of us) as naïve fantasist ... sees only moving shadows and construes the world in accordance with the easy unresisted mechanical "causality" of his personal dream-life. (The bad thriller or facile romance and its client).'[68] Moreover, the 'mediocre artist' (or critic) who prides him- or herself on having seen through the illusions of such bad art, turns into a smug debunker who 'parades his mockery and spleen as a despairing dramatic rejection of any serious or just attempt to discern real order at all.'[69] And even great art cannot protect itself from being 'taken over by its client as fantasy and pornography.'[70] Indeed, 'serious art is ... especially dangerous because it resembles the good, it is a spurious short-cut to "instant wisdom".'[71] For '[t]he great artists especially make us feel we have

[67] Murdoch 1997d: 347–8. [68] Murdoch 1997b: 452.
[69] Murdoch 1997b: 452. [70] Murdoch 1993: 13–14. [71] Murdoch 1993: 19.

arrived; we are home'. In contemplating their works '[w]e feel that we are already wise and good'.[72]

Murdoch does not, however, give up on art and notes that 'In fact Plato himself provides a good deal of the material for a complete aesthetics; a defence and reasonable critique of art'.[73] Interestingly, though, she rejects the standard Neoplatonic defence of art that I discussed above—the Plotinian idea that, as she puts it, 'the artist does not copy the material object but copies the Form'.[74] She suggests that this 'would be a "category mistake" since the model is not a particular thing'.[75] This doesn't seem entirely fair to Plotinus, who does not say that the artist *copies* the Form, but tries, rather, to evoke the Form in and through the particulars. But Murdoch goes on to suggest a different way in which a Platonist could take a positive view of art, asking, 'can [the artist] not attempt to see the created world in the pure light of the Forms?'[76] A central idea of Murdoch's explicitly Platonic ethics is, as noted above, that our ordinary perception of the world is constantly threatened by our tendency to see only what we want to find in it—to project onto it our own fantasies and resentments. A crucial part of the moral life is learning to see things (persons, situations) as they really are (recognizing this person as pitiable rather than merely irritating, recognizing these actions as manipulative rather than charitable). Bad art, Murdoch agrees with Plato, merely reinforces our tendency to fantasize.[77] But, she goes on to suggest, good art can serve as an example of, and an inspiration to, the truthful and honest vision of things as they really are: 'In the shock of joy in response to good art an essential ingredient is the sense of the revelation of reality, of the really real ... the world as we were never able so clearly to see it before'.[78]

This truthfulness is obviously not to be found in the sort of art that merely expresses the artist's fantasies or projects them onto reality. It comes through attentiveness to what is there around us. But neither is it a facile imitation of surface appearances: 'The painter and the writer are not just copyists or even illusionists, but through some deeper vision of their subject-matter may become privileged truth-tellers'.[79] What this involves is stated succinctly in a relatively early essay:

Art and morals are, with certain provisos ... one. Their essence is the same. The essence of both of them is love. Love is the perception of individuals. Love is the extremely difficult realization that something other than oneself is real. Love, and so art and morals, is the discovery of reality....The enemies of art and of morals, the enemies, that is, of love, are the same; social convention and

[72] Murdoch 1993: 13. [73] Murdoch 1997b: 449. [74] Murdoch 1997b: 392.
[75] Murdoch 1993: 11. [76] Murdoch 1997b: 452. [77] Murdoch 1997b: 452.
[78] Murdoch 1997b: 454. [79] Murdoch 1997b: 392.

neurosis...fantasy, the enemy of true art, is the enemy of true imagination: Love, an exercise of the imagination.[80]

Seeing the messy world of contingent particulars truthfully, 'in the pure light of the Forms', is to see them with love, that is, as worthy of love. (What truthful vision discloses is emphatically *not* a world of value-free facts—*that* is the fantasy projection, a world that makes no demands on us, one which leaves us free to act on it, manipulate it, as we please.) The true artist, then, is one who can depict things as they truly are, so that we too can see them as worthy of love—and as demanding it. And it is important that Murdoch insists that imagination—as distinct from fantasy—puts one in touch with reality rather than taking one away from it. The artist's imagination is precisely what enables him or her to see through the simplistic schemas encouraged by 'social convention' or personal neurosis/fantasy (or by the smug cynicism of the 'mediocre' debunkers) to a deeper truth of things. And an imaginative engagement with an artwork can enable others to see that too. But such engagement is hard work—our experience of artworks can itself be distorted by the filters of neurosis, convention, etc. or turned into an occasion for personal daydreaming. Imagination is thus a crucial part of what Murdoch means by attention, a central notion which she takes over from Simone Weil 'to express the idea of a just and loving gaze directed upon an individual reality...I can only act in the world which I can see, in the moral sense of "see" which implies that clear vision is a result of moral imagination and moral effort.'[81]

On Murdoch's view, then, art can bring us closer to the truth, and, in so doing, it performs a moral task. She is, however, somewhat ambivalent and conflicted on the exact relation of art and morality. She clearly repudiates a merely didactic use of art (and the assumption that this is the only alternative to a trivializing 'art for art's sake' theory[82]). At points in 'The Fire and the Sun'[83] she retreats from her earlier bold identification of art and morals and suggests instead that art might be taken as an *analogy* to morality, or perhaps that it might be useful as a sort of moral training. One can certainly see how novels or plays might be useful in this way, how they might help us to make ourselves sensitive to the morally perspicuous aspects of human interactions. This doesn't apply very obviously, though, to painting (or to other arts such as music). Murdoch does think they may still be morally useful in a less direct way, as encouraging the development of attention in her sense: 'Art remains available and vivid as an experience of how egoism can be purified by intelligent imagination.' It is however, not essential:

[80] Murdoch 1997f: 215–16. [81] Murdoch 1997c: 327, 329.
[82] See Murdoch 1997f: 218. [83] Murdoch 1997b.

Art, though it demands moral effort and teaches quiet attention (as any serious study can do), is a kind of treat...We have to make moral choices, we do not have to enjoy great art...But surely great art points in the direction of the good, and is at least more valuable to the moralist as an auxiliary than dangerous as an enemy.[84]

Here Murdoch, qua moralist, seems to take an instrumental, means-to-an-end view: art can help teach us to see well, and seeing well is essential to acting well. But other 'serious studies,' such as mathematics or learning a language,[85] can also help to teach attentiveness and the setting aside of the ego. And, of course, one can be a good person without engaging in any of these activities. However, if art is itself the product of, expression of, and incitement to a loving and truthful perception of the world, then it would seem to have a value in itself, independent of any auxiliary role it may play for 'the moralist'. A few pages after the passage I just quoted, Murdoch writes of:

the playfulness of good art which delightedly seeks and reveals the real...[We] see beauty as the artful use of form to illuminate truth, and celebrate reality; and we can then experience what Plato spoke of but wished to separate from art: the way in which to desire the beautiful is to desire the real and the good.[86]

Clearly, art is here taken as having intrinsic value, as a way of celebrating reality. And this presupposes that reality is worth celebrating, that what is real *is* good and beautiful, and that it is the 'disenchanted', value-free image of the world that is our distorting projection. It makes sense on this view to see the perspicuous re-presentation of the world in art as a way of celebrating it; and all of the arts, whether or not they are useful as moral training, can be taken as celebratory in this way—painting certainly included.[87] But this is not something purely 'aesthetic' in a narrow sense and wholly distinct from ethics, at least not if we think about ethics in the broad Platonic/Aristotelian sense as an account of human flourishing (perhaps a broader sense than that entertained by 'the moralist' above?). Human flourishing on a Platonic view consists in living in such a way as to relate properly to what is of real value (contemplating, appreciating, celebrating, it).[88] If the reality in which we live is of real value, and if our flourishing involves a truthful and loving engagement with that valuable reality, then the creation and appreciation of art would be at least one important form

[84] Murdoch 1997b: 453–4. [85] See Murdoch 1997e: 372–4.
[86] Murdoch 1997b: 459–60.
[87] Merleau-Ponty (1996b: 127) also thinks of painting as celebration: 'Painting celebrates no other enigma but that of visibility.'
[88] I argue for this in Rudd 2012: ch. 6.

that human flourishing could take;[89] and so the experience (and the creation) of art would be *ethically* important. An ontological delight or joy in existence that comes from a loving attention to the world would then be at the root of both ethical action and aesthetic contemplation or creation.

What metaphysical account of the world is needed to make sense of this 'celebratory' view of art? It clearly requires an evaluative realism that is incompatible with a fully disenchanted naturalism.[90] To see things truthfully, to attend to them—even to a blade of grass[91]—is worthwhile if they—down to that blade of grass—have their own real value; but if not, why should it matter? Why not remain tucked up in a cocoon of self-protective fantasy, if that makes one's (essentially meaningless) life more endurable? The truthfulness of art only makes it of value if it puts us in touch with what is itself of value. One might question this—it could be said that one value of art is to make us aware of terrible things, so that we may know how to properly respond to them. I don't deny that it can have that role. But this would seem to take us back to a justification of art in its truthfulness that is merely instrumentally—it enables us to learn about grim truths so we may be better prepared to cope with them. But this does not address the intrinsic value of art, and it does not explain the fascination—even the delight—we feel, even in art that depicts horrors (as I mentioned in Chapter One). I will, however, be returning to the topic of horrifying or morally disturbing art later on.

But although Murdoch's evaluative realism requires a robustly realist metaphysics of value, does it really need a *transcendent* metaphysics in the style of traditional Platonism? One might think—many do think—that we don't need a transcendent Good, that things have their own (real, objective, inherent) beauty and goodness even without a transcendent Beauty or Goodness backing them up, as it were.[92] Murdoch herself remained deeply ambivalent about the ontological status she assigns to the Platonic Good. Sometimes she does seem to propose a full-blown Platonic metaphysics of the Good, but at others she seems to retreat from that to something more modest.[93] I will eventually be returning to at least

[89] And it is important to bear in mind here that art—and, even more broadly, the appreciation and creation of beauty—is ubiquitous in human life. It certainly isn't the preserve of an elitist art world or the possession of a few connoisseurs.

[90] And one which is certainly much richer and more metaphysically substantive than the very thin sense of moral realism defined by Geoffrey Sayre-McCord (1988: 5), which simply states that moral claims can have truth values and that some are, in fact, true.

[91] See Murdoch 1997d: 357. [92] See Scarry 1999: 47–9.

[93] Murdoch 1997d: 360–1: 'If someone says "Do you then believe that the Idea of the Good exists?", I reply "No, not as people used to think that God existed".' (But she does explain the way in which she supposes people 'used to think' that or whether it differs from the way in which many people today still do think that). One might suspect that she takes the Good as a sort of regulative ideal or useful fiction, but she explicitly states that 'This is not a sort of pragmatism or a philosophy of "as if"' (Murdoch 1997d: 360). See Murdoch 1993: chs. 13–16 for her most extensive discussion of the nature of the Good (and its relation to God). This discussion is fascinating but continues to leave the ontological status of the Good mysterious—which is, no doubt, where Murdoch thought we *should* leave it.

touch on this question—how 'Platonic' (that is, transcendent) a 'Platonic realism' about (aesthetic, ethical) value needs to be if it is to meet the 'Platonic' challenge about the value of art. But we may set aside the question of the ultimate metaphysical horizon for now, while still agreeing with Murdoch that an account of art that places its value in its ability to reveal deep truths about the world can only *justify* art if it can show that the truths art gives us are worth knowing; that we cannot usefully discuss the value of art without raising larger questions about the nature of value; and that the discussion of why paintings matter cannot really be treated in isolation from the wider question of why anything matters.

V

Murdoch gives us a powerful and plausible account of why art matters, one that ties its truth-revealing capacities to the goodness of what it reveals and thus explains its value in a way that Crowell's account could not. But Murdoch operates at a quite high level of abstraction and is concerned with the value of art in general. Though she is interested in painting, her concern, when she does get more specific, is—understandably enough—mainly with literature. We still need to ask how *paintings* in particular reveal truth, what kind of truth it is that they reveal, and why we should care about that kind of truth. In Chapter One, we considered Crowther's definition of (visual) beauty (what I called 'broad-sense' beauty) as 'that whose visual appearance is found fascinating in its own right'.[94] And I argued that the value of painting we should be concerned with (why good painting specifically qua good painting should matter to us) must have to do with 'beauty' in this sense, rather than with historical context, etc. But what specifically is it about visually fascinating objects, or a particular subclass of them (good paintings), that reveals truth? Or, to put it the other way round, what is it about the truth-revealing capacities of good paintings that makes them visually fascinating? What, in other words, is the relation between truth and goodness on the one hand and beauty on the other? Murdoch says we 'see beauty as the artful use of form to illuminate truth, and celebrate reality'. She presumably means that beauty is the *outcome* of that process; but, granted that the artful use of form (taking that as broadly as possible, not in a narrow 'formalist' sense) can indeed illuminate truth and celebrate reality, *how is it that it does so*? To these questions, I will turn in Part Two.

[94] Crowther 2009: 16.

PART TWO

Chapter Three
Painting and Presence

I have been discussing the idea that painting can convey philosophically significant truth. But what sort of truth? We are not, as I have already noted, talking about the empirical information that paintings can, of course, convey. In general, the non-paraphrasability requirement seems to indicate that the important truths that we get from paintings can't be propositional ones. I suggested in Chapter Two that we should think of what we learn from paintings as a sort of knowledge by acquaintance (although in an extended sense from Russell's original one.) It does seem right to say that a portrait, for instance, conveys the information that its sitter looked like *that*, something that can't be adequately conveyed by propositions (which is not to say that we can say nothing at all about it, but nothing that we could say would be an adequate substitute for what the painting itself can tell us). Given the tendency of many analytical philosophers to equate truth with propositional truth, it is helpful to be reminded that there are truths that cannot be fully or adequately verbally articulated; but we need more than this to give us an adequate characterization of the truths which paintings can provide us with. A portrait, even a relatively mediocre one, may be of interest to a historian who wants to know (in more than verbal terms) what a historical figure looked like, but that doesn't explain the aesthetic value of a great portrait (Velazquez's of Pope Innocent X, for instance).

However, thinking more about the notion of acquaintance may take us further. One may know 'by acquaintance' what somebody looks like, even if that person is a stranger; but one may also be said simply to *know someone* with whom one is closely acquainted. And this knowledge too is plausibly irreducible to propositional knowledge (though different people may be more or less good at putting into words their understandings of the characters of their acquaintances). Information about someone, however extensive, is not a substitute for actually *getting to know* that person for oneself. In what follows, I want to explore the possibility that what we get to know in knowing a painting is at least somewhat analogous to what we get to know in knowing another person, that the truths we get to know through our acquaintance with paintings are akin to the truths about other people that we can only acquire through personal acquaintance with them. In exploring this idea I will be appealing to the notion of *presence*, a term that usefully connects art-critical literature with some philosophical discussions of interpersonal relations. And my approach throughout will be phenomenological—that is, I will be reflecting on what it is like, from a first-person point of view, to experience other

Painting and Presence: Why Paintings Matter. Anthony Rudd, Oxford University Press. © Anthony Rudd 2022.
DOI: 10.1093/oso/9780192856289.003.0004

persons, and to experience paintings, in order to characterize essential aspects of the different ways in which we may do so.

<div style="text-align: center;">

I

</div>

Early in Chapter One I referred to James Elkins's remarkable book, *Pictures and Tears*. For that book, Elkins solicited reports of their experiences from people who had undergone intense emotional reactions while looking at paintings. One respondent ('Rob') reported an experience in the Museum of Modern Art in New York:

> He was walking by a side room when he felt as if something had pushed him. He says it was like the feeling of sleeping on a train when 'you suddenly have to open your eyes because you feel someone is staring at you'. He looked into the recess and saw a painting of Rothko's. 'Its presence was so unmistakable', he writes, that 'I nearly wanted to step forward and warm my hands on it…I lifted up my hands in an involuntary gesture because I wanted to applaud.'[1]

What is the notion of 'presence' being invoked in this report? It is not the simple fact that the respondent found himself in physical proximity to the painting. One might say that the presence of the table I am writing on or the wall opposite me is 'unmistakable' and simply mean, 'Well, there it is. I can't doubt that it's there.' I don't have to experience it as significant in any way. Obviously Rob's experience of the Rothko was of a quite different kind. The presence made him want to celebrate it; it was present to him with an intensity that made him feel as though it were emitting heat from which he could warm his hands. Later in *Pictures and Tears*, Elkins reports the distinction made by another art historian and critic, Michael Fried, between 'presence' and 'presentness':

> In Fried's lexicon, presence denotes the bare physical nearness of the object; the feel of the paint, the weight of its support. 'Presentness', on the other hand, stands for the quality some artworks have of being immediately *there*, filling the field of experience, absorbing the viewer's gaze and thoughts.[2]

Elkins goes on to note that he is using 'presence' to mean what Fried calls 'presentness', and I am doing so too. But whatever words one uses to convey it, the distinction Fried makes is an important one.

[1] Elkins 2001: 54–5. [2] Elkins 2001: 179.

A further point to take from Rob's account is that he didn't first notice the Rothko and then get drawn into it (as can often happen with paintings); he was, in a sense, first addressed *by* the painting, with the force of a physical impact ('as if something had pushed him'). He elucidates this further with an image that is explicitly of intersubjectivity, realizing that someone is staring at you. The painting first looked at him.[3] This is, I think, important for the idea of presence that I am trying to elucidate. What is present to me is not just an object, a thing to be stared at; in some way I enter into a relation with it. There is a mutuality. Obviously, this is a difficult idea. I am not suggesting that the Rothko painting was conscious of Rob in the way that Rob was conscious of the Rothko. (Even a panpsychist isn't going to think *that*.[4]) But the mutuality is there (present!) in the experience. I don't want to sell that short with a hearty common-sense 'Of course, the painting isn't *really* addressing me.' What matters is to learn from the experience why expressions like those are the ones we naturally reach for when trying to articulate what we have experienced. (Even if you think expressions like 'The painting looked at me' are nonsense, it is worth remembering Wittgenstein's advice: 'Don't *for heaven's sake*, be afraid of talking nonsense! But you must pay attention to your nonsense.'[5])

So something that is naturally articulated in the language of intersubjectivity is involved in the experience of the presence of pictures, something at least analagous to intersubjectivity. How this might be unpacked we will need to see. But we should note that the distinction between presence in the charged sense with which I am concerned and presence in what we might call the simple sense (the distinction Fried tries to get at by distinguishing presentness from 'mere' presence) also applies to cases of literal intersubjectivity. I may be sitting in a public space and be aware that other people are around me. I am aware that they are subjects, persons, not just inanimate things. If one of them asks me for directions or what the time is, I will reply; if I want them to get out of my way, I will ask

[3] I'm not suggesting that this should be understood as involving anything paranormal; no doubt he had subliminally observed the Rothko out of the corner of his eye. (Nor need there be anything paranormal about the experience of being awoken by someone's stare.) But neither do I want to take Rob's language as a mere rhetorical *façon de parler*; it seems forced on him by the intensity of the experience itself and necessary to convey the nature of that experience.

[4] It should be said that panpsychism has been treated with increasing seriousness in recent philosophy of mind. Its contemporary defenders generally suppose that a sort of proto-mentality is pervasive but not that all things are actually *conscious*. See Buntrup and Jaskolla 2016. And even a theory which did claim that all things were conscious would not explain why it is the Rothko or the Bellini, rather than the mediocre daubs on the walls opposite them, that speaks to us.

[5] Wittgenstein 1980: 56. Philippa Foot (2001: 1) recalls an incident in which, during a discussion, 'Wittgenstein interrupted a speaker who had realized that he was about to say something that, although it seemed compelling, was clearly ridiculous, and was trying ... to say something sensible instead. "No", said Wittgenstein, "say what you *want* to say. Be *crude* and then we shall get on."' Foot comments: 'The suggestion that, in philosophy one should not try to banish or tidy up a ludicrously crude but troubling thought, but rather give it its day, its week, its month in court, seems to me very helpful.' It seems so to me too.

them, rather than pushing them aside or picking them up and relocating them. They are present to me, not just as objects, but as persons. And yet there is a contrast between that kind of presence and a heightened kind in which, one might say, I *really* notice, respond to, attend to the other person. Gabriel Marcel has some helpful reflections on the notion of presence in interpersonal relations:

> We can, for instance, have a very strong feeling that someone who is sitting in the same room as ourselves, sitting quite near us, someone whom we can look at and listen to and whom we could touch...is nevertheless far further away from us than some loved one who is perhaps thousands of miles away or perhaps, even, no longer among the living. We could say that the man sitting beside us was in the same room as ourselves, but that he was not really *present* there, that his *presence* did not make itself felt...One might say that what we have with this person is communication without communion.[6]

The person in question 'isn't all there' (or isn't all there to us). And Marcel notes that the lack of 'presence' in another person can make me feel 'in some sense also a stranger to myself; I am not really myself when I am with him.'[7] By engaging with others in a deadened, conventional, and superficial way, I am myself made deadened and superficial. By contrast, though, 'The opposite phenomenon...can also take place. When somebody's presence does really make itself felt, it can refresh my inner being...it makes me more fully myself than I should be if I were not exposed to its impact.'[8] The contrast Marcel is drawing is, I think, a familiar one. We all know what it is to engage in superficial small talk, but without really connecting with one's interlocutor. And we all know (I hope) what the opposite is like: to converse with someone in such a way that one does connect with what goes deep in them.[9]

What is going on in the former cases? Is the person not present to me, or am I not attentive to his or her presence? Either can happen. Someone may be really trying to communicate deeply with me, but I am too tired or distracted to notice. But the person may be engaging with me only half-heartedly, with his or her mind elsewhere. And, of course, it often happens that both are true; neither of us in really engaging with the other. It can take a real effort to attend to the other person—and it may take a real effort to let oneself be attended to.[10] The notions of presence and of attention are closely bound up with each other. Someone can

[6] Marcel 1978: 205. [7] Marcel 1978: 205. [8] Marcel 1978: 205.

[9] I'm not supposing that there need always be a sharp or clear distinction between these types of case, so that presence is either there or it isn't. No doubt there is a continuum.

[10] I should say, incidentally, that I don't suppose that such superficial everyday social interaction is necessarily bad or that we are morally obliged to be in a state of constant intense attentiveness to the presence of all those with whom we have to deal. It might indeed be inappropriate or intrusive so to be. What may be morally obligatory is to be sufficiently attentive to be able to see when we need to be more fully attentive to someone.

only be present to me when I am attentive to him or her. The mutuality Marcel is concerned with would seem to involve each party being attentive to the other. But there are other cases where attention can reveal presence without mutuality. Simone Weil, alluding to the parable of the Good Samaritan, notes how the beaten and injured man is reduced to the level of a thing:

> He is nameless, no one knows anything about him. Those who pass by this thing scarcely notice it and a few minutes afterwards do not even know that they saw it. Only one stops and turns his attention towards it. The actions that follow are just the automatic effect of this moment of attention. The attention is creative.[11]

Only one who is willing to be attentive—open, receptive—to the victim can see the humanity in that apparent mere thing. Here there is no mutuality (no immediate mutuality, at least)—the man in the example may well be unconscious. The same may be true even of less drastic cases. Suppose someone recognizes a person's distress or nervousness—perhaps seeing it through a mask of bluster or aggressiveness—and responds to that person with kindness and reassurance. The attentiveness in this case sees through even an attempt on the other person's part to shield himself or herself from that attentiveness. Obviously there is much more one could say on these topics, in terms of ethics and moral psychology, but for present purposes I need to return the discussion to the presence of pictures.

A painting can obviously be present to me in the ordinary, banal sense—it's just there in my proximity; I'm looking at it. Perhaps I'm even looking at it closely, spending time with it, speculating with my companion about the symbolism, or examining the texture of the brushstrokes. But it can also be present to me more strongly—it *fascinates* not by setting an intellectual or technical puzzle but by drawing me to it, so that I become deeply absorbed in it and want to just keep looking at it; though it may also disturb me so much that I want to turn away. Both are possible reactions to what I have been calling 'broad-sense' beauty—that which fascinates visually. Being emotionally involved with the painting is a crucial part of feeling it as present in this sense. Maybe—like those whose testimony Elkins solicited—I cry or clap (or find myself inhibiting an urge to do so). And as in the case of intersubjectivity, for a painting to be present to me, I need to attend to it. And in the case of painting too, such attention demands an effort. One can easily stroll through a gallery, glancing or even looking carefully at paintings, but without attending in the sense that concerns me here. I may feel too tired to be able to attend, and I may even feel that the demand for attention that the painting is making of me is an imposition: 'What are you that you demand this effort of me?'—as I may also feel with a person. When I do attend, I am surrendering

[11] Weil 1973: 103. This is, of course, the notion of attention which, as I noted in Chapter Two, so deeply influenced Murdoch.

myself, giving myself to the painting. So in some cases, it is a deliberate decision I make to attend. And when I start to do so, it is as if a gestalt shift has taken place; the object of my perception remains the same, but it also becomes quite different. But sometimes there is no decision and no option. The painting forces itself on me, as the Rothko forced itself on Rob. I might be glancing around inattentively, and the picture just hits me, draws me in, and I can't look away.

Of course, not everyone experiences paintings in this intense, charged way, and those who do have those experiences won't have them all the time when they look at paintings. And it is always possible to give a debunking account of such experiences, to try and explain them away psychologically. In a number of the particular cases Elkins records, such explaining away would indeed be appropriate; the painting in question clearly did just act as a trigger for the release of some pre-existing emotion. But many people today would be quite generally suspicious of, or cynical about, the idea of experiencing paintings with deep emotional intensity. This attitude is nicely expressed by an episode in Ben Lerner's novel, *Leaving the Atocha Station*. The protagonist, Adam, is a young American poet immersed in postmodernist literary theory who is living in Madrid. In the Prado one day he sees a man bursting into tears in front of a painting:

> Was he, I wondered, just facing the wall to hide his face as he dealt with whatever grief he'd brought into the museum? Or was he having a *profound experience of art*? I had long worried that I was incapable of having a profound experience of art and I had trouble believing that anyone had…Insofar as I was interested in the arts, I was interested in the disconnect between my experience of actual art-works and the claims made on their behalf; the closest I'd come to having a profound experience of art was probably the experience of this distance, a profound experience of the absence of profundity.[12]

Adam, despite his claim to be 'worried' by his inability to experience art profoundly, actually seems to be congratulating himself on the sophistication of his detached and sceptical attitude; and this attitude—this distrust of intense first-order emotional responses (to art or maybe to anything)—is certainly one of the pervasive characteristics of contemporary Western culture. There is, of course, no knock-down argument against such scepticism, and no way to force someone to have 'a *profound experience of art*'. But it is not hard to see the attitude of Lerner's protagonist as a defensive measure—he is frightened by strong emotional experience, of surrendering control, of letting go; and so he maintains a sense of detached superiority by keeping everything at a distance. And one suspects that this emotional need to avoid intense emotion is one of the main things that

[12] Lerner 2011: 8, 9.

attracts him to the postmodern theory which gives an apparent intellectual justification for his cool detached stance.

The art historian David Freedberg considers a case 'when we go into a museum and see a great picture or sculpture'. He goes on:

> We see the object and feel that history and common judgement have rightly sanctioned its status in the canon; we feel no doubt whatsoever of its presence; we feel the fullness of its aura and its great force...There is nothing like this repleteness with billboards or with the vast bulk of everyday imagery—not usually.[13]

Freedberg, like Elkins, naturally reaches for the term 'presence' and appeals to notions of repletion or fullness—a richness or intensity of being, one might say— to further explicate it. However, he seems immediately uncomfortable with the connotations of at least some of his language and goes on, 'By aura I do not mean something vague, mystical or unanalytic, or some mysterious quotient or residue of energy within a painting or a sculpture. Aura is that which liberates from the exigencies of convention.'[14] This strikes me as quite thin and inadequate. A great work, of course, is one that stands out from the rest, but it may do so without departing from conventions, but rather by utilizing the possibilities those conventions offer in a particularly striking way. And, obviously, there are lots of works that do depart from convention but are quite worthless. Many great works *are* very original, but originality is not a necessary, let alone a sufficient criterion for greatness. And actually, 'mysterious quotient or residue of energy' is not a bad description of what we do experience in great works. The odd thing about Freedberg's positivistic skittishness about sounding 'vague, mystical or unanalytic' is that he has devoted most of the remarkable book from which I have just quoted to insisting that we should *not* be afraid of sounding that way when thinking about human responses to images:

> People are sexually aroused by pictures and sculptures; they break pictures and sculptures; the mutilate them, kiss them, cry before them and go on journeys to see them; they are calmed by them, stirred by them and incited to revolt. They give thanks by means of them, expect to be elevated by them and are moved to the highest levels of empathy and fear. They have always responded in these ways; they still do. They do so in societies we call primitive and in modern societies; in East and West, in Africa, America, Asia and Europe. These are the kinds of response that form the subject of this book, not the intellectual constructions of critic and scholar.[15]

[13] Freedberg 1989: 432. [14] Freedberg 1989: 433. [15] Freedberg 1989: 1.

These kinds of responses certainly seem to be responses to a kind of felt presence—and one to which we respond (at least in part) as we do to the presence of a person. The people who do respond in the sorts of ways he mentions would indeed seem to experience a 'mysterious quotient or residue of energy' in the images. Freedberg notes that we respond in these intense and intimate ways to images of all kinds—not just great artworks, and often enough to images we wouldn't tend to classify as 'art' at all. He is keen to include the works of 'great art' that we put in museums as special cases of images in general and to play down the idea of a special, disinterested, aesthetic way of perceiving that is specially appropriate to serious artworks.[16] He still needs, of course, to distinguish works of 'fine art' from other powerful images—hence, I think, his falling-back on the notion of 'aura' in his thin sense. If this won't do—as I think it won't—we will need to find some other account of the distinction. There is a serious problem here, for it seems that mediocre, kitschy paintings, statues, etc., as well as images that we wouldn't consider artworks at all, may move people deeply and induce the sorts of reactions Elkins and Freedberg recorded. And yet there seems something right about using the degree of presence as a criterion for the greatness of a work and for equating it with its beauty. This is an issue to which I will, then, need to return, but I won't do so until I have further developed my own positive account. And in doing that, I shall follow Freedberg in arguing that we should try and understand what is powerful about what the modern West thinks of as 'fine' or serious art by starting from an account of images that were not originally intended or thought of in that way.

I want to say, then, that a good painting is one that has presence, which can be experienced as present in this charged sense, while a mediocre painting lacks it (or has less of it). It may be interesting, attractive, pleasing in a variety of ways, but it doesn't have that intensity of being that made Elkins's respondents cry out or burst into tears. And I want to equate presence in this sense with what I have called both 'broad' and 'deep' beauty. What Crowther called the visual fascination of a painting should be understood as its capacity to draw us into a communion with it, to be present to us. This is why 'beauty' in this sense is not only 'broad' but also 'deep'; it is significant or meaningful, not just agreeable or stimulating. Of course, we are talking here about the beauty specifically of a painting, a sense of presence conveyed by visual appearance. The sense of presence I mentioned in the case of personal relationships is conveyed in part by the expressive appearance of people's bodies, but also by, for example, what they say, and here too there is no analogy between the presence of paintings and that of persons. And a general theory connecting beauty and presence would have to find ways to deal with the

[16] Freedberg 1989: xxi–ii: 'I would in fact be happy if the long-standing distinction between objects that elicit particular responses because of imputed "religious" or "magical" powers and those that are supposed to have purely "aesthetic" functions could be collapsed.'

beauty of, for example, a piece of music or of a mathematical proof. This would be an interesting project, but not one I will be attempting here.

The points I have been trying to make in this section are beautifully expressed in Rilke's poem 'On an Archaic Torso of Apollo'—which is precisely about an object (or what is left of an object) originally created for a context of ritual and worship, but now decontextualized in a modern museum. For all that, it still speaks in its presence to the poet, who notes how, despite its mutilated state, the torso:

> "Still glows with brilliance from within
> Like a lamp, though dimmed, in which his gaze
> Still lingers and gleams....
>
> .
> If not, this stone would seem stunted and defaced...
>
> .
> Would not burst like a star from all its limits
> Till there is no place which does not see you.
> You must change your life."[17]

II

I have been suggesting that the truths that paintings (and other visual artworks) make available to us, the knowledge that they give us, have to do with presence. For something to be present in the charged sense that concerns me here is for it to show itself for what it is. To know something in its presence to me is to know not (just) truths about that something, but to know *it*, to be made acquainted with it. When something is present to me, it reveals or discloses itself. (The notion of truth that is relevant here is, therefore, something like Heidegger's notion of truth as disclosure or unconcealment.[18]) And it should be noted that although I have taken over the language of 'knowledge by acquaintance,' this kind of knowledge differs from what Russell originally meant by that in a number of important ways. In particular, the kind of knowledge that we receive in or from presence is *personal*—two people can be looking at something equally closely, in equally good light, etc., and be aware of all the same facts about it; and it can still be present to one and not the other. And it is an *emotional* knowledge: to have something be present to one is to be moved (positively or negatively) by it. This is

[17] My translation; my thanks to Troy Wellington Smith for his help. For the German original, see Rilke (1995), 67.

[18] See Heidegger 1962: div. 1, ch. 6, sect. 44; 2008.

why I have exploited the further resonances of the notion of *acquaintance with someone* to develop the idea of 'knowledge by acquaintance' into something much richer than the Russellian notion, while maintaining its irreducibility to propositional knowledge.

It is important to note that this kind of 'knowledge by acquaintance' does not compete with the knowledge by description that science or practical common sense may give us about the world. Martin Buber—whose distinction between the 'I-Thou' and the 'I-It' comes very close to the Marcellian distinction between presence and mere proximity that I have been working with—notes various scientific and other ways in which we can gain and know information about a particular tree and then comments:

> In all this, the tree remains my object…It can however come about…that in considering the tree I become bound up in relation to it. The tree is now no longer *It*…To effect this it is not necessary to give up any of the ways in which I consider the tree. There is nothing from which I would have to turn my eyes away in order to see, and no knowledge that I would have to forget. Rather is everything, picture and movement, species and type, law and number, indivisibly united in this event. Everything belonging to the tree is in this: its form and structure, its colours and chemical composition, its intercourse with the elements and with the stars are all present in a single whole. The tree is no impression, no play of my imagination, no value depending on my mood; but it is bodied over against me and has to do with me as I with it.[19]

Knowledge by acquaintance in my sense is not knowledge of *something else* (perhaps sense data rather than physical things), nor is it (as I noted in Chapter Two) a wordless 'non-conceptual' rapture; rather, everything that I can say and articulate about the object is taken up and included in my experience of its presence. (Buber himself notes that what we receive in the I-Thou encounter is 'not a "Content" but a Presence'[20])

Can just anything be experienced as present in my sense? I have been using as my main examples of presence, encounters with other people and with paintings. But Buber refers to a tree and thinks that anything can be experienced in the I-Thou mode, while according to Murdoch, as we have seen, everything down to a blade of grass can be perceived with loving attention. Since I have associated presence with broad-sense beauty, this question is closely related to that of whether everything, seen rightly, is in some sense beautiful.[21] Paul Ziff argues

[19] Buber 1958: 7–8. [20] Buber 1958: 110.

[21] That everything, at least everything in the natural world, is beautiful is the thesis of so-called 'Positive Aesthetics'; for discussions of this claim from various perspectives, see Carlson and Lintott 2008: pt 3. I will say more about this in Chapter Ten.

that anything, viewed in the right way, can be an object of aesthetic appreciation—a piece of dried dung as much as a Leonardo. From this he draws the conclusion that we should 'abandon the silliness of aesthetic judgement' and cease to suppose that anything is more or less beautiful than anything else.[22] Perhaps he is right that anything can be seen as aesthetically fascinating or as present in the charged sense; but even so it doesn't follow that everything has broad-sense beauty *to an equal degree*. Ziff's thesis has something of the same heroic implausibility as the Stoic doctrine that since everything is equally a necessary expression of the divine *logos*, everything that happens is (equally) good. But even the Stoics didn't find it easy to deny that some happenings were better than others; and it seems no easier to deny that some things are more beautiful than others. To take Ziff's thesis to a *reductio*, it would seem to justify property developers in flattening a beautiful old town and replacing it with brutalist concrete tower blocks on the ground that nothing is really ugly when looked at in the right way, so this would involve no overall loss of beauty. For that matter, though he is no doubt right that any painting can be seen to have *some* aesthetic merit that another lacks,[23] it doesn't follow that we can't make an all-things-considered judgement that some are better overall than others. Matisse's paintings are better than mine; therefore, aesthetic judgements about relative merit are not necessarily 'silliness'.

Although Ziff's conclusion is unacceptable, his argument raises important questions or emphasizes the importance of some of those questions I formulated with respect to Freedberg above.[24] How can we use the notion of presence to distinguish good paintings from emotionally effective kitsch or from numinously charged but aesthetically rudimentary religious images? And why should the notion of presence explain the value of *paintings* specifically, if it can be applied to so many other things? A start at an answer can be given by noting that paintings are intentionally created to be aesthetically striking or fascinating (broad-sense beautiful). A painting is made to be experienced in the charged way—to be an object of visual fascination. Some succeed in this more than others; they repay close contemplative looking, while others do not. (You can't experience my attempt at copying a Matisse with the same intensity with which you could experience the original.) So it seems reasonable to suggest that the presence that (good) paintings have may be significantly different in kind from that which natural objects have (and also different in important ways from whatever presence mediocre paintings might have). This is not to deny that natural objects and scenes are also often beautiful; I will return to the question of the relation between natural and artistic beauty in Chapter Eight and will also say more about the distinction

[22] Ziff 1998: 30. It should be said that he thinks some things can be more beautiful than others in some respects, but that everything is beautiful in some respects and we cannot weigh the relative importance of those respects against one another.
[23] See Ziff 1998: 30. [24] I will have a little more to say about Ziff's argument in Chapter Ten.

between good and bad painting in Chapters Six and Ten, once I have more of my theory in place.

Although in our experience of paintings we are, of course, aware of them as intentionally created objects, I have not said much about painters' intentions, or indeed about painters. The phenomenological account I have given so far has been of the viewer's experience of looking at paintings, not the painter's experience of creating them. This certainly does not mean that I think the agency of the painter is unimportant. I have no wish to embrace a 'Death of the Painter' thesis,[25] and I think one can sometimes have a strong experience of being communicated with by even a long-dead painter through his or her paintings. But the theory I will develop emphasizes first of all what the painting accomplishes, what the painting does as an object of experience, not what the painter's intentions were.[26] Many painters have been quite articulate about their intentions, and I have taken their testimony seriously in arriving at my account of painting. But nothing in my theory involves supposing that painters must have had anything like my theory consciously in mind. (As an amateur painter, even one who is also a philosopher, I am much more likely to be thinking 'How can I get this tree to look right?' or 'Do these colours clash?' than 'How can I make things present in their essential natures?') In the chapters that follow I *will* be quoting a number of individual artists reflecting on the nature of their art. But I quote them because they seem to give genuinely illuminating insights into the effects that their works have, not because artists are *necessarily* the best commentators on what they are doing. Sometimes they are, but it would not by itself be a refutation of my theory if a painter indignantly rejected my whole account of what it was that he or she had achieved.

A plausible starting point for thinking about what is distinctive about presence as it relates specifically to painting is to make a clear distinction between something being itself present and something making something else present. The images that Freedberg considers have their own presence or 'repleteness', but, qua images, they serve to make something else present; they have intentionality. That is, they point to, evoke, manifest, something beyond themselves; they represent. So it might seem that paintings—images generally—may not only be present to us themselves, but serve to make the other realities that they depict present as well. But this is complicated, for the example from which I began in this chapter was that of Rob's encounter with a Rothko, that is, with a work of what would normally be called 'non-representational' art. Rob experienced the Rothko as having its own overwhelming presence; but it might seem (on the face of it) that it wasn't making anything else present. We might then want to

[25] A parallel to the 'Death of the Author' thesis in literary theory, that is.

[26] Certainly not their conscious, explicit intentions. My theory will, though, give an important place to the sense in which a painting is expressive of the painter's sensibility; see Chapter Six, sections I–II.

distinguish between the presence of the painting itself and the presence of whatever it may be representing to us (if anything). A first thought would be that representational art has this double structure, making something else present through making itself present, while non-representational, abstract art presents only itself. But this may be too simple. Rothko himself insisted that his work, while not representational, was still intentional, was *about* something; and, indeed, he denied being an abstract painter at all, in a certain sense: 'I'm not an abstractionist. I'm not interested in the relationship of color or form or anything else. I'm interested only in expressing basic human emotions: tragedy, ecstasy, doom, and so on.'[27] In any case, he was certainly rejecting the idea of an art object that is simply about itself—his work is intended to 'point beyond', as Murdoch puts it.[28] Certainly, though, I need to say more about non-representational art and whether it can fit into the idea that painting *makes present*, but I will postpone that discussion till Chapter Six, by which time the notion of making present will have been developed more fully.

I think that in discussing even representational art we need to distinguish between a narrow notion of representation as simple copying and a broader notion of representation as making present, evoking, relating to. A work that is not representational in the narrow sense may still be representational in the broad sense. Part of the point of this distinction is that representation in the broader or richer sense is about more than conveying information. If an image can make something present to us (itself and/or 'something else'), it does so not just by making a list of facts about it available to us—not even facts about its visual appearance. This is the point of saying that it gives us knowledge by acquaintance, not just by description. It is certainly tempting to say that Rembrandt's self-portraits make us acquainted not only with themselves, but also with *Rembrandt* in a way that reading biographical information about him cannot, or that Rothko's works may make us acquainted with tragedy, ecstasy, and doom, as well as with themselves. But 'as well' might be misleading. A representational painting that has the double structure I am concerned with—making itself present and making something else present—cannot plausibly be thought of as doing two separate things. Rather, it makes something else present to me *by* being present to me itself, or its being present to me (in the charged sense I am concerned with) consists in its making something else present. This is why pure formalism is mistaken: the Rembrandt self-portrait does not make itself present to me by its purely formal properties and *then* somehow *also* make Rembrandt present to me; the power of the painting itself lies in its disclosure of what is beyond it.

[27] Quoted in Polcari 1991: 144. As just noted above, I do not take painters' own statements about what they are trying to do as decisive for interpreting paintings, but they are certainly worth attending to and taking seriously.

[28] Murdoch 1993: 5.

(Of course, these remarks are only pointers in the direction of what an adequate account needs to explicate; they are not themselves the explications.)

We should also be aware—as both Merleau-Ponty and Nelson Goodman would remind us—that even representation in the narrow sense of copying is *not* simple or straightforward. What we think of as realist, representational art is in significant measure dependent on convention; it certainly isn't a matter of just showing things as they are. However, like most insights, this one can be exaggerated. Goodman claims that 'Almost any picture may represent almost anything; that is, given picture and object there is usually a system of representation, a plan of correlation, under which the picture represents the object.'[29] It is true that a system of correlations may be set up so that (almost?) anything may serve as a sign for almost anything else,[30] but representation in painting is not *wholly* conventional in that way, and only a philosopher with a thesis to defend at all costs would really deny that some paintings resemble their subjects more than others. But although I am not denying the reality of 'narrowly' representational (copying) art, my concern is with the broader notion of representation (making present). This is not accomplished only by narrowly representational pictures, and where they do accomplish it, their doing so does not correlate with the degree of literal accuracy of their copying. However, in trying to get clearer about the 'broader' notion of representation, I think it will be helpful to start by looking at the way that this is achieved by some images that are representational in the narrower sense.

III

Before moving on to explicate further this notion of making present, it is worth noting some of the sources of resistance that it is likely to meet. I think many analytic philosophers will be likely to find the notion of presence in painting to be obscure or pretentious. Perhaps they might agree that there is something psychologically interesting about the sorts of examples I have been discussing but may feel that that is for psychologists to investigate. And after all, the cases that Freedberg mentions are, well, weird, primitive, magical. What do they have to do with the disinterested aesthetic appreciation of art? Other, Continental philosophers (or art theorists influenced by some trends in Continental philosophy) may find the notion of presence that I am invoking intelligible but pernicious—or, perhaps, just amusingly old-fashioned. Much recent Continental philosophy has, after all, inveighed against the 'metaphysics of presence' that has allegedly dominated the

[29] Goodman 1976: 38.
[30] Wittgenstein was fond of such examples, but he used them in part to point out how natural we find it to take a sign or a rule one way, even though we could, in principle, find lots of alternative interpretations.

history of Western thought, and has instead celebrated the liberation of the signifier from the signified. And this outlook has been adopted by a good deal of recent art theory (and practice). As Jean-Luc Marion sardonically observes, 'postulating that an image referred to any original would be taken to be largely due to an anachronistic lack of culture and concealed metaphysical obscurity'.[31]

To some extent I will have to respond to such criticisms by simply digging my heels in. I think we are unlikely to get far in thinking about the value of art unless we are willing to dwell with a degree of obscurity and mystery, and with personal and emotional experience, in a way that continues to leave some analytical philosophers uncomfortable.[32] And I am, on the other hand, certainly committed to rejecting the headier versions of postmodernism, with their ideology of free-floating signifiers or images without originals. However, it is important to be clear about the nature and extent of my disagreement with the postmodern critics of presence. If we trace the notion of the (bad) Metaphysics of Presence back to its roots in Heidegger, it originally meant the tendency to take the basic categories of one's ontology from the experience of objects as 'present-at-hand', that is, simply as distinct solid objects taking up bits of a homogeneous mathematicized space and laid out before the detached, objective gaze of a scientific observer. For Heidegger this was an abstraction (albeit a legitimate one) from our more basic experience of interacting with a world of interconnected 'ready-to-hand' equipment apprehended in terms of its significance for our projects as embodied agents.[33] (To put it in more analytic terms, Heidegger was objecting to ontologies that take reality to be (most basically, essentially) composed of 'middle-sized dry goods' (Austin), revealed in a 'view from nowhere' (Nagel).) But I hope it is obvious that the Marcellian notion of presence that I am working with here is utterly different from—and strongly opposed to—the metaphysics of presence *in this sense*.

When something is 'present' in the Marcellian sense, we do encounter the thing itself, and indeed we experience ourselves as getting to the heart of it. But 'presence' certainly does not mean a full and complete presentation of all that something is. For something that is present is always present *to someone*, and no finite subject to whom something is present can experience it as *wholly* present. In the simplest terms, if we talking about physical objects (which both paintings and embodied persons are, though that isn't all that they are), they must always be seen from one angle at a time, from one distance, in this light rather than that, and so on. And even when I am experiencing a deep Marcellian communion with another person, part of the experience is precisely that the other remains mysterious, beyond what I can grasp or know of him or her. Part of what it is for

[31] Marion 2004: 47.

[32] Happily, the notion of 'analytic' philosophy has expanded greatly, so there are many philosophers who can reasonably be so described who do not suffer from such discomfort.

[33] See Heidegger 1962: div. 1, chs. 2 and 3.

something to be present to me, then, is that it presents itself as having depths (literal or metaphorical) which I am not now experiencing, but the sense of which precisely as not being present forms the background to my experience of what does appear to me as present. Presence in this sense is as far removed as could be from the idea of having something spread out before me, fully exposed and completely dissected, as I gaze on it from nowhere and everywhere.

So I am happy to agree in rejecting much, at least, of what Heidegger meant by the Metaphysics of Presence and am sympathetic to much of his positive position.[34] That is not to say that I'm not really disagreeing with the postmodernists or that our differences are merely verbal.[35] Much of postmodernism *is* committed to rejecting not only the 'Metaphysics of Presence' in its original Heideggerian sense, but the Marcellian/Buberian notion of presence too. And, indeed, postmodernism, as it has come to pervade much of the wider culture, is associated with the sort of ironic detachment characteristic of Lerner's protagonist, which is fundamentally antithetical to any sort of Buberian I-Thou encounter—and, indeed, as I have suggested, may serve as a defence mechanism against it. So the differences are real and large. But it is important to be clear about what exactly they are; what I am and am not defending when I talk of presence.

IV

Turning, back then, to the question of what it is for a painting to make present, I will continue to take my lead from Freedberg, who argues that an image is not merely a sign that points to something distinct; rather it represents *epiphanically*: 'The image declares *and makes present* that which is absent, hidden, and which we cannot possibly know—but then do.'[36] Earlier in the book, Freedberg claims that 'the image ... becomes the locus of the spirit. It becomes what it is taken to represent.'[37] These may seem extravagant as well as obscure claims, but I think we can make sense of them, and even render them—or some aspects of them—plausible by looking at some quite everyday and familiar examples of the use of images. So I want to begin with a naive question: why do we appreciate—look at, purchase and indeed make—visual representations of things? (I'm not at this point wanting to distinguish between paintings, photos, sculptures, and so on, or between fine art and more banal images.) Well, we may have practical reasons—we want to use

[34] However, I am very sceptical about his claims for the pervasiveness of the Metaphysics of Presence so understood in the history of Western philosophy (e.g. in Plato); and his related (pejorative) notion of 'ontotheology' seems to me extremely dubious.

[35] It should be said that most of what is called postmodernism, however much it has taken from Heidegger, is, I think, very far removed from the real spirit of his work.

[36] Freedberg 1989: 404 (my italics).

[37] Freedberg 1989: 31. Note the casual shift from 'becomes the locus' to simply 'becomes [the very thing]'. It will matter in what follows to make a distinction here.

the representation to enable us to recognize its original or help us to remember how the original looks (as a detective looking for a suspect or a driver picking up a passenger might carry a photo of the person around[38]). But we may also have aesthetic reasons. People often hang pictures (whether photos or paintings) on their walls. Often these will be realistic (or 'realistic', if you prefer) depictions of objects with certain properties they find attractive—whether they be beautiful landscapes, cute kittens, or sexy nudes. And—if we set extreme Goodmanian scepticism aside—this is because of a certain transitivity. An accurate picture of a beautiful landscape is (somewhat) beautiful itself, even if its strictly pictorial merits are not great. (We're still sticking with artistically unsophisticated photorealism for these examples.) So people like to look at (accurate) representations of originals that they like to look at. (I'm not suggesting that this simple transitivity point is the whole story even about the sorts of examples I have considered so far. But it is a useful starting point.)

There are other cases, though, in which pictures are displayed for reasons that are neither simply practical nor purely 'aesthetic'. In some countries, pictures of the Great Leader are displayed everywhere. One usually thinks of dictatorships in this connection, but portraits of the president or the queen, etc. will often be displayed in the public buildings of more benign regimes. And protesters and opposition groups may prominently display portraits of *their* leaders and heroes. Pictures of the Great Leader are not usually displayed as practical reminders of what he looks like (just in case he comes into your shop). And—although some might think that Comrade Stalin looks rather handsome in that poster—they are not being shown for purely or narrowly 'aesthetic' reasons either. They serve as reminders of who is in charge—not because people might otherwise forget, but in order to make his dominance palpable, to show him as ubiquitously present. In this way (to anticipate a little) they have what we can call an iconic aspect—they somehow bring the presence of the leader into the space where his picture is displayed. Hence the Leader's portraits in Orwell's *1984* came with the slogan 'Big Brother Is Watching You'; they kept you constantly in his presence, under his eye. (The category of presence need not always be a benign one.) Something similar is true, of course, of images (statures, particularly) of now dead people that the society (or its rulers) counts as its heroes; their images make their values, what they stood for, still present—which is why they are sometimes so controversial. This iconic function of such images is indeed made particularly clear when there is a revolution—the revolutionaries will almost always make a point of toppling statues, defacing or burning pictures, or even creating their own effigies of the former leader precisely in order to burn or destroy them. The symbolic value of

[38] No doubt they would have it on their smartphones these days.

such actions is obvious—in overthrowing and smashing the statue, we are overthrowing and smashing the tyrant himself.[39]

But there is also a much more private sense of iconic representation. Many people have pictures of their beloved, their children, their parents, or their cat or dog. They may frame them and put them on a mantelpiece or on their office desk, or they may carry them in a wallet or purse.[40] They surely don't do so in order to remind themselves what their loved ones look like. Nor is the point purely 'aesthetic'. My child or my cat may look charming—but, if I am honest, no more so, and maybe a bit less so, than many other children or cats. The point is not just to have a picture of a nice-looking child or cat, but to have one of *my* child or cat—that particular individual. Here the idea that the picture in a sense makes what is depicted in it present is inescapable. This is especially obvious if the pictured person is physically far away; the photo still makes my spouse or lover close to me, brings her presence into the alienating space of the office. And the same may be true of a picture of a landscape or a house, say, if it is one that has particular significance for me. I look up from my office desk to the picture of the mountain scenery I love to walk in, and the picture 'takes me there'. There are also private honourings of public figures—many people like to keep pictures of athletes or pop stars or (less commonly) writers or thinkers; some of political reformers. And the motivation is (at least it often is) the same in these cases—the desire to be in the presence of those who are depicted.

The sense of presence in all these cases seems at least akin to what Marcel says of presence when he talks about the way in which someone may be physically proximate to us but not present—or vice versa. But what is it that the picture—whether of the Great Leader or someone's spouse—makes present? Not the person's surface appearance, the way he or she looked from that angle and in that light at the moment the photo was taken (though sometimes the moment captured, the event, rather than just the person depicted *is* important), but the person himself or herself. So we have gone from representation in a simple sense (accurate depiction of surface appearances) to a deeper sense of *re-presentation*—making present again, through an evocation of the essence of the person or thing.

I have been talking so far about the importance to us of looking at representations (or even just having them with us; knowing that I am carrying the picture of my beloved may matter to me even if I am not looking at it and even if I don't look at it frequently or regularly). But it may also be important to us to *make* representations of people (places, things) that matter to us. Elaine Scarry asks, 'What is the felt experience of cognition at the moment one stands in the presence of a beautiful boy or flower or bird?' She answers, 'It seems to incite, and

[39] On this, see Freedberg 1989: ch. 10. Again, the same applies to images of past heroes/villains; e.g. statues of Confederate generals in the American South or of Lenin in Eastern Europe.

[40] Or on their smartphones....

even to require, the act of replication. Wittgenstein says that when the eye sees something beautiful, the hand wants to draw it. Beauty brings copies of itself into being. It makes us draw it, take photographs of it, describe it to other people.'[41] This is clearly true with photos—we see a beautiful scene; we want to have a picture of it. Maybe just because a decent photo of a beautiful place will be (somewhat) beautiful or because we want to show off to our friends that we've been there; but also, I suspect, because in some way, having the picture will enable us still to be in the presence of what we found beautiful. However this may be with beautiful places (flowers, birds), it does seem to be part of why it matters to us to take photos of (or, if we have the skill, to draw) our friends, lovers, family members, or pets. To have, to look at, the picture is to bring ourselves into the presence of the person depicted—and that is a reason for making the picture. But the very act of making it (even if the 'making' only involves clicking a shutter) may already constitute an act of communion with what is pictured. This is, I think, important for understanding the relation of a painter to what he or she paints. But it may be true even at the level of the casually snapped photo. (I'm not now concerned with photography as a conscious art form.) Perhaps this is best brought out negatively by considering the phenomenon of the uninvited or unwanted or intrusive photo—paparazzi!—for to be photographed may be a violation. (The alleged belief of some 'primitive' peoples that to be photographed is to have one's soul stolen is by no means foolish.)

<div style="text-align:center">

V

</div>

I have been trying to show that we relate to images in quite everyday contexts as 'making present' in the charged way that Freedberg is concerned with. In the following chapters I will explore ways in which this ability of images to make present has been theorized. I will conclude this chapter, though, by reflecting on the fact that most of Freedberg's examples (though not all) are religious; divinity is somehow present within the image or made present by the image. Indeed, he insists that religious images are paradigmatic for images in general; the making present that images in general accomplish is most clearly seen in the religious case:

> [A]ll images work as religious images, including beautiful and artistic ones. All visual representation…[has a] strong ability to involve the beholder and to transcend natural law. It is dead but it can come alive; it is mute but has a presence that can move and speak.[42]

[41] Scarry 1999: 3. [42] Freedberg 1989: 374.

In making this dramatic and striking claim, Freedberg is explicitly following Gadamer.[43] Gadamer argues that a picture is not simply a copy of the surface appearance of a thing; nor is it merely a sign (a conventional designation pointing to the thing). 'Rather, the presentation remains essentially connected with what is represented, indeed, belongs to it.'[44] And he continues, 'only the religious picture displays the full ontological power of the picture ... the religious picture has an exemplary significance. In it we can see without any doubt that a picture is not a copy of a copied being, but is in ontological communion with what is copied.'[45]

These remarks are striking but rather obscure. When Gadamer claims that religious painting is exemplary for all painting, does he simply mean that there is a structural parallel? On this interpretation—call it the weak claim—all painting is supposed to do something like what religious painting is clearly and explicitly meant to do—that is, make present. On this (weak) claim such making present isn't necessarily a religious act in itself, nor is what gets made present itself necessarily of religious significance. The claim would still be quite substantive, that paintings, whether or not religious, are not just copies but are 'in ontological communion with what is copied'—whatever exactly may be meant by that suggestive but obscure notion. However, there are stronger interpretations. According to these, what is made present (however ostensibly secular) is itself of religious significance or the notion of presence or 'ontological communion,' which applies to all painting is itself an essentially religious one, or at any rate one that only makes sense in the context of a broadly religious world view. I think Gadamer himself intended to make only the weaker claim. However, I am not primarily interested in Gadamer exegesis here, but in the 'weaker' and 'stronger' claims considered as philosophical theses in their own right. Versions of the stronger claim have certainly been suggested by various thinkers—George Steiner being a notable modern instance[46]— and by artists too. One example—perhaps a surprising one—is Matisse, who once claimed: 'All art worthy of the name is religious. Be it a creation of lines, or colors: if it is not religious, it doesn't exist. If it not religious, it is only a matter of documentary art, anecdotal art ... which is no longer art.'[47]

In what follows I will be exploring whether some version of either or both of these claims might be defensible. (The strong thesis would seem to presuppose the weak one, but not, of course, vice versa.) In order to explore these questions it will be necessary to look in more detail at religious painting. Rather than attempt a survey, though, I will concentrate on one specific kind of religious painting, the Eastern Orthodox icon. Having just quoted Matisse, I should note that he was greatly impressed by the icons he saw on a visit to Russia in 1911 and commented

[43] See his citations from Gadamer in Freedberg 1989: 77. [44] Gadamer 2004: 134.
[45] Gadamer 2004: 137. (I already quoted the first part of this remark in the Introduction.)
[46] Steiner 1989; also Steiner: 2001.
[47] Matisse, 'Interview with Georges Charbonnier' in Flam 1995: 192.

not only that 'They are really great art' but also that 'From them we ought to learn how to understand art.'[48] I am proposing to take that thought seriously. This will require us to look a little at the history of the icon and, in particular, to consider the bitter Iconoclasm Controversy in the eighth–ninth-century Byzantine Empire, which hinged on the legitimacy of using images in worship and which established the sharp distinction between an icon and an idol. But I think that much at least of what is true of icons in this narrow sense is true of religious art more generally (and not just Christian religious art). Considering icons specifically is a useful way into discussing the broader issue of whether religious art can be paradigmatic for art in general, since there is a large body of sophisticated theological reflection, both classical and modern, on the significance of icons in the Orthodox tradition and because there has been a significant recent philosophical interest in the icon, stemming primarily from the work of J.-L. Marion.[49]

I should, however, make clear that although I will be discussing the theology of the icon in some detail, I am not intending to rely for the development of my argument on any specifically Eastern Orthodox (or even just Christian) doctrines, but will rather be considering the theology of the icon phenomenologically. That is, without committing myself to the truth of the specifically theological claims made by the authors I will discuss, I will take them as attempts to explicate the experience of icons as manifesting the divine. In so doing, I hope to show that Gadamer's claims about what the 'religious picture' does are not simply his retrospective interpretations but that they correspond to the self-understanding of at least this important tradition of religious painting—and the understanding of it in the wider culture in which it was (and is) embedded. And my ultimate intention is not just to explicate icons, or even religious paintings generally, but to test Gadamer's suggestion by seeing whether and to what extent the notion of making present that emerges from the discussion of icons can indeed be taken as a model for understanding painting in general, and whether, if so, that notion is one that can be fully secularized as it gets employed beyond the explicitly religious sphere, or whether all art is, as Matisse suggested, in some sense religious. So in what follows, I will be pursuing in my own way the two main questions raised by Gadamer's claims: firstly, what does it mean to say that religious pictures are in 'ontological communion' with their subject matter; and secondly, what would it mean to take them, in that respect, as 'exemplary' for painting in general?

It is worth adding one caveat: taking the icon as a clue to the ontological meaning of paintings is certainly not meant to suggest that all painting—or all good painting—should aspire to be as icon-like as possible. As I have noted above, it is a real danger in the philosophy of art that a philosopher should come up with a theory derived from reflection on one or two favourite artists or schools and then

[48] Quoted in Cormack 2007: 85. [49] See Marion 1991: ch. 2 and 2004.

use it to condemn or at least downgrade all kinds of other art. I think, on the contrary, that theorizing should be guided by our actual experience of the great range and diversity of good art. As I noted in Chapter Two, we intuitively judge many kinds and styles of painting to have value, and the best instances of them to have great value. My hypothesis is that icons make particularly clear that their value has to do with their capacity to make present. But other kinds of painting can do that in very different ways. Icons may be philosophically paradigmatic for the understanding of art, but I am not at all suggesting that what is stylistically or visually distinctive about icons should be taken as practically paradigmatic by painters—a standard that ought to be imitated.

Chapter Four
Painting as Revelation
The Icon as Paradigm

In seeking to explore how religious painting might be thought of as paradigmatic for painting in general, I will start by discussing the Eastern Orthodox icon and then draw some general conclusions from the discussion. I will then consider, though more briefly, the understanding of religious sculpture in Hinduism, before looking in rather more detail at the metaphysical significance of classical Chinese landscape painting.

<div align="center">I</div>

This section, then, will be concerned with icons defined fairly narrowly—painted images of sacred personages (Christ, the Virgin, saints—almost never God the Father) or events, composed in a stylized fashion and according to traditionally established models and intended to be used in liturgical and devotional contexts in Eastern Orthodox churches and monasteries—or for private devotion in the homes of Orthodox believers.[1] The existence of the extensive classical theological reflections on the icon that I mentioned at the end of Chapter Three is due to the fact that their use was for a time, extremely controversial.[2] As Freedberg reminds us, the history of the use of images in religious contexts is a long and complex one. Very many cultures—perhaps all—have made images of gods, spirits, or sacred beings, or used visual markers to delineate sacred sites. But in some religious cultures there has also been great uneasiness about the use of representational images. This is especially true of the Abrahamic monotheistic religions. Representational imagery is almost entirely absent from Islamic religious art and

[1] Of course, many icons today are reproductions of painted originals. It has become increasingly common to see icons in the Eastern Orthodox style used in non-Orthodox (Catholic, Protestant) churches; and original icons are now often to be found in art museums, presented as objects of aesthetic appreciation. And some people who are not Orthodox believers may have icons in their homes, which they appreciate in a part-aesthetic, part-spiritual way, while others may enjoy them simply as artworks.

[2] Hans Belting (1994: 144) has argued that it was pressure from popular piety that forced the church hierarchy to first accept and then positively promote the veneration of images. This is probably right, but it is a non sequitur for him to conclude that the theologico-philosophical justifications of images, which I will discuss below, were merely rationalizations of a policy accepted for practical reasons and therefore lacked a 'truly intellectual vigor'.

Painting and Presence: Why Paintings Matter. Anthony Rudd, Oxford University Press. © Anthony Rudd 2022.
DOI: 10.1093/oso/9780192856289.003.0005

has played little role in Judaism.[3] Christianity has, for the most part, taken a very different path, but it could have been otherwise. The Eastern Orthodox theological justification for the use of icons was hammered out in the course of the bitter Iconoclasm Controversy in (and beyond) the Byzantine Empire. Between 726 and 786, and again from 815 to 843, successive emperors banned the use of images in worship and often destroyed or defaced them. Their policy was bitterly resisted by many, and the conflicts brought the empire close to civil war at various points. The iconoclast policy was definitively reversed in 843—an event that is still celebrated by the Orthodox Church in the feast of the Triumph of Orthodoxy.

For the iconoclasts themselves (and nearly all their writings were subsequently destroyed, so we only know of them through their opponents' quotations or paraphrases) the veneration of icons was tantamount to idolatry. Their argument was both biblical and Platonic. They naturally cited the command in *Exodus*: 'You shall not make for yourself an image in the form of anything in heaven above or on the earth beneath or in the waters below. You shall not bow down to them or worship them.'[4] The meaning of this injunction has been much debated in both Judaism and Christianity. Does it forbid the making of representational images at all? Or does it only forbid using them for religious purposes? Or only *worshipping* them? But underlying the iconoclasts' exegetical claims about the Bible, there was the philosophical (Platonic) conviction that images take us away from reality and misrepresent its true nature. To make images of material things is to move further away from the immaterial realm which is truly real (and good) rather than towards it.[5] The iconoclasts' case does have an intuitive clarity. If God is invisible, infinite, and transcendent, how can he be represented by a (visible, finite) image? Doesn't this convey the message that God himself is finite and limited—one being amongst others, rather than the Absolute? And even if the image is that of a saint, surely we should be venerating the saint himself or herself and not being distracted by the mere image of the earthly appearance of the saint?

In response, the defenders of icons ('iconodules') agreed that God could not be represented directly.[6] However, they pointed out that God had become incarnate in Jesus Christ and argued that it was, therefore, both legitimate and desirable to have representations of God *as so incarnated*: 'I am emboldened to depict the

[3] Representational art has sometimes been frowned upon in the Islamic world even in contexts that are not explicitly religious; but in some Islamic cultures—e.g. Iran—secular representational art has thrived.

[4] *Exodus* 20, 4–5. (This quotation is from the New International Version of the Bible.)

[5] The study of Plato (and Aristotle) never died out in the Byzantine Empire; but whether or not the iconoclast theologians drew on Plato directly, the theology of the early Greek Church Fathers, to which all parties to the controversy appealed, was itself steeped in Platonism.

[6] Interestingly, the Western Church has generally been quite content to admit images of God the Father or of the Trinity, while Eastern Orthodoxy has always refused to do so. But then the Western Church has generally had a different understanding of the role and significance of images. I will touch on this further below.

invisible God, not as invisible, but as he became visible for our sake.'[7] The iconoclasts, however, refused to depict Christ because one could only *depict* him as a man, but this would mislead as to his true nature by failing to show his divinity. In response the iconodules argued that their opponents were effectively denying the reality of the Incarnation: by denying that God could be depicted as man, they were effectively denying that God could have revealed himself in human form and therefore implicitly denying that he could really have become man.[8] The iconodules agreed that it would be wrong to offer worship (*latreia*) to images, whether of Christ, the Virgin, or the saints. The image is, of course, different from its original and should be regarded differently. (Hence the embarrassment the theologians felt at those who treated icons as having magical properties, expecting, for instance, healing miracles from flecks of paint scraped from them.[9]) However, the image conveys something of the nature of its original to our senses, and it is, therefore, they claimed, proper to offer 'veneration' (*proskynēsis*) to the images.[10]

Underlying these specifically theological arguments is a fundamental philosophical assumption. The material world is an expression of God's nature through which we, as embodied beings, can be brought to some comprehension of the transcendent God:

> What place is there where divinity is not present, in beings with or without reason, with or without life? But it is present to a greater or lesser degree, according to the capacity of the nature which receives it. Thus if one said that divinity is in the icon he would not be wrong...but divinity is not present in them by a union of natures [as in Christ]...but by relative participation, because they share in the grace and the honor.[11]

If the iconoclasts' argument looked back, consciously or not, to Plato's critique of the arts in *Republic* book 10, the iconodules' counterargument is ultimately a Christianized version of Plotinus' vindication of the visual arts, according to which, since material objects are what they are through their participation in the Forms, images of material things (especially stylized ones which bring out their formal, essential properties rather than their contingent, accidental ones) can lead our minds to contemplation of the Forms: 'For we see images of created things intimating to us dimly reflections of the divine.'[12] For Plotinus the ultimate point of this ascent is to leave the material world behind; we use material images

[7] St John of Damascus 2003: 22; see also St Theodore the Studite 1981: 21: 'Christ is depicted in images and the invisible is seen.' St John and St Theodore were the most influential of the iconodule theologians; their polemical treatises in defence of icons were written during the Iconoclasm Controversy.

[8] See St Theodore 1981: 22–3, 78–99. This is why the iconodules considered their opponents not just mistaken about an issue of practice but actually heretical.

[9] See Cormack 2007: 29. [10] St John 2003: 25, 27–8; St Theodore 1981: 38.

[11] St Theodore 1981: 33. [12] St John 2003: 26.

only as steps on a journey which eventually takes us far beyond them. But this certainly is not the case in the Christianized version. St Theodore the Studite rejects the idea of a purely spiritual ascent by referring to the bodily nature of the Incarnation: 'If merely mental contemplation were sufficient, it would have been sufficient for Him [Christ] to have come to us in a merely mental way.'[13] St John of Damascus insists that 'since I am a human being and wear a body, I long to have communion in a bodily way with what is holy and to see it.'[14] He goes on to argue that because it is God's creation and is further ennobled by Christ's material body being taken up into divinity,[15] the material world 'is filled with divine energy and grace.'[16] An image, therefore, by depicting a material body in such a way as to show that divine energy and grace shining out from it, makes manifest to us—in a way that is proper to our own embodied nature—the nature of the material world as divine creation.

This understanding of the significance of images remains basic to the Orthodox theology of icons (and to the practice of icon-making). The icon represents the holy person or event. As such, it is, of course, different from its original, but, as Leonid Ouspensky puts it, 'Although the two objects are essentially different, there exists between them a known connection, a certain participation of the one in the other.'[17] The use of the Platonic term here is significant: not a mere copying or imitation or similarity, but a *participation*. What is depicted is, in some way, mysteriously present in the depiction. Paul Evdokimov emphasizes that the icon isn't merely a (conventional) sign, but a symbol; that is, it 'contains in itself the presence of what is symbolized'.[18] This will not be obvious to anyone who looks at it in any frame of mind; the symbol 'appeals to the contemplative faculty of the mind, the real imagination'.[19] As I noted above, it is only when one *attends* to another person or a painting that their presence reveals itself. And we have noted the connection that Murdoch draws between attention and imagination. Evdokimov's qualification, 'the *real* imagination', implies a distinction between kinds or levels of imagination that seems close to Coleridge's classic distinction between imagination, as a principle of ontological insight, and mere fancy.[20]

The earliest Christian art, according to Evdokimov, *did* consist merely of signs (the fish standing for Jesus, etc.), and this remained true of religious art in the medieval West. The Latin Church didn't usually have a problem with images as such, but it tended (at least in its official theology) to treat them in a purely utilitarian way, as teaching aids—and thus merely as signs[21] (although Evdokimov

[13] St Theodore 1981: 27. [14] St John 2003: 43. [15] St John 2003: 22, 29.

[16] St John 2003: 29. To deny this, St John (2003: 30) continues, is Manichean. So the iconodules saw their opponents not only as implicitly denying the Incarnation, but implicitly denying the goodness of the material world, and thus denying the Creation. (Of course, the iconoclasts would have indignantly repudiated these accusations.)

[17] Ouspensky 1999: 32. [18] Evdokimov 1990: 16. [19] Evdokimov 1990: 16.

[20] See Coleridge (1956) ch 13.

[21] This is why it wasn't characteristically bothered by depictions of God the Father.

does claim that at least early medieval art in the West managed in practice to do more than that[22]). By contrast, according to Evdokimov, '*The icon is a sacrament for the Christian East; more precisely, it is the vehicle of a personal presence.*'[23] He is careful, though (like St Theodore the Studite before him), to distinguish presence in the icon from Christ's 'real presence' in the Eucharist. Christ is not present in the matter of an icon; his presence there is conveyed through its representational content: 'There is therefore no question of some ontological presence being absorbed into the matter of the icon…the presence in no way incarnates itself in the icon, but the icon is nonetheless a center from which the divine energies radiate out.'[24] Whatever we may think of his gently polemical distinction between Western and Eastern approaches, it does serve as a reminder that not all painting with an officially religious subject matter is necessarily iconic in this sacramental sense—or even quasi-iconic in the way that religious art from other traditions might be.[25]

An icon is not concerned with empirical accuracy. The literal rendering of the appearance of a historical individual is not the point.[26] The Russian Orthodox Church aimed 'to regulate iconography and style on the understanding that an icon reveals rather than depicts Christian truths'.[27] This distinction between revelation and depiction is crucial for the understanding of icons and therefore for the whole account of painting which I am trying to model on the understanding of the icon. The icon is, according to Ouspensky, 'opposed to illusion';[28] it doesn't try to deceive us into thinking we are seeing empirical objects, and it deliberately reminds us of its imagistic nature. But in a deeper sense what it gives us is realism, though of spirit, of our essential being, not of surface appearance. In Christ the image of God in humanity—we were created in God's image (*Genesis* 1. 26–7), though it has been tarnished by the Fall—is restored; and those who share in Christ (the saints) thus become divinized. (Ouspensky quotes the Orthodox

[22] Evdokimov1990: 168. [23] Evdokimov1990: 178. [24] Evdokimov1990: 196.

[25] Many post-Renaissance pictures of the Madonna and Child seem to be just paintings—sometimes very fine ones—of an attractive young woman with a pretty baby. Its nominal subject matter does not necessarily make 'religious' painting religious in any deep sense.

[26] Belting (1994: ch. 4) has argued that the presence of an icon was originally connected to its supposed literal mimetic accuracy, citing the importance of authenticating legends, such as the one claiming that the original icon of the Virgin Hodegetria ('she who points the way') which was venerated at Constantinople for centuries, was painted from life by St Luke. (Ouspensky (1999: 25, 37 n. 3, 39 n. 2) also mentions this and similar stories.) But a desire to feel a direct connection between the image and its original is not necessarily a desire for literal empirical accuracy of depiction (which the original Hodegetria icon, as we know it now from copies, clearly didn't attempt); and in any case, the great majority of icons continued to be venerated despite the lack of such authenticating legends.

[27] Cormack 2007: 97; Cormack is referring specifically to the decisions of the Russian 'Council of a Hundred Chapters' (Stoglav) of 1551. For theological reflection on this close ecclesiastical regulation of icon painting, see Florensky 1996: 70–98. Such regulation was not always successful and not always consistently enforced; from the eighteenth century onwards a more naturalistic style is often found in Russian icons (see Cormack 2007: 97–8).

[28] Ouspensky 1999: 41.

dictum 'God became Man so that man may become god.'[29]) Icons present this hidden divinized reality, not empirical appearance:

> the icon is a likeness, not of an animate, but of a deified prototype; that is, [it] is an image (conventional, of course) not of corruptible flesh, but of flesh transfigured, radiant with divine light...Consequently, everything that reminds of the corruptible human flesh is contrary to the very nature of the icon...a temporal portrait of a saint cannot be an icon, precisely because it reflects not his transfigured, but his ordinary state. It is indeed this peculiarity of the icon that sets it apart from all forms of pictorial art.[30]

Iconographers did in a sense have a concern for 'accurate' depiction, and they included details indicating precise geographical and historical settings.[31] But the aim of the icons was to depict the transfigured humanity of the saint, not naturalistic detail. An authoritative tradition emerged for how different saints or events should be depicted in fixed (though never entirely rigid) ways—eventually manuals came to be composed.[32] The aim was always to convey the significance of who the saint was. Individual features remain, but they are stylized in the same ways (small mouth, large eyes, etc.) in order to show 'not the earthly countenance of a man, as does a portrait, but his glorified eternal face'.[33] But, according to Evdokimov, in seeing the deified saint, I am seeing an image of my own telos—which is to become, myself, deified. So I am being brought into the presence, not only of the saint—or even that of God, via the deified saint—but also into my own presence; that is, into the presence of my own essential (though currently unrealized or incompletely realized) nature.[34]

The icon communicates, but what it communicates is not simply information. To return to Evdokimov's contrast between the Eastern and Western churches, medieval theologians in the West had regularly argued that pictures could tell stories, make things known. They were commonly referred to as 'the books of the illiterate'. It was also regularly argued that even for the literate, they could convey the information, tell the stories, in ways which could make them more vivid. Images focus our attention and move our emotions. But in all these ways, it seems, images are being valued instrumentally. As Evdokimov says, they are used as signs—conduits through which the content of a teaching passes. But even in the West, a deeper justification for the use of images sometimes emerges, as when Pope Gregory the Great writes that images 'show the invisible by means of the visible'.[35] Ouspensky, at any rate, insists that the icon does more than convey

[29] Ouspensky 1999: 36–7. [30] Ouspensky 1999: 36. [31] See Ouspensky 1999: 37–8, 40.
[32] Ouspensky 1999: 37. [33] Ouspensky 1999: 39.
[34] See Evdokimov 1990: 237–8. Recall Marcel's point, noted above, that in becoming truly present to another I become more fully present to myself.
[35] Quoted in Freedberg 1989: 164.

information, but gives us knowledge by acquaintance: 'Through the icon, as through the Holy Scriptures, we not only learn about God, but we also know God.'[36] It attempts to establish, as it were, an interpersonal rapport with the viewer. So the icon is not only in 'ontological communion' with its prototype, but it aims to draw its viewer into that communion too. This concern to establish, as it were, an interpersonal rapport with the viewer is again expressed by the style and composition of the icon:

> the icon does not cut itself off from the world, does not lock itself up within itself. The fact that it addresses itself to the world is also emphasized by the fact that saints are usually represented turned towards the congregation, either full face or three-quarters. They are hardly ever represented in profile [even where the composition would warrant it]…In a certain sense the profile breaks communion, it is already the beginning of absence. Therefore it is allowed chiefly in the case of persons who have not yet attained sanctity [e.g. the shepherds or Wise Men at the Nativity].[37]

Despite the best efforts of composition and style, the icon's drawing us to communion with its prototype will not be obvious to just anyone who looks at it in just any frame of mind; the 'ontological communion' of icon and prototype will only appear to someone who is willing to be drawn, himself or herself, into that communion—communing with the prototype through the icon. It is only when one really opens oneself to the icon that what it makes present reveals itself.

This point is emphasized particularly in the most influential modern philosophical reflection on the icon, that of Jean-Luc Marion. For him what is crucial about the icon is that we don't just look at it—make it an object for our gaze—rather, we open ourselves to be looked at *by it* or, rather, by Christ or the saint looking through the icon. When the icon is properly (prayerfully) seen, we have 'the commerce of two invisible gazes—the one from a praying man, taken through the painted icon to look upon an invisible saint, the other the gaze of the invisible saint…visible through the painted icon'.[38] Clearly, a number of the themes we have developed in a secular context above—the picture as making present, a quasi-intersubjectivity, the aesthetic communication of a content that is not paraphrasable—are deeply embedded in the Orthodox understanding of icons. The non-paraphrasability of the icon is carefully stated by Orthodox theologian Vladimir Lossky:

> Icons impinge on our consciousness by means of the outer senses, presenting to us the…supra-sensible reality in 'aesthetic' experience…But the intelligible

[36] Ouspensky 1999: 36. [37] Ouspensky 1999: 39. [38] Marion 2004: 20.

element does not remain foreign to iconography; in looking at an icon one discovers in it a 'logical' structure, a dogmatic content which has determined its composition. This does not mean that icons are a kind of hieroglyph or a sacred rebus, translating dogmas into a language of conventional signs.[39]

This states well the three elements one needs to hold in balance: the icon (or painting generally) conveys a distinctively *aesthetic* content; it nevertheless has a conceptual structure and content; and this content cannot be made manifest simply by translating conventional visual signs back into language.

II

I have tried at various points in the discussion of icons above to relate them back to the earlier discussion of painting in general. But it might still be wondered how relevant the account of icons can really be to my main theme. Those who are not Orthodox believers (or believers of any kind) might find the whole account remote or mystifying or at any rate based on beliefs they don't share. Can it, then, be helpful for thinking about painting in general? For that matter, even Orthodox believers might doubt the connection, for very different reasons. The point, they may say, is that icons are *not* artworks: they have an essentially devotional and liturgical function and can only be properly experienced in a religious context. Of course, one can hang them on gallery walls and gain some merely aesthetic pleasure from contemplating their formal properties or whatever, but to treat them in this way is precisely to lose the theological meanings that I have just been discussing. So, one might think, an icon is its own thing; a 'normal' secular painting is—despite superficial similarities—something quite different; and thinking about the one isn't going to help us with thinking about the other. However, this line of thought ignores the fact that it is only in the West in the last three or four centuries that secular painting has come to be regarded as 'normal'. And the assumption that the right and normal way to experience paintings is to look at them with aesthetic dispassion as decontextualized artworks in galleries and museums is part of what I (and Freedberg and Elkins) am trying to challenge. If we bear in mind that most, if not all art was once religious art, it doesn't seem too crazy to suggest that what it tried explicitly to do might plausibly be taken as a clue to what even officially secular painting still tries to do, albeit, perhaps, in a significantly different way.

[39] Lossky 1999: 22.

Let us try then to sum up the main themes that have emerged from this discussion. The icon establishes an 'ontological communion' or makes present in that:

(1) It doesn't just copy but evokes or manifests its prototype and in some sense participates in that prototype. The prototype is present in the icon, though this should not be taken in a crudely literal, physicalistic, or superstitious sense.

(2) In order to do this, it attempts to evoke the essence of its prototype, rather than to imitate its surface appearance.

(3) Its viewer, if willing to be open to this, is brought into a sort of intersubjective connection with the icon and, through the icon, with the prototype.

(4) The icon communicates a definite content, but one that is only fully communicable through the icon's own sensuous, aesthetic presentation of it; it is not reducible to any kind of verbal paraphrase.

The question we need to turn to now is whether and in what sense these characteristics can be taken as 'exemplary' for painting in general. (Trying to answer this question will involve considerably expanding and developing this account of making present as well.) In fact, the question about exemplarity breaks down into two sub-questions. Firstly, what is it that (non-iconic) paintings, especially paintings with apparently purely secular subject matters—portraits, landscapes, still lifes, and indeed abstracts—can be supposed to make present? With *what* is the painting in 'ontological communion'—and how does it bring us into that communion also? Secondly, is there something about either what it is that is made present or the notion of presence itself (or both) that is somehow *inescapably* theological, that resists secularization? This is, of course, the point at issue between the 'weak' and 'strong' theses that I distinguished at the end of Chapter Three, the weak thesis being that the icon is exemplary only in the way it offers an *analogy* to painting in general. On this view, the iconic notion of presence *can* be detheologized.

However, as I noted above, even the weak thesis is substantive enough that it might seem metaphysically extravagant to many. Even a detheologized notion of presence may seem a bit strange. And, furthermore, even on the weak thesis, if there is to be a relevant *structural* parallel with icons—and in order for this account to make sense of why we *value* paintings—it must be that what is made present is itself something of value, something that we find it worthwhile to be brought into the presence of. So the weak thesis is still committed to some sort of broader evaluative realism (which should not come as a surprise, given the discussion of Murdoch in Chapter Two). Moreover, what it makes present to us must be something to which we can relate in some way which at least bears an analogy to intersubjectivity, something which is not only 'in communion' with the painting, but which it makes sense for us to think of us ourselves as being

brought 'into communion' with. So the weak thesis is certainly not so weak as to be bland, uninteresting, or uncontroversial. On the other hand, though the 'strong' thesis (that all paining is in some non-trivial sense religious) certainly *is* strong, I don't want the way in which it is strong to be misconstrued. An 'ultra-strong' thesis might be that painting (and perhaps art in general) cannot be understood philosophically, but only from the perspective of a specific religious, confessional tradition. I cannot rule that out a priori, but such a claim would go beyond the scope of this inquiry, which remains a purely (though, I hope, not narrowly) philosophical one. My 'merely' strong thesis is much more generic than the ultra-strong one: if the notion of presence which I am trying to explicate turns out to be irreducibly theological, the theology in question will have to be a philosophical theology, one that is not dependent on special revelation. (Of course, it may still be compatible with more confessionally specific theologies of art, which will want to add much to it, but might be able to accept it as far as it goes.)

I have been suggesting, then—at least as a hypothesis worth exploring—that the icon can be taken as a paradigm for painting generally, that what it does by way of making present is (at least in some sense) what all painting (all visual art?) does. But it might now be objected that—even with reference to religious art—my focus on the icon is unduly narrow. If, as I am arguing, some universal structure comes to light in the icon, shouldn't that be discernible universally? If I am not trying to do a confessionally specific theology of art, should I be taking my paradigm only from *Christian* religious art (and from one form of Christianity at that)? The concern is legitimate, but, as I noted above, my aim has not been to rely on any specifically Eastern Orthodox theological doctrines, but to consider the theology of the icon phenomenologically as an explication of the experience of icons manifesting the divine. And comparable experiences can be found in many traditions. My references to Freedberg on how images of all kinds, in very different cultures, are experienced as suffused with presence—and in most case, with *divine* presence—was intended to suggest that what (or some of what) is articulated in a sophisticated and specific theological way in the case of Orthodox icons may also be found in very different contexts and traditions. (This is not to deny that icons have a specifically Christian theological significance within Orthodoxy which goes beyond whatever universal expressive significance they may have.) It is beyond the scope of this book (and well beyond my own competence) to attempt a comparative survey of types of religious art in different traditions, but I do want to offer a brief case study of a different art form from the icon (sculpture) in an altogether different religious tradition (Hinduism) and use it to argue that there are, nevertheless, striking similarities between Hindu attitudes to sculptural images of the gods and Orthodox attitudes to icons.

III

Jessica Frazier describes as 'an axial feature of Hindu belief' that 'the divine can come to presence in the phenomenal world. Thus, in a world saturated with the divine, religious artifacts may be "crystallizations" of the sacred.'[40] She also notes that 'The Hindu temple is essentially a shrine, a house for the divine presence on earth ... rather than a prayer house [as churches, synagogues and mosques are]. The purpose of this religious building is to *have a face to face encounter* with the deity who dwells within.'[41] Diana Eck describes in more detail what is meant by this encounter in her book *Darsan: Seeing the Divine Image in India*. She emphasizes that *darsan* (or *darshan*) literally, the 'seeing' of the divine image 'is the single most common and significant element of Hindu worship.'[42] She continues, 'The central act of Hindu worship, from the point of view of the lay person, is to stand in the presence of the deity and to behold the image with one's own eyes, to see and be seen by the deity.'[43] This emphasis on the two-way nature of the process—that the believer not only sees the divinity in and through the image but is seen by the deity as well—clearly resembles the understanding of the icon we have been considering above. The deity 'gives' *darsan*, and the devotees 'take' it: '[S]eeing in this religious sense is not an act that is initiated by the worshiper. Rather, the deity presents itself to be seen in its image.'[44] But although the worshipper's role is receptive, and in that sense passive, seeing properly is also an active process; it is not simply a matter of pointing one's eye in a certain direction.[45] One must be in the right frame of mind to receive *darsan* (as one also must be not only to appreciate an icon, but also to get anything out of a visit to an art gallery).

Eck notes that *darsan* is not only of artefacts—made images—but can also be of holy persons—saints or sadhus—or of sacred places (mountains, rivers) as well as shrines and temples.[46] Some natural objects are regarded as charged with divine presence in themselves, without need of human shaping,[47] and images may be 'aniconic' (non-representational) as well as 'iconic' (meaning in this context, simply that they have recognizably representational properties—e.g. a statue in human or animal form). The idea that, while images can be made so that the divine can be seen in them (and can itself see *from* them), the seeing of the divine that such images allow is continuous with that which can be had through our experience of the natural, non-human, non-made world is itself very significant. It offers us a clue as to how we might start to think about the relation of art to

[40] Frazier 2014: 351. Of course, it should be borne in mind that 'Hinduism' is a portmanteau term for a wide variety of religious traditions and that this makes generalizations about it perilous. What follows is a characterization of some central threads of belief and practice in those traditions, but I haven't tried to include all the qualifications that might be appropriate in a more thorough treatment of the topic.
[41] Frazier 2014: 353. [42] Eck 1998: 1. [43] Eck 1998: 3. [44] Eck 1998: 6.
[45] Eck 1998: 14–15. [46] See Eck 1998: 5–6, 59–63, 65–9, 71–2. [47] Eck 1998: 34.

nature or of artistic beauty to natural beauty. And although I have not raised the point very explicitly before now, I will eventually be arguing that to understand this relation properly is essential to understanding what the value of painting might be. (And obviously, pilgrimage and the seeking out of sacred places and/or relics play a significant role in many different religions.)

Although it is not only anthropomorphic (and/or zoomorphic) images that can give *darsan*, such images are highly important in Hindu worship. As with Orthodox icons, their design is not left to the inspiration of the individual artist but is based on established and authoritative models.[48] And, again, as with the Orthodox iconographer, the artist who produces the image does not merely require the appropriate technical skills but is someone for whom 'the creation of an image is, in part, a religious discipline' involving prayer, meditation, and ritual purification.[49] Once created, the image is consecrated in a series of elaborate ceremonies, at the culmination of which '[t]he eyes of the image, which to this point have been sealed with a rich coat of honey and ghee, are now "opened" by the brahmin priest, who removes the coating with a golden needle'.[50] The emphasis here on the visual, on making possible the exchange of gazes between the image and its devotee, is striking.[51] (And recall the unnaturally large eyes of the saints in icons.) Here we see a strong emphasis on intersubjectivity—and the connection of intersubjectivity with incarnation. It should be noted that although the initiative in a sense is with the deity, there is an important sense in which the deity is limiting itself, making itself vulnerable by condescending to become present in an image and thus available for the intersubjective exchange of gazes: '[M]ost Hindus … take the notion of image-incarnation quite seriously. The image is a divine "descent" of the Supreme Lord who entrusts himself to human caretaking.'[52]

Like icons, Hindu images are not concerned with naturalistic likeness. Indeed, the multiple limbs and combination of human and animal parts in many images make the point even more strikingly than the stylization of the human figure in the icon. The images are imaginative expressions of the qualities of the god in question; and it should be remembered that the individual gods—Vishnu, Shiva, Ganesh—are themselves images of the one divine reality, ways of conceiving of some aspect or aspects of the Ultimate:

> Hindu thought is most distinctive for its refusal to make the one and the many into opposites…The very images of the gods portray in visual form the

[48] Eck 1998: 51–2. [49] Eck 1998: 52. [50] Eck 1998: 53.

[51] The consecration of statues through 'eye-opening' ceremonies is also important in Buddhism, in which devotion directed to images of the Buddha or bodhisattvas is a central act of worship. See Lachman 2014: 371–2.

[52] Eck 1998: 48.

multiplicity and oneness of the divine, and they display the tensions and the seeming contradictions that are resolved in a single mythic image.[53]

The image is a symbolic evocation, and in no sense an effort at depiction. And yet, because the divine is present everywhere, images from the sensible world can be charged with divine presence without limiting or circumscribing it (which had been the fear of the Byzantine iconoclasts):

> While far-sighted visionaries may describe the one Brahman by the negative statement, 'Not this…Not this…' still, from the standpoint of this world, one can as well describe Brahman with the infinite affirmation, 'It is this…It is this…' The two approaches are inseparable.[54]

My aim in pointing to these parallels has not been to promote a bland syncretism which would deny what is distinctive in the Hindu or Orthodox traditions; nor is it to suggest that *darsan* and the contemplation of an icon are either theologically or psychologically identical. But I do think the commonalities are striking: in both cases images are made and (for want of a better word) appreciated not as literal representations of gods or saints, but as ways of making present and communing with the divine. And there are innumerable cases—such as Freedberg's examples—of images serving this religious function in very different cultures with very different explicit belief systems. The current of distrust of images in Abrahamic monotheism is not a counterexample; images are denounced or destroyed precisely because their power (seen now as a power to mislead) is recognized and feared. For iconoclasts as well as iconodules, the issue is anything but a trivial one about church (temple, mosque, etc.) decoration. And, of course, the refusal of (nominally) representational imagery in some religious traditions does not mean that they lack any form of visually compelling expression. Islamic religious art is primarily abstract and geometrical, but no less powerfully expressive for that; and the simplicity of a whitewashed Calvinist chapel may itself be extremely eloquent. But even if it is conceded that religious art generally (or at least a lot of religious art in a variety of traditions) does serve to make present in the iconic sense summarized at the start of section II, it still needs to be shown what it would mean to take such religious art as 'exemplary' for art—or even just for painting—in general, even when it is apparently wholly secular. To this task I will start to turn in section IV.

[53] Eck 1998: 28. [54] Eck 1998: 31.

IV

Hindu temple sculpture, like Orthodox iconography, is an explicitly religious art. My aim is to see whether some of the basic characteristics of such religious art can be found in painting more generally. It won't be possible to embark on a comprehensive survey of different artistic traditions, but I want to conclude this chapter with a case study of a particular painting tradition that will, I hope, be helpful for the development of my argument. This is the classical Chinese landscape painting tradition as it developed between the Tang and Ming dynasties—a period very roughly corresponding to the European Middle Ages.[55] I chose this tradition for several reasons. Firstly, simply because of personal interest and liking. My motivation in writing this book was initially to try to understand what it is that moves me about painting,[56] and classical Chinese landscapes are amongst the paintings that have most moved and fascinated me. Secondly, because there is a large body of art criticism and art history which is contemporary with the classical paintings I am concerned with (some of it produced by distinguished painters themselves).[57] So—as with the theology of the icon—we are not just looking back at the art of the past and trying to understand it theoretically; we can look at how it was understood by its appreciators (and sometimes creators) at the time. Thirdly, my account of painting is aiming at a certain universality, and so it is important to consider work from outside the Western tradition (however broadly construed)—especially as Western philosophical aesthetics (to which this book itself is obviously a contribution) is largely based on consideration of Western art forms. As I mentioned in the Introduction, it is a fantasy to think we can escape from our particular cultural/historical conditioning altogether so as to reach a view from nowhere (to write or paint outside all traditions). But this does not mean that a culture cannot expand its horizons through dialogue with another.[58]

A final reason why it is particularly important to discuss Chinese art and art theory is that it has sometimes been presented as an antithesis to the Western tradition. Indeed, it has been suggested that Chinese (and, more generally, East Asian) art, philosophy, and spirituality should be seen as challenging what are claimed to be key Western assumptions about presence, being, substance, essence, and so on. Gay Watson, for instance, claims that 'the emptiness between

[55] I am talking here about its classic or formative period; the tradition, of course, continued past Ming times and remains vibrant today.

[56] Obviously, I am assuming that there will be something universally valid in the answer I am looking for; I'm not simply reporting on my personal psychological peculiarities. (At least, I'm not intending to do just that.)

[57] For a useful anthology of some of this material, see Bush and Shih 2012. Art history (and systematic art criticism) is generally taken to have started with Vasari in the West; these disciplines have been around for much longer in China.

[58] This is a central theme, of course, in Gadamer's philosophy; see Gadamer 2004 passim.

words ... is a place of which the Western philosophies of presence were not aware. Eastern art is not an art of representation: its aim is not so much to represent objects or essences, but to record a play of energies.'[59] And François Jullien claims that in classical Chinese art criticism, we can find 'a number of little tremors, unexpectedly shaking the foundations of our thought.' These tremors 'allow us to catch a glimpse along the fault-lines of another way of engaging in thought. This way is no longer based in Being or in God.'[60] For 'Painters and poets in China ... do not paint things to show them better and by displaying them before our eyes, to bring forth their presence.'[61] So it might be thought that the Chinese painting tradition offers a counterexample to my claim that painting 'makes present', brings us into contact with things as they essentially are. Perhaps it is just Western painting that does that (or tries to do that)? In what follows, I hope to show that this is not the case.

Painting in China has a long history, but little of it from earlier times survives. It seems however, to have been predominantly figurative.[62] With the widespread adoption of Buddhism in China and the development of Daoism as an organized religion—both during the long Han-Tang interregnum (roughly 200–600 CE)— religious painting (also mostly figurative) became important, and direct comparisons with Christian iconography would be possible. My concern, though, is with the tradition of landscape (shanshui, literally 'mountain and water') painting, which really developed in Tang times (618–907) and afterwards and which depicted (usually mountainous and/or watery) scenery without any direct historical, religious, or moral message being presented. I have noted above that icons seek not to copy their originals, but to evoke or manifest the essence of those originals in order to make them present to the viewer in a sense which has an analogy to intersubjectivity. But I think, despite its lack of direct religious reference and apparently 'secular' subject matter, all of this is true of classical Chinese landscapes as well.

The concern for conveying the essence of things rather than depicting their surface appearances is pervasive in classical Chinese art theory. Jing Hao (855–915), a painter and influential art theorist, recounts a story or fable about his encounter with an old recluse in the mountains who instructs him in the true art of painting. Jing had supposed that the basic truth about painting was 'simple': 'One obtains reality when one devotes oneself to obtaining lifelikeness.' But the old man corrects him: The painter:

> must not take the outward appearance and call it the inner reality. If you do not know this ... you may even get lifelikeness but will never achieve reality in painting ... Lifelikeness means to achieve the form of the object but to leave out

[59] Watson 2014: 58–9. [60] Jullien 2009: xvi. [61] Jullien 2009: 4.
[62] See Lin 2010: ch 1.

its spirit. Reality means that both spirit and substance are strong...if spirit is conveyed only through the outward appearance and not through the image in its totality, the image is dead.[63]

Or, as the Song dynasty painter and theorist Guo Xi (*c*.1020–90) put it, 'Each scene in a painting, regardless of size or complexity, must be unified through attention to its essence. If the essence is missed, the spirit will lose integrity. It must be completed with the spirit in every part, otherwise the essence will not be clear.'[64]

The modern Chinese art historian Lin Ci sums up this traditional understanding:

In the ordinary world, nature was often hidden behind the chores of daily life, so a painter needed to see through to nature clearly and access its true form in order for his mind to resonate with it. The talent of a good painter was also a force of nature, through which true nature would appear clearly.[65]

The truth to nature that painting aims at cannot be achieved by some kind of impersonal objectivity. Evoking the depths of things (their essence or inner principle) cannot be done by an impersonal description, but must involve allowing them to resonate with one's own inner nature. Lin Ci quotes another Song dynasty author, Su Shi, commenting on the work of a painter friend: 'When Wen Tong paints bamboo, all he sees is bamboo. As he integrates himself into the bamboo, his paintings look endlessly fresh.' Lin Ci comments, 'unlike laypeople and craft painters who tend to focus on every detail, Wen Tong concentrated solely on bamboo so that he could integrate himself into its nature and achieve a harmony that would show his feelings towards nature.'[66] Another art historian, Michael Sullivan, quotes a similar judgement on a somewhat earlier (Tang dynasty) painter, Zhang Zao, by a contemporary of his, Fu Tsai. What Zhang achieved was 'not painting but the very Tao itself.' He was able to 'reach into the dark mystery of things, and for him things lay not in the physical senses but in the spiritual part of his mind. And thus he was able to grasp them in his heart and make his hand accord with it'[67] The invisible essence of the subject matter is grasped and made visible—manifested—in the painting.

[63] 'The Significance of Old Pines' from 'A Note on the Brush', in Bush and Shih 2012: 146. (The editors use the older Wade-Giles system of transliteration, while I have preferred the now more widely used Pinyin system, and so they render Jing Hao as Ching Hao.)

[64] Guo Xi (Kuo Hsi) from 'The Lofty Message of Forests and Streams', in Bush and Shih 2012: 156. The Song dynasty ruled (firstly all of China and then only the southern part) from 960 to 1279; this era is regarded as a golden age for landscape painting, when the classical styles were first fully established.

[65] Lin 2010: 7. [66] Lin 2010: 101.

[67] Sullivan 1979: 49. (Sullivan refers to Zhang as Chang Tsao, using the Wade-Giles system.)

It might be thought that this account, in its emphasis on the artist's expressive powers, marks a contrast between Chinese painting traditions and the Orthodox icon; the iconographer is not supposed to indulge in self-expression, but to become a vehicle through which the divine truth can speak. But what the authors quoted above were concerned with was also not (or not primarily) *self*-expression; the painter aims, rather, to embody or identify with the *Dao*,[68] the basic creative principle underlying nature, so as to express through painting the same essence (of bamboo, orchid, or whatever) that *Dao* directly brings about in the natural world itself. As Julian Bell puts it:

> The painter may hope to act as a conduit for the *tao* of nature...to align the painter's personal sphere of activity—his eye, hand, mind, body, brush and ink—with that larger unnamable complexion of things. He is to feel with its energies, emergent forms and patterns of growth and flow.[69]

The traditional Chinese painter isn't simply performing a task that can be performed by anyone with the relevant technical skill, whatever his or her state of mind. Rather, the painter needs to be attuned to the underlying reality of *Dao*, just as both Orthodox icons and Hindu statues are supposed to be created in a state of meditational devotion.

The artist intuits the inner essence of things and by so doing is able to make it manifest in the painting. But the appreciator of that painting is then able to experience this making manifest or making present; what the artist was able to intuit is thus made manifest to the viewer as well. Guo Xi emphasizes the way in which a good painting can make the landscape present to its viewer: 'Without leaving your room you may sit to your heart's content among streams and valleys. The voices of apes and the calls of birds will fall on your ears faintly. The glow of the mountain and the call of the waters will dazzle your eyes glitteringly.'[70] The idea that a (monochrome) painting can show you glow and dazzle—and make you hear birds and apes—makes it clear that it is not literal, illusionistic representation that is the concern here, but conjuring up the total effect of a place. The painter needs to visit the landscape, not for the sake of photorealism, but in order to grasp its significant aspects. And if he or she succeeds, the painting enables the viewer, in a sense, to *be* in the presence of what it depicts, as the icon allows the devout viewer to be in the presence of the saint that *it* depicts.

A good painting 'shows the major aspects and does not create overly detailed forms...[it] shows the major idea without distracting signs of technique'.[71] The

[68] '*Tao*' in the Wade-Giles system.

[69] Bell 2017: 119. Cézanne said something similar: 'The landscape thinks itself in me...and I am its consciousness' (quoted in Merleau-Ponty 1996a: 67). I will return to this remark in Chapter Five.

[70] 'The Lofty Message of Forests and Streams', in Bush and Shih 2012: 151.

[71] 'The Lofty Message of Forests and Streams', in Bush and Shih 2012: 152.

idea that kinds of things have their own essential natures (*li*—'principle', 'pattern') and that painters should aim to show these, rather than accidental details, became basic to the practical education of painters. For instance, the classic seventeenth-century *Mustard Seed Garden Manual of Painting* starts by quoting a list of six essentials and six qualities from the much earlier (Song dynasty) author Liu Tao-ch'un: The third essential is that 'Originality should not disregard the *li* of things.' Correspondingly, the fourth quality is an admonition 'to exhibit originality, even to the point of eccentricity, without violating the *li* of things.'[72] A fundamental respect, not for surface appearances, but for the underlying principle that makes something what it is, is being urged here. Most of what follows in the manual consists of very detailed advice and instruction for painters on techniques for rendering specific objects or kinds of object so as to capture their *li*. (There are separate books on rocks, trees, etc., even ones specifically on, e.g. bamboo and plum trees.) For instance, an aspiring painter of orchids is told 'When one is able to convey the whole idea (*li*) without painting every leaf, then one indeed wields an experienced brush.'[73]

All of this may seem surprising to those who have been led to think that Chinese (or even 'Eastern') philosophy is fundamentally anti-essentialist. In fact the notion of 'principle' or 'pattern' (*li*) mentioned above is a basic philosophical concept used by all the main schools of Chinese philosophy, basically referring to the intelligible principle or form or ordering of things. The concept of *li* was especially emphasized by the 'neo-Confucians' (as they have come to be known) of the Song dynasty. The neo-Confucian philosopher Cheng Hao held, as JeeLoo Liu puts it, that:

> there is one principle unifying all things and there are myriad particular principles for each kind of particular things. The universal principle is identified with *Dao* or heavenly principle. Particular principles are identified as the paradigm or the archetype of each kind of things and Cheng Hao calls it the 'nature' or 'essence' of things.[74]

According to Zhu Xi (1130–1200 CE), who systematized earlier neo-Confucian thought and who went on to profoundly influence Chinese culture and thought throughout the remaining imperial era, *Li* as such is *the* pattern, the normative principle of cosmic order, which is both immanent in the physical world and transcendent of it. This pattern is, in a sense, wholly present in everything. But each thing or kind of thing also has its own specific pattern, which makes it the kind of thing it is. According to Zhu:

[72] From an abridgement of the *Mustard Seed Manual* in Sze 1959: 132. [73] Sze 1959: 273.
[74] Liu 2018: 86.

The myriad things all have the Pattern, and their Patterns all come from one source. However, the roles they occupy are different, so the Functions of their Patterns are not one...Each thing fully has the Pattern. And though each thing is different in its Function, everything is a manifestation of the one Pattern.[75]

And—as we have already seen with Cheng Hao—the neo-Confucians were happy to call this pattern 'Dao': for Zhu 'the cosmic order is called *dao*, while each individual thing partakes [in] this cosmic order. This cosmic order exemplified in each particular thing is its "nature".'[76] Hence, a painter, by evoking and making manifest the *li* of some particular thing or kind of thing, can also make manifest something of *Li* (*Dao*) itself—the fundamental order of the universe.

Not only do the Confucians, as well as the Daoists, use the term *Dao*, but the basic essentialism of the Confucians can also be found in Daoism—the sense of there being a coherent structure in reality to which the mind (and, more than that, the ethical or spiritual sensibility) needs to conform. (For both traditions, *Li/Dao* is essentially normative.) The foundational classic of Daoism, the *Daodejing*, insists that the 'myriad things' have their own distinctive, qualitatively different natures or powers (*de*), even though the *Dao* runs through them all. The world is a world of determinate things and kinds which behave in at least broadly predictable ways according to their own natures. There is a discernible rhythm in the way that things develop or interact which is natural to them,[77] and to 'force' them in a particular direction against their natures is to go against *Dao*.[78] Only humans generally fail to conform to *Dao*,[79] but in this they are going against their own natures and will bring disaster on themselves.[80]

Despite this, some have argued for an anti-essentialist interpretation of Daoism. For instance, David Cooper finds a doctrine in some passages of another classic Daoist (or proto-Daoist) text, the *Zhuangzi*, which he likens to Nietzsche's perspectivism.[81] On this view, Cooper says, 'There can be no "fixity" or "constancy" to the ways in which the world may be divided up and described...no sense attaches to the idea of a world—of a structured, determinate array of things—independent of all perspective.'[82] There are many different perspectives, and there is no sense in asking which of them is the right one, or even a better one: 'the point is not that we lack knowledge as to which perspective correctly mirrors reality. The point is the more radical one that it is senseless to regard any

[75] Zhu 2014: 173. [76] Liu 2018: 94.

[77] See *Daodejing* (*Tao Te Ching*) chs. 2, 16, 22, 39, 42, 64, 66, 76, 78. (There are innumerable translations of this work; it is included in full in Ivanhoe and Van Norden 2005: 163–203.)

[78] Ivanhoe and Van Norden 2005: 55. [79] Ivanhoe and Van Norden 2005: 77.

[80] Ivanhoe and Van Norden 2005: 30, 50, 52.

[81] However, he does admit that it is a speculative 'reconstruction' of Daoism rather than anything systematically and explicitly stated in the Daoist classics. See Cooper 2012: 61.

[82] Cooper 2012: 62.

particular perspective as correct.'[83] If this is the correct way to understand Daoism, then, given the undoubted influence of Daoism on much of Chinese painting, my account would be called into serious question. For on Cooper's interpretation, there is no way in which things are in their own right, no essential natures of things (*li*) which may be revealed more accurately by one perspective than another or made present to us by an insightful (rather than merely skilful) painter.

It is significant, however, that Cooper makes almost no reference to the *Daodejing* while developing this perspectivist interpretation of Daoism. And I think it is clearly the *Daodejing's* understanding of things as having their own essential natures, rather than Nietzschean perspectivism, that underlies the *apparently* sceptical or relativistic ideas in some sections of the *Zhuangzi*. Each creature (each *kind* of creature) will experience the world in its own way and live so as to attain its own good. But this implies precisely that things have essential natures, so that what is good for one is not good for another. And this insight cannot itself be a merely perspectival one, on pain of incoherence, so it implies the possibility of transcending the merely perspectival so as to see, however imperfectly, something of how things really are.[84] According to Phillip Ivanhoe, Zhaungzi's apparent perspectivism is intended to help people 'free themselves from the grip of tradition and the rational mind' but only in order that they can then 'perceive and accord with an ethical scheme inherent in the world'.[85] Such insights into the underlying true structures of things are not only for sages, mystics, and recluses, as the stories in the *Zhuangzi* about skilful craftsmen such as butchers and wheelwrights make clear. As Bryan Van Norden notes, the butcher mentioned in the third chapter of the *Zhunagzi*[86] explains that he never chips or dulls his blade while butchering an ox 'because he relies on the "Heavenly patterns" of the ox's body. The butcher is so effective because he has learned to intuitively follow the inherent natural structure of the world. So carving the ox's carcass skillfully is a small illustration of following the Way throughout one's life.'[87] And painting the ox skilfully so as to convey its 'inherent natural structure' would be another.[88]

[83] Cooper 2012: 62. [84] See Lai 2008: 154, 161.

[85] Ivanhoe 1993: 646–7, quoted in Lai 2008: 161.

[86] See Ivanhoe and Van Norden 2005: 224–5. [87] Van Norden 2011: 151.

[88] I am aware that I haven't yet explicitly mentioned Buddhism—the third great tradition in Chinese thought, and one that might more plausibly be considered anti-essentialist. This is far too complex an issue to adequately discuss here, but it should at least be noted that the doctrine of 'emptiness' in Mahayana Buddhism does not connote radical nominalism or conventionalism, let alone ontological nihilism, but rather a kind of radical holism. It's not that things don't have natures, but that everything is internally related to everything else, so that the nature of anything is inseparable from its place in the infinite network of internal relations which is reality. (On this see, e.g., Fazang, 'Essay on the Golden Lion', in Tiwald and Van Norden 2014, 86–91). And it is important to recognize that Buddhist holism does not deny individuality; it does not picture reality as an indeterminate blob, a 'night in which all cows are black'. On the other hand, it is also true for Daoists and Confucians—as we have just seen—that to understand anything properly is to understand it as a manifestation of universal *Li/Dao*.

There are, of course, dangers for the painter in this preference for the evocation of essence over the copying of appearances. Sullivan comments:

> If the artist's observation—of the variations in, shall we say, the texture of individual rocks or the bark of individual trees—did not match the schemata he was developing to represent rocks or bark, then it was the schemata that must be preserved because…they contained all that was essential and typical. Once this decision was taken, the abandonment of realism and the development of a formalized pictorial language was inevitable.[89]

This tendency to stylization is not necessarily a bad thing, but it could lead to a formulaic, mechanical way of painting and an over-reliance on manuals such as the *Mustard Seed Garden*, not as inspirations and guides, but as the source of models to be rigidly imitated. But in such academic painting, the connection between the inner *li* of things and the artist's personal insight into it has been lost. What is needed as an antidote to such mechanical art is, no doubt, a return to nature, but to the inner truth of nature, rather than a copying of externals. Harrie Vanderstappen notes that:

> In China, nature, or the world we live in, can be called *tiandi,* meaning heaven and earth or cosmos. Nature can also be defined as *ziran,* meaning 'naturally so' or self-existent. *Tiandi* is the world to be seen, to be governed and cultivated for subsistence…*Ziran*…is a world that is invisible. It is to be sensed; it is to be poetized as the source of energy, the vital force, and the origin of the ever-present self-renewing harmony of all that is living,[90]

He continues:

> Chinese painting that resembles the world of *tiandi* lacks true 'reality' and is merely an object of 'outward beauty'.…If painting is to truly resemble nature, then the artist must absorb the outward appearances, *tiandi,* and then proceed to reach its source—the 'naturally so', its inner reality. The resemblance is not in the effect of looking alike, but in the proper correspondence between nature and its representation in painting. In other words, the artist must understand the proper relationship between the thing as it appears and the energy that specifically accounts for its appearance.[91]

In non-abstract painting, of course, outward appearances are depicted, but they are shown so as to allow the inner reality of what they depict to shine through

[89] Sullivan 1979: 72. [90] Vanderstappen 2014: 1.
[91] Vanderstappen 2014: 1.

them. And so a good painting is not merely a 'realist' depiction, and not simply a record of self-expression either, but can serve, in its way, as an icon: 'the picture was not an object in a frame, to be looked at and admired for its form and colour, but rather a mysterious thing that, like the miniature garden, contained the essence of the world of nature'.[92] Gadamer's language of 'ontological communion' seems entirely apt in this context.

I started this section by noting that classical Chinese landscape painting did not convey a direct or explicit religious message, or serve a directly devotional function, as icons and Hindu temple statues (or Chinese paintings of explicitly Buddhist or Daoist figures or subjects) do. Nonetheless, they serve to make manifest to the properly appreciative viewer the essential natures of the things they depict and, beyond that, the metaphysically fundamental order of the universe itself. Is it too outrageous to suggest that in this they perform a quasi-sacramental function? Certainly, their creation and proper appreciation are forms of visual meditation in which one is brought into a sensory, non-discursive contact with the deep truth of things. So it seems that at least my 'weak thesis'—that there is a structural analogue between how icons function and how other paintings function—has been vindicated in respect of a tradition of painting very different from, and historically unconnected to, that of iconography. And moreover, since classical Chinese landscapes are intended to bring the viewer into communion with *Dao*, with the normative cosmic order, this discussion may indeed also lend support to the 'strong' thesis—that there is something religious or metaphysical about what all painting does. In Chapter Five I will try to develop at least my weak thesis further (while still leaving space for the stronger version) by looking closely at a much more recent (and Western) philosophical theory of painting—and one inspired mainly by European Modernism—that of Merleau-Ponty.

[92] Sullivan 1979: 29.

Chapter Five
Making the Invisible Visible
Merleau-Ponty

I am exploring the idea that paintings express significant and non-paraphrasable truths, in that they make things present to us, that they play a revelatory or disclosive role. The examples of both art and art theory that I have been using to flesh out this idea so far could be called 'traditional' ones; they all come from continuing traditions, the basic principles and the paradigmatic achievements of which are centuries old and which are themselves either explicitly parts of religious and devotional traditions or at any rate deeply influenced by metaphysical and spiritual ideas. Can an account of painting inspired by such sources really claim a universal scope, though? And can it make sense of modern, secular painting? In this chapter I will further develop my account of painting primarily through conversation with Merleau-Ponty, whose account of painting does make universal claims, but is developed mainly through reflection on the classic or 'high' modernist painting tradition of late nineteenth- and early twentieth-century Europe. Merleau-Ponty is one of a number of modern European philosophers (and particularly Phenomenologists) who have developed accounts of painting or of art generally that I have found to mesh well with the 'traditionally' inspired account given so far. Some (though not all of them) are identified by Robert Pippin as belonging to what he sees as a distinct 'ontologically disclosive' tradition in the modern philosophy of art, whose major figures he lists as Schelling, Schopenhauer, the young Nietzsche, Heidegger, and Merleau-Ponty, and which he distinguishes from the basically Hegelian tradition in which he himself stands. For these thinkers 'artworks are … *bearers of truth*' although this tradition 'does not link such a truth to propositional correctness'. Rather, it proposes 'that one should understand the uniquely "disclosive" power of art' in 'fundamental' and 'ontological' terms: 'A kind of fundamental truth, not formulatable discursively … is at stake in this tradition: the meaning of being.'[1]

I think Pippin is basically right to identify the tradition he does, although he does not mention the extent to which it continues—in some respects while not in others—the Platonic tradition that I discussed at the start of Chapter Two. Nor does he connect it to the 'disclosive' self-understanding of the traditions of

[1] Pippin 2014: 98.

Painting and Presence: Why Paintings Matter. Anthony Rudd, Oxford University Press. © Anthony Rudd 2022.
DOI: 10.1093/oso/9780192856289.003.0006

religious art that I have been considering. But the idea that art (painting) can disclose or reveal ontologically deep truths that are not discursively articulable, but which can be presented to us in directly sensory, aesthetic form is obviously close to the understanding of painting that is suggested by taking icons as exemplars. So it will be important for my project to engage further with this tradition, Merleau-Ponty being the representative of it I have found most helpful for my purposes.

I

I did mention back in Chapter Two that there is a lack of clarity in Merleau-Ponty about whether all painting (all good painting?) has an ontologically disclosive role or whether this status is reserved for some particular painters (Cézanne, Klee, etc.). I will, in any case, be trying to develop a general theory of painting as disclosure from my conversation with Merleau-Ponty in this chapter. He certainly does think that painting *can* play a disclosive role. In his early essay, 'Cézanne's Doubt' he treats Cézanne as doing something similar in his own way to a Husserlian Phenomenological reduction—that is, a stripping away of theoretical assumptions about what the world must be like or what our experience must be like in order to arrive at a fresher, less distorted apprehension of what it really is like.[2] Cézanne distinguished 'between the spontaneous organization of the things we perceive and the human organization of ideas and sciences ... Cézanne wanted to paint this primordial world.'[3] He was aware that what had been taken to be realism, either in classical perspective painting or in photography, was a distortion or idealization of our actual experience: 'Cézanne discovered what recent psychologists have come to formulate: the lived perspective, that which we actually perceive, is not a geometric or photographic one.'[4] Merleau-Ponty had published this essay just after his *Phenomenology of Perception,* in which he tries in great detail to get behind the distorting, intellectualizing assumptions of both empiricism and rationalism and back to the lived experience of the world, the way it shows up to us, not as detached recipients of sense data from a mechanical bodily apparatus, but as embodied agents, or 'body-subjects'. His subsequent essays on painting draw on these insights. In 'Cézanne's Doubt' he insists on the holistic nature of our basic experience: 'These distinctions between touch and sight are unknown in primordial perception. It is only as a result of a science of the human body that we finally learn to distinguish between our senses ... We *see* the depth, the smoothness, the softness, the hardness of objects.'[5] Cézanne is

[2] For this comparison see Johnson 1996: 9; see also Landes 2013: 129.
[3] Merleau-Ponty 1996a: 64. [4] Merleau-Ponty 1996a: 64. [5] Merleau-Ponty 1996a: 65.

commended not just for using colour to *suggest* tactile qualities, but for actually *painting* them:

> If the painter is to express the world, the arrangements of his colours must bear within this indivisible whole, or else his paintings will only hint at things and will not give them in the imperious unity, the presence, the unsurpassable plenitude which is for us the definition of the real.[6]

This is, of course, why Merleau-Ponty rejects the idea that classical perspective gives us a genuinely realistic image of the world.[7] It is actually more creative than it thinks it is, but in a way that falsifies the world as we really perceive it.[8] And this is why he aligns it with the scientific, spectatorial epistemology of Descartes.[9] While Merleau-Ponty is not anti-scientific, he does downplay the ontological significance of science. It presents us not with reality as it truly is but with abstract models of aspects of reality taken out of the context of the 'unsurpassable plenitude' of the world of ordinary perception: 'Science manipulates things and gives up living in them. Operating within its own realm, it makes its constructs of things ... it comes face to face with the real world only at rare intervals.'[10] Painting is more philosophically profound, more deeply truthful, more ontologically revealing. It takes us back to the world as we participate in it, not simply as we observe it: 'Now art, especially painting, draws upon this fabric of brute meaning which operationalism would prefer to ignore. Art and only art does so in full innocence ... Only the painter is entitled to look at everything without being obliged to appraise what he sees.'[11] This view, of course, inverts the scientism of the first 'Platonic' objection to art—that it takes us away from the truth, which we need science to reveal. As Duane Davis puts it: 'Contrary to the conventional wisdom that art is a capricious misrepresentation of the real world about which science gives us truth, Merleau-Ponty advocates that we should turn to art for the truth of the world which science presents via various distorted, albeit useful abstractions.'[12]

There are obviously problems one could raise at this point. One can ask whether the account of science Merleau-Ponty gives is an adequate one and whether the pre-scientific immediacy he contrasts it with is itself a myth—a fantasy of non-conceptual, linguistically unmediated pure experience. One may also ask, as I did back in Chapter Two, what value Renaissance painting can have if it doesn't, in fact, disclose the world of experience. But, furthermore, it may seem curious that Merleau-Ponty takes painting—on the face of it, precisely a

[6] Merleau-Ponty 1996a: 65.
[7] Merleau-Ponty 1996c: 84–8 and 1996b: 135–6 (and my discussion in Chapter Two).
[8] Merleau-Ponty 1996c: 86, 87. [9] Merleau-Ponty 1996b: 134–7.
[10] Merleau-Ponty 1996b: 121. [11] Merleau-Ponty 1996b: 123. [12] Davis 2016: 40.

detached, spectatorial art—as especially revealing of our active and embodied engagement with the world (more so, he claims, than music[13]). Connectedly, the claim that the painter does not 'appraise' seems—implausibly—to suggest that the painter adopts a merely passive attitude towards the 'primordial world' once the layers of scientific, etc. interpretation have been stripped away. And finally, one might wonder, even if painting does recover the immediacy of lived perception from scientific and philosophical overinterpretation, why that makes it so important. Don't we just live in the primordial perceived world all the time, anyway? Isn't Merleau-Ponty's point that this is what our actual experience is like? So why do we need art to get us there? And if the answer is that we are not often explicitly aware of what our actual perceptual experience is like, then we still have to ask what, say, Cézanne's recovery of it adds to Merleau-Ponty's own efforts to make us explicitly aware of it in the *Phenomenology of Perception* (the problem Crowell raised with reference to Husserl and Judd). Does Cézanne merely illustrate Merleau-Ponty, or does he give us another kind of insight altogether?

In response to these concerns one might start by emphasizing that Merleau-Ponty is not a naive empiricist.[14] He wants to rescue our lived experience from over-intellectualized accounts of it, but perception for him is anything but a passive taking in of a sensory give. (That is precisely one of the misleading philosophical theories—classical empiricism—that he rejects.) Rather, perception is an active process in which the 'body-subject' is constantly working to make sense of the world and its own being in the world. As Susan Bredlau puts it, for Merleau-Ponty 'We first encounter the world … not as an already given thing, but rather as an indefinite call to action … The present world and body only start to become a particular environment and a specific attitude with the body's response.'[15] His is a participative epistemology: the subject knows the world by and through its engagement with it, and neither the subject nor the world has a determinate existence outside that interchange. The artist, for Merleau-Ponty, cannot be merely a passive recorder of the 'primordial world' of pre-scientific experience, since this primordial world itself only arises with the questioning and interpretative activity of the 'body-subject'. The painter is someone who takes this questioning of the perceived world to a higher and more conscious level. But it is still a level of questioning that—unlike the interpretative attitude of the scientist as Merleau-Ponty understood *that*—remains engaged, rather than detached. Merleau-Ponty refers to Cézanne as refusing the dichotomy of thought versus sensation[16] and quotes him as saying, 'I agree that the painter must interpret it … The painter is not an imbecile.' Merleau-Ponty goes on to add, 'But this interpretation should not be a reflection distinct from the act of seeing'[17] or, we might add, from that of painting, the actual applying of paint to canvas. One may

[13] Merleau-Ponty 1996b: 123. [14] See Davis 2016: 8–9. [15] Bredlau 2010: 80.
[16] Merleau-Ponty 1996a: 63. [17] Merleau-Ponty 1996a: 66.

think in this connection of the Murdoch-Weil notion of 'attention', which is not a blank staring, but a focused, interrogative, imaginative quest to cut though the levels of 'social convention and personal neurosis' in order to see things as they are. Only by engaging with things actively, in a way that is analogous to an inter-personal interaction, can the painter get to the truth of those things. For the painter 'it is the mountain that he interrogates with his gaze ... What exactly does he ask of it? To unveil the means, visible and not otherwise, with which it makes itself mountain before our eyes.'[18]

It is crucial that for Merleau-Ponty the painter (the good painter, such as Cézanne) does *not* just take us back to the everyday level of active but non-intellectualized perception. The painter sees further, into the depths of things. Painting 'gives visible existence to what profane vision believes to be invisible'.[19] The painter, whether or not he paints from nature, 'paints, in any case, because he has seen, because the world has at least once emblazoned in him the ciphers of the visible'.[20] Again, 'Painting seeks, not for the outside of movement but for its secret ciphers ... All flesh, and even that of the world, radiates beyond itself.'[21] The artist aims to make manifest 'a Logos of lines, of lighting, of colour, of reliefs, of masses—a nonconceptual presentation of universal Being.'[22] This 'presentation' can be achieved in many ways—through concentration on colour or on line, through painting, through drawing, through sculpture—but in each case it aims to reveal that 'logos', not simply to give a faithful rendition of the superficial appearances (what Merleau-Ponty dismissively calls 'the envelope of things'[23]). The 'interrogation' by which the artist seeks this deep truth of things is not like a police interrogation of a suspect, but rather an interpersonal interaction in which there is a genuine mutuality:

> Inevitably the roles between the painter and the visible switch. That is why so many painters say that things look at them. As Andre Marchant says, after Klee: 'In a forest I have felt, many times over, that it was not I that looked at the forest. Some days I felt the trees were looking at me, were speaking to me ... I was there, listening.'[24]

The idea seems to be that painters somehow take in the essence of perceived things and present them so as to make them manifest to others:

> Things have an internal equivalence in me; they arouse in me a carnal formula of their presence. Why shouldn't those correspondences in turn give rise to some

[18] Merleau-Ponty 1996b: 128. [19] Merleau-Ponty 1996b: 127.
[20] Merleau-Ponty 1996b: 129. [21] Merleau-Ponty 1996b: 145.
[22] Merleau-Ponty 1996b: 142. [23] Merleau-Ponty 1996b: 142.
[24] Merleau-Ponty 1996b: 129.

tracing rendered visible again, in which the eyes of others could find an underlying motif to sustain their inspection of the world? Thus there appears a visible to the second power, a carnal essence or icon of the first.[25]

Painting is able to do this because it is continuous with ordinary perception, while at the same time going beyond it: 'Painting awakens and carries to its highest pitch a delirium which is vision itself.'[26] This is why it can teach us new ways to perceive, to appreciate, to inhabit our world: 'once it is present it awakens powers dormant in ordinary vision.'[27] And in doing that it doesn't just make it possible to expand the range and sensitivity of our response to the world; it also gives voice to nature itself. As we have already seen, Merleau-Ponty approvingly quotes Cézanne as saying (like a Song dynasty landscape painter), 'The landscape thinks itself in me ... and I am its consciousness.'[28]

This is, all at once, fascinating, suggestive, and obscure. It is clear, though, that for Merleau-Ponty the painter is someone who sees things with such an intensity of attention as to recognize in them something that is hidden from everyday, practical, routine perception as well as from science and who is then able to paint so as to manifest that deeper truth to others. It is, of course, significant for my purposes that Merleau-Ponty says that a painting (the 'second visible') is 'an icon' of the perceived world, or some aspects of it (the 'first visible'). In my terms, that is, it doesn't copy appearances, but makes present the inner essences of things. Of course, I need to be careful about simply reading my thoughts into Merleau-Ponty's poetic but enigmatic prose. He does, however, talk of 'presence', 'ciphers', of an underlying 'logos', and of 'the invisible.' This last notion was particularly important to him: at the time of 'Eye and Mind' he was working on a major book to be called *The Visible and the Invisible*, which was left unfinished when he died suddenly, soon after the publication of 'Eye and Mind'. We have already come across the idea that icons make the invisible visible. Merleau-Ponty interestingly claims that painting makes visible what 'profane vision' *thought* was invisible. He also paraphrases Klee as saying that 'the line no longer imitates the visible, it "renders visible"; it is the blueprint of a genesis of things'.[29] John Sallis notes this as a 'reference ... to the celebrated opening line of Klee's *Creative Credo*: "Art does not reproduce the visible but makes visible."'[30] (And, of course, what is *made* visible was previously *not* visible—perhaps just because it had not been thought to be visible.) Later, and again referring to Klee, Merleau-Ponty notes that 'the hallmark of the visible is to have a lining of invisibility in the strict sense, which it makes present as a certain absence'[31] (which seems a quite Daoist line of thought).

[25] Merleau-Ponty 1996b: 126.
[27] Merleau-Ponty 1996b: 142.
[29] Merleau-Ponty 1996b: 143.
[31] Merleau-Ponty 1996b: 147.

[26] Merleau-Ponty 1996b: 127.
[28] Merleau-Ponty 1996a: 67.
[30] Sallis 2015: 130.

In what follows I will try to unravel something of the idea that painting makes the invisible present—indeed, makes it visible. In so doing I will continue to use Merleau-Ponty as my main conversation partner and will try to explicate some of the enigmatic remarks which I have been quoting from him without much commentary in the last few pages. My main aim, though, is not Merleau-Ponty exegesis as such, but to take from him what I can for the development of my thoughts about the value of painting. And I will be commenting only tangentially at most on the fascinating but tentative, enigmatic, and incomplete ontology that Merleau-Ponty left us at his death.

II

So what is meant by 'the invisible' here and in what sense can painting be said to show it or make it visible? Of course, the idea seems strange, but quite a few distinguished artists as well as philosophers and critics have said such things, and all of them were well aware of the paradoxical nature of such claims. According to Michel Henry, for instance, 'To paint is to show, but this showing has the aim of letting us see what is not seen and cannot be seen.'[32] And in this he is not only explicating Kandinsky's paintings, but following Kandinsky's own theoretical reflections.[33] As with the notion of an intersubjective relation between viewer and painting (to which it is related), we need to have the patience to linger with a striking but strange formulation and try to find the sense(s) in it. I don't want to assimilate Merleau-Ponty and Henry (or Klee and Kandinsky) to each other and I don't want to associate any of them too quickly with either the traditional theological claim that icons make the invisible visible ('Christ is depicted in images and the invisible is seen'[34]) or with the idea that landscape paintings can make the invisible energies of nature (*Ziran*) visibly manifest.[35] Nor, however, do I want to simply assume that there are no connections to be found. Let us then investigate some possible senses of 'the invisible' and what it might mean to make it visible in painting.

Perhaps the simplest sense is one that has already come up in the discussion above, that the painter makes us see the world with a new freshness, rescuing it both from layers of taken-for-granted theoretical interpretation and from the familiarity with which it shows up to us in our ordinary practical activity. The painter really *attends* to what our eyes usually slide over without really noticing and by so doing makes it available for the rest of us to attend to also. In this sense,

[32] See Henry 2009: 10. [33] See Kandinsky 1977: e.g. 9, 17–18, 20, 24–6.

[34] St Theodore the Studite 1981: 21.

[35] Or, indeed, Plotinus' claim that art can in a way or up to a point make the (invisible) Forms manifest visibly to us. See the discussion of this point in Chapter Two.

what the painter 'makes visible' is not anything that is inherently invisible, but what is invisible *to us* in the rush of practical life because we don't look closely enough:

> In the work of Cézanne, Juan Gris, Braque and Picasso [objects] do not pass quickly before our eyes in the guise of objects we 'know well' but, on the contrary, hold our gaze, ask questions of it, convey to it in a bizarre fashion the very secret of their substance, the very mode of their material existence and which, so to speak, stand 'bleeding' before us. This was how painting led us back to a vision of things themselves.[36]

Or, as Marion, puts it, 'We look at what is offered by the painter only in order to see a visible that remains inaccessible to our vision. For if he paints what he sees ... he does not paint what, as a rule, *we* see at first sight.'[37] But there are other relevant senses of invisibility. Merleau-Ponty sets out some of them in one of his working notes for *The Visible and the Invisible*:

> The invisible is
>
> (1) what is not actually visible but could be (Hidden or inactual aspects of the thing—hidden things, situated 'elsewhere'...)
>
> (2) what, relative to the visible nevertheless could not be seen as a thing (the existentials of the visible, its dimensions, its non-figurative inner framework)
>
> (3) what exists only as tactile, or kinaesthetically, etc,
>
> (4) the *lekta*, the Cogito ...[38]

Merleau-Ponty isn't directly discussing painting in this note, but it does suggest some of what he may have had in mind when talking about 'the invisible' in 'Eye and Mind'. At any rate, it suggests some interesting and relevant possibilities. To start with the most straightforward sense (1): the far side of an object is invisible to me when I am looking at its near side. This is far from a trivial point, though: the Phenomenologists have made much of the fact that when I see the surface of an object, I see it *as* presenting to me an object which has other sides. If I were to walk around it and discover that I had just been seeing a facade, I would usually be surprised or shocked.[39] In that sense, even in the most banal of everyday perceptual states I am in some sense *aware* of what is currently invisible—and aware of it in and through my perception of what *is* currently visible. I see what is now visible to me not as a self-contained sensory given, but as essentially referring

[36] Merleau-Ponty 2009: 69–70. [37] Marion 2004: 24–5.
[38] Merleau-Ponty 1968b: 257 (also quoted in Johnson 1996: 53).
[39] See, e.g., Gallagher and Zahavi 2012: 8.

to other, currently hidden aspects. The same, of course, is true for the interior of an object, which I could only see if I broke the object apart. Even when I've looked at an object from all angles, I don't just see its surfaces: I see them *as* the surfaces of an object which has (literally and, again, quite banally) hidden depths. And clearly this has application to painting and to its representational content. A few dabs of paint on a canvas can present to us not just a smear of colour but an object, and not just the surface of one but an object which we see as having unseen aspects, depth, solidity. (One might, it is true, think of the Impressionists as *trying* to paint mere surfaces, or surface effects of light and colour, and Merleau-Ponty praises Cézanne for restoring the solidity to things without simply reverting to academic realism.[40]) The point, though simple, is fundamental to representational painting at least, for that just is the presentation to us of three-dimensional objects through the creation of two-dimensional images.[41]

Merleau-Ponty's second sense of 'the invisible' is a bit more mysterious.[42] But when he talks about the 'dimensions', he must be referring to the basic structure of the space in which the object exists—which is not reducible to Euclidean or Cartesian geometry. A thing's way of being in space is not literally visible in the same way an object is (though it is a further and questionable step to say that it isn't visible at all). One could then think of various techniques—Renaissance perspective, say, or Cézanne's or Matisse's deliberate refusals of perspectival consistency[43]—as different ways of presenting the ways things are in space, their ways of spatial being. Marion takes this idea a little further when he suggests that through perspective and other forms of compositional structure the painter doesn't just reproduce objects, but shows or makes manifest to us the conditions of the possibility of things appearing to us. We only see what is visible—Austin's 'middle-sized dry goods'—because of our capacity to organize our perceptions in depth. Space (especially depth, but also left- or right-handedness) is not itself visible, but this invisible makes the perception of the visible possible: 'It is the invisible … that renders the visible real.'[44] And painting can make this invisible manifest to us.

Merleau-Ponty's third sense of the invisible ('what exists only as tactile, or kinaesthetically, etc.') seems fairly straightforward: one cannot literally *see* the texture, the hardness or softness, of something. Except that, according to

[40] See Merleau-Ponty 1996a: 62–3.

[41] Or close to two-dimensional; of course, a painting has some (literal, physical) depth.

[42] His talk of 'existentials' of the visible is—presumably intentionally—provocative, given that Heidegger (1962: 70–71) sharply distinguishes between existentials—the basic characteristics of *Dasein* (human existence)—and categories—the basic characteristics of non-human beings.

[43] See Merleau-Ponty 1996a: 64–5.

[44] Marion 2004: 4. Marion refers to Kant on the ideality of space and Nietzsche on perspectivism in this connection, though there is also at least an interesting analogy with Wittgenstein's argument in the *Tractatus* that linguistic representation depends on conditions that cannot themselves be directly represented but only 'made manifest'.

Merleau-Ponty, one can. As we have already noted above, he insists that we do *see*, for instance, the roughness of the old blanket, the cool rippling lightness of the water, the solidity of the granite boulder. Perhaps that is the point, though: this is an example, not of what really is invisible, but of what 'profane vision' *thinks of*—wrongly—as invisible. However, even if this is the case, it is also true that according to Merleau-Ponty himself, it is our actual everyday perception—recovered and articulated in Phenomenology—that experiences the allegedly 'invisible' as visible. This doesn't, therefore, seem to be a case where we need *painting* to reveal the visibility of the supposedly invisible to us. So this is one point where we need to ask what it is that painting does that is distinctive. How does it do more than what Phenomenological philosophy can do? Or even give us insights beyond those that we can get by just attending to our own perceptual experience? Still, if we set these complications aside for now, the example of texture does at least suggest a fairly clear sense in which good painting can be said to make what we might still want to think of as the—*strictly speaking, literally*—invisible visible. For a good painter really can show us the texture of velvet or fur, really make us sense its softness and particular feel, through the representation of its visual appearance. Or, in a different mode, an artist may make vividly present to us the dense viscosity of the paint that he or she is using in and through the visual appearance of the brushstrokes.

Merleau-Ponty's fourth category includes two quite different things, though presumably also others which he doesn't mention, as the breezy 'etc.' indicates. According to Galen Johnson, the Greek term *lekta* means both 'that which is gathered, chosen, and picked out' and 'that which is capable of being spoken'.[45] One can see a sense in which the way things are organized, selected, grouped together or apart is 'invisible'—it is not visible in the same way as one of the objects itself. All the same, in a perfectly everyday sense, the way things are grouped—that the apples are on this side of the table, the oranges on that side—is often entirely visible. I think Merleau-Ponty's point is to get away from the (bad) 'Metaphysics of Presence'—the compelling but simplistic picture of reality as simply consisting of 'middle-sized dry goods', bits of stuff. The ways things are grouped or arranged—which certainly is connected to the possibility of speaking them (to use language is to group together or to categorize)—is not itself another thing or object, but it is still an essential aspect of the world as we experience it. It is also, of course, an essential aspect of any painting: the painter will have to compose or arrange it, put some objects in the foreground, others farther back, to the side, and obviously this is still true for abstracts too. The effect of any painting will depend in large measure on how it is organized and composed; and the viewer will also appreciate the painting differently, depending on which parts he

[45] Johnson 1996: 53.

or she chooses to focus on—or which angle he or she chooses to view the painting from. (A painting can look radically different depending on whether it is viewed from one side or the other rather than head-on.)

In referring to the Cogito, Merleau-Ponty is addressing a whole other set of issues. One can assume that what he means is subjectivity in general, the inner life. Thoughts and feelings are not literally visible. But they come to visibility in a person's expressions, actions, ways of speaking, walking, gesticulating: 'All perception, all action which presupposes it and, in short, every human use of the body is already *primordial expression*.'[46] This is a central part of what Merleau-Ponty means by his crucial term 'body-subject'. The scientific account of the body as a physiological machine is an abstraction from our first-person experience of our own bodies as our ways of being and acting in the world—and our second-person experience of one another's bodies as the embodiments or expressions of our subjectivities, of our personalities. As he strikingly puts it in the *Phenomenology of Perception*, 'The body cannot be compared to the physical object but rather to the work of art.'[47] It remains, I think, nonsense to say that I literally *see* your pain—that would be behaviourism (the pain just is the behaviour) which is absurd. Nevertheless, I do see *you in pain*; I see your gestures (and hear your cries) as expressive of pain. And this is not a matter of seeing them as signs or symptoms which I need to interpret or decode. They make your pain manifest to me; they convey it to me with immediacy.[48] To transfer this point to art (though it's interesting that Merleau-Ponty, in the remark quoted above, starts from assuming an expressive understanding of art and uses *that* as a model for thinking about embodied subjectivity), a good painter, especially a good portrait painter, is able not just to depict human bodies but to depict them as the embodiments of human minds, as expressive of kindness, anger, sternness, fear, and so on. More deeply, a good portraitist can depict a human body and (especially) face as expressive not just of this or that distinct feeling or trait, but of a whole personality. (As MacIntyre put it, the aim of the portrait painter is to show the truth of Wittgenstein's dictum, 'The human body is the best picture of the human soul.'[49])

III

Following the distinctions Merleau-Ponty made in his note, we have considered several quite straightforward ways in which painting could be said to make the invisible visible. But it's not clear that we have yet got to the heart of what

[46] Merleau-Ponty 1996c: 104. [47] Merleau-Ponty 2012: 152.

[48] For a much more detailed account of expression as central to our knowledge of other minds, see Rudd 2003: pt 2.

[49] See MacIntyre 2007: 189, quoting Wittgenstein, 1958 Part II, p, 178.

concerned him about painting in 'Eye and Mind', or what has concerned other painters and commentators who have spoken about painting as making the invisible visible. Let us continue considering some further senses of an invisibility that might come to visibility in painting. We might start by radicalizing the point about making subjectivity externally manifest. A good portraitist can paint so as to make his or her subject's inner life and personality apparent to us. What is itself an expressive medium—a human body, especially a human face—is being expressively portrayed so as to make its expressive properties perspicuous. But what if this is true in some sense of all painting? Recall Merleau-Ponty's references to the 'ciphers' or to the hidden 'logos' present in things, which the artist is able to understand and then make manifest in painting to the viewer. And recall also his invocations of intersubjectivity—the 'questioning' of the mountain, the artist's sense of being looked at by the trees. The point is not to take such expressions with a flat-footed literalism, as in some straw man version of panpsychism, but to consider the idea that objects, landscapes, and, for that matter, patterns of colour and shape have their own essences or essential natures. That is, that there is a sort of 'formula', as Merleau-Ponty put it, an organizing principle, in a thing, or even an assemblage of things, which gives it its cohesion, the rationality of its structure. The artist is able to find that principle, to appreciate it, and then to depict that thing so that its essence is manifested in and through its appearance, as a person's confidence or insecurity is expressed or manifested in and through his or her facial expression, posture, and so on.

I am well aware that the term 'essence' carries a lot of philosophical baggage and that some of its connotations for some people may be off-putting or misleading. I should, however, emphasize that I am not trying to rely here on any philosophically recondite notion of essence, the sort of thing I would have to write another book to explain. The distinction between what is essential to something and what is not is an everyday and commonsensical one, however complicated it may get when one tries to analyse it philosophically. In using the notion of essence or of what is essential here, I am wanting to stick to this common-sense level; and to the extent it can be explicated, it will be phenomenologically, by appealing to how we actually experience things. In particular, I want to guard against two serious misunderstandings of the claim that the good painter shows us the essences of things rather than merely their appearances (the 'envelope of things'). Firstly, I want to be clear that I am using 'essence' here to refer not only to the general kind or nature that something exemplifies, but also its haecceity, its individual nature, what makes it the distinct particular that it is. This is what Gerald Manley Hopkins was trying to get at with his coinage, 'inscape', defined by the *Oxford English Dictionary* as 'the individual or essential quality of a thing; the uniqueness of an observed object, scene, event, etc.'[50] These two senses of 'essence'—the collective,

[50] Oxford English Dictionary, s.v. inscape.

species nature and the individual inscape—should not be thought of as somehow opposed to each other. Indeed, the opposite is true: something can only be a determinate individual if it has universal characteristics.[51] My cat is very much an individual, but she is an individual *cat*; it's not as though her species characteristics aren't really part of what she is. Mont Sainte-Victoire is the distinct, particular mountain that Cézanne painted, but it is a particular *mountain*, and when Cézanne painted it, he made present to us something of what a mountain is in general, as well as making that unique mountain present. The second misunderstanding I want to avoid is that if the painter makes essences manifest, this would mean that he or she is really depicting not the concrete visible reality but *something else*, something lurking behind the visible thing, of which the thing is simply a sign. This would be a serious confusion. The painter does indeed depict the thing itself, but to do that is not merely to replicate the surface appearance of the thing. The good painter does show how some thing appears—from a certain angle, in a certain light, etc.[52]—but does so in such a way that the essential nature or character of the thing is made visible through this. The whole thing, as it really is, is made present to us, not just how it appears to us from this angle, in this light, although only that appearance is literally depicted.

The idea that things have essential natures (as both individual and kind) is central not only to Merleau-Ponty's aesthetics but to his philosophy as a whole. In his account of what makes a thing a thing he rejects the traditional alternatives that it is either just an assemblage of sensory qualities or a Lockean metaphysical pincushion, a qualityless substratum in which qualities mysteriously inhere. Rather, he argues, a thing's qualities are internally related—to one another and to the thing whose qualities they all are—by manifesting a common style or way of being:

> The unity of the thing beyond all of its congealed properties is not a substratum, an empty X, or a subject of inherence, but rather that unique accent that is found in each one, that unique manner of existing of which its properties are a secondary expression. For example, the fragility, rigidity, transparency and crystalline sound of a glass expresses a single manner of being. If a patient sees the devil, he also sees his odor, his flames and his smoke because the meaningful unity, 'devil', is just that acrid, sulfurous, and burning essence. In the thing, there is a symbolism that links each sensible quality to the others.[53]

[51] As Spaemann (2015c: 142) puts it: 'From the denial of universals follows the denial of identifiable individual entities...A thing can be identified as a "this" only insofar as it is at the same time qualitatively determined as a "such".'

[52] Or perhaps, as in cubism, from several angles simultaneously.

[53] Merleau-Ponty 2012: 333.

In our 'primordial' pre-scientific experience of the world, we experience things—and not just persons—as expressive.[54] And the analogy with persons is really the best way to see what Merleau-Ponty is getting at. When you get to know a person, you get to know not just a list of characteristic traits that he or she tends to display under these or those circumstances, but, more fundamentally, you get to understand the character or personality which expresses itself consistently through all these apparently disparate traits.[55] For Merleau-Ponty we experience things too as having quasi-personalities, each having its 'unique manner of existence' or 'style' which is manifest in all its various properties.[56] Of course, he doesn't just assimilate things to persons,[57] but his distinction between them is less sharp than, say, P. F. Strawson's is.[58] Things, for Merleau-Ponty, like persons, are essentially expressive: 'The thing accomplishes this miracle of expression; an interior that is revealed on the outside.'[59] And *what* they express—the 'interior' that is made manifest in how they appear—is that 'single manner of being' or, as Merleau-Ponty himself sometimes says, 'essence'.

Merleau-Ponty doesn't, in this expressive context, hesitate to use the language of intersubjectivity to speak of our relation to things: "nature must be our interlocutor in a sort of dialogue ... every perception is a communication or a communion".[60] We have been dealing just now with his account of perception in general, but presumably his idea is that, although such "communication or communion" does go on in all perception, the artist takes it to a higher, more conscious level: he or she somehow sees more deeply, reads the expression of things more perspicuously. (Hence his talk of art awakening our "dormant" powers.) I have already quoted Merleau-Ponty as saying that some classic modernist painters portray objects so as to convey to our gaze 'the very secret of their substance, the very mode of their material existence'. Elsewhere he notes how Cézanne would search for an intuitive gasp of:

> the landscape in its totality and in its absolute fullness, precisely what [he] called a 'motif'...all the partial views one catches sight of must be welded together... His meditation would suddenly be consummated: 'I have a hold on my *motif*,' Cézanne would say...Then he began to paint."[61]

[54] For more detail on this, see Rudd 2003: 192–201. See also Landes 2013, which takes the notion of 'expression' as the key to understanding Merleau-Ponty's work as a whole.

[55] Of course, there are those who deny that we have coherent personalities in this sense. See, e.g., Doris 2002. I think they are just wrong about this; see Rudd 2012: ch. 3 for a defence of the unity and coherence of character.

[56] See Matherne 2017: 693–727.

[57] Still less does he assimilate persons to things; see the detailed critique of behaviourism in his first book, Merleau-Ponty, 1967 and of naturalism generally, even in its subtler forms, both there and in Merleau-Ponty 2012.

[58] See Strawson 1959: pt 1. [59] Merleau-Ponty 2012: 333.

[60] Merleau-Ponty 2012: 334. [61] Merleau-Ponty 1996a: 67.

The coherence of a representational painting at least derives from a vision of the underlying coherence of the thing(s) that are its subject matter; the painting of it thus becomes, to use Merleau-Ponty's own word, an 'icon' of the subject matter, one in which its essential nature, not merely its appearance, becomes manifest.

It should be said that Merleau-Ponty is careful to note that we don't encounter objects in isolation, but always in some larger context; indeed, the sense of the 'atmosphere' of a region may precede any sense of the individual objects into which it may be subsequently decomposed. As David Cooper notes:

> For Merleau-Ponty, the atmospheres of places are entirely familiar to us, yet rarely remarked upon and discussed...partly because, once we pay close attention to what we are experiencing, it is no longer an atmosphere, but particular objects and properties, on which we tend to focus. It would be a mistake, however, to suppose that our initial experience of a place takes the form of perceptions directed towards particular objects...Rather, particular faces, cafes and trees are noted only through 'standing out against the city's whole being' and against a backdrop of 'a certain style or signification which Paris possesses for him'.[62]

It is here that I think we can find a place for Heidegger's account of how an artwork can disclose a *world*. In Heidegger's technical sense a world is a network of interrelated things, activities, institutions, and persons, connected by some common horizon of meaning. So we might speak of 'the business world', 'the academic world', 'the world of the fifteenth-century French peasantry', 'the world of Tang dynasty Buddhism', and so forth. Heidegger's famous example is of a painting of a pair of boots by Van Gogh and how, when properly attended to, they can evoke or disclose the whole world of the peasant woman to whom Heidegger supposed the boots belonged:[63]

> From the dark opening of the worn insides of the shoes the toilsome tread of the worker stares forth. In the stiffly rugged heaviness of the shoes there is the accumulated tenacity of her slow trudge through the far-spreading and ever-uniform furrows of the field swept by a raw wind. On the leather lie the dampness and richness of the soil. Under the soles slides the loneliness of the field-path as evening falls. In the shoes vibrates the silent call of the earth, its

[62] Cooper 2006: 49.

[63] Mayer Schapiro (1994: 135–52) has argued that Heidegger was probably mistaken about this—that the boots were more likely to have been Van Gogh's own. What, if any difference it would make if this were true is an interesting question. If a painter uses a model when depicting a historical or mythological personage, need the resulting painting be less truthfully expressive because it wasn't really Alexander the Great or Venus who was painted? However, I won't try to explore this issue further here.

quiet gift of the ripening grain and its unexplained self-refusal in the fallow desolation of the wintry field.[64]

One important thing to take from Heidegger's analysis[65] is that if painting makes present to us the essences of things, those essences are not just discrete things pertaining to self-enclosed objects; they are relational. I have noted above that for Merleau-Ponty the qualities of an individual thing are internally related; but for both Heidegger and Merleau-Ponty those things are themselves internally related to other things, so they are what they are (at least in part) in virtue of their relations to one another.[66] To understand what a pair of boots is does not just involve understanding their visible, physical properties, but recognizing them as artefacts, as manufactured and purchased in a society which includes bootmakers and commercial relations of various kinds; it involves understanding what they are for (footwear), what sorts of circumstances call for strong boots, rather than delicate slippers, what sorts of lives need heavy boots as essentials of daily living (and what sorts require them only for occasional leisure activities), and so on, and so on. Here indeed is another philosophically important sense of 'the invisible' and the way in which it can be made visible. One might think that someone just looking carefully at the boots could see them as disclosive of a whole way of life (even though the way of life, the 'world' is not itself something that can be literally looked at) and that Van Gogh was not only able to see them in this way but to depict them so as make that disclosive quality vivid to anyone who views his painting. This might still leave us wondering why we really need the painting if we could get that disclosure of world by just looking at the actual boots. However, Heidegger insists that the revelation comes from the painting, that truth, ontological disclosure, happens in the artwork in a way which it does not in ordinary living and perceiving:

> The equipmental quality of equipment was discovered. But how? Not by a description and explanation of a pair of shoes actually present; not by a report about the process of making shoes; and also not by the observation of the actual use of shoes occurring here and there; but only by bringing ourselves before Van Gogh's painting. This painting spoke.[67]

I think it is fair to say, though, that Heidegger never very perspicuously explains why this is so; and this is not just a problem for Heidegger and what he says about

[64] Heidegger 1971a: 33–4.

[65] I should note that my aim here is simply to learn from certain insights that Heidegger has, not to incorporate or even discuss his whole account.

[66] On the importance of the networks of internal relations between things for Merleau-Ponty, see Johnson 2009: 34–5.

[67] Heidegger 1971a: 35.

equipmentality and world, but a problem for disclosive theories in general (including Merleau-Ponty's). This is an issue I will return to in Chapter Six.

It is important to bear in mind that, as I have emphasized above, Merleau-Ponty's epistemology in general is a participative one: to know things in our ordinary perceptual interactions with them is not to gaze at them in a detached, dispassionate way but to interact with them. It is an embodied, practical knowledge by acquaintance and at the same time a knowing how to cope and engage with them.[68] This active, interrelational quality of knowing is not lost when we move from ordinary perception to painting. The model of literal intersubjectivity is again helpful here. In our expressive perception of other persons it matters that I don't just *notice*, for example, the nervousness that is manifest in someone's smile, but that I respond to it, perhaps automatically (it makes me feel nervous too) or perhaps consciously (I try to put the other person at ease). Of course, ignoring or trying to ignore it is also a way of responding to it. But, as I discussed near the beginning of Chapter Four, we also sometimes respond to paintings in analogous ways. If they can make manifest the formula, the essence, the motif, of things, it is not by simply showing it to us in a take-it-or-leave-it sort of way, but by summoning us to relate to it through them. To return to Gadamer's language, the painting is in an 'ontological communion' with its subject. And it makes it possible for the viewer to be brought into that communion also.

It also needs to be stressed that to know the essence of something is to know not only what it now is but also what it could be (and could not be). Something's style or manner of being can be projected in some directions but not others; given something's essential nature it is able to do or become *this*, but not to do or become *that*. The fundamental Phenomenological method of 'eidetic variation' involves imaging different possibilities, ways in which a thing might change or alter, in order to see which of them would be compatible with its retaining its identity and which would not, or to see which of them would be a genuine possibility *for that thing* and which would not.[69] A rabbit can hop but it can't fly; flight is incompatible with the essential nature of the rabbit. This sense—that to understand something's essence is to understand its possibilities—has not been lost on painters. Klee writes, 'I do not really want to render the human being as he is but rather in the way he could be.'[70] John Sallis comments on this passage: 'This is not to relinquish the orientation of art to truth; it is rather to insist that the truth of things goes well beyond what they appear to be; that it goes, for instance into the depth by which it is determined what a person *could* be.'[71] This is true not just of persons, though, but of any subject matter. (That Klee intended his remark

[68] On this last point, see Jackson 2010. [69] See, e.g., Gallagher and Zahavi 2012: 29–31.
[70] Quoted in Sallis 2015: 95; for the context and a rather different translation, see Klee 1966: 53.
[71] Sallis 2015: 95.

that way is clear from the context.) The painter paints things to show them not just as they are, but as they might be (and therefore, implicitly, what they might not be); a good painting shows its subject in a limited space of possibilities. This, then, is another sense in which painting can be said to render the invisible (here the realm of currently unrealized possibility) visible. Sallis says that 'the depiction of a thing in its density and depth [as determining its possibilities] will necessarily appear phantastical',[72] but I don't think this is *necessarily* so. To depict something so as to make manifest its possibilities may involve the imaginative reconfigurations of which Klee was such a master, but it can also be done in a traditional realist style. (Rembrandt's portraits show his subjects as real people, with their whole lives outside the painting implicit in his depictions of them.)

As we have noted before, Merleau-Ponty quotes Cézanne as saying that once he had grasped the motif and started painting 'the landscape thinks itself in me ... and I am its consciousness'.[73] We might take that image a little further by saying that the landscape *paints* itself through the medium of the painter. Cézanne did stress the painter's need to open himself to the landscape, to internalize it: 'He [the painter] must silence all the voices of prejudice within him, he must forget ... And then the entire landscape will engrave itself on the sensitive plate of his being.'[74] Once it has done that, *then* the painter can paint it, not by external copying, but from within himself. This would not, however, be an act of self-expression; rather, the painter would be acting as the landscape's amanuensis, so to speak. And if the resulting painting would thus be in a sense the *landscapes'* self-expression, it could then draw the properly attentive viewer into relation with the landscape, so that in this heightened consciousness that I as viewer have of the landscape, the landscape thinks itself in *me* too. I too am able to internalize what the painter first internalized. Cézanne makes his vision of the landscape available to me, but in so doing enables me to commune not only with Cézanne but with the landscape.

It is interesting to compare what Cézanne says here with an image that Klee uses to describe the artist's relation to nature—that of a tree. According to Klee, the artist 'finds his way' in the natural world and develops 'a sense of direction in nature and life' that Klee compares to the tree's circulatory system: 'From the root, the sap flows to the artist, flows through him, flows to his eye ... Battered and stirred by the strength of the flow, he molds his vision into his work.'[75] And Klee compares the work to the crown of the tree, its branches and leaves. He uses the image in part to reject the demand for a naturalistic or realist art: 'Nobody would affirm that the tree grows its crown in the image of its root. Between above and

[72] Sallis 2015: 95.
[73] Merleau-Ponty 1996a: 67. It is interesting that Kandinsky (1977: 17) says of Cézanne that 'He was endowed with the gift of seeing the inner life in everything.'
[74] Gasquet 1991: 150. [75] Klee 1966: 13.

below can be no mirrored reflection.'[76] But he also uses it to insist that the artwork, though not a copy of nature, is still an expression of it—and the artist a means to that expression: 'He does nothing other than gather and pass on what comes to him from the depths. He neither serves nor rules—he transmits. His position is humble. And the beauty at the crown is not his own. He is merely a channel.'[77]

So in seeking to render the invisible visible, the painter aims to make present the underlying truth or essence of the subject. But we should recall Merleau-Ponty's comment that 'The hallmark of the visible is to have a lining of invisibility in the strict sense, which it makes present as a certain absence.'[78] One possible meaning of this remark is that there is something inexhaustible in the essences of things: however well a painting captures something's or someone's nature, it can never capture it completely. There is always more to be said (painted). As Marta Nijhuis—herself an artist as well as a theorist of art—puts it:

> if the invisible could really turn into visible without any residue, without any latent trace of invisibility, art would lose its mystery and the painter would turn into a sort of carnival magician...However, by conceiving the visible itself as inseparable from the invisible, by stating that what is invisible will never completely turn into visible and that what is visible will always exceed its visibility, Merleau-Ponty preserves both the mystery of the world and the mystery of art.[79]

Any painting, then, carries with it the sense that what it conveys is true but can never be the whole truth; what it does not present are all the other ways in which the painting could have been painted but was not, all the ways in which that underlying formula of its subject could have been manifested, so that some other aspect of it stood out more perspicuously. And *this* invisibility is what is present in the painting as absence. To paint something so as to make it really present to us is to paint it precisely (if paradoxically) as *not* being fully present. If it were presented so that we felt we had fully and completely grasped it, then it would not have been presented realistically, for the reality of presence involves the sense of its exceeding our grasp. This is not just the point that one cannot paint something so as to show it from all angles at once, etc.—we have already seen Merleau-Ponty's response to that, which is that the good painter shows it so that its essence *is* made manifest even in the partial view that he or she selects. But the further point I want to make here is that even in that case, the essence of the thing is never *fully* manifested, that not even the best painting can give us a full ontological grasp of what anything is. But the better the painting, the more it

[76] Klee 1966: 13. [77] Klee 1966: 14.
[78] Merleau-Ponty 1996b: 147. [79] Nijhuis 2016: 89.

makes us aware of that surplus—of what it does *not* directly express. The painting may try to, in a way, explicitly depict the 'lining of invisibility' itself through the use of empty space or the suggestive but concealing mists that swirl around many Chinese paintings. But it may succeed in doing so implicitly as well. We might think especially of portraits here. Although I have emphasized the importance of the expressive powers of the human body and face, it is also true that the face does not reveal everything about a person: however expressive we are, there remains an element of 'mystery', as Nijhuis says, in any human face, a sense of how much more could be expressed but is not. And a good portrait—as opposed to a caricature or an allegorical painting of Fortitude, or Malice, or whatever— expresses not only its subject's personality but also the fact that there is always more to the person than is expressed in the portrait. Its realism consists precisely in the sense of mystery that it conveys.[80]

IV

The discussion so far has, I hope, made a case that there is indeed an analogy between how the icon has been understood as making the divine present and the way in which Merleau-Ponty sees painting generally as disclosing the essences of things to us, bringing us into communion with them. These parallels do seem to me quite striking. But up to this point I have not gone beyond what I called in Chapter Four the 'weak' thesis—that there is simply an *analogy* between the aim of the iconographer and that of the secular painter. One might, however, also consider a final sense in which painting may be said to make the invisible visible, in line with my 'strong' thesis—that what it discloses is God or, more broadly, perhaps, the realm of the transcendent, the absolute (the Form of Good). When one talks about the visible and the invisible, and of painting as making the invisible visible, one is inevitably summoning up religious connotations, and it's clear that Merleau-Ponty himself was well aware of doing this. Indeed, many of the other terms he uses in his late work—incarnation, advent, flesh, not to mention logos and icon—have specifically Christian theological connotations. Not that he is using them in their specifically theological senses, but he is clearly letting their theological associations play around them, as it were. This has been noticed, with various degrees of nervousness, distaste, enthusiasm, and scepticism by a variety of commentators.[81] There does seem to be an openness to religious possibilities in the late Merleau-Ponty, albeit a tentative and indefinite one; and he

[80] Thanks to Paul Coates for emphasizing this point.
[81] See, respectively, Johnson 1996: 52 and 2009: 131–3; Davis 2016: 44–5; Kearney 2010; and O'Leary 2010: 178–82. Edgar 2016 is a reading of Merleau-Ponty's ontology which, without directly theologizing Merleau-Ponty's work, nevertheless takes these theological resonances as key to a proper understanding of it.

does at moments connect this to his interest in painting. This doesn't emerge very clearly in 'Eye and Mind' (although Johnson notes a 'spiritual tone' in that essay[82]) but appears in some of his late lectures on nature, where he makes frequent references to Klee. There Merleau-Ponty asks why paintings look different from the world and answers that they don't try to copy appearances but to make manifest 'nature, not appearances, not "the skin of things" [but] … nature naturing'.[83] John Sallis notes the last phrase as a reference both to Spinoza and 'to Schelling's later thought in which the secluded ground of things is distinguished from—and taken as anterior to—the existence of things'.[84] Merleau-Ponty continues that painting 'offers what nature wants to say and does not say'—which is almost a paraphrase of Schopenhauer's claim that the true artist is someone who 'understands nature's half-spoken words'.[85] Furthermore, now quoting or paraphrasing Klee, Merleau-Ponty tells us that painting offers 'the "generative principle" that makes things and the world be; "first cause", "brain or heart of creation", "absolute knowing"'. Merleau-Ponty continues (in his own words), '[It is] a principle older than God himself', adding a parenthetical reference to Schelling and (drawing on his own idiom from this period) 'brute Being'.[86]

I mentioned back in Chapter One Clive Bell's 'Metaphysical Hypothesis', which claimed that painting makes us aware of 'the God in everything, of the universal in the particular, of the all-pervading rhythm … that which lies behind the appearance of all things'.[87] The reference to 'God' here may be a bit of a rhetorical flourish, but Bell is certainly suggesting that painting can put us in touch with some underlying principle at the heart of nature. Merleau-Ponty would agree with that, but from the remarks just cited it seems that he was willing to go further than this and to at least consider the idea that the 'invisible' that painting makes visible is not only the inner heart or activity of nature, but perhaps also a 'principle' more fundamental than nature itself. Of course, Merleau-Ponty, channelling Schelling, suggests that the 'principle' is more fundamental than God too.[88] I don't want to get into the details of Schelling's eccentric theology here or the extent to which Merleau-Ponty may himself have been drawn to speculation along such lines. (It is interesting, though, that the Klee phrases he quotes ('first cause', etc.) seem to suggest a more orthodox theism than these Schellingian allusions do.) But it would seem at any rate that Merleau-Ponty doesn't rule out something like the 'strong' thesis, according to which painting can disclose, make present, not only the deep ('invisible') natures of visible things but also something of the transcendent. We might distinguish between the claim that this is something all painting does and the more modest suggestion that this is one thing

[82] Johnson 1996: 52. [83] Quoted in Sallis 2015: 134. [84] Sallis 2015: 134.
[85] Schopenhauer 1958: i, 222. [86] Sallis 2015: 134. [87] Bell 1914: 69–70.
[88] Schelling (2006) distinguished between a personal God and the deeper, darker Godhead from which even God emerges.

that painting can do, and that *some* painting does it. But for the moment I will set these theological issues aside and continue to take Merleau-Ponty simply as having helped us to flesh out a version of the weak thesis. I will, however, be coming back to the question of whether a stronger claim is possible or necessary in Part Three of the book.

V

I have—following Merleau-Ponty himself—been sticking to a very abstract level of discussion so far. I don't take myself to have *proved* anything (nor does Merleau-Ponty claim to have done so). There are, I know, a lot of possible questions about, and objections to, what I have said so far. For instance: Is the notion of essence that I am relying on here a philosophically defensible one? Even if we can make sense of this notion, *what* essences does a painting try to disclose? Even if it is representational, is it about the essences of *all* the things it depicts? Or only some of them? Or does it disclose the essence of the subject matter as a whole? But then, does a landscape, say, *have* an essence that a painting of it could evoke? Does a collection of objects brought together to form the subject matter of a still life? And what about non-representational art? What, for that matter, about the artist? If a painting makes its subject matter present, doesn't it also make present the painter's own sensibility? I will try to respond to at least some of these questions in the following chapters. I hope, though, that enough has been said to give at least the broad contours of a disclosive account of painting modelled on the understanding of the icon but developed in modern terms in dialogue with Merleau-Ponty. The only way in which one can, I think, adequately justify any such account—and, indeed, the only way to make it fully comprehensible—is to *work* with it, that is, to look at paintings with this account in mind and see whether it helps to articulate what we experience when we look closely at them. This I can only ask each reader to do for himself or herself; but I can perhaps try to elucidate what I have said so far by looking at a few examples and considering the ways in which they can be thought of as making 'invisibility' present or manifesting the essences of things. I have no pretensions to being an art critic or art historian; all I can do here is to say a little about a few paintings and mention a few of their salient features, in order to encourage close attentive dwelling with them. (I would encourage readers to find decent images of the works I will discuss on the internet or elsewhere, though obviously there is no replacement for looking at the originals if possible.) Please note that I am not going to try and explain how this or that technique manages to make present or make the invisible visible—on my account this is something *all* good painting does, so there is no one technical trick (or bag of tricks) to achieve it. Rather, I will be concerned to point out how very different techniques and styles—used in very different

cultural and historical settings—may all serve, in their very different ways, to make present the essential natures of things.

The most obvious examples to start with would be portraits. Consider any good portrait, one that has psychological depth, that gives you a sense of the person depicted. Look at it; dwell with it. You find yourself—in the most compelling cases in a rather uncanny, even disturbing way—in the presence of the person depicted. You no doubt learn a number of facts about the sitter—what colour his or her eyes were, and so on; you may even learn a few psychological facts (perhaps that the sitter looks self-confident or worried). In the case of mediocre portraits, that is about it. But in the most powerful ones you find yourself gaining a knowledge by acquaintance, getting a sense of being in the presence of the person depicted, a sense of the person that cannot be fully captured in any set of propositions about his or her psychological dispositions. (I will just mention two examples from personal experience: Rembrandt's late self-portrait in Kenwood House, London, and his portrait of his son Titus in the Wallace Collection, also in London.) The experience can be so intense that one has to turn away—or anaesthetize oneself by considering the texture of the brushstrokes or wondering what the decoration on the sitter's jacket is. In such an experience—which one cannot force, but which one can try to open oneself to—what is meant by a painting showing the inner nature of its sitter through the depiction of his or her facial features will be made more clear than it can be by any philosophical theorizing.

Portraits are an obvious choice, but let's move to a (somewhat) different genre—paintings of animals. My first example is Dürer's *A Young Hare* (1502). The animal is depicted against an almost blank background, though its shadow appears on its right side. The only hint of location is that a window is shown reflected in one of its eyes. But the hare itself is depicted in wonderfully meticulous detail, every hair and whisker being shown with patient fidelity to life. It is accurate enough to serve as a scientific illustration, and there is a clear sense of the anatomical structure beneath the furry surface. But although it is not impressionistic, it still feels as though one could reach out and stroke the fur—as Merleau-Ponty would say, one *sees* the softness of the texture. At one level the painting is a showcase for Dürer's skill as a representational artist. But one isn't struck by it simply as a display of technical virtuosity; it isn't simply for that that it became one of Dürer's best-known images. (Numerous copies were made in his own lifetime, and today the image is ubiquitous in reproductions and parodies.) Nor is it because the subject of the painting has any particular historical, political, or religious significance, or is in any way exceptional or exotic. Dürer simply puts us in the presence of an animal that is neither particularly rare (for a European) nor particularly astonishing in its appearance and makes us see it with an intensity that gives rise to wonder. It is *there*—both as an individual animal and as an exemplary instantiation of its species. But perhaps primarily the latter. We don't

mostly, I think, have strong intuitions about the individual personalities of hares (perhaps we should), but Dürer presents us with the essence of the Hare, of what hare-ness is. (This example is also useful for making the point that although good painting isn't simply about the accurate depiction of surface appearances and although icons deliberately use stylization to invoke the transcendent, it does not follow at all that representational and even hyper-realist paintings cannot also make essences present.)

My second example is a painting by a twentieth-century Chinese artist, Chao Shao-An, now in San Francisco's Asian Art Museum. Titled *Perching*, it shows a small bird perching on a branch.[89] The picture is mostly monochrome (done in ink); there is a blank, light-grey background against which a single twisting, gnarly branch is shown in varying shades of grey to almost black. The bird is sitting on it in the top right of the painting and is made from a few dabs of grey and black, with the red of its throat and orange of its breast being the only bright colours in the painting. It is like Dürer's *Hare* in that it is a study of an animal which focuses just on the animal itself with minimal background or context to distract us (though the branch has its own lively elegance). But its technique couldn't be more different. In contrast to Dürer's minute detail, we have just a few carefully chosen strokes of the brush—each stroke by itself just a rough dab of colour or ink. But as a result, the bird is *there*, intensely alive, quivering with animation. (Of course, the wonderful economy with which colour is used plays an important part in the effect of the painting.) The most painstaking and the most economical of means can both bring to life and show us a living being. I don't even know what species Chao Shao-An's bird is, but it exemplifies the rapid, peering-around, vulnerable but feisty small-bird quality that anyone can recognize.

Let's turn to paintings of inanimate things. I have already referred to Cézanne's numerous paintings of Mont Sainte-Victoire in Provence. The very fact that Cézanne found himself drawn back repeatedly, over years and decades, to paint it again and again is itself significant; for we can see him in a continuing dialogue with the mountain. (As Jessica Wiskus puts it, 'The presence of the mountain … could not be endured by the painter except by a repeated summoning.'[90]) No one picture can fully capture what the mountain is, but the whole series has its own cohesion as a continuous exploration (not that it was ever planned as such). In such a series, I think, we see the point of Merleau-Ponty's remark about the invisibility—that is, the inexhaustibility—of the essence being made present as absence. Never could Cézanne simply announce, 'Well, now I've got Mont Sainte-Victoire down. What next?' Each new painting of the mountain certainly discovers new techniques, new ways of representing, but it is not as if the

[89] See http://searchcollection.asianart.org/view/objects/asitem/Objects@7340/43/titleSort-asc?t:
state:flow=80978608-7ab6-41e4-81b7-81831edfc6ba, accessed 3 February 2022.
[90] See Wiskus 2016: 79.

mountain were merely a pretext for technical experiments. More deeply, each painting discovers new facets of the mountain itself, facets that Cézanne was able to evoke as he experimented with different styles and techniques.

Though I would strongly urge the reader to look closely at several of these paintings, comparing the sometimes strikingly different styles that Cézanne used and the ways that he employed them to bring the mountain to the viewer, I want to turn now to mountain paintings from a very different time and culture—Song Dynasty China. Consider Fan Kuan's *Travellers among Mountains and Streams*.[91] The scale of the work is important—it is about 7 feet high and much taller than it is wide. The foreground is dominated by large rocky outcrops; then comes a road, crossing the painting horizontally. A small group of travellers with a donkey train can be seen on the road. Beyond it are some rocky and tree-covered hills; the roof of a temple can be glimpsed near the top of the right-hand hill. This would be an impressive composition in itself; the travellers on the road are already dwarfed by the hills beyond them. But this is only the lower third of the painting. Above it is an almost blank space—a mist, making it impossible to decide the exact depth; and then immense cliff faces, somewhat lower on each side, but the central mountain rising to almost the top of the picture. A bit farther down, on the mountain's right flank, a waterfall emerges and cascades down until it is lost in the mist, with no indication of how much farther it has to fall. The painting combines intricate detail—on the trees, the temple roofs, the rocks—with a sense of immensity. One critic notes that 'Fan paid no heed to traditional layout that would have emphasized depth; instead he put the steep precipice in the center.'[92] We cannot see beyond the mountain, and the mist makes it impossible to see exactly how far back it is or how far down it rises from. (There is, though, a sense of recession in depth from the first summit we reach through the series of summits to the highest one at the back.) The mountain emerges from the indeterminacy of the mist, but as we follow it up, it is presented with detail and precision; the texture of the rock and the trees clinging to it where they can are carefully modelled. The sheer scale of the mountain relative to the tiny travellers—and even to us the viewers—and its filling of the horizon give it an overwhelming presence, while its emergence from the misty abyss into massive determinacy is almost a visual metaphor for Merleau-Ponty's talk of the invisible emerging into visibility.

An interesting stylistic contrast is provided by Mi Fu's *Auspicious Pines in Spring Mountains*.[93] It is a much smaller painting, on quite an intimate scale, in

[91] Fan Kuan (*fl.* 990–1020 CE). The painting—the only certainly authenticated one by him to survive—is in the National Palace Museum, Taipei, Taiwan.

[92] Lin 2010: 99.

[93] Mi Fu (1051–1107). As with Fan Kuan, few of his works survive, though they were very influential. Even the authenticity of *Auspicious Pines*—also in the National Palace Museum in Taipei—has been questioned, though if it isn't authentic, it is certainly an early copy.

fact (35 × 44 cm). What it does have in common with Fan's *Travellers* is what we might call 'the excluded middle'—the middle ground of the painting is entirely obscured by mist. The foreground is sharply, though rather schematically delineated—there are hills, the eponymous pines, and a pavilion. No human figures are present at all, the pavilion being the only reminder of culture within nature. In the distance, emerging out of the fog, are several mountain peaks. There are actually three sets of them, each set comprised of three peaks, one in front of the other. Unlike Fan's great craggy cliff, they are all neatly triangular or pyramidical, though one doesn't get much sense of depth in them. The whole picture has a certain deliberate artificiality; Mi is clearly rejecting naturalism and paring the elements in his scene down to their basic essentials.[94] The surfaces of the mountains are hazy or impressionistic, composed with wet ink washes and, especially around the edges, with small dots of ink—what came to be known as 'Mi-dots'—which from a distance, create a blurred and slightly shimmering effect. And yet this is not simply an assemblage of conventional signs; it is a compelling evocation of landscape; hazy as they may be, the mountains emerging from the misty void have a compelling presence even—or especially—in their refusal of any detailed self-revelation. And the 'auspicious pines' seems to greet the mountains and introduce them to us, the viewers, from across the chasm.

Let us look at one more mountain, returning again to European (proto-) modernism. This is an oil sketch of Mount Kenya by the Finnish artist Akseli Gallen-Kallela from around 1909 or 1910. Its very sketchiness is a large part of its appeal. Again, there is a sort of 'excluded middle', although, and with great economy, we are made aware of a wide plain between our implied position on the lower hill in the foreground and the mountain beyond. The foreground, taking up the first third of the painting, consists of thick, heavily applied strokes of ochres, greens, and blues, which are by themselves an abstract swirl, but which, in context effectively evoke the hill with its dense African vegetation. The rest of the painting consists almost entirely of light blue, forming the mountain and the sky; the blue of the mountain is a bit darker but not very much. There is no outline, but the colour contrast, mild though it is, makes the mountain stand out with surprising effectiveness. The colour in both the sky and the mountain is uniform and thickly applied, though less so than in the foreground. The obvious brushstrokes give the mountain texture, though really no more than the sky has. Otherwise, the mountain is characterized only by some dabs of white or pink-white representing snow on the ridge and towards the summit. The mountain could almost be taken for a shadow, a darker region of sky, as though it had crystallized from it. And yet the very paleness of its colour, by generating an impression of great distance, accentuates the sense of its scale—still utterly dominating and filling our field of

[94] As he himself said, 'Most of my paintings … are not a literal representation of nature.' Quoted in Lin 2010: 104.

vision, even from that distance. The work is very simple, rough—a sketch. And yet these few smears of paint are enough to evoke Mt Kenya in all its immensity.

<h1 style="text-align:center">VI</h1>

The idea I have been pursuing above—that paintings make present to us not the surface appearances of their subject matter but their underlying essences—can be seen as a development of the classic representational theory of painting. Although it rejects any simple view of good painting as accurate depiction, it does continue to suppose that what matters about painting is the way it makes available to us the truth about something other than itself. The representational theory of painting, or art generally, is standardly contrasted with two rival theories—expressivism and formalism.[95] I don't think any of these three theories in its classic form(s) is adequate by itself to explain the value of painting, but all of them do contain important insights, and I think these insights can be developed in ways that are compatible with one another and which indeed converge. I have focused mainly so far on the disclosive role of painting; in Chapter Six I will give accounts of the ways in which both the expressive and the formal properties of paintings contribute to their value. I will try to show that all three elements—disclosure, expression, and form—contribute to the value of any painting, though not always necessarily in equal amounts, and, indeed, that they are all involved in 'making present'.

[95] The strengths and weaknesses of these theories are discussed in most introductory works on aesthetics or philosophy of art; see, e.g., Sheppard 1987: chs. 2–4; Carroll 1999: chs. 1–3.

Chapter Six
Expression and Form

The Merleau-Pontian disclosive account of painting that I sketched in Chapter Five is a development from the traditional representational theory of painting; it at any rate takes the value of painting to lie in the way that it gives us access to other things or makes them present to us. In this chapter I will consider how to develop aspects of the other traditional theories of art—expressivism and formalism—so as to integrate them into my developing account. And I will try to show that what is right about each of the three theories not only is compatible with what is right about the others, but requires it. What is valuable about any painting involves disclosive, expressive, and formal properties, and we need to see how they all work together in order to really understand what it is for a painting to 'make present'.

I

A simple version of the expression theory would claim that what a painting primarily makes present to the viewer is the artist's personal feelings and emotions. Some paintings and some painters do seem to do this, Van Gogh being one obvious example. But many others do not seem particularly concerned with personal expression. That I am taking the icon as a paradigm might appear to be an anti-expressivist move, since the aim of the iconographer is precisely *not* self-expression, but a setting aside of self in order to let the divine speak through the iconographer's mastery of the traditional practice of icon-making. It is certainly true that strong personal expressiveness of the Van Gogh kind is neither necessary for nor universal in good painting.[1] However, there may still be something to be said for a more subtle kind of expressive theory, for it does seem plausible to say that—setting personal emotion aside—a good painter does always express something distinctive, a style, a sensibility. (Indeed, even iconographers have their distinctive styles, reflecting something of their individual sensibilities.[2]) Merleau-Ponty makes this point, reacting against Malraux's claim that modern art is all about the painter's own self: 'The painter does not put his immediate

[1] This is not to say that there is anything necessarily wrong with it; I certainly don't want to suggest that Van Gogh should be misprized because of the intensely personal way in which he makes irises or cornfields present, any more than icons should be misprized because of the (relative) anonymity with which they makes saints present.

[2] See Yazykova 2010, esp. ch. 6 and appendix A.

Painting and Presence: Why Paintings Matter. Anthony Rudd, Oxford University Press. © Anthony Rudd 2022.
DOI: 10.1093/oso/9780192856289.003.0007

self—the very nuance of feeling—into his painting. He puts his *style* there.'[3] And Merleau-Ponty insists that the painter has to discover what that style is through doing the work of painting. It is not something that exists fully formed in the painter's soul and open to introspection, prior to its expression. Moreover, once expressed in the paintings themselves, this 'style' or 'inner schema' 'ceases to be in possession of itself and becomes a universal means of understanding and of making something understood, of seeing and presenting something to see'.[4] I can learn from a painter a new and distinctive way of seeing the world.

Ideas along these lines were worked out in much more detail than Merleau-Ponty gave them and at about the same time by his older contemporary, Jacques Maritain. He too sees art as disclosive of the inner, 'invisible' depths or 'secret ciphers' of things: 'What is imitated—or made visibly known—is not natural appearances but secret or transapparent reality through natural appearances'.[5] But Maritain is much more interested in the psychology of artistic creation than Merleau-Ponty.[6] For him, the disclosure of truth that a work of art can afford is made possible by what he calls 'an intercommunication between the inner being of things and the inner being of the human Self which is a kind of Divination'.[7] This intuitive sense for the depth of things is what Maritain calls 'poetic knowledge', and to further explain it he appeals to Aquinas's category of 'knowledge by connaturality'. This is a kind of knowing by being, or by being so closely related to something as to be transformed by it.[8] In the case of 'poetic knowledge', the emotion that something—a bird, a hare, Mont Sainte-Victoire, the Boulevard Montparnasse—arouses in someone who is attuned to it:

> while remaining an emotion…is made…into an instrument of intelligence judging through connaturality…it becomes for the intellect a determining means or instrumental vehicle through which the things that have impressed this emotion on the soul, and the deeper invisible things that are contained in them, or connected with them, and which have ineffable correspondence or coaptation with the soul thus affected and which resound in it, are grasped and known obscurely.[9]

Something in the object sets up a resonance in the perceiver, a sense of connection between, as Maritain said, 'the inner being of things and the inner being of the human Self' which gives the perceiver an obscure sense (as it were, from the inside) of what the things truly are. (One thinks again of Merleau-Ponty's citation

[3] Merleau-Ponty 1996c: 89. [4] Merleau-Ponty 1996c: 90. [5] Maritain 1955: 164.
[6] I am referring here to *general* truths about the psychology of creation. Merleau-Ponty 1996a is concerned with how Cézanne and Leonardo both expressed and transcended their personal psychological peculiarities in their work.
[7] Maritain 1955: 3. [8] Maritain 1955: 85. [9] Maritain 1955: 88–9.

of Cézanne: 'The landscape thinks itself in me ... and I am its consciousness.'[10]).
This poetic knowledge is at once cognitive and creative. It is an insight into the
nature of things (and the nature of the self that experiences them) that can only
come to full expression in the creation of a work which concretely embodies that
insight. Indeed, such insights only really come into existence, as more than dim
intimations, through their embodiment in a work and only exist in that
embodiment. The artwork is not merely a stage on the way to a fuller, more
articulate consciousness that would explain the meaning of the work in discursive
prose. (Again, we need to insist that paintings are not paraphasable.)

What is important for current purposes is that, in creating such a work of art,
the artist inevitably expresses not only the 'hidden depths' of things, but also the
hidden depths of his or her own self. (It is important for Maritain that poetic
knowledge is born in and remains rooted in the unconscious.) The thing, with all
its 'secret ciphers' and inner depths is evoked not just 'objectively' but as it
resonates with the artist's own unique subjectivity. Cézanne shows us Mont
Sainte-Victoire, but he also, inseparably and in so doing, shows us something of
Cézanne—of his own distinct sensibility. He paints it as it shows up to *him*, using
techniques that he had developed in order to express his personal style (in
Merleau-Ponty's sense, that is, his distinctive artistic sensibility[11]). The same
mountain showed up very differently when Renoir painted it.[12] Maritain is clear
that an artist cannot express himself or herself without also expressing the world:
'While endeavouring to disclose and manifest the artist's Self, the poetic
perception which animates art catches and manifests at the same time what
matters most in Things, the transapparent reality and secret significance on which
they live.'[13] But equally, the artist cannot express the world without expressing it
as it affects his or her specific sensibility: 'The thing grasped is grasped only through
its affective resonance in and union with the subjectivity.'[14]

Maritain has relatively little to say about the experience of the viewer or
appreciator of the artwork: his focus is much more on the psychology of artistic
creation. But from what he does have to say on the subject, it is clear that he
thinks that the spectator, in contemplating an artwork, 'participates in' the poetic
knowledge enjoyed by the artist.[15] It seems that there is some 'poetry' in everyone's
soul, some instinct for the hidden depths of things, but most of us lack the creative
intuition to express this sense artistically. However, when we encounter the work
of someone who has this capacity, we feel a shock of recognition. Something that

[10] Merleau-Ponty 1996a: 67.
[11] This, to repeat, is not to be identified with his personal empirical psyche, with whatever 'personal
neuroses' might have been swimming around in that.
[12] This, of course, raises again the question of how these very different visions can all be truthful, a
question I will return to shortly.
[13] Maritain 1955: 29. [14] Maritain 1955: 93.
[15] Maritain 1955: 210. For a fuller account of Maritain on the 'contemplative' appreciation of art, see
Trapani 2011: chs. 9 and 10.

we had obscurely felt but never been able to express has found expression here: '[W]hen the work strikes the eyes of another, it causes a communication of intuition, a passage from creative intuition to receptive intuition.'[16] This is why artworks can fascinate so deeply. And it is why, as Merleau-Ponty said, an artist's 'style' can become a 'universal means of understanding.'[17] The point about universality is a complex one, however. The poetic knowledge expressed in a particular artwork or by a particular artist may resonate more with one person than with another. Poetic knowledge is participative knowledge that involves the subject with the object; it is a knowledge of the object *as it resonates with me*. This is not subjectivism in any standard sense. Good art really does express a knowledge of the object; but it is not a 'view from nowhere' kind of knowledge which leaves the particularities of one's subjectivity behind. Even an artwork infused with genuine poetic knowledge won't appeal equally to everyone. As John Trapani says:

> since the secrets of being that are captured by poetry [in Maritain's very broad sense] are limitless, each person in his or her own way will divine some secrets...in the work that others may not. Some of those who encounter this work will 'vibrate sympathetically', while others may not.[18]

But although not every viewer will experience a 'sympathetic vibration' with an artist's style, those who do are still responding to something that is not only personal to that artist but also universal. And although we may assume that an artist creating an anguished *Crucifixion* or a serene *Madonna* would have been emotionally engaged with the work he or she was doing, what matters to us is not really what was going on in the artist's soul, but the way in which a universal emotional quality is made present in the picture. This is another 'invisible' that a painting may make visible. And this is not restricted to specifics—for instance, how a painter has captured the expression of grief, surprise, etc. on someone's face—but also has to do with how a painting as a whole can convey emotions. The facial expressions, etc. of characters portrayed in a painting may be a part of this overall emotional tone, but such a tone will also be present in paintings in which no persons are represented or, indeed, in paintings that are not representational at all. Some have argued that this overall emotional expressiveness is the essential function of painting; for instance, Kandinsky thinks its ultimate aim is the expression—and thus the evocation for the viewer—of emotion through the composition of coloured shapes, as music expresses emotion through the composition of sounds.[19] I don't want to say that this emotional expressiveness is *the* essential function of painting, but I do think that it is an essential *part* or aspect of what

[16] Maritain 1955: 208–9. [17] Merleau-Ponty 1996c: 90. [18] Trapani 2011: 65.
[19] See Kandinsky 1977: 16–17, 20, 27–9.

painting does. What the successful painter, like the composer, expresses is not so much his or her own current feelings but universal emotions. But just as a mountain or a bowl of fruit can only be expressed artistically as it resonates with the artist's subjectivity, the same is true of those universal emotions. What matters is not personal emotional confession but an irreducibly individual way of making manifest what is universal.

II

Every (good) painter has an individual style or sensibility, but there are also collective styles. One might say that in icons we are typically aware of the artist more as a representative of the tradition than as an individual and that it is the sensibility of the tradition, rather than that of an individual, that primarily makes itself manifest in the icon. And, of course, there are a variety of distinct iconographic traditions or sub-traditions. The iconographer is trying to make manifest the grace of God, as itself manifested in the image of a saint; but a later historian can quite legitimately also see the resulting icon as expressive of characteristic features of, say, fourteenth-century Byzantine, or sixteenth-century Russian iconographic style. And any artist—even when he or she paints abstracts or icons or landscapes rather than scenes of everyday life—will unavoidably express the spirit of his or her culture, time, and place. So the zeitgeist of twentieth-century Europe is made present in Picasso's *oeuvre* as well as Picasso's own artistic sensibility—distinctive and intense though that certainly is. Here we can see how the 'ontologically disclosive' tradition of aesthetic thought can reach out to and perhaps incorporate what is best in the Hegelian/Marxist historicist tradition. What great art does, amongst other things, is to make us acquainted not with empirical information about past ages, but with the spirit, the feel, the essence, if you like, of those ages, and not simply through what it depicts, but in how it depicts it.

We can now, I think, helpfully return to a concern that I mentioned in Chapter Five in connection with Heidegger, but which is really raised by any disclosive account of art: if painting matters because it can disclose to us the reality of *something else*, make it present to us, isn't this still, in the end, an instrumental justification? And doesn't it, in the end, make the painting itself superfluous? Why should I bother with Cézanne, if I could just go and look at Mont Sainte-Victoire (or even a bowl of apples) for myself? It may be said in reply that it is because the artist sees the objects (and shows them to us) with a more than quotidian freshness, that the artist shows the essence and not the appearance, that the artist makes the object really present to us. Very well. So I would have to look at the mountain or the fruit with the same intensity and attentiveness that Cézanne did in order to make his paintings redundant as a mode of disclosure.

Admittedly, this is a significant proviso, but it *is* possible to attend deeply and carefully to natural beauty, as it is to paintings, and when one does so, the experience is profoundly moving—as much as any experience we may have of artworks. There seems no good reason to doubt that when we do experience the natural world (or even just an apple or a chair) with a deep and serious aesthetic contemplation, we *do* experience it with that freshness and essentiality of vision mentioned above; it's not only the great artists who have that, nor do the rest of us have to go to art (rather than nature) if we are to enjoy that experience.

One way to start answering this problem would be to turn to formalism and emphasize the specifically painterly qualities of the painting—the composition, the texture of the brushstrokes, and so on—which, obviously, only a painting can give us. These are certainly important, and I will turn to the discussion of formalism shortly. But even before doing that, we can give a partial response to the problem by combining two points already mentioned above: the inexhaustibility of the essences which painting discloses and the unique style or sensibility with which a good artist discloses them. So, what a great artist does is to give us a vision of things as filtered through that artist's unique sensibility. However deeply and freshly I may experience Mont Sainte-Victoire for myself, I need to go to Cézanne's paintings to see it as Cézanne saw it. The point is not so much to enter into or explore Cézanne's personality as such, but to experience the world (a mountain, a bowl of apples) as Cézanne was able to explore and express it. It's not primarily about the painter's subjectivity, but the way the painter (or the tradition or the culture) sees and expresses the world and how that vision of the world is made available to us. As Zola put it, a painting is 'a corner of nature seen through a temperament'.[20] And this is where the inexhaustibility point becomes important. There are always multiple ways the world (or even an apple) can show up: the truth of anything is inexhaustible. Each of us sees the world differently—in terms of some desire or projects rather than others, some things appearing as familiar, others as unfamiliar, and as familiar (or not) in different ways or for different reasons. The point is not solipsism—our worlds overlap in all sorts of ways and can be communicated to one another at least to some extent (though I think we do often underestimate how different our worlds are—usually because we assume that everyone else experiences things in the way that we do). But this is why, for example, Monet, Cézanne, and Van Gogh can all be truthful, all disclosive, even though what they disclose seems so different.

The point is not relativism any more than it is solipsism. That there are so many different but true 'worlds' is not because '*the*' world in itself is too amorphous or indeterminate for any representation to be more or less true to it than any other. And it certainly isn't because there *is* no 'real world' but only the different versions.

[20] Quoted Bell 2017: 62.

It is, rather, because the world is inexhaustibly rich and multifaceted. Maritain writes that each individual thing 'is, for us, an inexhaustible well of knowability. We shall never know everything there is to know about the tiniest blade of grass or the least ripple in a stream.'[21] Furthermore, anyone's experience of the world is a function of what the world is like *and* of that person's sensibility, cultural background, personal history, etc. The world always shows up as filtered through some personal as well as cultural/collective sensibility.[22] A painting's disclosure of the world is a function of the painter's experience of the world and his or her capacity—both technical and more than technical—to express that experience, that world so experienced, and render it visible. A truthful painting, then, is not one that simply records the objective fact of how something is, thus giving us indirect access (via a representation) to something (the fact) that we might prefer to just go and inspect directly for ourselves. Rather, the painting records the dialogue between painter and world. Thus, it makes available to the viewer the reality of the world, not as seen from the vantage of some impossible objectivity, but presented via a particular sensibility that allows us to experience it in a way we could not otherwise have done, however carefully and attentively we had looked for ourselves.

I have tried to reply to the 'redundancy' problem faced by a disclosive theory of art by drawing on aspects of the expressive theory. But we can note that there is an analogous problem faced by a pure expressive theory: if I value the painting only as an expression of its creator's personality, isn't that also an instrumental valuing? And wouldn't it thus make the painting redundant, at least in principle, if the painter was still living and I could get to know him or her personally? This problem is met by shifting from the idea that paintings express personalities to the idea that they express sensibilities or styles. But these are essentially styles of disclosure; ways in which the world may be disclosed. What is particularly and irreducibly valuable about a painting lies neither simply in representation nor simply in expression, but in its disclosing *this reality* in *this way*. The disclosive and the expressive have to go together in order to explicate the value of painting.

In Chapter Two I argued that one requirement for an adequate truth-based account of the value of painting was that it could explain how many very different artists, traditions, and styles can all be truthful, and I hope to have indicated how

[21] Maritain 1956: 74.

[22] In doing science, we set aside the personal resonances and significances that haunt and constitute our experience (and which do not cease to do so even when in the laboratory) and we are thus able to converge on certain structural and quantitative descriptions of the things we are examining. But—perfectly real though they are—the aspects of things thus revealed by science cannot be abstracted out to stand on their own as an adequate 'view from nowhere' picture of the world 'in itself.' (As Dummett (2006: 94–5) noted in the remark I quoted in Chapter One, section III, it makes no sense to think of reality as possessing *only* structural elements.) And even the apparently impersonal vision of the world that we get from science is itself still filtered through the sensibility of a particular historical-cultural tradition and through certain concerns—prediction, control, or even just pure curiosity.

the disclosive-expressive account given so far can do this. But that there can be many truthful ways of experiencing and expressing the world doesn't mean that *all* modes of experiencing and expressing it are equally true. To recall Murdoch's phrase, someone's vision of the world may be falsified by 'social convention' or personal 'neurosis'[23] (if we take these in the broadest sense). Consider an individual who sees his or her world through a filter of resentment or injured vanity, or a whole culture or subculture which sees the world exclusively in terms of possibilities for conquest or commercial exploitation. Each may indeed see some things very clearly and intensely, but their vision as a whole is a distorting and corrupting one. The point isn't just that the vision is partial—all visions are partial—but that what the partiality blocks out is things that matter, that are of real value, and that what is left is not merely incomplete but deformed. And if it is an artist who has such a corrupted experience of the world, then it may lead him or her to produce corrupt art. So while there are a vast number of ways in which paintings may be truthful, not all painterly visions are truthful. Sentimental art is an obvious example—even if the painter is genuinely and sincerely expressing his or her sentimental vision of the world. (Some sentimental paintings are, of course, produced in a cynical spirit, purely for the market.) Other kinds of bad painting may go to the opposite extreme by expressing a cheap cynicism or smug nihilism. (And there is a market for that sort of thing too, so a hack may produce nastily cynical work in a spirit of cynicism about his or her cynical work.)

It might be objected that this account risks becoming excessively moralistic. Is it always true that a corrupt person must produce corrupt art? It might seem that someone might be a deeply unpleasant person, but still a great artist. I should say that I am assuming here something like the connection Murdoch makes between moral goodness and the capacity for honest and truthful perception. But, given this assumption, and since greatness in an artist isn't just a matter of technical skill—which people may indeed have or lack quite independently of anything about their moral characters—the question is whether someone can have a truthful and non-corrupt vision in his or her artistic work but fail to attain it in the rest of his or her life. This may be harder to do than the influence of certain sub-Romantic stereotypes might lead us to think; it would certainly be hard for someone to prevent a basic dishonesty in his or her life coming *in time* to corrupt the truthfulness of his or her artistic vison. People are complicated, though, and one could only really address the question properly through detailed biographical case studies. (Clearly the reverse is true: an ethically admirable character may still be a rotten painter. And this needn't simply be due to technical incompetence: a technically competent painter who is an ethically insightful person in the

[23] Murdoch 1997f, 216.

Murdochian sense—not just a moral rule-keeper—may still be unable to express his or her truthful vision adequately in painterly form.)

One might be troubled by the question of whether an artist's neurotic or violent or sexually predatory tendencies might, in fact, positively contribute to his or her production of intense, if disturbing artworks, ones which are truthful in that they do give powerful expression to what is, after all, aspects of reality. (One might think of some works by Caravaggio, some by Picasso.) I'm inclined to agree that a great painting may, for instance, not only depict but evoke horrible violence, and that its doing so may derive, psychologically, from some violent inclination in the artist's personality. But if it is to be a really great painting, it must integrate that intense sense of the reality of violence into a broader context that recognizes and expresses primarily the horror of it. An artist whose own violent tendencies enable him or her to present scenes of violence with great intensity, but without that broader ethical context, would be a purveyor of sadistic pornography— maybe a frighteningly talented one—not a great artist. This is, of course to use an explicitly ethical criterion for artistic greatness. But if one takes truthfulness— and essential truthfulness, not mere accuracy in copying—as a criterion of artistic greatness, and if one connects ethics with truthfulness in that sense, then one can hardly help doing this.

In making this connection between art and ethics, I am not, however, retracting the scepticism about didactic art which I expressed in Chapter One.[24] The point is not that paintings should provide us with explicit moral or political lessons but that they should express a truthful vision of the world. The connection with ethics comes from the Murdochian association of truthfulness and goodness. If one were working with a more narrowly 'act-centred' conception of morality— whether deontological or consequentialist—then it would be hard to see much connection between morality taken in this sense and painting.[25] Most painting are not about specific moral problems or actions, and painting as such is not well suited to assessing the rightness or wrongness of particular acts. Of course, there are paintings which are about specific historical events and which express moral/ political judgements about those events. Many of these tend to the kitsch (official socialist realism in the Soviet Union being an obvious example[26]), but some are certainly masterpieces (e.g. Picasso's *Guernica*, Goya's *Third of May, 1808*, and David's *Death of Marat*). Even in these cases, though, what is powerful about these paintings is not so much their comments on particular events but something

[24] For a helpful discussion of art and ethics generally, see Gaut 2007. Gaut's 'ethicist' position has affinities with the view I am taking here, though his way of approaching the issues is somewhat different from mine.
[25] There would, of course, be more connections between morality so conceived and literature or film—a reminder that generalizations about 'art and ethics' are risky and that one would do well to look instead at the relation of ethics to specific forms of art.
[26] Not that all socialist realist paintings are bad, but to the extent that they have artistic merit, it is usually despite rather than because of the official programme they are following.

more general. *Guernica* was painted as a protest against the Nazi bombing of a Basque town during the Spanish Civil War. But the only thing about the painting that refers specifically to this event is the title. Would it be less powerful if it was retitled *Dresden* or *Hiroshima* or even *The Sack of Troy*?[27] Indeed, it's not even obvious on the face of it that it depicts a man-made rather than a natural disaster, and several of its elements—for example, the bull and the dying horse—were images that had haunted Picasso for years and had appeared in earlier works. Goya's *Third of May, 1808* depicts French soldiers executing Spanish rebels against the Napoleonic occupation of Spain, but with a change of title and perhaps some alteration to the soldiers' uniforms, it could depict Spanish troops executing Napoleonic collaborators (perhaps even justifiably, if capital punishment is ever justified). Such paintings are powerfully truthful, not because they make the correct judgements about the rights and wrongs of those Spanish wars, but because they depict human suffering, vulnerability, and cruelty—universals in human history, whatever one thinks about particular historical events. This is perhaps made even clearer by *The Death of Marat*, a consciously propagandist piece intended to glorify its subject as a noble patriot dying for his service to the public good. In fact, Marat was a cruel and fanatical perpetrator of political terror, and it's hard not to feel a good deal of sympathy for his assassin, Charlotte Corday. So isn't the painting a falsehood (even if a technically brilliant one) and therefore, by my standards, a bad painting? I think not. Though intended to glorify Marat, what the painting really shows—with poignant honesty—is human vulnerability: a man stabbed to death while naked in a bath. However horrible Marat in fact was, and even if we think he deserved his fate, we see him here in the simple humanity which even the worst of us share and which David's genius is able to make intensely present to us.[28]

III

So a (good) painting makes present to us its subject matter as presented, expressed, filtered, through the painter's sensibility and that of his or her culture. The painter is never merely a neutral conduit through which the essence of the subject matter reveals itself. Nor is the subject matter (whether or not representational) ever just a pretext for the painter's self-expression (not even when the painting is a self-portrait). On this account, it seems that sufficiently

[27] It's true that there are complex debates about the extent to which a title, the circumstances of painting or of first exhibition, etc. enter into the meaning of an artwork—see my comments on 'aesthetic empiricism' in Chapter One.

[28] David did create other works which *are*, I think, basically dishonest, such as his *Napoleon Crossing the Alps* (although, if we don't take it with the seriousness that David seems to have intended, we can still enjoy it for its sheer visual flamboyance).

sophisticated and developed versions of the representational and the expressive theories coincide. You can never represent anything without representing it as it appears to *you*; nor can you express yourself without expressing how *the world* appears to you. (This is a general epistemological truth, but it applies all the more to painting.) What, though, of the third of the classic aesthetic theories that I have mentioned—formalism? The basic idea here is that what matters about a painting is not its representational or expressive properties, if it has those, but simply its own visual appeal as an array of coloured shapes and lines. It will be obvious that I want to resist such an exclusivist thesis, but there is a truth in formalism which needs to be integrated with the truths in representationalism and expressivism. I can't represent the world without expressing myself, and I can't express myself without representing the world, but I can't do either/both in painting without arranging colours and lines on a surface. And—the challenge of non-representational art to what I have said so far—it might seem that I can arrange the colours and lines without representing anything—and perhaps without expressing anything either.

Closely connected to the issue of formalism is the idea that a painting *itself* can be present to us in the particularly charged sense with which I am concerned. This was, after all, what I started from when I introduced the notion of presence in Chapter Three: Elkins' account of 'Rob' feeling an overwhelming sense of the sheer presence of a Rothko painting in the Museum of Modern Art in New York.[29] We have so far considered two main kinds of answer to the question of what is it that paintings make present to us—the essences of the objects they depict and the sensibilities of their creators—but we also need to take seriously the idea that they simply make *themselves* present. And it is tempting to explain what this might mean precisely by appealing to formalism, broadly conceived. The painting—considered simply as a visible, physical object, an array of coloured shapes—makes itself present by offering me an intense experience of its own aesthetic properties. Étienne Gilson claims that 'Each painting … is a completely self-sufficient system of internal relations regulated by its own laws.'[30] And it might indeed be thought that in appreciating it for itself, as making itself present, I am concerned with it simply as a self-contained system and not concerned with whatever else it might make present by representing, evoking, or expressing— whether that be a mountain in Provence or Paul Cézanne's sensibility.

I shan't rehearse the standard objections to formalist theories of painting in any detail here. Obviously many paintings do depict things and many paintings express emotions, and to claim that these features of them are simply irrelevant to their aesthetic merits is highly implausible. The claim that these features *can* be set aside—that we can simply abstract from them when appreciating a painting

[29] Elkins 2001: 54–5. [30] Gilson 1957: 135.

aesthetically—seems psychologically unrealistic, and the claim that we *should* do so seems to demand an absurd narrowing of what, in fact, goes on when we seriously appreciate paintings. It does not, however, follow from this that what formalism values *isn't* important. When we are struck by the presence of a painting in the way that I tried to describe in Chapter Three, what draws us to it is, obviously, the way it looks. We may, of course, be interested or excited by what it represents, but if our interest is aesthetic rather than *just* historical or sociological or biographical, then our concern is not simply with this subject matter but with this subject matter *presented in this way*. And this means that we are drawn by the formal, structural elements—how a work is composed, how the figures are arranged in relation to one another, the juxtaposition and contrasts of colours, and so forth. We may be powerfully impressed by the emotions that the painting expresses, but its expressiveness is conveyed through its formal arrangement.

It might be said that the formal features of a painting are an indispensable means to the end of either depiction or expression (or both) but are not themselves what we appreciate when we appreciate a painting. But this seems just as artificial as the strict formalist claim that we can ignore the fact that this painting is, for example, of the Crucifixion and concentrate aesthetically just on its formal aspects. The formal elements cannot be factored out from its expressive or disclosive ones. The precise geometrical arrangement of the figures in Piero della Francesca's *Baptism of Christ* is crucial to the feeling of solemn peacefulness that the picture expresses. The dominant central placement of the great cliff face in Fan Kuan's *Travellers among Mountains and Streams* is essential to the painting's evocation of the mountain scenery. That the formal elements in a painting are not merely a means to an end (as if they were one way of communicating a content that could be communicated unchanged in some other way) is, indeed, implied in the non-paraphrasability thesis on which I have been insisting. If a painting discloses something about the essence of its subject matter or expresses its creator's sensibility, it does so *qua painting*, that is, through the arrangement of colours and lines, and not in any other way. If I am struck by Gallen-Kallela's depiction of Mt Kenya, this isn't simply a matter of being struck by Mt Kenya (I certainly might be if I were there, but that is a different matter), nor is it a matter of being struck by Gallen-Kallela's personal psychology or the sensibility of early Northern European modernism. I am primarily struck by the *depiction*, that is, by the picture itself. The picture is what I value (though, of course, I may value the subject or the artist too). This does not mean that I value it only for its formal elements but that its disclosive and expressive powers are inseparably bound up with its formal aspects and vice versa.

Perhaps, though, this is true for some paintings but not for others. It might be agreed that expression and disclosure are essentially accomplished in and through the creation and deployment of formal properties and that an essential part of

what we appreciate in the formal properties of representational paintings is the power that they have to represent, evoke, and express. But it seems that with abstract, non-representational painting, this is not true. If a painting only has formal properties, then it is only for those properties that we can value it. This poses a challenge to the universality of the disclosive (or disclosive-expressive) account of painting I have been giving so far. Perhaps that does work well enough for representational art: it might be conceded that my account can, as suggested above, give a proper place to the formal properties of such art, and it might also be agreed that attempting a purely formalist analysis of representational paintings would indeed be quixotic. But can a disclosive/expressive account deal adequately with abstract art? Doesn't that require something like a purely formalist theory? And if that is correct, then the hope of giving a general theory of painting would have to be abandoned. It would have to be accepted, instead, that what matters about representational art is something that is just very different from what matters about abstract art.

The first step in responding to this challenge is to point out that non-representational art can at any rate still be expressive. I have already referred to Kandinsky's theory—taken up by Michel Henry—that the whole point of abstract art is to express emotion through the deployment of a visual language of pure line, shape, and colour. If the term was not now so specifically associated with New York in the 1950s, we might well call this approach in general 'abstract expressionism'. And the basic idea does fit with abstract expressionism in the narrow sense: there is no real doubting the emotionally expressive qualities of, say, Rothko's or Pollock's works. For instance, to sit for any time with any attentiveness in the room in the Tate Modern in London devoted to Rothko's Seagram murals is to experience a deep, brooding, emotively powerful presence. And there is no question either that the major abstract expressionists understood themselves to be expressing emotion through painting. (I quoted Rothko in Chapter Three as saying 'I'm interested only in expressing basic human emotions: tragedy, ecstasy, doom, and so on.'[31] An artists' self-understanding should not be taken as a definitive guide to the interpretation of his or her works, but it should not be ignored or dismissed either.) That abstract art can express emotions (not necessarily the painter's personal subjective states, but universal emotions, as discussed above) I take to be obvious.

However, it might still be claimed that while *some* abstract art is, indeed, emotionally expressive, that isn't a necessary feature of it, that there can be pure, non-expressive, abstract art as well. So although there is a tradition of 'warm' emotionally expressive abstraction deriving from Kandinsky, what about the alternative tradition of 'cool' abstraction deriving from Mondrian? Maybe

[31] Quoted in Polcari 1991: 144.

Kandinsky's compositions in all their complexity are designed to play on the keyboard of our emotions,[32] but what about Mondrian's geometrical grids with their occasional chaste rectangles of pure colour? In response, I am inclined to say, simply, 'Yes, them too!' Emotional expression doesn't have to be, as it were, loud and unnerving: what draws us to a Mondrian, in its simplicity and apparent triviality, is precisely its quiet but powerful expression of calm, of serenity. Obviously, the only way one can really resolve this argument is to look at paintings and see whether one is moved by them or not. However, if you did show me an abstract painting which I agreed had no expressive qualities at all and didn't move me in any way, I would then be inclined to think that you had just shown me a painting that wasn't interesting or good. Is this cheating? Am I making my thesis analytic and thus invulnerable to refutation? And doesn't that make it trivial? I think there is, indeed, a conceptual connection here, but I don't think it is a trivial one. For a painting to be visually fascinating, worth looking at, *is* for it to engage us emotionally in some sense, to express an emotional tone to which we respond. This may be obvious (Munch's *Scream* expressing anxiety) or something much subtler—one may only be able to indicate the emotion a painting expresses by pointing to the painting. Perhaps I may find an abstract work is not moving or emotionally engaging in any way, while still admiring some technique that its painter has used or being impressed by some clever trick of composition. But such a case would be similar to one in which I was impressed by the technical skill that an academic representational painter had used, while still finding the work empty and artistically lifeless.

A (good) abstract painting, like a representational one, may or may not express its creator's immediate personal feelings, but it will always express his or her sensibility or 'style', in Merleau-Ponty's sense. (Neither a Mondrian nor a Kandinsky is simply a formal arrangement of coloured shapes; each is clearly expressive of a distinct and distinctive artistic sensibility.) Moreover, it will always manifest an emotional tone which—as discussed above—is universal (grief, joy, serenity, anger), though also filtered through the artist's personal sensibility. And I think it is also clear that abstract art is expressive in another of the senses that I have discussed above, that is, it can—and, indeed, it inevitably does—express something of the spirit of its culture or of its time. For instance, the drive towards abstraction in early twentieth-century painting in Europe was part of a general movement towards a greater simplicity and austerity that arose in reaction to what was perceived as late Victorian clutter and fustiness—a movement of sensibility that can also be seen in contemporary poetry, architecture, music, and design (and philosophy—Russell, as against Bradley, for instance)—and even in changing fashions in clothing and hairstyles.

[32] DeLay (2017: 160–1) gives some eloquent descriptions of the emotional impact of a number of works by Kandinsky.

IV

Still, even if it is conceded that abstract art can be (and even must be) expressive in these ways, can we think of it as disclosive? If what representational art is doing is making visible to us the deep essences of things, how can this disclosive account apply to abstract art? Well, obviously it won't do so in quite the same way. And I should emphasize that although I am trying to give a general account of the value of painting, the account is also intended to be highly pluralistic. There are lots of kinds of good painting, and they differ in all sorts of ways. So although I am trying to describe what is valuable about painting as such, my account is, necessarily and deliberately, a very general one. And there are certainly lots of more specific things that could be said about what makes for a good *abstract* (or a good *portrait* or a good *icon*, etc.) Indeed, what makes any painting a good painting has to be, up to a point, unique to that painting. One can make legitimate generalizations about what makes for merit in paintings—or, say, in portraits or landscapes, etc.—but there is no formula for it.

So the point is not to squeeze abstract art into an account designed to fit other kinds of art. However, I think there is a disclosive element in good abstract art which is at least analogous to, if not identical with, the disclosive aspect of good representational art. Maritain has been one of the inspirations for the disclosive-expressive view of painting I have developed so far, and I think it is interesting to look at his actually somewhat conflicted view of abstract painting. He sees it as attempting to express a pure beauty by cutting itself off from nature. But—although he expresses his admiration for Mondrian and Kandinsky—he thinks it aims for *too much* purity. He compares it in this to idealist philosophy,[33] complaining that abstract painting 'turns away from Things … and renounces seeing into the inner depths of nature'.[34] (Interestingly, though, he makes a distinction between the 'idealism' of modern Western abstract art and what he calls 'the objective abstract art of Islam'.[35]) In its drive for purity this idealist abstraction ends up—unwittingly—rejecting the poetic intuition that is essential to true art and ends in a formulaic academicism.[36] It should be recognized that there is something to this criticism. Early and mid-twentieth-century abstractionism seemed radical and cutting-edge; today, the walls of corporate offices and chain hotels are covered with tastefully bland abstracts. Abstract painting does risk degenerating into mere decoration. However, Maritain continues, 'I should hate to be too systematic' and admits that there is a real 'poetry' in some abstract art.[37] And he argues:

[33] Maritain 1955: 161. [34] Maritain 1955: 159.
[35] Maritain 1955: 158. [36] See Maritain 1955: 160; 161–2. [37] Maritain 1955: 160–1.

When a painter happens—contrary to the theory—to be actually intent on the existential world of Nature and put in motion by poetic intuition, but uses abstract or nonrepresentational forms as means of expression, these forms are not in reality purely abstract or nonrepresentational. They make present on the canvas, they *represent*—be it in the most bare and dematerialized manner— some vital element, a rhythm, a contrast, a contour which has been seen in nature and which is just enough to suggest some natural appearance with the significance it is laden with, even if this meaningful appearance moves you without your being able to recognize or identify the Thing to which it belongs.[38]

One might put the point another way by reminding ourselves that an abstraction is arrived at precisely by abstracting *from* something concrete. Maritain insisted as much as Merleau-Ponty that the artist was not concerned with copying the appearances of things but with evoking their essences. Perhaps in order to do that, the artist ends up abstracting so far from the appearance that what he or she paints is no longer recognizable as the thing that initially inspired him or her. And yet it may still be a response—by an act of creative intuition—to the world as the artist experienced it, as it resonated with him or her. (Remember Klee's image, referred to in Chapter Five, section III: the branches of a tree needn't resemble its roots but are still their product and remain in vital contact with them.) One can, indeed, trace this process in the careers of both Mondrian and Kandinsky, both of whom started as representational painters; one can see how over the years they moved to greater and greater degrees of stylization and abstraction until explicit objective reference vanished from their work altogether. And yet it continues to linger there implicitly, and the act of tracing their development can help the viewer to be aware of that.

One might still argue that although this may be true of 'abstract' art, it isn't necessarily true of all 'non-representational' or 'non-objective' art. This distinction is made by the painter Pat Steir, who says, 'I consider my work non-objective and I think abstract is an abstraction of something, like a landscape. Abstraction means something is abstracted. It relates to something. Non-objective relates to nothing. It has no object.'[39] As an artist, Steir is understandably concerned not to be constrained by requirements of even quasi-representational fidelity to appearances, and yet a painting that would really relate to nothing at all visually— which was spun purely *ex nihilo* out of the artist's imagination—seems hard to conceive. And the fact that Steir's own best-known works—which involve long, thin, vertical lines of paint dripped down very large canvases—are called the 'Waterfall' series suggests that she is not as puritanical in practice as that remark might seem to imply.

[38] Maritain 1955: 162–3. [39] Simmonds 2016.

Much of the inspiration for abstract (non-representational) art comes, of course, not from a concrete thing or things (substances) but from the basic *elements* of perceived reality, of our visual world—that is, its colours, shapes, lines. The artist is inspired by them to create his or her own arrangement of them on a canvas (or whatever) in a way that is personally expressive (see above) but which also evokes and celebrates the essence of colour, shape, line. Iris Murdoch, mulling over the idea that 'art is the imitation of nature', considers the challenge posed by abstractionism: 'One might say, is abstract painting about nature? I am inclined to say, "Yes it is", but what does that mean?'[40] A crucial part of what it means for her is (as we have seen in Chapter Two) that art is *truthful*: it illuminates what is other than it. And she insists that this does apply to abstract painting:

Good abstract paintings are not just idle daubs and scrawls, forms wandering round at random in spaces, they are somehow about light and colour and space, and I think this is something the abstract painter is very conscious of, he is not in a state of total freedom, he is relating himself to something else.[41]

By abstracting the pure geometrical possibilities of shape, the pure possibilities of tone, intensity, and contrast of colour from the world of concrete individuals, the abstract artist can make them present to us with a particular richness and power. For Murdoch and for Maritain, abstract art can be truthful, disclosive, because although it abstracts, the basic elements in the visual world from which it abstracts are still there, celebrated and evoked in their essential nature, in the work. Nature may not be represented, but it is still present. There is a valuable testimony to this from Barbara Hepworth, discussing the underlying inspiration for her own abstract art (in sculpture, mainly, rather than painting, but the point still applies):

All my early memories are of forms and shapes and textures. Moving through and over the West Riding [of Yorkshire] landscape with my father in his car, the hills were sculptures, the roads defined the form. Above all, there was the sensation of moving physically over the contours of fullness and concavities, through hollows and over peaks—feeling, touching, seeing, through mind and hand and eye. The sensation has never left me. I the sculptor, *am* the landscape.[42]

[40] Murdoch 1997a: 244.

[41] Murdoch 1997a: 256. I don't think Steir would actually disagree with that. But when she says that 'Mondrian was basically a spiritual painter, not an abstract painter' (Simmonds 2016), I think she sets up a false antithesis.

[42] From Hepworth 1970; quoted in Bowness 1977. Note the similarity between Hepworth's concluding remark and Cézanne's 'The landscape thinks itself in me ... and I am its consciousness', quoted in section I above.

Hepworth's abstract sculptures embody a lifelong meditation on fullness and con-cavity, hollows and contours, that was *inspired* by landscapes and (another important source for her) the human body, while *representing* neither. Elsewhere she notes: 'In the contemplation of nature we are perpetually renewed, our sense of mystery and our imagination is kept alive and, rightly understood, it gives us the power to project into a plastic medium some universal or abstract vision of beauty.'[43] Nature is not imitated as such, but it is the contemplation of nature that gives the sculptor (or painter) the vision of forms that he or she is then able to make abstract and embody in his or her work. But now the difference between such a work and a 'representational' painting (or sculpture) which eschews a mere copying of appearances and concerns itself with an evocation of essence would seem to be one of degree, not of kind. The point is nicely made in a discussion of abstract expressionism by Christopher Dustin and Joanna Ziegler:

> [T]he power of abstraction in art…is not simply a matter of 'getting rid' of content and leaving only pure form. The 'taking away' is, in effect, a concealing—allowing something to remain hidden in order to reveal the inner being (the substance or soul) of what we ordinarily see only the outside of.[44]

That painting—even abstract painting—aims at truth does not mean that the painter is a merely passive recorder or transmitter of that truth. (Truth is never arrived at purely passively: it is an achievement of the actively searching mind.) The painter, whether representational or not, is, of course, creative and any (good) painting is the result of a delicate balance between the artist's freedom and the demands of his or her subject matter. One might think that the abstract painter has a greater degree of freedom, even though he or she does not simply cut lose from the responsibility to a subject matter. (Perhaps this is why so many abstract artists chose to subject themselves to a certain rigid formula—Mondrian's grids, Barnett Newman's zips—precisely to impose a needed constraint.) Cut loose from even a broad or loose requirement of representation, the abstract artist is free to explore the pure aesthetic possibilities of colour, form, and space and to create new kinds of beauty from them. One important element in (some) abstract art is the possibilities it opens up for the pure exploration of space. This is, indeed, something that all painting does: it opens up a space for the viewer to enter into imaginatively. One can let one's eyes wander through a Vermeer interior or a Constable landscape; one can enter into spaces that are not one's own. Each painting in a sense makes a world available to us, a space we can lose ourselves in, imaginatively move around in and explore. In some abstract work this possibility can be particularly heightened, though not in all. The immense presence of

[43] From Bowness 1977; originally in Read 1934. [44] Dustin and Ziegler 2007: 229.

Rothko's colour fields invites static contemplation or absorption rather than active exploration, while Mondrian's grids channel one in rather strictly limited directionslike a (very) formal garden. But consider Gerhard Richter's series *Cage (1)—(6)* (2006) (named after the composer, John Cage[45]). These six large paintings have a room to themselves in the Tate Modern in London (just around the corner from the Rothko Seagram murals in their own room). The Tate's website has the following helpful description:

> The paintings all have a similar thickly painted surface that is rough and textured in appearance. They are composed of a progression of horizontal and vertical bands and a series of multi-directional scratches and indentations that are scraped into the painted surface. In specific areas of the paintings, the upper layers of paint have been removed and several sublayers of colour exposed. In each painting, the layers of colours and the composition of the bands and marks are different.[46]

The effect, in each painting (and each painting, despite the obvious similarities that make them a series, has a different mood or tone or feel to it). is to create a world of texture, light, and shape that invites the eye to both linger and explore. Commenting on these paintings, the contemporary artist Luke Elwes claims that 'There is little to hold onto visually, little to suggest a way in or through the pallid top coat. The surface, now verging on emptiness, becomes the work.'[47] I find this a strange remark. It is true that the very lack of determinate reference or an easily graspable structure in the Richter series, combined with the complexity of shape and texture, means that one is not overwhelmed by a sense of either the presence or absence of content (whether figurative or not). But what I find myself experiencing is not emptiness but a positive sense of space, not simply as a geometrical abstraction, but a space that has a rich and complex content of its own.[48]

As one's eye moves around in each painting, one's mind spontaneously searches for recognizable images or even evocations, almost finds them, and then loses its grip on them. Another remark I found more or less accidently online (and cannot now trace) comments that looking at the Richter *Cage* paintings was 'like looking into a beautiful lake'. I'm sure that this would not be regarded generally as a sophisticated piece of art criticism, but I was pleased to see it, for on my several visits to the *Cage* paintings I have always been struck by their watery quality. The combinations of horizontals and verticals, together with the shimmering

[45] Cage was also—interestingly—a significant influence on Steir.

[46] See http://www.tate.org.uk/art/artworks/richter-cage-1-6-l02818, accessed 5 February 2022.

[47] See http://lukeelwes.squarespace.com/journal/2011/11/16/gerhard-richters-cage-painting.html, accessed 5 February 2022.

[48] Elwes's remark is the odder since his own paintings—surely influenced by Richter—have something of that same quality of creating a space of possibility and suggestion.

translucency of the paintings, does suggest (though more in some of the paintings than in others) water—perhaps the surface of a lake—with reflections. The roughness of the surface actually adds to this sense; looking at the paintings has something of the same hypnotic quality as watching the movements of waves and ripples on the surface of a body of water.[49] And yet they are not even stylized representations of water, and just when one is being drawn into a sense of their being evocations of a lake surface, one is snapped out of it again by their reminding one that they are abstracts—simply arrangements of texture, colour, and line. They create their own autonomous space in which one can explore what one might call the possibilities of a world or worlds; from that space possible worlds may start to emerge, and seem to crystallize, but without ever simply coalescing or becoming fully real. One might say, a little paradoxically, that what is made present here is possibility.

I do think, then, that a disclosive, as well as an expressive function, can be found in non-representational art. And I should add that what it discloses may not only be the essence of colours or line—or the possibilities of experiencing visual space that these elements offer—but something more metaphysically fundamental. This, indeed, is a point that I have already alluded to above, but it is worth returning to it here. I have referred in passing above to Clive Bell's 'Metaphysical Hypothesis' according to which the formal properties of paintings matter to us because they make us aware of 'the God in everything, of the universal in the particular, of the all-pervading rhythm ... that which lies behind the appearance of all things, that which gives to all things their individual significance, the thing in itself, the ultimate reality.'[50] Bell was writing before Mondrian and Kandinsky had moved to pure abstraction, but both of them had precisely this 'metaphysical' understanding of the significance of their own work. Both saw themselves as attempting to dig below the surface appearances of things in order to reveal either (in Mondrian's case) the pure forms and structural harmony of reality or (in Kandinsky's) the primal energies of being. As Mondrian put it:

> The new plastic idea cannot, therefore, take the form of concrete representation, although the latter does always indicate the universal to a degree, or at least conceal it within. This new plastic idea will ignore the particulars of appearance...[It] thus correctly represents actual aesthetic relationships...The picture can be a pure reflection of life, in its deepest essence.[51]

[49] I have no idea whether the watery suggestion that they make was consciously intended or even recognized by Richter.

[50] Bell 1914: 69–70.

[51] Mondrian: 1917, as quoted in Friedenthal 1963: 236. For Kandinsky's reflections on the metaphysical significance of art, see Kandinsky 1977: pt 1.

This is, of course, as Michel Henry picks up in the case of Kandinsky, another sense in which painting may be thought to make the invisible visible—in this case, we might say, it makes the noumenal appear phenomenally. (This is even more explicitly the case with Hilma af Klint, who turned to pure abstraction before either Kandinsky or Mondrian but never exhibited her abstract work in her lifetime. It was, she believed, literally inspired by the spirits who contacted her during theosophical seances, in order to express complex symbolic meanings.[52]) This metaphysical understanding of non-representational art is also suggested in a remark by Klee: 'And now I no longer saw any abstract art. Only abstraction from the transitory remained. My object was the world, even though not the visible world.'[53] I will return to the question of painting and the metaphysical, but clearly this self-understanding of abstract artists fits well with Merleau-Ponty's insistence that painting, by disclosing the underlying 'Logos of lines, of lighting, of colour, of reliefs, of masses' provides us with 'a nonconceptual presentation of universal Being.'[54]

I am, therefore, inclined to hold that all three of the elements I have been discussing—disclosive, expressive, and formal—are present in all paintings and that they are all involved in the making present that paintings do. It is achieved by the formal arrangement of colours, lines, and shapes in such a way that they fascinate us, strike us, and draw us in. Whatever of the world is disclosed, whatever of the artist is expressed, is done so in and through the creation of a visual object which fascinates visually. The aesthetic form is not a dispensable means to the content that is communicated; it is essential to the content that it is communicated visually in this way. In all painting there is, therefore, a threefold structure: the painting makes itself present, and by so doing it makes present something both of the essence of its subject matter and of its creator's sensibility. Which of these three elements predominates or the nature of the balance between them may differ. But all three are always present in some degree.

V

It might be useful at the end of this chapter and this part of the book to pause and summarize the position we seem to have reached. Paintings are of value because they *make present* in a threefold way: through their own presence as paintings with certain formal and aesthetic properties, they make present to us the essences of their subject matters, in a way that expresses and makes present to us the sensibilities of their creators. And these three aspects of making present always go

[52] Both Mondrian and Kandinsky were significantly influenced by theosophy themselves. See Lipsey 2004: chs. 3, 4, and 6.
[53] Quoted in Sallis 2015: 28. [54] Merleau-Ponty 1996b: 142.

together. To 'make present' in this sense is not simply to offer information about in a neutral and detached way. The knowledge that it gives us is knowledge by acquaintance. This has two main aspects. Firstly it has a sort of directness: we are being brought into relation with something, not just learning about it. This does not mean that the relation is necessarily immediate in the literal sense of non-mediated; the whole point, after all, is that the painting itself mediates the mountain or animal or whatever is depicted to us. Nonetheless, what it does is to take us to 'the things themselves', just as the icon brings its devout viewer into the presence of the saint. Secondly, the relation is one that alters us: this sort of knowledge by acquaintance is a participative knowledge. By being brought into relation to the object, we as subjects are changed. This means that we need to be receptive; for the icon to work as an icon, it must be approached in a devout frame of mind. This is not the kind of knowledge that can be taken in by anyone who just points his or her open eyes in a certain direction.

Although I have not used the word 'beauty' much in the last few chapters, they can be said to have developed a theory of beauty in that they have been concerned to explain what makes paintings aesthetically, intrinsically valuable. If we think of 'beauty' as the most general term of aesthetic approbation, I have, then, given an account of what the beauty of paintings consists in. I am, of course, talking about paintings being beautiful in the 'broad sense' which includes their being not just pretty, elegant, etc. but visually compelling, fascinating, and also embodying significance or meaning (the 'deep' sense of beauty). So, let me spell out my theory of beauty in painting explicitly: for a painting to be (broad-/deep-sense) beautiful is for it to make present in the threefold way I have described. Or, to reverse the equation, what it is for a *painting* (as distinct, let's say, from a heartfelt speech or a piece of music) to make present is for it to do so by presenting a visually compelling appearance, that is, to be (visually) beautiful. The appearance is beautiful in what I have called the 'deep' sense (meaningful, not *just* visually pleasing, striking, etc.) because it makes present, conveys truth, and what is visually compelling about it is the irreducibly visual way it makes present.

PART THREE

Chapter Seven
Metaphysical Implications
Essences, Concepts, Value

In the Introduction I noted Merleau-Ponty's dictum that 'Every theory of painting is a metaphysics,'[1] and the account of painting that I have given clearly involves some far-ranging philosophical claims. In Part III I will be looking more explicitly and in more detail at the metaphysical presuppositions and implications of my theory. I will start in this chapter by clarifying and defending the essentialism that my account of painting involves and discussing whether or to what extent my account is committed to a notion of 'non-conceptual' knowledge. I will then begin to discuss what will be the main topic for the rest of Part III—realism about value. This will lead me, for reasons which I hope will become clear, to discuss our aesthetic experience of the natural word (in Chapters Eight and Nine); and in Chapters Nine and Ten I will return to the question of religion and aesthetics, and to the still unresolved question of whether we have reason to go beyond what I called the 'weak' interpretation of Gadamer's thesis that religious painting is 'exemplary' for all painting to a stronger interpretation according to which all painting has (in some sense) a religious significance.

I

I have spoken of paintings as disclosing the essences of their subjects (and perhaps the essence of their artists' sensibilities and/or the zeitgeist of their culture). But what, really, do I mean by 'essence' here? Is the notion philosophically defensible? And how does the painter's supposed quest for essences relate to the scientist's concern to discover the essential natures of things? I am very aware that 'essence' is a philosophically loaded word and that much of the baggage that it carries may be misleading. But it is hard to find another word that will do. I do want to emphasize that my use of it is not meant to be tied to a specific philosophical theory; it is important to me that it is a word that is used in ordinary life. We do talk about distinguishing between what is 'essential' in some situation and what is not. Artists look for and try to convey what is essential about what they are

[1] Merleau-Ponty 1996b: 132.

Painting and Presence: Why Paintings Matter. Anthony Rudd, Oxford University Press. © Anthony Rudd 2022.
DOI: 10.1093/oso/9780192856289.003.0008

painting, and it is the ability to do that—rather than to mechanically create an accurate copy of appearances—which makes a good painter. I think artists understand very well that this is what they are doing, whether or not they have read any philosophical theorizing about essences, and it is this pre-philosophical sense of essence, or of what is essential, that I have been trying to rely on. Dürer saw the essence of the hare and presented it for us to see. You don't have to be a philosopher (or a scientist) to understand that, and it doesn't even particularly help to be.

So I think there is an informal, commonsensical and non-theoretical notion of essence—and that is what I am relying on in my discussion of what painting does. But there are natural questions which arise about the relation between the artist's quest for the essence of his or her subject matter and scientific as well as philosophical notions of essence, or of a natural kind. One might say that in depicting an animal (or a plant or, perhaps, a certain kind of rock) so as to show us the essence of its kind, its species, the artist *is* following, or working alongside, the scientist, who picks out natural kinds and tries to identify their defining characteristics.[2] Of course, the artist *shows* us the essence, makes it immediately accessible to the senses, and does so in and through the way that he or she presents an individual to us, while the work of the scientist (although grounded in the observation of individuals) is general, abstract, and theoretical. In other cases the relation between what the artist and what the scientist are doing is more distant. A portraitist trying to capture the essential nature of his or her subject is trying to evoke something irreducibly personal and individual. I insisted in Chapter Five that the notion of essence which concerned me could be as much individual as collective. I made the point by using technical philosophical and/or literary terms—haecceity, inscape—but, again, the understanding I was wanting to elucidate is a commonsensical one, and one that is implicit—and often explicit—in artistic practice. A good portrait, whether or not it captures all the accidental details of a person's appearance, is one that gets across something of the heart—the essence—of who that someone is. 'Yes, that's really got him' or 'No, that's really not her at all,' a critic may say.

The most obvious examples of the 'things' whose essences a painter may reveal are persons and Austin's 'middle-sized dry goods'. But of course, these are not the only subject matters even of representational paintings. As John Sallis observes of Monet's series of paintings of wheatstacks (or haystacks—*meules de blé)* 'Their concern is not with showing what a wheatstack is, not with disclosing the essence

[2] Interestingly, although I have taken Dürer's *A Young Hare* as my example, the hare is not really a natural kind, scientifically speaking. According to John Dupré (1993: 112), 'The distinction between rabbits and hares is...from most biological perspectives...trivial to the point of invisibility.' But, Dupré (1993: 112) continues, 'It is, nevertheless, one that is commonly drawn by experts neither technically scientific, nor scientifically technical, such as farmers, hunters and amateur naturalists.' That something doesn't count as having a distinct essence in scientific contexts doesn't mean that it can't be thought of as having an essential nature at all.

of wheatstack, but rather with showing how light spreads through the atmosphere at certain times of day and year.'[3] One can paint the essence of light—or of winter evening light on snow—as much as one can paint the essence of haystacks. And although I agree with Sallis that Monet was primarily interested in the light and not the haystacks, he, of course, painted both, and an artist may paint both the light and the object it illuminates with equal interest and concern. In other cases, though, one might want to say that there isn't really anything—either a species or an individual thing, or even something more amorphous like light—that has an essence, and so there can be no essence for a painter to make present to us. A landscape, for instance. Surely this is just an arbitrarily selected slice of the world as perceived? Its contents may be real enough—hills, fields, houses, rivers (as well as the light falling on them)—and perhaps an artist can be thought to depict *them* in their essential natures, but landscapes themselves don't feature in either scientific theorizing or as items in anyone's ontology. However, I think it *is* plausible to talk about the essence of a *kind* of landscape—of limestone uplands or chalk downs, of sand deserts or tundra, of mangrove swamps or prairies. And this essential nature is something an artist may try to evoke through the particular scene that he or she paints. Here the artist's interests may converge quite closely with those of the scientist—geologists and physical geographers are certainly interested in such *kinds* of landscape, and they do not think of them as random assemblages of objects, but as systems with their own coherence, the elements of which can only be understood in relation to one another.

What, though, if we are considering particular landscapes, rather than kinds of them? Aren't *they*—Mont. Sainte-Victoire seen from this particular place—arbitrary and conventional? But when Cézanne searched for the *motif* of a landscape, he was trying to make sense of the way in which the various elements arrayed in front of him fitted together. And (as a geologist would tell you) there is nothing arbitrary about this stretch of river being in *this* relation to *that* hill,[4] and nothing arbitrary about the artist's concern to show most effectively what we might call the logic of the landscape, the coherence of its elements. One might be tempted to say that a *vista* is something that exists only relatively to a perceiver, but the *landscape*—in the sense of the way this bit of the material universe is structured and arranged—is not (although there may be something conventional about where the boundaries of a landscape are said to lie). Even with vistas, though, we should remember that the world as perceived does not divide up into an assemblage of randomly distributed discrete entities, any more than the world as seen by a geologist or a biologist studying ecosystems does. Our perceptual experience has a holistic character; we do not typically encounter distinct objects,

[3] Sallis 2015: 105.
[4] For example, the hill—or that face of it—exists because it was eroded away by the river.

one by one, as it were, but as they exist in patterns of meaningful relation to one another. As the German Phenomenologist Dietrich von Hildebrand puts it:

> We see not only a hill, a mountain, a meadow, the grass in the meadow, a tree, a group of trees, an alley or a brook; mostly, these present themselves to us as a whole, unified thing. Naturally, we can look at them individually…but for the most part the immediate experience is an overall impression…the world of the visible is a world of wholes of every kind….which…often come together to form an organic total picture, for example a landscape in the typical sense of the term.[5]

Although the landscape painter's interests may align closely with those of the geologist, they do not have to: the former's concern is to bring out the essential features of the *visual* logic of the landscape, the essentials of the way it shows up to us (which is why a landscape painter may use devices such as stylization, idealization, or exaggeration in ways which would not be permissible for an illustrator of geological textbook.[6]).

That the notion of essence with which I am concerned is an informal and common-sense one doesn't mean that it involves no metaphysical commitments. (Our common-sense understanding of ourselves and our world involves lots of them, although there may be a variety of different philosophical systems attempting to explain and analyse them which are consistent with those basic commitments.) What I have said so far about essence does, at any rate, involve the assumption that there is some real structure in the world, that it is not a nominalistic blur in which all distinctions and classifications are ultimately arbitrary and conventional. It doesn't necessarily follow from that that there is one system of classifications that is the only possible one or the uniquely right one; plausibly, the structure or order of the world is rich enough that it underdetermines the (nevertheless non-arbitrary) classifications that we can make of it. Different aspects of reality show up when we (or when other rational beings) approach it with different interests. (I have, of course, insisted already that the value of painting lies in part in the access it allows us to the different ways in which reality shows up to different sensibilities.) But this does not mean that anything goes; systems of classification are constrained by the way the world is, even if there is no one system that uniquely mirrors the order of things.

That is a minimal (and largely negative) specification of realism about essences. This much would need to be accepted by anyone who takes at face value what

[5] Hildebrand 2016: 113–14. See Hildebrand's (2016: 308–24) very interesting discussion of landscapes as natural rather than merely conventional aesthetic unities.

[6] However, of course, scientific illustrations do idealize, schematize, etc., but for their own purposes and in their own ways (and these may overlap with the artist's ways of schematizing, etc.; for scientific illustrations can be beautiful, and they may be works of art in their own right).

science tells us about species and natural kinds—and about the differences between individual instances of those kinds. But it does not imply that the classifications made by natural science are the only ones that should be treated realistically, that it is only science that 'carves nature at the joints', as it were. And as I have noted above, there are two ways in which the artist's concern with essences differs from the scientist's. Firstly, the essences that an artist is interested in may be—and are—more than the natural kinds with which science is concerned (though the artist is concerned with those too). The artist may evoke, for instance, the individual character of a person, may express the spirit of an age, or may confront us with the pure intensity of ultramarine blue.[7] None of these is a scientific concept. Secondly, even when the essence that the artist is dealing with is something that science does treat as a species or genus or natural kind—the sparrow, say, or limestone—the painter conveys it to us not theoretically or discursively, but with the immediacy which characterizes knowledge by acquaintance.

To point out the difference between the artist's and the scientist's concerns with essence—or, more broadly, we might say, with the order of things—is not to disparage science (as Merleau-Ponty was perhaps occasionally tempted to do), and it does not involve any sort of anti-realism or instrumentalism about scientific claims. The distinctions and classifications that science makes are indeed based on real differences and commonalities among things. The abstractive procedure of what we have come to think of as science since the seventeenth century—its exclusive focus on what can be quantified and understood in terms of efficient, mechanical causality—has enabled us to achieve a far better understanding of those aspects of reality than ever before. However, although what science shows us is real, it doesn't and cannot show us everything about reality. Unfortunately, its very success has led too many philosophers to take the abstract models of aspects of reality that it creates as though they were by themselves adequate pictures of the way the world really is. (This is a little bit like taking a Mondrian to be a literally accurate depiction of the world.) Natural science leaves out far too much—the mind of the scientist, for a start—for the model of reality it gives us to be credible as a complete ontology.[8] Our ordinary concept of the order or structure of the world—which is what I take to be relevant to the understanding of what painting does—is a broader and richer one than that given by the natural sciences, valuable though that certainly is.

The remarkable Czech Phenomenologist and environmental philosopher Erazim Kohak notes that 'English philosophical usage has traditionally relied on the term "essence" to designate the uncoercible, intangible something that makes

[7] I'm talking about the colour's phenomenological essence—how it looks—not about what might be revealed by a spectral analysis of wavelengths or a chemical analysis of a tube of paint.

[8] I will be saying more about this in Chapter Nine.

a being the kind of being it is.'[9] This is exactly the sense that I am using the word to try and convey. But he is uncomfortable about 'essence', continuing: 'The cluster of commonplaces associated with that word is all wrong. It suggests a mysterious component, distinct from the being itself, which that being is yet supposed to bear somehow within it.'[10] And this expresses exactly what I don't want the word to be taken to mean. Kohak worries that 'Even if we were to specify that we do indeed wish to use the term "essence" to indicate the integrity of a total meaningful presence of a reality, the living reality of a pine tree, a boulder ... the word would betray us, evoking connotations of its own.'[11] This is a risk that I have chosen to take, knowing that it is a risk, and I hope the reader will bear in mind throughout that I am using the word 'essence' to refer to Kohak's 'total meaningful presence' and *not* to the idea of a 'distinct' 'mysterious component' that the word may suggest to some.

Whatever the terminology, Kohak insists that:

> Nature is not simply there, as an aggregate of physical properties ... It has its own intrinsic sense, much as we can speak of the sense of a person's gesture or the sense of a text ... in meaningful interaction with our world we are reading the text of nature; encountering it in its meaningful presence.[12]

He does not refer in this context to Merleau-Ponty (though he does to Husserl and Ricoeur) but what he says seems very close to Merleau-Ponty's account of how the sensible properties of a thing are internally related in that they all express a common 'manner of being'.[13] Neither a sparrow nor a limestone outcrop is simply a random agglomeration of properties—or even one somehow all held together by a hidden 'mysterious component'. Each has a nature of its own which is conceptually prior to the properties which manifest that nature. Whether or not we use the word 'essence' to designate it (and I continue to do so simply for want of an alternative that wouldn't itself be liable to mislead), this notion is not a philosopher's invention. It is grounded in our basic experience of the world, as a world of things and kinds of things which have their own coherence, their own integrity.

This can be said to apply in the human, cultural world as much as in the natural world. (I am not suggesting that we should consider this contextually useful distinction as a strict dichotomy.) I have mentioned that paintings may disclose and will inevitably in some way express the spirit of their times. But what we are concerned with here is what is *essential* to the spirit of the times, not some purely accidental features of a particular era, and the underlying assumption is that there

[9] Kohak 1984: 68–9. [10] Kohak 1984: 69. [11] Kohak 1984: 69.
[12] Kohak 1984: 69. [13] Merleau-Ponty 2012: 333.

is something non-arbitrary about such distinctions.[14] I also mentioned that paintings inevitably express emotions. But if Rothko, say, did indeed manage to express the universality of the emotions of tragedy, ecstasy, and doom, he did so by painting so as to evoke something about the *essences* of those states. Again, I don't want to rely on any particular philosophical theory of essences, but I think our common-sense understanding of human psychology, history, and culture is non-nominalistic. We do (and I think rightly) assume that, running through all the immense complexity of these spheres, there are 'real patterns', that our ways of classifying are not just arbitrary, which is why a painting may (without slipping into mechanical allegory) disclose something of what compassion or cruelty essentially is. Or one might say that a painting may *express* compassion or horror while *disclosing*, revealing, a kind of cruelty. (Again, Goya's *Third of May, 1808* comes to mind.) By contrast, the paintings that reveal cruelty and suffering without expressing compassion or horror are the ones I condemned as merely pornographic at the end of Chapter Six. A painting may evoke the vulnerability or the strength or the erotic allure and mystery of the human body (none of which is simply a biological feature of it, grounded in our biology though they certainly are). And again, I think we do assume—and rightly—that there is something to be evoked, that the paintings are attempting to convey something essential about aspects of what is essential to us, to our humanity.

The notion of essence is closely connected, both in philosophy and in ordinary thought and experience, with that of substance. It is, I think, not a culturally specific but a universally human truth that we experience the world as containing *things*, substances, distinct entities. Peter Strawson has given a sophisticated transcendental argument that it is necessary for us to suppose that the most basic objects of our experience are reidentifiable material substances (together with embodied persons).[15] Whether or not he has succeeded in showing that this way of thinking and experiencing is *necessary* for us, I think he is right that this is, at any rate, an important part of how we do *in fact* experience our world and that this is a genuine cross-cultural universal.[16] Such persons and things have *essences*, that is, they are not amorphous lumps, but have their own integrity and meaningful coherence as the beings that they are. And I think it is also generally

[14] A good cultural historian may indeed pick out all sorts of apparently trivial, contingent, and accidental features of a time or culture and show how, when all taken together, they do all express a common spirit or sensibility. None of this is meant to suggest that a zeitgeist or a culture is monolithic. But this time's or place's way of being pluralistic or conflicted is itself characteristic of that time or place.

[15] See Strawson 1959, esp. ch. 1 and (for persons) ch. 3.

[16] See the discussion of "descriptive metaphysics" in Strawson 1959, 9–12. I've added the qualification 'an important part' because I don't mean to suggest that Strawson's ontology of material things and persons is complete or exhaustive. Just descriptively, it is patently true that most cultures have believed in a variety of other kinds of thing (supernatural entities for a start); and it is certainly arguable that we *should* include other things in our ontologies.

recognized that they fall into *kinds* which are natural and not wholly conventional or artificial.

It might still be complained that this is really an over-intellectualized view and that our basic experience is better captured in something like Heidegger's analysis of our being-in-the-world, in which we relate to things as 'tools' or items of equipment (*Zeug*) which refer to one another within networks of significance oriented around our practical projects.[17] (The hammer isn't primarily experienced as a substance with properties but is taken up in practice and used for driving nails into wood in a workshop.) I think Heidegger's holism and his emphasis on practice are important reminders: we do encounter things in contexts and usually with practical concerns in mind. I would also add that we at least very often encounter them in the dimension of value—as beautiful or ugly, fitting or discordant, good or evil, sacred or desecrating. But these accounts should be seen as expanding on the abstract Strawsonian picture of reidentifiable substances rather than replacing it: even while I wield a hammer unselfconsciously in the context of my workshop, I am grasping it (literally *and* metaphorically) as a distinct thing with its own character, which serves my projects *because* it has the nature it does (a 'hammer' made of sponge would not do the trick) and which is non-arbitrarily classed with other hammers and not, say, with saws. That we typically encounter things in practical contexts does not mean that their distinct 'thingly' character simply disappears into a holistic network of relations.[18]

Strawson's discussion of reidentifiable substances *is* too abstract to get at the texture of our lived experience of the things with which we interact, and this is indeed a failing of much analytic philosophy (and a failing of much traditional, e.g., Aristotelian and Thomist philosophy too). It is, therefore, important to supplement it with phenomenological analyses. Heidegger's account emphasizes the ways in which things show up to us in the contexts of practical use, but other Phenomenologists do emphasize precisely the *thinginess* of things. Kohak's talk of 'the uncoercible, intangible something that makes a being the kind of being it is'[19] and Merleau-Ponty's talk of a thing's distinct and distinctive 'manner of being'[20] are modes of description which go beyond Strawson's abstract level to give us a sense of what it is to experience something *as a thing*, as having its own coherence and integrity. I do think this basic understanding of things as having essential natures is a cross-cultural human universal, though no doubt it is also culturally

[17] See Heidegger 1962: div. 1, chs. 2 and 3.

[18] Heidegger came, I think, to recognize the one-sidedness of his analysis in *Being and Time* (Heidegger 1962); hence his concern, from 'The Origin of the Work of Art' (Heidegger 1971a) on, to do justice to the 'thinghood' of things and not just their role in the network of significance relations that constitute our 'worlds'. See, for instance, his later essay 'The Thing' (Heidegger 1971b).

[19] Kohak 1984: 68–9. [20] Merleau-Ponty 2012: 333.

inflected in all sorts of ways.[21] It is, indeed, for the most part implicit in our practical dealings with things—the ways in which we pick things up, sort them out, and so on. But it is also expressed more explicitly in ordinary prosaic conversations as well as in poetry and in visual art. Any culture which develops a tradition of explicit philosophizing will produce various (and rival) attempts to analyse these basic pre-philosophical understandings of things, which will lead to explicit philosophical *theories* of substance and essence, of universals and individuation, and so on. But what I am relying on here is not any of these sophisticated theoretical accounts of substance and essence, but on the more basic pre-theoretical experience of them.

In concluding this section I should note that the basic ontological notion that I have been claiming is universally present in human experience—the sense of a thing as having its own integrity and coherence—is one that a *painter* can hardly help having. I have argued that a thing is not just an assemblage of properties but is a meaningful whole. But this is even more clearly true of a painting considered specifically *as a painting* and not just as a material thing. In creating a painting an artist is trying to create a meaningful unity. Unity in variety, a notion central to the neoclassical aesthetics of German rationalism, may not be the key to understanding all forms of beauty, but it is, I think, unavoidably something that an artist aims at.[22] The elements of the painting, its parts, are so placed and assembled in order to form parts of a meaningful whole. This figure and that brushstroke are intended not simply to stand alone but to work as elements in a complete composition, and if they fail to do so, then the painting fails as a painting, no matter how appealing some of the individual details may be. This remains true even when the effect the painter is intending is dissonance or chaos. 'Why didn't you put these figures *here* rather than *there*?' a painter might be asked and might reply 'Because that would have made it look too orderly, too balanced.' 'Why did you juxtaposes these clashing colours?'—'So as to create an effect that will disturb you and upset your bourgeois sensibility!'

II

A rather more specific concern about the notion of essence may be raised at this point. If things have essential natures—and if those are to be thought of as connected to the *meaning* or *sense* of things—it would seem that these should be capable of being articulated conceptually. And yet Merleau-Ponty and Maritain

[21] The claim that humans in general do, in fact, experience the world as one of distinct, enduring substances is compatible with, e.g., the Buddhist claim that we are deeply mistaken in doing so; as Buddhists are well aware, theirs is a radically revisionary metaphysics.

[22] See Beiser 2009: 8, 10, 14.

both talk about the revelation that painting achieves as 'nonconceptual'.[23] Part at least of what they mean is that the insights art conveys are non-discursive; they cannot be captured in any verbal paraphrase. And this non-parphrasability claim is something that I have insisted on throughout. The knowledge we get from paintings is immediate, intuitive, by acquaintance. But can knowledge have this intuitive immediacy and still count as *knowledge*? Can we, to use Merleau-Ponty's language, give or be given a 'nonconceptual presentation' of a 'logos'? If 'logos' is rational order, how can it be presented nonconceptually?

Worries along these lines have been expressed by philosophers in both the Continental and the analytic traditions. So Lyotard criticized Merleau-Ponty for supposing (as he saw it) that either art or everyday experience can give us a pure knowledge that is uncontaminated by the endless possibilities of interpretation that characterize the discursive realm.[24] And Derrida's notorious statement 'There is nothing outside the text'—though it shouldn't be caricatured as the thesis that only books exist—does seem to deny the possibility of escaping from the discursive into a realm of pure presence.[25] In analytical philosophy there has been much lively debate about 'non-conceptual content' and whether it is even possible. Philosophers such as John McDowell have taken what we might call a pan-conceptualist position, arguing that *all* our experience is conceptually permeated,[26] so that, in a sense, there is 'nothing outside the concept'. I mentioned in Chapter Two that I didn't take my claim that painting is non-paraphrasable as committing me to a notion of non-conceptual content that would be vulnerable to such criticisms, but the point is important enough to say at least a little more about it. Presence in my sense certainly involves a kind of immediacy and an irreducibility to discursive verbal articulation. But I think that presence and non-paraphrasability are quite compatible even with McDowellian pan-conceptualism, so I am not committed to a notion of non-conceptual content in the sense which McDowell denies. Since I do myself accept the pan-conceptualist position, it matters to me to show that it is compatible with the non-paraphrasability thesis. But I am not attempting to mount a full defence of pan-conceptualism here. My aim is simply to show that it is compatible with non-paraphrasability, and if that is so, then a range of weaker positions will be also.

Much, of course, will depend on exactly what one means by 'conceptual'. In Chapter Two I argued that we should distinguish between the (non-)discursive and the (non-)conceptual, and I am inclined to give a rather deflationary reading of Merleau-Ponty's and Maritain's references to the 'non-conceptual' nature of the

[23] I have already quoted Merleau-Ponty (1996b: 142) speaking of 'a Logos of lines, of lighting, of colour, of reliefs, of masses—a nonconceptual presentation of universal Being'. Maritain (1955: 80) refers to 'poetic' intuition as 'knowledge in act, but nonconceptual knowledge'.
[24] See Lyotard (1996a) and (1996b). [25] See Derrida 1976: 158.
[26] See especially McDowell 1996.

knowledge that painting makes available to us as simply meaning non-discursive.[27] McDowell, at any rate, is very clear that the realm of the conceptual is not equivalent to that of the discursive; nothing he says supports the—I think clearly unacceptable—idea that all our experience is somehow a kind of explicit intellectualized thinking. As he argues, it is a serious mistake to think that this is what the pan-conceptualist is committed to:

> The idea is not that experiential knowledge is always the result of determining what reason requires us to think about some question. Normally when experience provides us with knowledge that such and such is the case, we simply find ourselves in possession of the knowledge; we do not get into that position by wondering whether such and such is the case and judging that it is … [Rather,] in such knowledge, capacities that can figure in that kind of intellectual activity are in play.[28]

It is clearly not the case that there is nothing more to experiencing, for example, that the rug is blue than explicitly *judging* that the rug is blue.[29] To say that perception is conceptually permeated is not to say that perception is itself merely a kind of thought—the taking in of a content that could be exhaustively characterized in purely verbal forms. That I see this as a blade of grass—if I am a good botanist, as a blade of this genus and species of grass—does not mean that I (or anyone) could give a verbal description that would fully capture the sensuous immediacy of the shade of green that it is, its particular shape, the way the light hits it, etc. With a blade of grass, as with a painting, I miss something—in a way I miss everything—if I am just given a verbal description, however good, of it, and what I miss is not anything that could in principle be captured in further verbal descriptions (though there is always more that could be said).[30] Nor is it the case that the 'something more' is a dumb, sensory, brute given, *added on* to what I already knew from the verbal description.[31] It is, rather, all the conceptual truths about the thing, everything mentioned in the description, made flesh, as it were,

[27] However, I am not, in the end, so much concerned with exegesis as with what we should think about the matter.

[28] McDowell 2013: 42.

[29] This move is one often made by materialists and functionalists in response to the argument that their accounts cannot handle qualia or 'raw feels' (the *locus classicus* being Armstrong's (1968: chs 10 and 11) heroically implausible analysis of perception as (merely) belief acquisition). Though these responses seem to me quite hopeless, the classic qualia-based arguments are themselves problematic because they typically assume something like the 'Myth of the Given', which McDowell, following Sellars, rightly criticizes. So the argument between functionalists and 'qualia freaks' in philosophy of mind repeats the 'oscillation' between empiricism and coherentism in epistemology that McDowell analyses so cogently.

[30] And, of course, the verbal description may itself be beautiful, may itself be a work of art, and may help me to look better at the grass, to see it better.

[31] This is the mistake typically made by the 'qualia freaks'.

presented to me in and through the sensory immediacy of vision. Typically I just see the rose *as* red, and to do this I need to have the concept of red, and that involves knowing how it fits into a network of conceptual possibilities.[32] But to know that red is a colour is not simply to know how to use the word as a counter in a self-enclosed syntactic game, for it involves knowing that a colour is something that is taken in in a visual experience. And to have more than the most abstract understanding of colour (such as someone born blind might have) involves knowing what it is like to see colours. 'Red' is a concept, but when I loses myself visually in the deep, sensuous beauty of the rose, I am not just exploring a concept. Nor is the red I experience, in which I immerse myself, something different from the red I talk about.

One of McDowell's most prominent critics is Hubert Dreyfus, who argues (in 'The Myth of the Pervasiveness of the Mental') that McDowell's conception of experience is over-intellectualized and that detached rational thinking presupposes a much more fundamental basis of engaged practical coping. This absorbed coping is meaningful and goal-directed, but nevertheless not only non-conceptual, but downright mindless: 'There is no place in the phenomenon of fully engaged coping for intentional content mediating between mind and world. Now we must add there is no place for an "I".'[33] McDowell has responded that Dreyfus's insistence that absorbed coping must be mindless and non-conceptual shows that it is Dreyfus who is held captive by a myth, in this case, the myth of the mind as detached.[34] Since he takes for granted that mental activity, conceptualizing, and thinking must be explicit, theoretical, and detached, he assumes that it cannot exist implicitly *within* our practical coping activities. But this is precisely what McDowell *is* claiming—that the same conceptual capacities which we deploy in detached, discursive thinking are present in everyday unreflective perception and coping activity. A sportsperson 'in the flow' (to use one of Dreyfus's favourite examples) is not, of course, explicitly thinking 'I must move my left arm up to catch this ball' or whatever; but he or she is still consciously aware of the situation, that this is a ball that I need to catch, because it's just been hit by a player on the opposite side who I can get out if I do catch it. And this understanding—though implicit in the fielder's experience and action rather than discursively articulated as I have just done—is precisely the same understanding that he or she could spell out explicitly if asked. The 'I', the self-aware self, does not simply disappear in the flow; a musician better not be thinking, 'Hmm, now I need to put my right index finger on middle C', but will still be perfectly well aware, for example, of being in a concert hall, performing a Beethoven sonata.[35]

[32] See Brandom 2009: 7–8. [33] Dreyfus 2013: 28. [34] See McDowell 2013, esp. 41.
[35] See McDowell 2013: 45–6; see also Montero (2013, esp. 303–4, 312–15), who draws on her own experience as a dancer to criticize Dreyfus's claims about the mindlessness or lack of self-consciousness of skilled performances.

The crucial point for my purposes is that even on McDowell's pan-conceptualist picture, the sensual, felt quality of perceptual experience is not somehow reduced to or dismissed in favour of some kind of bloodless theorizing. And there is nothing in his picture to deny an important role to knowledge by acquaintance. A wine writer may give me a very rich and lively description of what a wine tastes like, but this is not a substitute for my tasting the wine. And this is not because the tasting is a purely non-conceptual sensual experience that is pleasing in itself but doesn't add to my knowledge of the wine. The tasting, after all, as McDowell would remind us, is what either justifies the wine writer's description or exposes it as pretentious verbiage. It could do neither if I couldn't experience the wine *as*, say, full-bodied with a strong tannic structure and a pronounced blackcurrant taste. The experience is conceptually informed, but it is also sensuous, and it is both at once. Knowledge by acquaintance does not have to be unmediated by concepts in order to count genuinely as acquaintance. And although Merleau-Ponty is often concerned to stress the sensuous immediacy of perceptual experience and its being intermeshed with practical activity, this does not in any way contradict the pan-conceptualist thesis, properly understood.[36]

All of this is true for our experience of paintings as well as of wine. The insight that Dürer's *A Young Hare* gives us can't be formulated as one more bit of information about the animal but is a more direct intuition of what it is like. Nonetheless, we know that it is a *hare* we are coming to know better from looking at Dürer's painting, and we also know that the hare is an animal, that it is a mammal, etc. Similarly, actually looking at the painting itself, rather than reading even a very good description of it, gives us a further knowledge (by acquaintance) of the painting which is not simply a matter of coming to learn more statable facts about it. But that sensory knowledge still includes and takes up into it our discursive knowledge that what we are looking at is a painting, maybe a Northern Renaissance work, a Dürer, a realist picture, etc. All the conceptual capacities that are deployed in the judgements we may make about hares and about paintings are present in our perceptual experience of the Dürer *Hare*; they are not somehow left behind in an ineffable rapture.

[36] Drefyus frequently appeals to Merleau-Ponty, as well as to Heidegger, in making his anti-conceptualist argument about engaged coping, but I think he seriously misreads both of them. It would be far too much of a diversion from the subject of this book to pursue this line of inquiry in any detail, but I will just note that Dreyfus' picture of unselfconscious coping has a zombie-like quality of unawareness that I simply don't find in Merleau-Ponty or in Heidegger. Indeed, it is very hard to see how a *phenomenology* of absorbed coping could even be possible on Dreyfus's account, since phenomenology aims to describe experience, what it is like; and for Dreyfus it seems that there *is* no 'what-it's-like' about absorbed coping. A critique of Dreyfus along these lines is developed by Zahavi (2013: 321–2).

III

There is, of course, much more that could be said about these issues. But I want to turn now to the question of value. My argument that paintings disclose things in their essential natures implies an at least moderate realism about things and their essences, that is, about the existence of some coherent rational order in nature. But even if painting is able to reveal to us deep truths about the essences of things, this doesn't seem enough by itself to explain the value of painting. We still need to know why it is *good* to know such truths. And, as I argued with reference to Murdoch in Chapter Two, I don't think a disclosive theory of art (painting) can plausibly explain the value of art unless what art discloses is itself of value. I quoted Murdoch in Chapter Two as saying that art not only 'seeks and reveals the real' but that, in so doing, it 'celebrate[s] the real' and that 'to desire the beautiful is to desire the real and the good'.[37] If beauty is a true disclosure of reality rather than a consoling illusion, then the reality it reveals is (in some sense) good, is such that we have reason to 'desire' and to 'celebrate' it. So the second major metaphysical implication (or presupposition) of my theory is a realism about value, that value is really present in the world and is not just our construction or projection.

This is, of course, in line with the teaching of my premodern sources of inspiration. According to classical Chinese aesthetics, painting matters because to show something in its essential nature (*li*) (which is what good painting does) is to make it present to us as a manifestation of the fundamentally normative order of reality (*Dao*). But is this basic conviction—one that has, of course, been differently articulated in different traditions—one that can be made plausible or even intelligible in the contemporary condition of modernity or postmodernity? I believe that it is actually present, although sometimes in a rather implicit or concealed form, in many of my more recent sources too—both artists and philosophers. In Chapter Two, I noted Steven Crowell's remark that Phenomenology has not only been influential on the philosophy of art, but 'has recently been enlisted in support of a renewed philosophy of *natural* beauty' and that 'some environmental philosophers' have drawn on Merleau-Ponty in particular, in attempting 'to revive the idea of a "legible" or meaningful nature'.[38] Galen Johnson has also suggested that Merleau-Ponty's philosophy of painting needs to be seen in the context of a broader concern with natural beauty as pointing to a meaningful order in nature. He notes that although 'Merleau-Ponty seldom spoke of beauty, yet his philosophy is about the beautiful'[39] and that, for Merleau-Ponty, the beautiful is 'the depth, rhythm and radiance of Being itself'.[40] Certainly, for Merleau-Ponty, when we experience—in art or directly in nature itself—the 'secret

[37] Murdoch 1997b: 459–60. [38] Crowell 2011: 50–1, n. 2. [39] Johnson 2009: xvii.
[40] Johnson 2009: xvii, 210, and 218.

ciphers', the hidden 'logos', in things, we don't just respond with a coldly intellectual interest or curiosity; we are delighted, fascinated, perhaps overwhelmed, in any case, drawn to and by them. So if we accept the 'broad' definition of beauty with which I have been working as that, the visual appearance of which *fascinates*, then I think we should indeed accept Johnson's claim that beauty is a basic notion in Merleau-Ponty's aesthetics and that beauty for Merleau-Ponty is not a projection but a fundamental characteristic of being itself. Johnson finds a notion of the sublime as well as the beautiful in Merleau-Ponty, although he rejects any sharp distinction between the two: 'Beauty and the sublime blend into one another when the beautiful grows powerful, majestic, mysterious and transcendent.'[41] Johnson concludes his discussion of the sublime with an eloquent passage: 'Merleau-Ponty argues that the philosopher can participate in the return to the wonder of the "there is". This is the perceptual faith, that there is a world, that there is wildness, and that the world maintains a generosity that will speak to a spirit of wonder and openness.'[42] However obscure the philosophical underpinnings of this 'perceptual faith' in Merleau-Ponty's late ontology, it seems clear that his attitude to nature is far removed from the vision of a neutral, value-free realm of scientific fact postulated by standard forms of 'disenchanted' naturalism.

However, the issue cannot be settled by any appeal to authority. I think the best way to show that nature can be thought of as a realm of objective value is, indeed, to turn to a phenomenology of 'natural beauty', that is, to reflect on the direct aesthetic experience of nature itself. We find it valuable to have aspects of nature made present to us in painting, but it is not simply an *inference* from the experienced value of painting that what it discloses to us must be of value. I want to claim that we can directly experience the natural world as a realm of value and that this is, indeed, precisely what the aesthetic experience of nature is. So far in this chapter I have defended a moderate realism about essences and natural kinds. I am committed to supposing that there is a rational order in nature and to rejecting the sort of nominalism which would claim that all classification is ultimately arbitrary or at any rate a matter of human convenience. In aesthetic experience, however, I think we are aware of nature as having not simply a *rational* order but a meaningful and value-laden order. To see nature as having this value-laden character is to experience there being the kinds of things that there are and their having the characters they do, their connecting together and interacting in such intricate ways, as occasions not simply for puzzlement or curiosity but for wonder, awe, and gratitude. In Chapter Eight I will, then, turn to a discussion of the aesthetic experience of nature, interpreting that as the experience of the world as an order of value.

[41] Johnson 2009: xix and 224. [42] Johnson 2009: 230–1.

Chapter Eight
Natural Beauty

In this chapter, I will be discussing the *direct* aesthetic experience of the natural world (as distinct from the aesthetic experience of paintings as disclosing nature). This discussion is motivated by two closely connected concerns. Firstly, as I mentioned at the end of Chapter Seven, I want to further defend and further explicate the claim that the order of nature which painting discloses to us is an order of value. And this, I think, is best done by considering our direct aesthetic experience of nature. I will argue that when we experience nature aesthetically, we experience it as a realm of (objective, intrinsic) value. But also (my second reason) I think a disclosive theory of painting needs, in any case, to be supplemented by some account of the direct aesthetic experience of nature. In Chapter Six I considered the challenge that my disclosive view of painting as 'making present' would make painting superfluous, since it should be possible for us to experience nature in this intense, revelatory way without the mediation of art. I hope I was able to indicate an adequate answer to that objection, but it was important to consider it, because, as I said then, 'it *is* possible to attend deeply and carefully to natural beauty, as it is to paintings; and when ones does so, the experience is profoundly moving—as much as any experience we may have of artworks'. So, granted that such experience of nature doesn't render painting superfluous, it still seems important to at least sketch out an account of the aesthetic experience of nature (what is often these days called 'environmental aesthetics') and consider to what extent the account of painting already given can serve as a model for such an account and to what extent they must differ.[1]

I

Of course, there are complexities that arise even in defining this project. We can have direct aesthetic experiences of the things that paintings disclose, but these

[1] The topic of natural beauty was generally neglected by aestheticians for much of the twentieth century, but has attracted much more attention in recent decades. For a good introductory overview, see Carlson 2009. Carlson and Lintott 2008 is an excellent collection of influential articles on the topic. I have chosen to proceed not (for the most part) by engaging directly with this literature, but phenomenologically, by reflecting on our aesthetic experience of nature and how it relates to the account of painting I have developed so far. Those familiar with the recent debates in environmental aesthetics will note the convergences and differences between the views I advance and the various positions taken in those debates.

Painting and Presence: Why Paintings Matter. Anthony Rudd, Oxford University Press. © Anthony Rudd 2022.
DOI: 10.1093/oso/9780192856289.003.0009

are not necessarily just bits of nature, as distinct from culture; (representational) paintings may be still lifes or street scenes, or may depict historical events, and even landscape paintings often depict, for example, farmland rather than pure wilderness. My main concern in this chapter *is* with the aesthetic appreciation of the world of non-human nature, but it should be noted that there is a whole range of interesting questions about the aesthetics of everyday objects—of humanly created artefacts—and how our aesthetic experience of them relates to that of their depiction in paintings.[2] Even in talking about non-human nature we have to bear in mind that pure nature is not always easy to find; even 'wilderness areas', nature reserves, etc. are humanly managed and bear the marks of human activity. Like most valid points, though, this one can be taken too far, as it is by those who claim that nature itself is merely a social construction.[3] Against these exaggerations, it is worth remembering that even cities, let alone farmland, are not humanly created *ex nihilo*. All our creations are manipulations, arrangements, or transformations of things and materials that exist independently of us.[4] Although it may be rare for us to glimpse pure or pristine nature, nowhere do we ever find ourselves really apart from nature. And of course, *we* are parts of nature too.

Although the distinction between 'art' and 'nature' as objects of aesthetic appreciation is blurred and complicated, I do think that the distinction remains useful and indeed necessary in aesthetics. That there are substantial differences between the aesthetic appreciation of art and of nature is obvious. Works of art are deliberately created, and we can ask about the intentions of the artist (why did he or she put that brushstroke there?) in a way that we can't about natural things. And artworks are (usually) objects with discrete boundaries. (Paintings are commonly framed.) Although we can just look at a particular natural object—a tree, an animal, a rock—often what we appreciate in nature is a whole landscape, and the appearance of this particular configuration of objects is in part up to us— where we stand, at what angle or distance we are looking from, etc. The painter, by contrast, does more of the work of composition for us.[5] But without absurdly trying to assimilate the appreciation of nature to that of art, I think there are genuine and illuminating parallels to be found.

We can start by simply noting that just as people are moved by paintings, so too people are struck by the beauty of nature—awed by great mountains, soothed by flower-dappled meadows, enchanted by reflections of light on a fast-flowing river. People make journeys to be in beautiful places; some are set aside as national

[2] For some relevant reflections, see Leddy 2012 and Saito 2010.

[3] See, e.g., Berleant 1993: 234: 'The natural world is no independent sphere but is itself a cultural artifact.'

[4] At any rate, in the sense of 'empirical realism': I'm not wanting to beg any questions against philosophically serious versions of idealism (or anti-realism).

[5] See Carlson 2009: ch. 2.

parks or 'Areas of Outstanding Natural Beauty'[6] and protected from development. But even apart from the spectacular natural beauty that we go out of our ways for, it matters to people to be surrounded by or close to natural (or even 'natural') beauty in their everyday lives. Office parks and housing developments often feature attempts at landscaping; these are often feeble enough, but that the effort is even made is significant. People like to grow and look at flowers, even when they are unable to do more than have a pot of them on the windowsill of an urban flat. People like to have and cultivate gardens, and to make them look as beautiful as possible. (Gardening is, of course, the activity that most obviously blurs the distinction between 'art' and 'nature'.[7]) And these things *matter* to people—to a great many people, anyway. To be able to enjoy natural beauty—directly or at second hand, on the grand or the intimate scale—matters deeply. It is not a trivial or marginal aspect of people's lives, even in an economic order that tends precisely to force it to the margins. (It is, of course, also true that people want to live in beautiful or at least visually attractive man-made environments, to live in beautiful rather than ugly towns, or at least to be able to visit the beautiful ones on holidays.)[8]

Of course, in all this, as in the experience of art, there are elements of social construction, conformity to cultural ideals, and so forth. No doubt some people visit a beauty spot as some visit the Mona Lisa—because it's just what one does—and stay long enough to take a selfie. But with the appreciation of natural beauty, as with art, it is cheap cynicism to think that these sorts of debunking analyses can explain it all away, that they can capture all that is going on. There is also a widespread subjectivism about the experience of natural beauty, as there is about art, but I think there is no more reason to accept such subjectivism in the one sphere than in the other. Our experience of natural beauty is intentional—we experience *the mountain* as breathtaking, *the array of flowers* as beautiful; we don't just experience a pleasant feeling in ourselves which these objects happen to trigger off. Projectivism is not a descriptive but a radically revisionary account; no one believes it while they are actually having the experience, for the experience itself carries with it the sense that what we are experiencing (the beauty of the

[6] An official designation in the UK.

[7] See Cooper 2006 for some interesting philosophical reflections on the meaning of gardening.

[8] It would be both false and insufferably patronizing to suggest that the appreciation of (natural) beauty is a middle-class indulgence and irrelevant to the poor. As if the aesthetic impoverishment of crudely designed concrete housing estates, whether in capitalist or communist states wasn't—and isn't—itself a mark of the contempt of the powerful for the poor *and* a further element of the brutalization of the latter by the former. And it is worth remembering that the 'Ramblers' movement in Britain in the interwar years, which opened up access to the countryside, establishing rights of way across private property, was largely a working-class movement (see, e.g., Marr 2009: 283–5).

scene) is real.[9] This is not, of course, a refutation, but we should be aware of how radically contradictory to our experience itself projectivism is.

Relativism about natural beauty is also widespread (in theory). It is often claimed in support of it that tastes in natural beauty change and/or vary across places and cultures. There is certainly some truth in this, though I think it is often exaggerated. But nothing in my account of painting denied that people, even of equally sophisticated artistic sensibilities, may differ in their appreciation even of canonically great paintings. On my view there is something genuinely analogous to intersubjectivity in the appreciation of art, and what 'resonates' with one viewer may do so less with another. We are finite creatures; none of us can appreciate anything from an absolute point of view, and so there is always a subjective or perspectival element in any experience or appreciation. And I think it is plausible to suggest that not only individuals but whole cultures may differ in their tastes, in what 'resonates' with them. However, that doesn't mean that any perspective is as good as any other; it remains important to free ourselves from the distorting effects of 'personal neurosis and social convention'[10] precisely because they *are* distorting. They prevent us from seeing what is really there. And this is true in the case of natural beauty too. That tastes in it may differ to some extent doesn't show that there is nothing really out there (no actual beauty) to be appreciated or that one person (even one culture) may not be better than another at doing so.[11]

To set subjectivism and relativism aside and to stick with the experience of appreciating natural beauty, one clear parallel between that and the appreciation of art is that natural beauty, like artistic beauty, doesn't necessarily show itself to any casual glance. We have to look in order to see, and looking isn't just a matter of having one's eyes open and pointing in the right direction. Attentive looking is called for, an openness to what the world around has to offer. As Thoreau notes:

Objects are concealed from our view, not so much because they are out of the course of our visual ray as because we do not bring our minds and eyes to bear on them... There is just as much beauty visible to us in the landscape as we are prepared to appreciate it—not a grain more.'[12]

As with art, we may need to make an effort to lay aside our preoccupations, our assumptions. But also as with art, this state is not one of pure passivity; it can't simply be a matter of emptying one's mind. Rather, it may require an active,

[9] Hildebrand carefully analyses paradigm cases of projection (2016: 40–43) or association (2016: 43–47) in order to show that these are importantly *different* from the experience of beauty. Being affected by beauty is an intentional relation, not a causal one, as when a feeling is stimulated in us by some object (see Hildebrand 2016: 48–9).

[10] Murdoch, 1997f, 215.

[11] Consider the (at least apparent) lack of appreciation for mountain scenery in medieval Europe, compared with China at the same time.

[12] Thoreau 1980: 173–4; quoted in Dustin and Ziegler 2007: 37–8.

disciplined focusing of attention, a use of imagination to see beyond routine expectations or assumptions and to see beauty in what might at a casual glance have seemed ugly or dully commonplace. Nan Shepherd writes in *The Living Mountain*, her wonderfully perceptive book on the Scottish Cairngorms:

> Why some blocks of stone, hacked into violent and tortured shapes, should so profoundly tranquilise the mind I do not know. Perhaps the eye imposes its own rhythm on what is only a confusion: one has to look creatively to see this mass of rock as more than jag and pinnacle—as beauty. Else why did men for so many centuries think mountains repulsive?[13]

But this creative looking is not an arbitrary fantasy, imposing itself on a neutral material. Shepherd continues: 'A certain kind of consciousness interacts with the mountain-forms to create this sense of beauty. Yet the forms must be there for the eyes to see. And forms of a certain distinction; mere dollops won't do it.'[14] A sort of intersubjectivity is being evoked here. The beauty of things is not always something that can be registered with any casual glance. But the imaginative looking which is needed to evoke that beauty does not invent it.

Again as with paintings, this doesn't mean that the aesthetic appreciation of nature is always hard work. Sometimes—often—we may just be struck by the beauty of a natural scene, pulled out of ourselves, our self-absorptions, in a way we can't summon or control (like 'Rob' with the Rothko). Whether or not it involves conscious effort, perceiving the beauty of nature remains a process of interaction in which we need to be rightly attuned to what we are seeing. When we are so attuned, it seems fair to say that natural things or scenes can become present to us in something like the charged way paintings can. They cease to be the taken-for-granted backdrop to our activities and stand out for us, strike us, move us. We become aware, to recall Kohak's expression, of 'the integrity of a total meaningful presence of a reality, the living reality of a pine tree, a boulder'.[15] The sense of the presence of things is one in which we really attend to their being and to their being what they are, and find ourselves drawn into relation to them. Robert Macfarlane, writing about the poet Edward Thomas, notes that 'Nature and landscape frequently have this effect on him: trees, birds, rocks and paths cease to be merely objects of contemplation, and instead become actively and convivially present, enabling understanding that would be possible nowhere else, under no other circumstances.'[16] Henry Bugbee describes this sense of the presence of nature in a passage that deserves to be quoted at length:

[13] Shepherd 2011: 101–2. [14] Shepherd 2011: 102. [15] Kohak 1984: 69.
[16] Macfarlane 2013: 341.

I weighed everything by the measure of the silent presence of things, clarified in the racing clouds, clarified by the cry of hawks, solidified in the presence of rocks, spelled syllable by syllable by waters of manifold voice, and consolidated in the act of taking steps, each step a meditation steeped in reality. What all this meant I could not say, kept trying to say…The aspens and larches took on a yellow so vivid, so pure, so trembling in the air, as to fairly cry out that they were as they were, limitlessly. And it was there, in attending to this wilderness, with unremitting alertness and attentiveness, yes, even as I slept, that I knew myself to have been instructed for life, though I was at a loss to say what instruction I had received.[17]

The 'instruction' we receive in such experiences is what we also experience paintings as disclosing: the manner of being of things—'that they were as they were'. We learn to be amazed, one might say, both at their essence (what they are) and at their existence (that they are). Bugbee didn't just learn some interesting thing about, say, the aspens and larches: he was 'instructed for life' through his attentive dwelling with them. Presence to nature, as to paintings, involves something transformative; there is the mutuality, the analogy to intersubjectivity, that we noted with respect to paintings earlier.

In the case of nature, that mutuality is, indeed (at least in one sense), more obvious. When enjoying natural beauty, we do sometimes take up a spectatorial attitude rather similar to that which we usually adopt while appreciating paintings. We stand or sit on a viewpoint and drink in, purely visually, the scene that is spread out before us. But often our experience of natural beauty is much more obviously participatory, immersive. Consider what it's like to be walking through a wood, enjoying the constantly changing views as you walk, the shifting patterns of light filtering down through the leaves, feeling the path beneath your feet and the movements of your legs, breathing in the fresh air, hearing the birdsong and the rustling of the branches in the breeze, smelling the blossoming shrubs and flowers. It is a multisensory experience and one which one enjoys with an explicit consciousness of oneself as an embodied agent. Of course, when you look at a painting, you can (and should) move around, appreciate how the painting looks from different angles—the difference is often rather startling. The size of the painting—relative to that of your body, of course—is often important, as are the lightning conditions and the general sense of the space you are in. (Seeing a painting in a quiet old church may be a very different experience from seeing that same painting in a brightly lit crowded modern gallery space in an exhibition.) I have emphasized throughout the active, participative nature of the

[17] Bugbee 1999: 139–40.

appreciation of paintings. But for all that, the aesthetic experience of nature is usually much more obviously and richly participative.

II

I have tried to briefly indicate that various aspects of my account of the aesthetic appreciation of paintings can be applied to the aesthetic appreciation of nature. But what about truth? My account of painting has emphasized its significance in conveying truths to us. But can it make sense to think of the aesthetic appreciation of nature as truth-revealing in this sense? For some philosophers it would seem not. T. J. Diffey says that:

> it seems to me that truth...does at least have more initial purchase in connection with art than with nature. I am more willing, that is, to consider what the expression *a truthful work of art* might mean, than what *a truthful landscape or prospect* say, might mean or be.[18]

Perhaps, though, we should start not with the question of what a 'truthful landscape' might be, but with what it is to see a landscape truthfully, and whether that might have a connection to seeing it aesthetically. One philosopher who thinks there is such a connection is Allen Carlson, who has argued that the serious aesthetic appreciation of nature must be an appreciation of it for what it really is. But for him, this means apprehending it under the relevant *scientific* categories. If one's appreciation is to be other than very superficial, one must appreciate a landscape, say, *as* having been shaped by glaciation, a kind of animal or plant *as* the outcome of certain evolutionary pressures, etc.[19] This does seem to me over-intellectualized. I don't deny that scientific knowledge may enhance our appreciation of a natural scene, but what it is enhancing is something more immediate that exists prior to the knowledge.[20] If my understanding of geology is so integrated into my experience that I can just immediately see this *as* a glacial valley (in the way that I might come to see a painting immediately *as* a work of analytical cubism), then this may enrich my experience.[21] But being able to bring scientific knowledge to one's experience of nature can't be a necessary condition

[18] Diffey 1993: 60.

[19] See his essays collected in Carlson 2002. He gives a brief summary and defence of his views Carlson 2009: chs. 2–3.

[20] For some helpful criticism of Carlson's proposal, see Brady 2003: 93–102.

[21] But, as Hepburn (2001: 7) notes, 'It may well enrich our perception of a U-valley to "think-in" its readily imaginable glacial origins,' but it is doubtful whether less imaginable scientific truths—e.g. about the 'set of transformations at the molecular and atomic level that produced the rock of which the valley is made'—can really be integrated with our experience in such a way as to enrich it aesthetically.

for genuine aesthetic appreciation of it. To say that someone who does not understand geology, evolutionary biology, etc. is incapable of seriously appreciating the beauty of the world around him or her seems obviously false (not to mention disturbingly patronizing and elitist). Nor is it a sufficient condition: a geologist may be able to immediately 'read' the landscape in the sort of way noted above, while remaining entirely unmoved by it and concerned only with the possibilities of its commercial exploitation.

I think Carlson is right to insist that there must be a connection between perceiving nature aesthetically and perceiving it truthfully. But what is the truth in question if it is not (primarily) scientific truth? It will probably not be a surprise at this point that my answer is the truth of presence. I have argued in section I that the notion of presence or becoming present is applicable to nature as well as to art. I want, then, to say that a natural object or scene can be truthful because it makes present in a way that is at least somewhat similar to that in which a painting makes something present. But if art is truthful through its disclosure of the essences of the things it depicts (if we set aside complications about the way they are expressively filtered through the artist's vision, etc.), what is there, analogously, for a natural object to be truthful about? A Cézanne is truthful because it discloses Mont Sainte-Victoire to us. But what does Mont Sainte-Victoire itself disclose? Can that question make any sense?

If we ask, 'What does a mountain, looked at with proper aesthetic appreciation, make present?', the first answer to consider would be '*Itself*'. When we look attentively, appreciatively, we see things, not just as backdrops to our activities or as obstacles or in terms of what we can use them for, but for themselves, as just being and being themselves. Presentness isn't always about making *something else* present. Although I have insisted on the disclosive character of paintings, I have also stressed that a painting has its own presence, that it manifests itself to us (as in Rob's encounter with the Rothko). And when I started to explore the notion of making present, I did so through examples of persons making themselves present or refusing their presence. One might say in such cases that there is still a two-stage process going on: the person's facial expression, for example, makes his or her feelings present to me. But one could also say that in the case of non-personal, natural objects: the way the mountain looks, in this light from this prospect, makes the mountain itself, as a whole, present to me. We could, for that matter, respond directly to Diffey by suggesting that 'a prospect' may be truthful in that it offers us a good, clear, perspicuous view of Mont Sainte-Victoire (and thus discloses it in that sense). But we might still wonder whether we can talk about the mountain itself as 'truthful'. I will return in a minute to a way in which we might make some sense of that expression. Still, it isn't how we usually talk, and it would be more natural to say that *we* make natural things present when we perceive them truthfully. They are waiting, as it were, to be noticed, but it is only when we attend properly to them that they become present to us. The substantive

point is, though, that the aesthetic appreciation of nature isn't just about having nice feelings or sensations aroused in us. Such an account could make no sense of how we experience the beauty of nature as really *mattering* to us. It is about seeing things as they really are. This is why it seems natural to say that someone—an experienced hiker, for instance, or a nature writer, a Thoreau or John Muir or Annie Dillard—has a 'truthful vision' or sees things truly, sees the truth of things.

I think, then, that the kind of truth that our aesthetic experience of nature conveys is the same kind as paintings give us about things: it gives us knowledge by acquaintance, the knowledge not just of truths *about* them, but knowledge *of* them, although not in a 'view from nowhere' way, but as they relate to us. In discussing Merleau-Ponty in Chapter Five, I noted his claim that each thing has its own distinctive manner of being, its own, in a sense, personality. One can set out a long list of true propositions describing the properties that a thing has, but to really know the thing is to intuit the common manner of being that all these properties express. (As I emphasized, this does *not* mean knowing the thing, the substance, *as distinct* from its properties; it is to know the substance in and through its properties.) This intuition is not an exceptional kind of mystical transport; it is, according to Merleau-Ponty, present in our everyday experience of the world. (We experience things as things, not as mere assemblages of properties.) Nonetheless, it remains mostly implicit, muted, buried. When we really attend to things, become aware of their presence, we are really knowing them—by acquaintance. The serious aesthetic experience of nature is an experience of the truth of things. But 'things' needs to be taken in the broadest possible sense; just as paintings may be abstract as well as representational, so our (aesthetic) experience of nature is not simply an experience of things (objects, substances) but also of assemblages or networks of things (landscapes, ecosystems), and also of colours, shapes, lines, shifting patterns of light—all the subject matter of abstract art.

We saw that for Merleau-Ponty painting is ontologically revelatory because it 'awakens and carries to its highest pitch a delirium which is vision itself ... once it is present it awakens powers dormant in ordinary vision'.[22] But even apart from art, ordinary vision can become extraordinary in the genuinely attentive aesthetic appreciation of nature. This does not, as I argued in Chapter Six, mean that paintings are only a substitute for nature, a way of getting indirectly at what we could appreciate directly. The painting shows us the truth of things as they resonate with a particular artist and as they are evoked in a particular sensuous medium with particular formal properties. We shouldn't accept a simple mimetic theory according to which art derives its significance from nature—it's beautiful simply because it imitates what is beautiful—nor should we accept the opposite

[22] Merleau-Ponty 1996b: 127, 142.

theory, according to which it is only through art that nature becomes transformed into something aesthetically significant (the object depicted as only the grit that the pearl forms around).[23] Looking at a Cézanne is not a second-best substitute for looking at Mont Sainte-Victoire, nor is the mountain itself, as it were, a poor preliminary sketch for the achieved aesthetic result of the Cézanne. But if there is a priority, it does rest with nature. Art (painting) is a response to, a celebration of, nature. It transforms and adds to natural beauty, but remains always dependent on it.

So mountains (natural objects generally) disclose themselves, can be present to us. But can they also be said to disclose something beyond themselves, to be truthful in the sense of faithfully revealing something else? One might think, for instance, that a mountain reveals its granitic nature, that is, the nature of the granite (or the limestone or whatever) that forms it. Or that it reveals the nature of mountainhood. 'Now *that's* a mountain!' one might say. ('In the case of Scafell Pike opinions must agree that here is a mountain without doubt and a mountain that is, moreover, every inch a mountain.'[24]) One might indeed say, 'That's a true mountain!' ('That's a real mountain') or 'That's a true/real storm!' We might also say, 'That's not much of a mountain!' if it is rather low or has gentle grassy slopes. Reflecting on moments when we might say such things can help us to make sense of the traditional notion of ontological truth. Modern philosophers tend to think of truth, at least primarily, as propositional. What we say about things can be true or false, but not the things themselves; they just are. However, for most classical and medieval thought, ontological truth was primary. A thing is true to the extent that it truly realizes its essence or is true to some standard.[25] This is, despite its neglect by philosophers, a notion that we do still use and understand well enough in ordinary life, as in the examples given above, or as, for instance, when someone may be (or may not be) called a 'true friend'.

This sense of truth was crucial to the Neoplatonic (Plotinian) theory of art, discussed in Chapter Two, according to which, when the painter (sculptor, etc.) depicts things 'truly', this is so as to show us the Form as it expresses itself in and through the particular. But it seems that this experience of seeing the universal, the Form, in the particular, can be part of our direct experience of nature. Consider the following meditation on looking at waves on the ocean:

[23] See Wilde 1998: 41–5.

[24] Wainwright 2007: 220. (Wainwright is here discussing whether the fells of the Lake District should be categorized as mountains or hills, noting that 'The difference between a hill and a mountain depends on appearance, not on altitude.')

[25] This is as true for the Confucian as for the Platonic and Aristotelian traditions. See the discussion of Zhu Xi on *li*, 'principle' in Chapter Four. But Zhu was bringing out and developing more systematically a notion that had long been present in Confucianism and, indeed, in the wider culture beyond it. We can, for instance, see Mencius approvingly quoting from an ancient poem collected in the *Book of Odes*: 'if there is a thing there is a norm' (Mencius 6A6, in Ivanhoe and Van Norden 2005: 148).

What there is to see in these waves is an inexhaustible variety of particular forms. Each is utterly unique, none precisely identical to any other … and yet, as one contemplates this ceaseless ebb and flow, one also sees a movement that is eternal, a form that is universal, that returns again and again, but is manifest only in what is ephemeral and fleeting.[26]

This is, I think, part of what might be meant by saying that there is *truthfulness* in the aesthetic perception of nature. We see not just passing phenomena but, in and through those phenomena, an underlying structure or order. But it might be misleading to say that seeing the form in the particular is seeing it as disclosing *something else*, beyond itself. The Merleau-Pontian point I made above was that we perceive the essence, the 'manner of being' that makes something what it is, but that *is* itself, not some other thing—or, as Kohak put it, the essence of something is its own coherent integrity as the thing that it is, not a mysterious extra standing behind it—and as I also argued in Chapter Five, even when we are talking about universals rather than individual essences (haecceities). Still, something's having certain universal formal or species characteristics is part of what it is for it to be the individual that it is. (My cat is an individual, but she is an individual *cat*.) Similarly, Mont Sainte-Victoire doesn't point me to limestone as though that were something quite other than itself, for Mont Sainte-Victoire *is* a chunk of limestone. Still, when we see things as instantiating universals, we do see them in their more than particular significance; it does seem fair to say that looking with real attention at the Matterhorn not only makes me acquainted with that particular mountain, but with something of mountainousness in general.

So things disclose themselves (their individual essences), and, in so doing, they disclose universal essences too. Going up to a further level, we might say that they also disclose Being, what it is simply to be. I do think this is or can be an important part of the aesthetic perception and appreciation of nature: when we see things in such a way that we cease to take them for granted or think of them simply in terms of what they can be used for, we may be struck by wonder both that they are what they are (that these leaves have this delicate tracery) and simply *that* they are, that they exist at all. To be struck by this is not to raise a problem about how they came into existence, a question that could be answered by a causal story; it is to feel a mystery, a sense of astonishment that anything should exist. As Coleridge asked:

Hast thou ever raised thy mind to the consideration of EXISTENCE in and by itself, as the mere act of existing? Hast thou ever said to thyself thoughtfully, it is! Heedless, in that moment, whether it were a man before thee or a flower, or a

[26] Dustin and Ziegler 2007: 119–20.

grain of sand: without reference, in short, to this or that particular mode or form of existence? If thou hast, indeed, attained to this, thou wilt have felt the presence of a mystery, which must have fixed thy spirit in awe and wonder.[27]

Coleridge is not just wanting us to find it interesting, or even surprising, that things exist: in drawing our attention to the sheer being of things he is expecting that we, like him, will feel awe and wonder that anything is. And, like Coleridge, most writers and thinkers who have raised this 'question of being' have felt the mystery and the wonder in a deeply positive sense. As Kohak puts it:

> The experience of Being is all around us, just below the fleeting particularity of what is…You must not insist, you must not impose yourself upon it. But if you are willing to listen to it, it is there, the fullness and the unity of life, the presence of Being—and it is one and good.[28]

(The great outlier in this is Schopenhauer, for whom the uncanny mystery that anything is at all is connected with the sense that it would have been better if nothing had been.) But for Coleridge, Kohak, and the long tradition in which they stand, being is good, and to perceive the world in its beauty is to see it as good and to feel a grateful awe at its being.

III

This brings us back to the crucial issue which I raised at the start of this chapter, the idea of the *goodness* of nature, the idea that the natural world is a realm of value. As I have noted above, my account of both painting and of the natural beauty that it celebrates and evokes depends on at least a moderate realism about essences and natural kinds. It is committed to supposing that there is a rational order in nature and to rejecting the sort of nominalism which would claim that all classification is ultimately arbitrary or at any rate a matter of human convenience. It is, I think, very difficult to give a convincing account not only of art or natural beauty on this sort of view, but also of science; and I think most philosophers (including most philosophers who would call themselves naturalists) would accept at least some kind of moderate realism about natural kinds and natural laws. That is, they suppose that nature really does have 'joints' and that the aim of science is to carve it at those joints. Of course, there are many different ways in which such a basic commitment can be further articulated, and

[27] Coleridge 1969: 514.
[28] Kohak 1984: 60–1. Kohak goes on to powerfully evoke 'the opposite experience…the terror of sheer nothing' (1984: 61–2).

there are vigorous debates between proponents of those different ways. But there is a widespread agreement that there is some sort of rational order in nature and that it is, at least partially, accessible to the human mind, that our science strives to at least approximate to that order.[29]

In aesthetic experience, however, I think we are aware of nature as having not simply a *rational* order but a meaningful and value-laden order. Of course, that things have a rational structure, that they don't just cluster together in some random fashion already makes them 'meaningful' in one sense. (And it is this basic coherence of things, the stability of their structures, that makes linguistic, semantic meaning possible.) But there is a further sense of 'meaning' that is connected to value and to purpose.[30] To see nature as having this value-laden character is to experience there being the kinds of things that there are and their having the characters they do, their connecting together and interacting in such intricate ways, as occasions, not simply for puzzlement or curiosity but for wonder, awe, and gratitude. These emotions are proper, fitting responses to the way things really are. What we respond to when we respond in this way is what Kohak calls 'the moral sense of nature'.[31] He fully recognizes that, to us moderns, this phrase is likely to sound 'obsolete' and probably 'inappropriate'.[32] But he still uses it, of course, precisely in order to startle us, to slow us down, to make us question our assumptions. So let us try and unpack its meaning.

When Kohak speaks of the 'sense' of nature he means, as I have already discussed in Chapter Seven, its coherent articulation, its being an order of essences and haecceities.[33] He notes that he is thinking in terms of the Czech word *smysl*, which 'has no exact English counterpart' but which he paraphrases as 'the meaningful presence of a reality'. This is what he is getting at when he speaks of 'the *sense* of life, the *sense* of nature' in order to 'evoke the recognition that nature does have a sense of its own, an integral mode of meaningful being'.[34] Nature is not just an undifferentiated blob of stuff, a sort of cosmic plasticine which can be moulded into any shape that we might happen to desire. There is, rather, an order in things which we didn't create and which has its own integrity and coherence. This isn't enough, though, to get us to an idea of the *moral* sense of nature. People clearing ground for open-cast mining or an office development

[29] Widespread but, of course, not universal: forms of radical nominalism have been very popular in twentieth-century French philosophy (from Sartre to Foucault and Deleuze) and are familiar in Anglophone analytic philosophy too—e.g. in Goodman and Rorty as well as in Kripke's exegetically dubious but philosophically challenging interpretation of Wittgenstein.

[30] We might at first formulate the connection between these two senses of 'meaning' by saying that something is meaningful in the broadest sense if it stands out as significant for my purposes. But those purposes themselves are only meaningful (in the richer sense) if they are directed at achieving something worthwhile. My actions can be meaningful if the things (situations, states of affairs, etc.) they are directed towards can themselves be meaningful, in the sense of valuable or worthwhile.

[31] Kohak 1984: 68. [32] Kohak 1984: 70.

[33] However, as I noted in my earlier discussion, Kohak is uncomfortable with the term 'essence'.

[34] Kohak 1984: 68, 69.

may see the forest they are destroying simply as an obstacle to be overcome, but they still have to reckon (at least to some extent) with the particular ecosystem that it is, the kinds of trees, the nature of the undergrowth, the contours of the land. So they do realize nature has a 'sense' (its own coherent structure), but they are not working *with* it as, say, a gardener is;[35] they are not recognizing that sense as placing any moral or evaluative constraints on them (and even the unavoidable practical constraints it imposes are there to be overcome as far as possible[36]). This is why Kohak insists that nature has not just a sense but a 'moral' sense, that the 'meaningful' presence of nature includes the richer, value-laden sense of 'meaningful' noted above. What he says about this deserves quoting at length:

> The sense of nature includes also a dimension of value, not merely as utility but as intrinsic, absolute value ingressing in the order of time. The chipmunk peering out of the stone fence is not reducible simply to the role he fulfils in the economy of nature. There is not only utility but also an integrity, a rightness to his presence. When humans encounter that integrity in a trillium or a lady's slipper, they tend to acknowledge it by speaking of beauty, and it's not inappropriate. It is, though, also more—the presence of absolute value, the truth, the goodness, the beauty of being, the miracle that something is, though nothing might be. With the encounter with nature in its integrity, there comes also the recognition that its presence is never free of value, acquiring its value only contingently in its utility. It is primordially good. The order of nature is also an order of value.[37]

It is this basic conviction—that the order of nature is an order of value—that underlies any more than utilitarian/anthropocentric form of environmentalism. There are, of course, good practical reasons for supposing that it will be bad for us humans if we damage our natural environment. But beyond these is this sense— however obscure, however implicit, however differently and more or less adequately articulated—that the world of non-human nature makes moral demands on us and that it does so because it is itself of value—intrinsic (not merely instrumental) value.

But does intrinsic value have to be objective value? A number of philosophers have thought it important to distinguish between two questions here: whether

[35] Of course, the extent to which gardeners do that will vary depending on how 'formal' the garden is. See Harrison 2009: ch. 10 for an eloquent expression of horror at the way in which nature is forced into subjection in the gardens of Versailles.

[36] I am, for convenience, here working with a simple, demonizing stereotype of the clearance workers. Of course, they may personally regret what they are doing, they may think it regrettable but necessary in the larger picture, and they may perhaps be right about that. The point is not to peer into their souls but to contrast the nature and meaning of the work they do—whatever their personal attitudes to it—with that of the gardener.

[37] Kohak 1984: 70–1.

value is instrumental or intrinsic and whether it is subjective or objective. John Benson, for instance, thinks confusing these two questions 'sets up a false dichotomy between instrumental value and value as a real, mind-independent property of things'.[38] The idea seems to be that we may value A for the sake of B, but B for its own sake, even if B wouldn't have had value if we didn't value it. John O'Neil thinks confusions arise from some writers conflating the *source* of value with the *object* of value.[39] Even if I am the source of the value I ascribe to X, it is still X that has the value (and it can be intrinsic if I'm not valuing X as a means to something else). Benson seems to think we are valuing something in this 'intrinsic' but still possibly subjective way so long as we contemplate it aesthetically or scientifically, rather than trying to use it for practical purposes.[40]

These arguments seem to me to neglect the necessary distinction between *values* and *valuing*. A person can value (or disvalue) something by taking up a positive (or negative) attitude towards it, or by having positive (or negative) feelings about it. And a person can in this sense value something intrinsically if he or she enjoys it for itself, not looking to gain any further practical benefit from it. But no amount of such *valuing* can by itself give something (intrinsic) *value*; make it the case that one (anyone) *ought* to value it. Valuing subjects are certainly the sources of *acts of valuing*, but it doesn't follow that they are or could be the source of *values*.[41] Thomas Hill correctly notes that to say something is valuable in itself implies not just that it is valued but that it is *worthy* of being valued.[42] But he still claims that we can make sense of this without 'resorting to a metaphysics of intrinsic value as an independently existing property'.[43] However, his suggestion for how we might do this is simply to say that the 'claim of worthiness ... seems, at least in part, to express the speaker's endorsement of valuing the object for its own sake, perhaps with an expectation that other reasonable and aware persons would tend to share this attitude if appropriately situated'.[44] This is, of course, true, but it simply leaves us asking *why* the speaker endorses the valuing or expects others to agree with it if it is not based on a recognition that the object actually has 'intrinsic value as an independently existing property'. If the expectation is that specifically 'reasonable and aware' persons would endorse the valuing, this surely implies that their doing so would be based on their awareness of or responsibility to something, and what would that be if not the object itself with its intrinsic value? That a reasonable person would think that X is A cannot

[38] Benson 2000: 6. [39] O'Neil 2003: 132.

[40] Benson doesn't actually asset subjectivism about values—he leaves that an open question—but he does think that subjectivism is compatible with valuing something intrinsically.

[41] *Pace* Callicott (1999: 248), who claims that 'From the point of view of Modern philosophy, value is conferred on or ascribed to an "object" by an intentional act of a subject... If there were no valuing subjects, nothing would be valuable.' Obviously nothing would be valu*ed* without a valuing subject, but it doesn't follow either that nothing would be valu*able* or that there is anything that valuing subjects can do to make anything intrinsically valuable that wasn't already so.

[42] Hill Jr 2019: 110. [43] Hill Jr 2019: 111. [44] Hill Jr 2019: 111.

be the ultimate ground for the judgement that X is A or make it the case that X is A; it may indeed give us reason for thinking that X is A, but that is only because we suppose that a 'reasonable' person is one who is good at spotting how things really are.

Of course, one could just redefine 'intrinsic value' in a subjectivist sense so that 'X has intrinsic value' simply means 'Someone values (enjoys, appreciates) X apart from any practical, instrumental use it may have for that person.'[45] But this notion is too thin to do any serious moral (or aesthetic) work. That X has 'intrinsic value' *for you* in this sense does nothing whatever to show that it should have any such value for anyone else, or even for you ten minutes from now, if your feeling or your attitude to it happens to have changed. (And it doesn't make any essential difference if your attitude or feeling is, in fact, widely shared in a group or even by the whole human race.) On such a redefinition, it is analytic that valuers are the source of values, but the claim has been sustained only by being rendered trivial. It would be less misleading simply to say that there are no values, only acts of valuing. Callicott claims that 'The ethically all-important distinction between instrumental and intrinsic value can...be preserved within the metaphysical constraints of the Modern world view'[46] (by which he means subjectivism about values). But I think it is clear that the ultra-thin sense that is all that subjectivism can give to 'intrinsic value' is incapable of preserving anything of ethical importance. It certainly cannot get us to Kohak's sense that nature itself makes moral demands on us.

How exactly those moral demands are to be articulated and how they are to be balanced with one another and with human needs are, of course, enormously complex issues and ones that would take us far beyond the limits of this book. The point is certainly not that human activities of clearing, pruning, culling, or even bulldozing are always wrong: as Kohak notes, we need to recognize the *relative* values of things, that some have to be sacrificed to others. Without that 'the sense of the intrinsic goodness of being would become paralyzing'.[47] He is also well aware of the pervasiveness of suffering and pain in nature itself: 'The chipmunk, searching for seeds amongst the boulders of the stone fence, companion of my days, is the food of the great owl, the majestic companion of my nights.'[48] And of course, such awareness may easily block out our awareness of the

[45] One might still wonder whether even this subjectivist valuing can *really* be thought of as intrinsic. On a subjectivist view, if I value something 'for itself', am I not really valuing it for the pleasure or satisfaction it gives me? After all, I would cease to value it 'intrinsically' if I ceased taking pleasure in it, so am I not really valuing it for the sake of my pleasure, and thus instrumentally? (The pleasure in question can be as refined, contemplative, and disinterested as you like; that isn't the issue.) So I am not sure that subjectivism can even allow for the intrinsic valu*ing* of anything other than the valuer's own happiness. I can, however, leave this as an open issue, since the inability of subjectivism to move from intrinsic valuing to a non-trivial sense of intrinsic value is sufficient for my argument.

[46] Callicott 1999: 248. [47] Kohak 1984: 98.

[48] Kohak 1984: 83.

value of things or lead us to deny any 'moral sense' in nature: 'We have seen too much of the grievous harm that beings cause one another in the order of time to retain a clear awareness of their intrinsic goodness simply in the order of being.'[49] But Kohak still insists that sense of the goodness of things is 'not ... a speculative conclusion, but ... a lived experience'. He continues:

> There is the ageless, lichen-covered boulder at the foot of the dam. I had long taken it for granted, unheeding. Only slowly did I begin to realise how intensely, fundamentally good it is that the boulder *is* ... The boulder does not do. Its presence in the order of being is obscured by the preoccupations of doing in the order of time. Humans do obscure it. When, though, the dusk suspends human doing and solitude brackets chatter, when the pain of loss reminds us of how easy it is not to be, then the lichen-covered boulder stands out in its deep goodness. It is good that it is.[50]

It seems to me obvious that this basic sense—'It is good that it is'—is what, for instance, underlies the attitude of people who campaign to save endangered species or ecosystems. Beyond any practical considerations of long-term benefits to humans, it's just good that there should be Siberian tigers or coral reefs. The order of nature—even with all its pain and predation—is one that we *rightly* respond to with delight and awe.

IV

But what does this 'moral sense of nature', this sense of its goodness, have to do with the aesthetic experience of nature? The brief answer is: everything. To respond aesthetically to nature *is* to respond to it (as it appears to us) with delight and awe, to be glad that things are, and are as they are; and this is to experience them as good (not just as pleasing to me). (To recall Ruskin's distinction from Chapter One, the serious aesthetic experience of nature with which I am concerned would count as 'theoria,' not mere 'aesthesis'.) Kohak indeed notes, in one of my quotations from him above, that we think of what we are responding to when we experience the integrity, the meaningful presence, of a delicate flower as 'beauty'. But although he says that term is 'not inappropriate', he thinks it inadequate to the range of our responses to nature. He is clearly thinking of 'beauty' in a rather limited sense, connoting gracefulness, intricacy, and delicacy, but when he goes on to talk about 'the truth, the goodness, the beauty of being', he

[49] Kohak 1984: 95; cf. also 40–6. [50] Kohak 1984: 95.

is using 'beauty' in a much broader sense[51] (the sense in which, say, the sublime can be regarded as a subset of the beautiful rather than as a contrast to it). To experience nature aesthetically is to experience it as present to us, and to do so is to experience it in its presence as good. So, on Kohak's view (which, just to be clear, I am endorsing), the aesthetic experience of nature, the experience of natural beauty broadly construed, *is* the experience of nature as good, as having a 'moral sense'. It is the experience of that in a direct, immediate, sensory way. Environmental ethics and environmental aesthetics are, in a way, one and the same.[52]

I do fear, though, that Kohak's talk of nature's 'moral' sense is too liable to mislead, even if this is the fault of what he calls the 'trivialisation' of the term in modern thought.[53] One cannot judge what happens in (non-human) nature as either moral or immoral, as one can judge human actions. Of course, it makes no sense to morally censure (or indeed praise) a hawk or owl for predating a rodent. So it is important to emphasize that what we are trying to articulate here is a notion of *ontological* rather than of moral goodness. So what sense of goodness is this? To say that nature is 'good' is to say that the deep aesthetic appreciation of nature is not just a perfunctory pleasure in a pretty surface appearance; it is not a superficial delight that is undercut when we realize what the underlying reality is. To be awed by the tiger, to be glad that there are tigers, is to delight in its strength and magnificence—in the essence of its being. That there is also something horrifying about the tiger makes the experience of it powerfully ambivalent: but that is part of what it is to experience the sublime.[54] One might try saying that in the aesthetic experience of nature we experience it as having *depth* rather than goodness; seeing things with real attention, we are awed by the intensity of their being. For instance, Charles Taylor notes that even in a post-Schopenhauerian, post-Darwinian, post-Nietzschean world, many people have still found it possible to see nature as the Romantics had, as 'a great reservoir of force, one that we need to regain contact with'. However, he continues, 'It is no longer seen as a domain of spirit, of goodness; quite the contrary. But to be cut off from it is to fall into desiccation, emptiness, dullness, a narrow and shrivelled life.'[55] But although this shift in terminology might help us to get away from the moralistic connotations

[51] Kohak 1984: 70–1. Like the medievals, he is treating it as one of the 'transcendentals'—those predicates applicable to whatever is. I will have more to say in Chapter Ten about the idea of beauty as one of the transcendentals.

[52] Of course, this is a claim that needs careful qualifications and explications if it is to stand; and it certainly doesn't mean that we only have an obligation to protect those parts of the natural world which we find immediately appealing. (That *would* be a reduction of the serious aesthetic experience of nature with which I am concerned here to a trivial 'aesthesis'.) For various helpful discussions of the relation between environmental ethics and aesthetics, see Carlson and Lintott 2008: pt 4.

[53] Kohak 1984: 70.

[54] That ambivalence is powerfully captured in Blake's famous poem, 'The Tyger'.

[55] Taylor 1989: 445.

of 'goodness', it doesn't change the basic point. The aesthetic experience of nature involves an essentially positive evaluation. The experience may not be tame or easy or pleasant, but it vivifies, makes us feel more alive. It fascinates, or, more to the point, its objects do. We are drawn to them when we experience them with aesthetic attention, and if we turn away from them, it is because that intensity has become more than we can bear.[56] It is a crucial question whether this ontological sense of the goodness (depth, intensity) of being can connect with goodness in anything like a moral sense (as Kohak believes that it does). I will have a little (though only a little) more to say about that question in Chapter Nine.

In any case: to experience nature aesthetically, to appreciate natural beauty, *is* to be delighted by it, to be glad for it. And not just instrumentally—I'm glad for this bird or that vista because it sparks off a pleasant feeling in me (through causal mechanisms that might be explained by neuroscience or evolutionary biology). To emphasize it once more, the aesthetic experience is intentional—it is part of the experience itself that it is the bird or the landscape that shows up to me as beautiful. I enjoy the experience because the object of the experience is worth experiencing. Nan Shepherd notes that when she first started exploring the Cairngorms:

> I was not interested in the mountain for itself but for its effect on me…But as I grew older and less self-sufficient, I began to discover the mountain in itself. Everything became good to me, its contours and colours, its waters and rock, flowers and birds. The process has taken many years and is not yet complete. Knowing another is endless.[57]

The aesthetic experience of nature as a good, meaningful order also, of course, includes the experience of ourselves as parts of that order (as I argued above, our experience of natural beauty is a participative one) and includes the experience of our capacity to experience it aesthetically as a capacity that is attuned to and revelatory of the deep truth of things.

Of course, none of this by itself is any sort of knock-down proof for realism about the value of nature. It is a reminder that the 'disenchanted', scientific world view, which denies that there really is objective value in nature, is not one that can take aesthetic experience (of nature or of art, given a disclosive understanding of art) seriously, at face value. It is necessarily committed to some kind of debunking, subjectivist analysis. And conversely, to think of (more to the point, to experience) nature as having aesthetic properties is to experience it as a realm of value, as

[56] 'Go, go, go, said the bird: human kind / Cannot bear very much reality' (Eliot 2020, 'Burnt Norton', lines 42–3); 'For beauty is nothing / but the beginning of terror, which we can barely endure / and we are so awed because it serenely distains to destroy us' (Rilke 'Duino Elegies I', lines 4–7). My translation for the original German, see Rilke 1995, 331.

[57] Shepherd 2011: 107–8.

having a metaphysical status that cannot be explained in the world view of disenchanted naturalism. One philosopher who has made an interesting and instructive attempt to resist this conclusion is Noel Carroll; he wants to show that we can give an objectivist account of natural beauty without going beyond an austerely disenchanted naturalistic metaphysics. He is concerned to reject what he calls a 'reductionist' view, which 'regards our being moved by nature as a residue of religious feelings',[58] that is, as a cultural hangover from a time when we saw nature as full of gods or as an expression of the divine.[59] It is interesting that Carroll seems to take for granted that if the aesthetic appreciation of nature *was* shown to be ultimately religious in character, that would serve to debunk it; but in any case he insists that 'The emotions aroused by nature that concern me can be fully secular and have no call to be demystified as displaced religious sentiment.'[60] But Carroll also wants to avoid the subjectivism according to which experiencing certain natural phenomena simply causes some people to have certain feelings which might be causally explained in one way or another—and that's it. He wants to show on the contrary that our being aesthetically moved by nature can be justified as an *appropriate* response to natural phenomena, while also showing that the appropriateness of our responses can be explained in wholly secular, naturalistic terms. And he wants to do so while also avoiding Carlson's scientistic and intellectualizing version of objectivism.[61]

In attempting to do all this he stresses, quite rightly I think, that the emotions have a cognitive dimension; they are not mere brute feelings but are ways of responding to a situation and can be assessed as appropriate or inappropriate. So, he says, 'Suppose ... I am exhilarated by the grandeur of [a] waterfall. That I am exhilarated by grandeur is not an inappropriate response, since the object of my emotional arousal is grand'.[62] I'm happy to agree with this. But what does Carroll mean by the 'grandeur' that he ascribes to the waterfall? He says that:

All things being equal, being excited by the grandeur of something that one believes to be of a large scale is an appropriate emotional response ... If someone denies being moved by the waterfall, but agrees that the waterfall is large scale and says nothing else, we are apt to suspect that his response ... is inappropriate.[63]

[58] Carroll 2008: 171.

[59] Rather as the secular notion of moral obligation was seen by Anscombe as a 'survival' from a theistic world view, which has persisted despite the loss (for many) of the context which is needed to make sense of it. See Anscombe 1958.

[60] Carroll 2008: 171.

[61] At least he wants to say that the aesthetic experience of nature doesn't *need* to take the form that Carlson thinks it does. See Carroll 2008: 170–1.

[62] Carroll 2008: 175. [63] Carroll 2008: 180.

Here 'grand' seems just to mean 'big', or big relative to us. Well, of course, the size of a waterfall or a mountain—and its scale relative to us (a giant may well find the waterfall less impressive)—is important for our aesthetic response to it. But 'grandeur' carries emotive and evaluative connotations which are simply not present in 'big' or 'large-scale'. Of course, we should be exhilarated by grandeur, because 'grandeur' is a 'thick' evaluative term;[64] part of what it means to call something 'grand' in this sense is that it is appropriately responded to with exhilaration (or awe or something of the kind). But if 'grand' is taken simply as a synonym for 'big (relative to us)', then that doesn't by itself call for any particular response as appropriate or inappropriate. It seems that the only objective sense in which things can be said to be 'grand' in the disenchanted world view that Carroll takes for granted is that they are large relative to a particular class of perceivers. But to claim that 'grandness' *in this sense* renders it appropriate to respond to them with the exhilaration due to grandeur in the richer sense simply depends on an equivocation.

Carroll seems tempted to bridge the gap between 'big' and 'grand' by appealing to intersubjectivity: 'If the belief in the large scale of the cascade is one that is true for others as well, then the emotional response of being excited by the grandeur of the waterfall is an objective one.'[65] But why should it help that everyone else agrees that it's big (relative to a normal human scale)? It would be odd if they didn't. This still doesn't get us to the waterfall itself making our exhilaration appropriate; indeed, on this communal account, 'appropriate' just seems to mean in conformity with some social standard of what a 'proper' reaction to nature is. We are just swapping subjectivism for cultural conformity. Carroll does try to respond to this worry by suggesting that there is a non-arbitrary basis for our tendency to intersubjective agreement in our responses to natural phenomena. For him, though, this is something to be explained scientifically. He refers to various attempts at evolutionary explanations of such responses. For instance:

> when we find a natural environment serene, part of the cause of that sense of serenity might be its openness—the fact that nothing can approach us unexpectedly across its terrain. And such a response need not be thought to be mystical nor a matter of displaced religion. It is connected to information processing moulded by our long-term evolution as animals.[66]

But here Carroll seems to have slipped back into a debunking scientism. He wants to say that my delighted response to the landscape as serene is appropriate, not because the landscape really is serene, but because he can give a causal explanation

[64] The distinction between 'thick' and 'thin' evaluative terms has been much discussed in ethics since it was introduced by Bernard Williams (1985: 129–31, 140–5).

[65] Carroll 2008: 180. [66] Carroll 2008: 184.

of why looking at it gives rise to certain feelings in me (and in humans generally). But this is just subjectivism, albeit of a collectivist kind, underpinned by an allegedly scientific explanation of the relevant psychology. Carroll does try to distinguish his position from Carlson's scientism by pointing out that for him (Carroll) we are not appreciating the evolutionary mechanisms that give rise to such feelings but are just enjoying the feelings (the appreciation of serenity) without necessarily giving any thought to the mechanisms underlying them.[67] But this is precisely what is characteristic of debunking accounts: according to them, we *think* we are responding to the actually serene quality of the landscape, but *really*, it's just an effect in us brought about by... The only objective facts referred to are disenchanted (i.e. value-free) ones—the openness of a stretch of terrain and thus the capability it affords to certain creatures of scanning it for signs of danger. And nothing in any such account can explain how an evaluative response (one involving irreducibly evaluative concepts such as grandeur or serenity) can be *appropriate* (justified as fitting its object) rather than just explicable in causal terms.

Carroll's attempt to give an account of how our aesthetic/emotional responses to nature can be appropriate (justified, in some sense objective) while accepting the standard disenchanted picture of the natural world seems to me to fail, but the failure is an instructive one. For it is hard to see what other options can be left to a non-realist about the intrinsic value of nature who still wants to be an objectivist about aesthetic judgements. If our aesthetic response to nature isn't justified by the actual (intrinsic) grandeur, serenity, etc. of the phenomena, then it isn't justified either by our understanding those phenomena to have certain scientifically ascertainable features (Carlson) or by our experiencing in a more immediate way that they are *big* (or whatever) (Carroll). And it seems the same would apply to any account which takes the bottom-line facts of the world which we experience aesthetically as lacking any real, intrinsic aesthetic value, as being accurately and adequately characterized in completely value-free terms (whether scientific or more everyday/intuitive). Judgements of value (whether aesthetic or ethical) cannot be justified by reference to purely value-free facts. That is what is true in the traditional fact–value distinction; what is false about it is the claim that all facts (or perhaps any facts) *are* value-free. But *if* the only facts *were* value-free, then there could not be any justified evaluative judgements.

[67] Carroll 2008: 185.

Chapter Nine
The Re-Enchantment of the World

I have been arguing for realism about the aesthetic properties of the natural world—that there is real beauty (sublimity, etc.) 'out there' in the world. But I have also argued against thinking of these aesthetic properties in a compartmentalizing and perhaps trivializing way, as though they constituted a realm of their own, distinct from other forms of value. On the contrary, to experience nature aesthetically is to experience it as ontologically good. The beauty of things is, one might say, the way their goodness shows up to us. I noted in Chapter Two the problems for aesthetics caused by the 'disenchantment' of the world that is characteristic of modernity—the loss of belief in the goodness of being, in a meaningful cosmic order, in the objective value of the world. The older aesthetics based its account of the value of art on a more fundamental account of the value of nature (in the broadest sense). Modern aesthetics, having lost a sense of the latter, has struggled to account for the former. On the view I have developed here, this struggle cannot succeed. If art—painting—is valuable because (to put it very crudely) it makes nature present to us, then nature itself must be of value. Neither the aesthetic experience of nature nor that of art can be veridical—be anything other than a pleasing illusion—unless nature constitutes a meaningful order which is at any rate, as I have said, 'ontologically' good (however that might relate to moral goodness). In other words, to make sense of aesthetics, we need— to use a term that has been much in vogue lately—a 're-enchantment' of the world: although I think it would be better to talk about finding ways to look at the world so as to see that it *is* and always has been 'enchanted' (beautiful, meaningful, value-laden) and that it is the view of the world as a value-free mechanism that is our distorting projection.[1]

I

I have been using the terms 'disenchantment' or 'disenchanted naturalism' fairly freely and intuitively up to now, as referring to a view of the world as lacking inherent value, but it might be helpful at this point to attempt a somewhat more

[1] Despite this I will continue to talk about 're-enchantment', since the term has become well-established. For some examples of recent works discussing 'the re-enchantment of the world' from various perspectives, see Bilgrami 2014; Taylor 2011; Graham 2008; Smith 2008; McGrath 2002.

Painting and Presence: Why Paintings Matter. Anthony Rudd, Oxford University Press. © Anthony Rudd 2022.
DOI: 10.1093/oso/9780192856289.003.0010

precise characterization. What is definitive of disenchanted naturalism ('DN') as I am using that term is not the denial of rational order in the universe—the order of natural law that science investigates—but of something further, an order of meaning or of value.[2] While DN accepts that the natural world obeys natural laws and exhibits order and regularity, it supposes that that order has no normative dimension. It has no inherent *rightness* to it. It isn't in any objective sense good. Nor does it exist for any purpose or have any meaning. That things are and that they are as they are are simply brute facts. Nor is this order one in which we— self-conscious rational beings, persons—have any particularly significant place. We are late, local evolutionary accidents. The basic argument for DN points to the achievements of the natural sciences and claims that they have enabled us to explain (or to see in principle how to explain) nature, at least at the most ontologically basic level, in terms that are neither normative nor teleological nor mentalistic. Reductive/eliminative versions of DN claim that *everything* can ultimately be explained in natural-scientific terms. But there are also non-reductive versions, which deny that science can explain or eliminate, for example, conscious experience or the need for teleological explanation of human actions. They do still assume, however, that the inanimate, material world—what is taken to be ontologically most basic—is not mentalistic, teleological, or imbued with inherent value. And while some versions of DN are entirely subjectivist about value, others may think there is a rational, for example, constructivist basis for value judgements within the human sphere, even though values are not 'out there' in the world.

The contrast is clear, however, between all forms of DN and premodern (though, of course, still widely held) views according to which there is a cosmic order that is at once rational, value-laden, and purposive and in which humans (persons) have some special significance.[3] Such views may take the order of the natural world to be rooted in a further, transcendent reality or see it as purely immanent, but both kinds of view are rejected by disenchanted naturalism. (It should be noted that this terminology would allow for a view being 'naturalistic' but not disenchanted—one could indeed describe what I have just called the 'purely immanent' visions of cosmic order as forms of 'enchanted naturalism'.[4]) I will not be trying to develop or defend a detailed theoretical account of nature as a realm of objective value. My account of painting does depend on the general

[2] There is a further—arguably even more disenchanted—philosophical option: the radical nominalism that I referred to in Chapter Seven, which denies that there is even a rational order in nature, let alone an order of value, and treats even science as a kind of fiction.

[3] This is not to say that these views necessarily suppose that the world revolves around us, in the sense of simply existing for our benefit.

[4] Note that 'enchanted' naturalism is more than just non-reductive naturalism: it sees human beings not simply as having irreducible mental states, but as existing in the context of a meaningful cosmic order. Corrington (1992 and other works) uses the term 'Ecstatic Naturalism' for his version of such an outlook; see also Niemoczynski and Nguyen 2015.

assumption that nature is meaningful in this sense and that we experience it as such in our serious aesthetic appreciation of it. But this experiential sense of nature as beautiful, as ontologically good, as meaningful—or, to anticipate slightly, as sacred—is prior to the attempts that have been made to further articulate that sense in different traditions. My primary concern is with the basic vision, not with defending one or other more specific articulation of it (though some of my preferences in that regard will become evident). And the only positive argument for that basic vision is, I think, phenomenological, one that directs us to attend closely to our experience of the world as a meaningful order—as I have tried to do in Chapter Eight.

The claim that in aesthetic experience we enjoy a vision of the real value of nature—one that had been occluded by Enlightenment scientism—was, of course, central to Romanticism. Perhaps the most famous articulation, at least in the English-speaking world, of the Romantic view of 'enchanted' nature is Wordsworth's, from his *Tintern Abbey*:

> And I have felt
> A presence that disturbs me with the joy
> Of elevated thoughts; a sense sublime
> Of something far more deeply interfused,
> Whose dwelling is the light of setting suns,
> And the round ocean and the living air,
> And the blue sky, and in the mind of man:
> A motion and a spirit, that impels
> All thinking things, all objects of all thought,
> And rolls through all things.[5]

Nature, when experienced intensely, aesthetically, in full attention to its detailed particularity, points to 'something', to a 'spirit' that isn't simply identical to the particular phenomena of nature (the sun, the ocean, the sky) or to them as a totality but isn't clearly distinct from them either. It would be missing the point to ask Wordsworth to develop a precise philosophico-theological account of the nature of this 'spirit'; he is evoking a vision, an experience, of the sacred in nature, not theorizing about it. For this way of thinking or form of sensibility, to see nature truthfully is to see it as manifesting, giving expression to, this spirit which 'rolls through all things'—including the human mind that perceives it in nature. This makes the vision a profoundly participative one: I recognize myself as also an expression of the same essential spirit that I see around me in nature.

[5] Wordsworth, 1971, 23–4: lines 94–103.

Wordsworthian 'nature mysticism' is sometimes discussed in modern analytic aesthetics, but usually with a sort of embarrassment or discomfort. T. J. Diffey, for instance, while clearly feeing an attraction to it, concludes that:

> The modern world...does not permit us a Wordsworthian faith in the divinity of nature. Indeed, the beauty of the landscape now has in some degree to *compensate* those of us who cannot, or can no longer, believe that in nature we are in the presence of some kind of noumenal meaning.[6]

It will be clear that, given my commitment to an account of aesthetic experience in general as disclosive of the depths of things (their 'noumenal meaning' if you like), I cannot make this distinction between beauty and deep meaning. But why should we think, as Diffey obviously, though wistfully, does, that 'the modern world' rules out the Wordsworthian vision? I think lots of people today still find that Wordsworth or other poets who have articulated comparable visions do speak for them, do put words to what they have experienced in nature. But despite that, many contemporary philosophers clearly assume that 'we' can't really believe that sort of thing any more, that the idea of re-enchantment is a nostalgic delusion. If so, then, of course, my whole project collapses. But is there any good reason to think so? Philosophical and/or theological theories which have tried to articulate an 'enchanted' or re-enchanted outlook in more precise or specific terms are, of course, open to all sorts of specific criticisms, to which they may or may not be able to adequately respond; but is there any good reason to suppose from the start that the whole project of re-enchantment must be a delusion?

The most common basis for the assumption that the disenchanted world view is the only option for us now is surely the belief that science rules out Wordsworthian 'spirit'. It is not very clear why we should think that, though. Have careful scientific investigations revealed that there is, as a matter of fact, no spirit dwelling in the light of setting suns, the round ocean, and the living air? Have we looked very carefully for it in those places with our most accurate scientific instruments and failed to find it? The silliness of these questions should alert us to the dubiousness of the claim that such Wordsworthian belief is somehow 'unscientific'. Obviously it is *not* scientific: it is not suggesting a hypothesis for scientific investigation, but that doesn't mean that it is *anti*-scientific or contradicted by any established results of science. But given the widespread assumption that disenchanted naturalism (DN)—as defined above—is somehow supported by the authority of science, it is worth examining this question in at least a little more detail.

[6] Diffey 1993: 59.

Science has investigated the natural, physical world and is, indeed, able to explain much of what happens in it in mechanistic, value-free, and non-mentalistic terms. However, as I have already suggested in Chapter Seven, it would be radically misleading to say that science has looked very carefully at the world (or even just the inanimate, non-biological world) and has not found any values or purposes there. For 'science' as we have come to think of it (and create it) since the seventeenth century is a way of looking at the world that excludes and sets aside purposes, qualities, values, and indeed mentality and subjectivity. It looks only at the objective, quantitative, and mechanical-causal aspects of reality. I am happy to accept (*pace* radical Rortian pragmatism or Foucauldian postmodernism) that these aspects are perfectly real, not just social constructions or whatever, but I also think that meaning and value are real too, and not just our projections. A picture of the world that refers only to those aspects of it that modern natural science studies is an idealization or abstraction, not a complete representation of how things really are. As Kohak puts it:

> Sensing the life of the forest around me, I think only a person wholly blinded and deafened, rendered insensitive by the glare and the blare of his own devices, could write off that primordial awareness of the human's integral place in the cosmos as mere poetic imagination or as 'merely subjective'. The opposite seems far closer to the truth. It is what we are accustomed to treating as 'objective reality'—the conception of nature as a system of blind matter propelled by blind forces—that is in truth the product of a subject's purposeful and strenuous activity, a construct built up in the course of an extended, highly sophisticated abstraction. It is, undeniably, a highly useful construct for accomplishing a whole range of legitimate tasks. Still it is a construct, not an experiential given.[7]

To say that science as we now think of it has not found purpose, value, or mind in nature is a bit like saying that we have scanned the heavens with our telescopes and not observed God or that the soul has simply failed to show up when we have done fMRI scans. That we can't see God with a telescope is analytic (anything we could see through a telescope would, by definition, not be God), and it is not, therefore, any evidence against the existence of God that we have failed to do so. Similarly with the idea that Wordsworthian spirit does not show up in our scientific investigations of the round ocean and the setting sun.

In response a proponent of DN may agree that, of course, science could not in principle detect God, values, purposes, etc. But the serious argument for DN is that the model of the world which science creates and which makes no reference to any such things has proved to be perfectly adequate explanatorily. We don't

[7] Kohak 1984: 6.

reject value, teleology, etc. because we have failed to detect them with instruments (physical and conceptual) that were never intended to detect them; we reject them because we can explain everything perfectly adequately without them. There are two responses that a critic of DN can make to this. The first—directed against the more hard-line, reductive/eliminative versions of DN—is to note that we cannot, in fact, explain everything without reference to mind, meanings, values, and purposes, for we have completely failed to explain human psychology in that way. The dream that we could have an adequate psychology that was completely reductive, mechanistic, and non-teleological remains just that—a dream. And this is as true today, with our impressively developed neuroscience, as it was a century ago at the birth of behaviourism. Hard-line materialist philosophies, such as those advocated by Daniel Dennett or by Paul and Patricia Churchland, with their denial of the reality of human mental life—even down to the basic fact of conscious experience—really are unacceptable.

Of course, proponents of non-reductive disenchanted naturalism will be happy to agree with this. They will accept the irreducible reality of mental phenomena (or at least some of them) in humans and maybe other animals. But they will still want to exclude reference to mind, meaning, and value (MMV) from the explanation of non-human (or perhaps even just of non-biological) nature. They suppose that the ontologically most basic levels of reality can still be explained adequately in purely natural-scientific terms, without reference to MMV. This is where the second anti-DN response comes in, and this is to ask: adequate for what purposes? A purely mechanistic, value-free account of, at any rate, inanimate nature may well be adequate for some purposes—notably prediction and control. This does not mean that it is adequate for other 'purposes'[8] or, to put it in a better way, that it is adequate to make sense of our experience of nature when we approach it with different concerns, for instance, to simply appreciate it or to dwell with it. If you want to move the old lichen-covered boulder that Kohak referred to, or to blow it up, or to use it to hold something down or prop something up, then physics may be a good enough guide and you need not mention the experienced goodness of the boulder. But the purely scientific account is patently inadequate to the contemplative—but also active and participatory—dwelling with things that Kohak describes.[9] One can certainly recognize that *science* is justified by the explanatory success it does indeed achieve

[8] I use scare quotes since the whole notion of a 'purpose' may carry connotations of practical, instrumental thinking that would distort our understanding of what aesthetic contemplation is.

[9] Actually, moving it or using it in some ways may constitute ways of appreciating and dwelling with the boulder and need not conflict with the aesthetic appreciation of it or the recognition of the deep ontological value of its being. The contrast is really with treating it simply as a resource to be used for our purposes. See Dustin and Ziegler 2007, which is concerned throughout with the idea that craft—an active engagement with things that respects their integrity, works with their grain—is a kind of aesthetic contemplation and that contemplative thinking is itself a craft. The contrast is not between contemplation and active crafting in this sense, but between both of them together on the one hand

in its own sphere, that it does serve some of our purposes very well. But to say that this by itself is enough to justify a disenchanted naturalistic philosophy is to assume that we have no other relevant purposes.

It is also worth noting that a non-reductive but still disenchanted naturalism which accepts the reality of mind, meaning, and value (MMV) in the human realm, while denying that they characterize the more ontologically basic level of reality, is committed, despite itself, to a kind of radical dualism. The human realm is pervaded by MMV, but they do not apply to the realm of non-human nature, which, according to DN, simply consists of mindless, purposeless, and valueless stuff moving around according to mechanistic laws. And yet humans are supposed, on any naturalistic view, to be parts of nature, and the natural world, while differentiated in all sorts of ways, to be characterized by no yawning qualitative gaps. The anti-reductionism pulls one way while the defining commitment of DN—its refusal to admit MMV at the ontologically basic level— pulls in another. To insist on the reality of MMV in the human sphere while denying its reality beyond it is to posit human existence as incomprehensibly separated from the rest of nature. In particular, it seems impossible for a non-reductive version of DN to explain how MMV could have developed in the first place.[10] The point can perhaps be made most clearly if we focus on the case of conscious experience. Something qualitatively different from anything at the (*ex hypothesi* purely objective, physicalistic) base level is supposed to have come into being as a result of developments at the base level, but in a way that nothing about the base level can explain. If it could explain it, we would be back to reductionism; but if consciousness really is irreducible, and if what is ontologically most basic is just bare non-conscious physical stuff, then the emergence of consciousness from the ontological base cannot be intelligible.[11]

Obviously, these are no more than sketches for arguments which would need to be spelled out at much greater length.[12] But I hope to have indicated why I don't think DN ought to be taken as a default position, why I don't think that someone whose experience of the natural world has left him or her with something like the sense that Wordsworth or Kohák articulates—the sense of it

and the modern technocratic mindset on the other, which treats everything as mere resource, to be used for whatever purpose we can impose on it.

[10] On this, see Nagel 2012.

[11] It is significant that a realization of what a deep problem this is for standard versions of non-reductive naturalism in philosophy of mind has led in recent years to a revival of interest in panpsychism, and/or 'Russellian monism.' These views suppose that mentality or proto-mentality is a pervasive characteristic of reality (although full-blown minds only emerge when proto-mental elements are combined in the right way under very special evolutionary conditions). This represents in my terms a move—albeit partial and limited—away from *disenchanted* naturalism altogether (although its proponents are usually still keen to call themselves naturalists). See Alter and Nagasawa 2015 and Buntrup and Jaskolla 2016.

[12] For a recent collection of essays criticizing naturalism that in various ways flesh out the arguments sketched above, see Copan and Taliaferro 2019.

expressing a 'spirit' or an order of meaning or value—should feel that intellectual rigour forces him or her to reject that experience as illusory. I have emphasized that one can reject DN while still endorsing science, and indeed scientific realism; there is nothing in science that refutes Wordsworth, but also nothing in the Wordsworthian vision that requires us to reject any established results of science. I also hope that my emphasis on the aesthetic qualities of nature will not be taken to imply a sharp contrast between the aesthetic and the scientific. Science should not be caricatured as something cold, dispassionate, exploitative. Nor is it fair to suggest that science is simply driven by concerns for prediction and control, with all the overtones of the technocratic domination of nature that these might suggest. Although there certainly is a connection between the scientific way of looking at the world and the purposes of prediction and control, this should not be taken (as it is perhaps by some Foucauldians) as a reductive, debunking move. Not only are the aspects of things that science considers perfectly real, but they can be contemplated aesthetically (even if it was initially for practical reasons that we learned to focus on them), and they have their own beauty. Much of science is, I suspect, actually driven by an awed delight in the intricacy of the natural world, and it is a familiar point that scientists are often struck not only by the beauty of many of the particular entities they study (from stars to birds) but also by the beauty (elegance, harmony, symmetry) of natural laws and are drawn to the hypotheses that postulate the most beautiful laws. But as with the more immediate aesthetic response to the beauty of nature, it is hard to see how these responses could be justified or made sense of within a disenchanted ontology. As Mary Midgley notes, one cannot make sense of the value of science (any more than of art) in an otherwise value-free world: 'The world that we think *about* has to be seen as important, as having value in itself, if we want to claim that there is any great value in thinking about it.'[13] If this is so, then DN is unable even to give an adequate account of the science from which it claims to take its bearings.

II

If, as I have argued, the aesthetic experience of nature itself contradicts disenchanted naturalism and if attempts like Carroll's to give a non-subjectivist but still 'fully secular' account of natural beauty fail, should we conclude that there is, after all, an essentially religious dimension to the aesthetic experience of nature? Well, it depends on what you mean by 'religion'. If one takes the term 'religious' in a fairly (but not I think excessively or idiosyncratically) broad sense, one could say that the vision of the cosmos as meaningful and value-laden, which

[13] Midgley 1992: 72.

modern disenchantment rejects, could properly be called a religious vision (whether or not it is further spelled out in theistic terms and whether or not it is connected to any particular religious institution or tradition). Some may prefer to keep the term 'religion' to refer to belief in a cosmic order based on an ultimate transcendent reality, rather than a purely immanent cosmic order. To me this seems a distinction between two different kinds of religious vision—putting it *very* crudely, one might say between theism and pantheism—but it will be important not to get stuck on questions of terminology, particularly concerning a term which is both as vague and as contentious as 'religion'—and it is to some extent a terminological choice whether we want to say that a non-disenchanted view of the world is by definition a 'religious' one.

I am, however, still inclined to say that it is and thus to use 'religion' in a broad sense. This is because I think that what we have come to call the various 'religions' are attempts to further articulate (and to prescribe ways of living in the light of) a basic experiential sense of the sacred, the holy, the numinous. And this sense is at least very closely connected to what we now think of as the 'aesthetic' appreciation of nature—and of art. It should be born in mind that 'religion' itself is a modern, Western concept—as 'art' and the 'aesthetic' also are. In modern Western (or Westernized) societies 'religion' has been invented (or socially constructed) as a somewhat marginal social phenomenon, distinguished from, for example, politics, economics, art, and other compartmentalized forms of social life. In premodern societies, by contrast, the sense of the sacred permeated all social forms and activities.[14] So a contemporary proposal to see art or the aesthetic experience of nature as essentially religious is liable to appear as a quixotic take-over bid, an imperialist attempt by one marginal cultural form to swallow up another (or others). My suggestion is not that what we have now come to think of as the 'aesthetic' should be understood as 'really' part of what we have now come to think of as the religious but that our current sense of the aesthetic is a descendant of a sensibility in which the aesthetic and the religious were not divided. It is crucial here to proceed phenomenologically, to take 'the religious' back to its experiential roots. To see the world 'religiously' is not to first develop a theory, for example, that there are such and such gods and *then* experience the world as displaying traces of their activities. It is to start by experiencing the world as being filled with sacred, numinous, sometimes consoling, often terrifying energies. Talk about the gods—theologies in a literal sense—comes afterwards, as attempts to articulate such experiences.

[14] Of course, this is a huge generalization and is subject to all the qualifications that must attend such generalizations. But it is still, I think, as broadly true as such generalizations get. See Taylor 2007 for the best account that I think we have of the process which has taken us from the pervasive sense of the sacred to its current marginalization.

Linda Zagzebski has helpfully directed philosophers of religion back to considering the experiential roots of religion:

> It is doubtful that there is any belief common to all religions, but all religions express and foster a sense of the sacred. I am convinced that the sacred is indefinable...we do not really understand it until we have had the characteristic emotion associated with it...to understand the sacred one must have felt reverence. Reverence is an emotion directed towards the sacred...Beliefs typically appear when a person becomes reflectively aware of his or her emotion and trusts it, so beliefs are consequent to the emotion. If so, the emotion of reverence is a more basic feature of religion than any belief.[15]

I would qualify this statement slightly to emphasize that the emotion of reverence is intentional and contains an element of belief—that *this is sacred*. (Emotions are not just raw feelings—they are intentional and have cognitive purport.) Awe or reverence is the first form that belief in the sacred takes—it is articulated discursively later.[16] But I agree with Zagzebski that one cannot understand what the sacred is or what reverence is without having felt reverence, experienced the sense of the sacred—though I think one can get hints or intimations of it by reading or hearing good first-person descriptions or evocations of it. So I won't be proceeding by attempting a definition of the sacred. But I do not think the experience of it is anything esoteric or remote but is something entirely natural to, and deeply rooted in, human beings. As the great historian of religion Mircea Eliade notes:

> Experience of a radically desacrilized nature is a recent discovery; moreover, it is an experience accessible only to a minority in modern societies, especially to scientists. For others, nature still exhibits a charm, a mystery, a majesty in which it is possible to decipher traces of ancient religious values. No modern man, however irreligious, is entirely insensible to the charms of nature. We refer not only to the esthetic,[sic] recreational, or hygienic values attributed to nature, but also to a confused and almost indefinable feeling in which, however, it is possible to recognize the memory of a debased religious experience.[17]

Eliade is here, of course, accepting the conclusion that Carroll wanted to avoid—that the aesthetic experience of nature is indeed a residue of, or a descendant of, an experience of nature as sacred and that if we managed to abstract away from

[15] Zagzebski 2007: 2–3.
[16] I don't think I am disagreeing substantively with Zagzebski here: she is using 'belief' more narrowly than I am to refer to consciously articulated beliefs.
[17] Eliade 1961: 151–2.

that entirely, we would only be left with an experience that was 'esthetic' in the trivializing sense of superficially agreeable to the senses.

Keith Ward, trying to reach back to the experiential sense underlying the stories of the Greek gods, notes that 'When we get through the veil of literalization, we see that we are not dealing with quarrels among a race of superhuman persons. We are dealing with the raw energies of the natural world, beautiful and terrifying in their power.'[18] However, the gods are not just picturesque ways of talking about natural forces. They don't just 'stand for' the sun, the sea, the power of the storm, or the fecundity of the earth, regarded simply as mechanically understandable value-free phenomena in the style of modern naturalism. Rather, the gods personify, sum up, a way of experiencing those natural forces as irreducibly sacred, as having an inherent value, a goodness that perhaps has little to do with moral goodness, an intensity of being to which we appropriately respond with awe and reverence:

> the gods … are stupendous energies, which are not so much malign as indifferent to concerns of human well-being and morality. They are the energies of the cosmos, or, more properly, energies which express their natures in and through the cosmos. They are beneficent energies of new life and startling beauty, but also fearsome energies of death and time … [T]he total sense of the holy is the sense of a reality at once wholly beyond rational comprehension or description, which fills one with awe and dread, yet at the same time evokes fascination and irresistible desire.[19]

This sense of the natural world as sacred is not simply something irrevocably past and lost; even where the gods are no longer explicitly worshipped (and they still are, in one form or another, in much of the world), they may live on in metaphor or image. And even when they are no longer referred to at all, the kind of experience of nature that Ward describes remains possible and actual, though now redescribed as aesthetic. A number of conscious attempts at a re-enchantment of the world have indeed invoked 'the gods'—most influentially Nietzsche's and Heidegger's.[20] More recently Hubert Dreyfus and Sean Kelly have argued that we can overcome the sense of boredom and emptiness that they see as pervading modern life by surrendering to the basic energies or intensities of life that found classic expression in Homeric polytheism. For Homer, *physis* ('nature'):

[18] Ward 2002: 10. [19] Ward 2002: 27, 29.

[20] Julian Young (2006 and 2002) has argued that both Nietzsche and Heidegger have a fundamentally religious—ultimately pantheistic—vision. (The gods are personified aspects of the one divine reality.) These are obviously controversial readings, but I'm afraid I do think that the legion of commentators who have tried to deny, minimize, or ignore the religious element in Nietzsche's and Heidegger's thinking are trying to pretend that an elephant in the room isn't really there.

is the name for the way the most real things in the world present themselves to us...the most real things...well up and take us over, hold us for a while and, then, finally, let us go. If we had to translate Homer's word, *physis*, then whooshing is as close as we can get. What there really is, for Homer, is whooshing up.[21]

What, though, about *theistic* religion? Can this allow for a sense of the sacred in nature? Theism, with its stress on the divine as transcendent, as above or beyond nature, has often been either praised or blamed for the desacralizing of nature that was eventually taken up and extended by scientific materialism.[22] This is a huge and complex topic, and certainly one can see events such as the conflicts between the followers of Yahweh and those of the *baalim* (nature gods) in ancient Israel, and the cutting down of sacred oak groves by Christian missionaries in early medieval Germany, as testifying to a theistic refusal to accept the particularizing or localizing of the sacred.[23] On a more intellectual level, I think there is no doubt that the stress on absolute divine sovereignty in late medieval nominalism was a major source, historically, for the disenchantment of nature that was eventually more fully accomplished by the rise of modern science and its associated technology.[24] But theism has always sought to balance the idea of divine transcendence with that of God's immanence within creation. How this has been done has, of course, varied widely, but even Calvinism, which has particularly stressed divine transcendence (and has been particularly blamed or credited accordingly for its role in bringing about disenchantment) has, in fact, seen God's creation as beautiful and to be delighted in, rather than fled from in Manichean distain or treated manipulatively for purely utilitarian purposes. According to Calvin himself, God has:

> displayed his perfection in the whole structure of the universe. So he is constantly in our view and we cannot open our eyes without being made to see him. His nature is incomprehensible, far from human thought, but his glory is etched on the creation, so brightly, clearly and gloriously, that no one, however obtuse and illiterate, can plead ignorance as an excuse...Wherever you look, there is no part of the world, however small, that does not show at least some glimmer of beauty; it is impossible to gaze at the vast expanse of the universe without being overwhelmed by such tremendous beauty...The superb structure

[21] Dreyfus and Kelly 2011: 200–1.

[22] *The locus classicus* for the now often repeated blaming of Judaeo-Christian theism for the development of an exploitative attitude to nature in the West is Lynn White (1967). For a variety of recent reflections on White's claims, see LeVasseur and Peterson 2017.

[23] Of course, established theistic religions have never themselves dispensed with localized sacred spaces, rituals, etc., as reformers in both Christianity and Islam have often complained.

[24] On the pivotal role played by Occam's nominalism in the development of disenchantment, see, e.g., Gillespie 1995; Pfau 2013: 160–182; and Farrell 2019: 1–19. See also Spaemann 2015a: 47–53 and 2015d: 24–9.

of the world acts as a sort of mirror in which we may see God, who would other-wise have been invisible.[25]

We looked in Chapter Five at various ways in which painting might be thought to make the invisible visible; here Calvin argues that—seen in the right way—nature itself makes God visible.[26] It is important to distinguish this experience of God as manifest in nature from any kind of inferential 'argument from design' which would posit God as the most plausible causal explanation for the beauty, order, intricacy, etc. of nature.[27] Rather, nature is a theophany—a showing or revelation of God—and the experience of it as such is an intensely emotional and personal one. Consider this testimony from the eighteenth-century American Calvinist theologian, Jonathan Edwards:

> my sense of divine things gradually increased, and became more and more lively…the appearance of everything was altered; there seemed to be, as it were, a calm, sweet cast, or appearance of divine glory, in almost everything. God's excellency, his wisdom, his purity and love, seemed to appear in everything; in the sun, moon and stars; in the clouds and blue sky; in the grass, flowers and trees; in the water, and all nature…I often used to sit and view the moon for a long time; and in the day, spent much time in viewing the clouds and the sky, to behold the sweet glory of God in these things…I felt God, if I may so speak, at the first appearance of a thunder-storm; and used to take the opportunity at such times, to fix myself in order to view the clouds and see the lightnings play, and hear the majestic and awful voice of God's thunder, which oftentimes was exceedingly entertaining.[28]

In this ecstatic revelling in nature as a manifestation of the divine, Edwards seems positively Romantic. It would be easy to compile a large anthology of such remarks from many different theistic traditions. (I have chosen Calvinism simply because it might have seemed *less* likely to encourage such attitudes than other traditions.[29]) The texts I have cited certainly express an 'aesthetic appreciation of nature'; Calvin speaks of the 'tremendous beauty' of the natural world. But it is a beauty that reveals God to us—it is, therefore, I think, proper to say that these remarks also express a sense of nature, qua theophany, as sacred. But I should cancel the word 'also': the theophany is accomplished in and through the beauty.

[25] Calvin 1986: 32–3.

[26] While, of course, remaining, *literally*, invisible—not something one could see through a telescope.

[27] As Alvin Plantinga (2000: 175), consciously following Calvin, writes, 'The heavens declare the glory of God and the skies proclaim the work of his hands; but not by way of serving as premises for an argument.'

[28] Edwards 1966b: 85. See also Edwards 1966a: 251–3.

[29] See Lane 2011 for a fascinating account of Calvinist theologies of natural beauty.

Of course, different theistic traditions, different theologies, have understood God's relation to nature and the aesthetics of nature in a variety of different ways, and I cannot attempt a survey in a context such as this. But I do want to emphasize how hopelessly artificial it would be to suppose that one could separate out what is 'aesthetic' and what is 'religious' in experiences like those that Edwards records, or in Thomas Traherne's affirmation:

> You never enjoy the world aright, till the Sea itself floweth in your veins, till you are clothed with the heavens, and crowned with the stars…The world is a mirror of infinite beauty, but no man sees it. It is a temple of Majesty, but no man regards it. It is a region of light and peace, did not men disquiet it. It is the paradise of God.[30]

III

Like Eliade, Ward is clear that this sense of the world as sacred still lives on in what we think of as the aesthetic experience of nature at its deepest:

> There is a knowledge which cannot be articulated, an apprehension which eludes conceptual thought, a sense of 'presence' which all our images and symbols only dimly express, before which we can in the end only be silent, speechless…And we may sometimes sense the intoxication of beauty, almost too intense to bear, as we suddenly, in a miraculous moment, discern the world in all its intricate order and subtle intensity.[31]

But if there is at any rate some close connection between the experience of the world as sacred, as full of gods, and the (serious) aesthetic experience of the world as beautiful (sublime, etc.), what, more exactly, is that connection? Am I saying that the experience of a nature lover in contemporary Western(ized) society is really the same as that of a worshiper of the gods in a polytheistic culture? Or that a theist's experience of nature as manifesting God's glory is really the same as the experience of either a polytheist or an atheistic aesthete? Well, not quite. Of course, the experiential sense of the Greek gods (for instance) was bound up with a whole network of rituals, stories, customs, and beliefs (though not with anything much in the way of a dogmatic theology), and it would be naive to think that we could simply recreate that total mindset for ourselves. (Hence the silliness of much contemporary neopaganism, though it does testify to a hunger for a deeper sense of connection to 'the energies of the cosmos'.) For all that, the aesthetic

[30] Traherne 2018: i, 29 and 31. [31] Ward 2002: 29.

experience of nature today—and I am concerned here with the deep appreciation of a Nan Shepherd or a Henry Bugbee, not with a casual, distracted glance round at a beauty spot—has, I think, a real similarity to the religious experience of the sacred in nature.

Mountains (in general or specific mountains) have been seen in very varied cultures as sacred.[32] So how does the experience of, say, a Hindu pilgrim to a sacred mountain differ from that of a post-Wordsworthian Westerner struck by the sublimity of a mountain vista? Well, no doubt it may differ in all sorts of ways, but I think it is implausible to deny a basic commonality. The writer and climber Robert Macfarlane seems to have felt it:

'There's a Sanskrit word, *darshan*,' Jon said as we stared up at Konka [Minya Konka, a Himalayan mountain]. 'It suggests a face-to-face encounter with the sacred on earth; with a physical manifestation of the holy.' I hadn't known the word, but I was glad to have learnt it. *Darshan* seemed a good alternative to the *wow!* that I usually emitted on seeing a striking mountain.[33]

He continues:

Four hours' work brought us to a pass. And there before us—two miles away and nearly two miles up—was Minya Konka, far closer than I had expected. *Darshan!* I sat down in the snow, under a rope of weathered prayer flags, gulping for breath, astonished by the mountain, trying to make sense of its architecture.[34]

The extent to which one's beliefs may influence one's experiences is a complex and difficult question. One's explicit beliefs, in any case, are probably less relevant than the way one's mind is shaped by certain concepts, images, and habits of thinking and feeling, which may remain in the minds even of those who have become sceptical about a particular belief system. I cannot develop a full or adequate account of it here, but I do think that there are extreme positions which pretty clearly need to be avoided. At one extreme is the idea that experience is one thing and its conceptual interpretation and articulation something entirely other. On that view, two people with radically different conceptual frameworks may still have qualitatively identical experiences of, for example, an imposing mountain. At the other extreme is the idea that all our experience is socially constructed or something of the kind, that no sense can be made of any underlying experience itself as something to which our concepts strive to be true. In my discussion of

[32] As I noted in Chapter Eight, medieval Europe seems to have been a bit of an outlier in this respect.

[33] Macfarlane 2013: 269.

[34] Macfarlane 2013: 272. It is, of course, significant that *darshan* (or *darsan*) is the same word used to describe the seeing of the gods as manifested in their statues, which I discussed in Chapter Four.

non-conceptual content in Chapter Seven, I made clear my own sympathy for a McDowellian pan-conceptualism but also noted that this does not involve the idea that sensory, perceptual experience can simply be reduced to or collapsed into thought. And to this I should add Kohak's astute reminder that concepts themselves do not arise from nowhere or nothing; to understand them we need to trace them back to the experiences that called them into being: 'In discourse, articulating lived experience, words function typically not by designating but by evoking the lived sense of experience.'[35] This does not mean—and Kohak doesn't think it means—a reversion to the Myth of the Given, a supposition of a pure non-conceptual experience which the concept in question subsequently tries to articulate. Concepts and sensations go together all the way down for us; any adequate theory has to recognize that our experience is (a) our active attempt to make sense of (b) the world that is given to us.

One does not first believe that the mountain is the abode of the gods and then feel awe in its presence; one feels awe (though, as I have emphasized, this is already an intentional and contentful state, not just a raw feeling) and then comes to further articulate it by telling stories about the presence of the gods in that place or, in a different culture, one feels awe and then reaches for some concept of the sublime (or experiences it as showing the work of God's hand). The concepts which we have used to explain to ourselves our appreciation of the mountain may vary and change, but this does not mean that there isn't an underlying continuity in the actual experience of appreciation. There may be a significant agreement in actual response, hidden by a difference in conceptualization or vocabulary. To experience a mountain as sublime may not be quite the same as to experience it as sacred, and what it is to experience it as sacred in one religious culture may not be the same as in another, but all these experiences may still be quite close. It is not just that something like the same experiences may recur under different concepts but that the *concepts* themselves may be less different than we might assume. And sometimes learning a new concept may enable us to better articulate what we had already been experiencing or enable us to experience it more richly. Macfarlane seems to have immediately grasped that *darshan* was the right word to express what he felt on seeing the mountain; and also, perhaps, that knowing that concept enabled a deepening of what he felt. In sensing the appropriateness of the term, in any case, he seems to have recognized his long-standing fascination with mountains as itself a kind of religious experience.

Just as I don't want to simply assimilate contemporary aesthetic experience of nature to the polytheistic experience of it as sacred, so I don't want to assimilate the theistic experience of nature (or, more generally, the experience of those who believe in a transcendent reality, whether or not it is thought of in 'personal'

[35] Kohak 1984: 53.

terms) to that expressed in a purely immanent version of re-enchantment. But nor do I want to exaggerate their differences. Whether re-enchantment should take a transcendent or a purely immanent form is a large and crucial question (at least for those who accept the need to resist the disenchanted outlook), but too large and too far removed from my main topic (which, I have not forgotten, is painting) for me to address here. I will just note that, on any transcendent view, 'the gods' (the personified energies of nature) are not ultimate,[36] and this allows for the possibility of a lack of complete fit between 'God' and 'the gods', that the intense but often terrifying and destructive forces and energies of the natural world may not be fully expressive of what is ultimately divine/good. In Chapter Eight, I noted that the 'ontological goodness' of nature which is made present to us in aesthetic experience may seem hard to relate to any notion of *moral* order and that much in the natural world may leave us both awed and horrified. On a theistic (or more generally transcendent) view, this ambivalence with which we experience nature is itself ontologically grounded; for the world is rightly experienced as sacred, but not as ultimate. How a world that is expressive of divine goodness can also be so full of suffering and horror is, of course, the classic problem of evil. This is not the place to enter into that discussion; in any case, the issue for theists is perhaps less whether there is an intellectually compelling 'solution' to this 'problem' but with what it may mean to live with it. Belden Lane, for instance, speaks of the continuing existential challenge posed by his need to 'know how to retain a God of feral and untamed beauty while affirming a moral universe where all life is sacred'.[37]

By contrast, advocates of a purely immanent re-enchantment, such as Dreyfus and Kelly, are faced with a dilemma: either they accept that there are evaluative standards higher than those of the natural order or they do not. In the latter case—if nature, as they do suppose, has a genuinely normative force, an ontological goodness, *and* there is nothing beyond nature—they would seem to be committed to a Nietzschean amoralism or even anti-moralism.[38] This would at any rate resolve the ambivalence, by simply affirming nature—as Nietzsche sought to—in all its intensity and destructiveness, without moral compunction. But if they cannot accept this, if they hold to standards which purport to justify an ethical hesitation in endorsing the 'whooshing up' of nature in all its pain and suffering as well as its magnificence, then they need to explain where those higher standards come from and what gives them their overriding force. Dreyfus and Kelly are well aware of the problem. They argue that what is needed is not a

[36] However, Buddhism and both theistic and pantheistic versions of Hinduism have always been comfortable enough with belief in the gods, and many Christians have been quite happy to invoke them metaphorically.

[37] Lane 2011: 9. The problem, one might say, is how to avoid falling either into a pantheism which treats nature as divine or into a Manicheanism which sees it as radically separated from the divine.

[38] See, e.g., the section 'Morality as Anti-Nature' in Nietzsche 1968a, 42–6.

standard that is beyond nature, but a vision of nature itself that is 'more varied
and more vibrant' than Homer's; a polytheism that includes elements of the sacred
that are 'gentle and nurturing'.[39] But their proposal (to caricature it only slightly) is
to *add* Jesus and the Buddha to the pantheon alongside Ares and Aphrodite. And
this leaves us without any criterion for which voice to listen to when these various
'gods' might be calling us. Whatever its problems may be, the transcendent view
opens a space for the ethical which I think a purely immanent view cannot find,
and I think this gives us good reason to be sceptical of proposals such as Dreyfus
and Kelly's to return to a pre-Axial, purely immanent sense of the sacred. However,
for my current purposes, the commonalities between the transcendent and imma-
nent versions of re-enchantment are more important than their (undoubtably
large) differences; for both of them are based (at least in part) on taking our aes-
thetic experience of nature—both directly and indirectly, through art—seriously,
as ontologically revealing, in a way that the disenchanted world view cannot.

[39] Dreyfus and Kelly 2011: 223.

Chapter Ten
Painting, Beauty, and the Sacred

Chapters Eight and Nine have been concerned with the aesthetic appreciation of nature. But my inquiry into that topic was motivated in large part by the concern that a disclosive theory of art (painting) cannot really explain the value of art unless it can explain the value of what it discloses. And we can now see that my defence of a 'Wordsworthian' view of aesthetic experience as disclosing a sacred order in nature has led (in a perhaps rather indirect-seeming way) to a vindication of what I called (in Chapter Four) the 'strong' thesis about the relation between religion and painting—that painting in general is not only structurally analogous to iconography, but that all painting is, as such, religious. For if it makes manifest or discloses the essential elements of nature, and if nature itself is a sacred order, then all of painting is a disclosure of the sacred and, as such, plays a quasi-sacramental role.

<div align="center">I</div>

Let me spell out the argument for the strong thesis a little more fully. I have been arguing that in the serious aesthetic experience of nature we experience the natural world as present to us (in the 'charged' sense). And I have argued that this is, if not quite equivalent to seeing it as sacred, then at least extremely close. But if the charged sense of presence is (roughly speaking) the sense of the sacred, then to make something present—or to make something that makes present, as the painter does—is itself a sacred act. And so the painting—that which makes present, which brings us into 'ontological communion' with the depths of things—is itself uncanny, numinous, sacred. I quoted Matisse when I first introduced the strong thesis; another—perhaps still more surprising—witness is Picasso (though he also testifies to the widespread modern discomfort with religious language):

> Something sacred, that's it. We ought to be able to say that word, or something like it, but people would take it the wrong way, and give it a meaning it hasn't got. We ought to be able to say that such and such a painting is as it is, with its capacity for power, because it is 'touched by God'. But people would put a wrong interpretation on it. And yet it's the nearest we can get to the truth.[1]

[1] From Parmelin 1969: 32. Quoted in Lipsey 2004: 19.

Painting and Presence: Why Paintings Matter. Anthony Rudd, Oxford University Press. © Anthony Rudd 2022.
DOI: 10.1093/oso/9780192856289.003.0011

James Elkins, from whom I initially took the term 'presence' to designate something that we experience in paintings when they move us deeply, eventually admits that it is really a sort of euphemism: '"Presence" makes it possible to avoid naming God.'[2] He notes that there are other such words used by art critics—'aura', 'enigma', 'the numinous', etc.—and comments 'Each word is a strategy for not quite naming God.'[3] Words like 'presence' enable us:

> to name the fullness, immediacy, pure existence and urgent mystery that used to be called God … Sudden, unexpected, out-of-control *presence* is one of the main reasons people cry in front of paintings, and the best meaning I can put to it, the one that explains it most fully, is to say it's a religious feeling.[4]

Of course, some people may concede that we do find it natural to reach for terms like 'religious' or 'sacred' (or for related euphemisms) when discussing intense aesthetic experience—whether of art or nature—but take this simply as a loose rhetorical way of indicating the force or intensity of the experiences. I think this gets it precisely the wrong way round. We don't call the experience sacred just because it is psychologically intense; rather, the experience has the intensity it does because it is of the sacred, because its objects have the significance that they do have. The sense of the sacred is basic to human experience, but we in (post) modernity have grown tongue-tied and confused about it. Intense aesthetic experience is one area of human life in which it continues to make itself manifest to us.

That painting has an essentially religious significance is—in a backhanded way—recognized by radical postmodernist critics. They are, indeed, committed to rejecting (or at least deconstructing, which isn't *quite* the same thing) *all* the main concepts on which my account of painting relies—presence, essence, 'logos', meaning, truth, the sacred. For them, there is no meaningful order of value that can become present to us, and the 'aura' of art that claims to have and/or disclose such presence is precisely what postmodern theory—and at least a good deal of the avant-garde artistic practice associated with it—wants to dissipate. According to Victor Burgin, an influential theorist as well as practitioner of conceptual art:

> The function of the insistence upon presence is to eradicate the threat to narcissistic self-integrity (the threat to the body of 'art', the body-politic) which comes from taking account of difference … What was radical in conceptual art, and what, I am thankful to say, has not yet been lost sight of, was the work it required—beyond the object—of recognizing, intervening within, realigning, reorganizing, these networks of differences in which the very definition of 'art'

[2] Elkins 2001: 174. Elkins uses the term 'euphemism' on p. 180.
[3] Elkins 2001: 181. [4] Elkins 2001: 174.

and what it represents is constituted: the glimpse it allowed us of the possibility of the absence of 'presence', and thus the possibility of change....the history and pre-history of modern art in our patriarchal, phallocentric, culture is stamped by the presence of fetishism, the fetishism of presence.[5]

This, like so much of postmodern theory, reads as an unintentional self-parody, but for all that, it raises issues of fundamental importance. Such writing is at any rate symptomatic of a widespread cultural sensibility which is indeed characterized by a hostility to presence and related notions—essence, order, self-identity.[6] And I think this hostility shows a deep awareness that the issue at stake is an ultimately religious one. For if presence—in the sense of the manifesting to us of a meaningful order of value—is an ultimately religious notion, then if we do want to get rid of God, we will need to get rid of presence. And, if I am right that painting (art generally?) is all about presence, we will need to get rid of art as well—at any rate, of painting. (It is not insignificant that Burgin disdainfully refers to painting as 'the anachronistic daubing of woven fabrics with coloured mud'.[7]) And this does seem to be what a good deal of recent radical art or anti-art practice as well as theory is concerned to do; to repudiate the whole idea of art as traditionally understood, precisely because that understanding is of art as having significance through its disclosure of meaningful order. As George Steiner put it, noting the same connections as Burgin, but from the other side of the argument:

> there is in the art-act and its reception... in the experience of meaningful form, a presumption of presence... an account of the act of reading in the fullest sense, of the act of the reception and internalization of significant forms within us, is a metaphysical, and, in the last analysis, a theological one. It is a theology, explicit or suppressed, masked or avowed...which underwrites the presumption of creativity, of signification, in our encounters with music, with art.[8]

For Steiner's thesis to be plausible, one needs to take 'theology' in a pretty broad sense—one that would include a purely immanent (pantheistic) sense of the sacred in nature. When I introduced the distinction between the 'strong' and 'weak' theses above, I also distinguished the 'strong' thesis from an 'ultra-strong' claim that art could only be fully or properly understood from some specific confessional, theological standpoint. Nothing I have said so far supports *that* thesis, and the notion of the religious or the sacred with which I have been working is an intentionally vague and general one. It is not so vague as to lack substantive import; as I have just insisted, it is an ontological claim, not just a way

[5] Burgin 1976a.

[6] I noted in Chapter Three that the notion of 'presence' is ambiguous but that postmodernism generally repudiates what I would consider the good sense of presence as well as the bad one(s).

[7] Burgin 1976b. [8] Steiner 1989: 214, 215–16.

of talking about certain psychological experiences, and it is incompatible with the widely held metaphysics of disenchanted naturalism, as well as with the (anti-) metaphysics of postmodernism. Of course, there are various more specific options available to someone who accepts the strong thesis in its generality. I want to distinguish three of these positions here:

(1) The 'ultra-strong' thesis mentioned above. Of course, there will be a range of different ultra-strong theses associated with different religions and denominations, each making claims about painting on the basis of its specific theology.

(2) What we might call the middling-strong thesis. By this I mean the claim that art needs to be understood not from a specifically confessional standpoint but from that of belief in a transcendent Absolute, rather than a purely immanent cosmic order.

(3) What we might call the 'least strong' thesis, which does take painting to be disclosive of a meaningful immanent order but which either denies the transcendent altogether or thinks it at any rate not directly relevant to the understanding of art.

In so far as my project has been to give an account of painting that is not tied to a specific theology, it might seem that I am committed to rejecting claim (1). I certainly am committed to rejecting the idea that an understanding of art that is not based on a specific confessional standpoint must be confused, incoherent, or misleading. But nothing I have said rules out the idea that such an account may be *incomplete*. The account I have given certainly is very broad and general, and so it leaves room for the possibility that it may need to be supplemented by confessionally specific claims, which may build on but go beyond the generic account I have been giving here. And while I haven't disguised my preference for a transcendent rather than a purely immanent version of re-enchantment, the account of painting I have given is also neutral as between (2) and (3). I do want to say something about how we might think of the relation between explicitly religious paintings, such as icons, which do aim to evoke or make present the transcendent, and painting generally, given the claim that all painting is, in a sense, religious. But before I turn to that question, though, I need to address some unfinished business concerning the concept of Beauty and the relation of art (painting) to Beauty, especially given the strong thesis.

II

I have been arguing that painting is of value because what it discloses is of value and that this disclosure (making present) is sensuous and aesthetic, not coldly

abstract and intellectual. For something to make present and to be present (in the charged sense) through its visual appearance *is* for it to be beautiful (visually fascinating). So, as seems appropriate if we are to satisfy Plato, the Good, the True, and the Beautiful all go together. The disclosure (Truth) of value (Goodness) is experienced as Beauty. But I need to say more about their relationship. And this will involve considering the 'positive aesthetics' thesis, the claim that everything (or, at least, everything in unspoiled nature) is beautiful. I have talked about aesthetic experience revealing nature as awe-inspiring, sacred, etc., but does that mean that *all* nature is beautiful? That all of it is beautiful *when rightly attended to*? Beautiful as a whole but perhaps with parts that are not beautiful? And what exactly is the metaphysical status of beauty? Is it just 'out there', an objective quality simply present in nature (and/or in artworks) or is it in some way relational, involving human perceivers? And if the latter, can this be so without our falling back into subjectivism?

Let us start with the question of objectivity, which I raised but left unresolved in Chapter One. I think a realist about beauty needn't deny that the way we experience nature (and art) is something specific to us—in some sense that is obviously true. We are, after all, talking about aesthetic, sensuously experienced beauty—the radiance of colour and light, the grandeur of a high waterfall or a great mountain. Of course, what we are appreciating is nature or art *as it shows up to our senses* (and to creatures of our size). The giant wouldn't find the waterfall so imposing (he or she might find it charming); the Martian (with radically different colour perception) wouldn't know what to make of the Matisse. So the beauty to which we respond aesthetically is the beauty of the world as it is for us—not just for us as individuals (though, of course, there will be elements of personal preference and association) but as members of a species with shared access to a common world. But still, this is the world as it shows up to beings like us. Are we forced, if we accept these obvious points, into a species-relativistic account of beauty? But if so, what then becomes of the whole idea that our experience of beauty is a disclosure of the deep truth of things?

To resolve this dilemma, I think we need to adopt a distinction which has been made by a variety of thinkers between 'aesthetic' beauty and 'metaphysical' or 'transcendental' beauty. For us to experience things as aesthetically beautiful is for us to experience—in the way that creatures of our nature and sensibility can—the inherent metaphysical beauty of things which have value in themselves. The distinction is clearly made by Simone Weil:

> The beauty of the world is not an attribute of matter in itself. It is a relationship of the world to our sensibility, the sensibility that depends on the structure of our body and our soul. The Micromegas of Voltaire, a thinking infusorian organism, could have no access to the beauty on which we live in the universe. We must have faith that, supposing such creatures to exist, the world would be

beautiful for them too; but it would be beautiful in another way. Anyhow we must have faith that the universe is beautiful on all levels, and more generally that it has a fullness of beauty in relation to the bodily and psychic structure of each of the thinking beings which actually do exist and of all those which are possible. It is this very agreement of an infinity of perfect beauties which gives a transcendent character to the beauty of the world. Nevertheless the part of the beauty which we experience is designed and destined for our human sensibility.[9]

Weil is drawing on distinctions which were made in medieval scholasticism (I will say a little more about this shortly), but it is interesting to note that a similar distinction was made in traditional Chinese aesthetics. According to Wangheng Chen, aesthetic beauty was regarded neither as an objective fact 'out there' nor as merely subjective; it existed relationally, *between* subject and object: 'In traditional Chinese philosophy, environmental beauty in landscapes is a reunification of objective scenery and subjective perception ... the landscape is both the mode of existence of environmental beauty and its noumenon—the 'in-itself' unknowable by the senses.'[10] The use of this Kantian language is interesting and, I think, can be helpful, so long as it is taken in terms of the 'Two Aspects' and not the 'Two Worlds' interpretation of Kant. In other words, noumena and phenomena are not distinct entities, but phenomena just are noumena as they show up to beings like us.[11] So the 'noumenon' in the quotation above is the underlying reality which appears relative to us as sensory or 'environmental' beauty when we attend properly to it, but appears, of course, in a way that is fitted to our senses. This is why, although 'natural landscapes are visual manifestations of Tao',[12] it is still the case that it is through 'human acts of discovering, recognizing and appreciating' that 'human beings become the discoverers and creators of natural beauty'.[13] Discovery and creation are not seen as contradictory here—'aesthetic' beauty is created when human perceivers attend to and thus discover the 'metaphysical' beauty of Tao. I noted in Chapter One the dubiousness of the claim that something can be real only if it is 'objective' in the sense of mind-independent. (This claim is, of course, really part of the whole disenchanted world view.) Our minds are parts of reality, not alien extras hovering outside it. That aesthetic beauty is something relational that arises between our minds and the world does not make it a mere projection or somehow unreal. It is a genuine disclosure of the beauty of the world, 'a manifestation of Tao', though, of course, a 'visual' one, one which enables it to become manifest to and to fascinate sensory beings like us.

Of course, we might choose to use a different terminology. Instead of distinguishing between metaphysical and aesthetic beauty, we might just reserve the

[9] Weil 1973: 119–20. [10] Chen 2015: 49.
[11] See Allison 2004 for the classic statement of the 'Two Aspects' view of Kant.
[12] Chen 2015: 18. [13] Chen 2015: 20.

term 'beauty' for what I have been calling aesthetic beauty and, instead of 'metaphysical beauty' talk about the order of nature in its ontological goodness—or, indeed, just say 'Tao'. The important point is that when we experience nature as beautiful (which involves it appearing in ways that are specifically related to human sensibility) what we are experiencing is the ontological goodness, the meaningful order, of nature. I am inclined to still talk about metaphysical beauty, though, in order to make the anti-subjectivist point that our experience of something as beautiful is not our projection: it is a way of experiencing the object that is genuinely revelatory of what it is.

The distinction between aesthetic and metaphysical beauty is also important for helping us to think about the positive aesthetics question. Beauty, in the philosophical theology of the Middle Ages, was widely regarded as a 'transcendental', that is, a concept that applies in some degree to everything.[14] The other commonly accepted transcendentals (there wasn't complete agreement about what should go on the list) were Being, Oneness (i.e. to be at all anything has to have a unity or integrity to it, which makes it a unit), Otherness (the flip side of Oneness—if anything is something definite, then it differs from other definite things), Truth (that is, ontological truth, as discussed in Chapter Eight—this oak really being an oak), and Goodness. Since they apply to everything, they are 'convertible' (anything which is any one of these is also all the others.) To claim that everything that is (has Being) possesses (ontological) Truth and is Good is to put in abstract metaphysical terms Kohak's experientially or phenomenologically grounded affirmation that reality (nature) is a 'moral order'—a rationally coherent world of determinate entities—and that it is good that it is and is as it is. And, I have argued, to experience the world in this way is to experience it as beautiful, so that what has Being, Truth, and Goodness also has Beauty. This fits nicely with Maritain's claim that Beauty is a sort of meta-transcendental—'the radiance of all transcendentals united'.[15] And it explains why beauty *matters*, why, as Robert Spaemann says:

> beauty is not just some ornament to life; it is the very meaning of life. There is nothing more serious, nothing more worth pursuing, than beauty. Beauty is what is truly redemptive, because it is what is truly real; it is the *splendor veri*, the splendor of truth, as Thomas Aquinas says.[16]

It has, however, sometimes been argued by philosophers in the broadly Thomistic tradition that Beauty is a 'perfection' rather than a transcendental, since it seems

[14] For helpful discussions of medieval debates about the transcendentals and the place of beauty among them, see Viladesau 1999: 125–34 and Dadosky 2014: 29–38.

[15] Maritain 1955: 124. In this he is apparently following Bonaventura more than Aquinas: see Dadosky 2014: 34.

[16] Spaemann 2015b: 118.

that not everything is beautiful: we do, after all, distinguish between what is beautiful and what is ugly (or just dull).[17] Maritain, among others, deploys the distinction between transcendental beauty and aesthetic beauty to defend the claim that, metaphysically speaking, everything *is* beautiful. Maritain does note that 'beauty' is an analogous term, so a flower is not beautiful in the same way as a mathematical theorem. But the term isn't merely equivocal; the different senses in which different things are beautiful are all related. That everything is beautiful does not mean that everything is *equally* beautiful, any more than everything is equally good, although for the medievals, everything that exists is good in some degree. However, although all things are (somewhat) beautiful in themselves, they are not necessarily so as they appear to our senses. In 'aesthetic beauty… senses and sense-perception play an essential part and … as a result, not all things are beautiful'.[18] However, our aesthetic experience is not merely and passively sensory in a naive empiricist way; our sensory experience is itself 'permeated by intellect',[19] and it's not as though aesthetic beauty is just one thing and transcendental beauty another: 'Aesthetic beauty … is a particular determination of transcendental beauty; it is transcendental beauty as confronting … the intellect and the sense acting together in one single act'.[20] We are thus confronted with what to us in our finitude may appear ugly, but which in itself has some degree of beauty.

As we have seen, for Maritain the artist is someone who can recognize intuitively the essential nature of things (and so their essential beauty) and express this poetic understanding in a work of art. But a work of art is necessarily aesthetic—that is, something designed to be apprehended and appreciated by the senses and for its sensuous properties. So art is the struggle to see and to express *aesthetically* the transcendental beauty that exists in everything—even, paradoxically, in what is aesthetically ugly:

> Art … draws beauty from ugly things and monsters, it tries to overcome the division between beautiful and ugly by absorbing ugliness in a superior species of beauty and by transferring us *beyond* the (aesthetic) beautiful and ugly. In other words, art struggles to surmount the distinction between aesthetic beauty and transcendental beauty and to absorb aesthetic beauty in transcendental beauty.[21]

The paradox is that art not only finds transcendental beauty in what is aesthetically ugly but that it is able to express and present that transcendental beauty *aesthetically*. This does not mean that art prettifies the ugly; even aesthetic beauty is

[17] These arguments are described (though not endorsed) by Viladesau 1999: 125.
[18] Maritain 1955: 125. [19] Maritain 1955: 126. [20] Maritain 1955: 125.
[21] Maritain 1955: 126.

not mere prettiness or what is immediately pleasing to the senses. But this means, I think, that even though Maritain starts from Aquinas's definition of beauty (what pleases when seen), he is really committed to thinking of aesthetic beauty in a more expansive way, along the lines of what I have called the broad sense of beauty, as 'that whose visual appearance is found fascinating in its own right'.[22] This can include the sublime—even in some ways the terrifying.[23]

Maritain might seem to be agreeing in a way with Paul Ziff's claim (mentioned in Chapter Three) that everything has positive aesthetic properties if perceived in the right way.[24] Aesthetic ugliness is only apparent. Although it is natural for us with our sensory faculties to experience some things as ugly, when we look carefully enough, with the artist's loving attentiveness, we can see them as having the beauty that they really do have. And this seems to make sense on the view I have defended here, for if nature as a whole is a moral or sacred order, which, if we dwell appreciatively enough with it, can become present to us, then shouldn't it all be (even aesthetically) beautiful? This may not be obvious at first sight, but even those who are not artists can learn to look for the beauty in all things:

> Clouds, seashores, mountains, forests, even deserts are never ugly; they are only more or less beautiful; the scale runs from zero upward with no negative domain. Destroyed forests can be ugly—a burned, windthrown, or diseased forest But even the ruined forest, regenerating itself, still has positive aesthetic properties. Trees rise to fill the empty place against the sky. A forest is filled with organisms that are marred and ragged—oaks with broken limbs, a crushed violet, the carcass of an elk. But these are only penultimately ugly; ultimately these are presence and symbol of life forever renewed before the winds that blast it.[25]

It seems, then, that there are two ways in which we can think of a gap between aesthetic and metaphysical beauty. In the first instance it is due to the specifically human-relative ways that we perceive things (our colour vision, our size, etc.). This is unavoidable. In the second instance, it is based on our tendency to react to some things as ugly (grotesque, disgusting, etc.), which is natural to us, but which it is possible (in principle) for us to overcome. If we did do so, we would see everything as it is—beautiful (though still, obviously, only beautiful in the way that it can show up to human senses).

There are two ways in which Ziff's claim is excessive, though. Firstly, the positive aesthetics thesis is usually only applied to natural beauty, as opposed to art.

[22] Crowther 2009: 16.

[23] I think this enables us to defend Maritain against the criticisms of Hildebrand (2016: 89–93), who insists that some things just are ugly in themselves and that aesthetic ugliness is, if you like, a reflection of real metaphysical ugliness (although he doesn't use exactly that terminology).

[24] Ziff 1998. [25] Rolston III 2005: 20.

However, Ziff applies his thesis even to artworks: looked at in the right way, even the most miserable daub has some positive aesthetic properties. But it seems that we have criteria for making judgements of aesthetic *failure* in considering art which do not apply to the natural world. For, on a disclosive theory, a beautiful work of art is one that successfully manages to disclose the beauty to be found in its subject matter, even when the subject matter in question might seem unpromising, while an ugly (or sentimental, kitschy, etc.) work is one that fails to do so. It doesn't follow that the bad painting may not have some positive aesthetic properties, but we can still judge it as having failed in what it set out to do. (Perhaps there is *some* analogy in nature: we may delight aesthetically in a great oak tree that has fully realized its specific potential and is flourishing qua oak, while being (aesthetically) pained by the spectacle of a stunted, deformed specimen that hasn't had enough water or light or good enough soil, which we might say has failed to properly, fully, become an oak.) The second problem for Ziff is that (as I noted in Chapter Three) even if everything (natural or artistic) has *some* positive aesthetic properties, it certainly does not follow that everything has equal all-things-considered aesthetic merit (which is why the medievals quite rightly though in terms of *degrees* of goodness and of beauty). I have suggested that it is quite plausible to hold the positive aesthetics thesis, according to which all of (untouched) nature is beautiful. It would still seem highly implausible, though, to say that it was all *equally* beautiful.

This thought underpinned my earlier *reductio* argument, that on Ziff's view, for example, the destruction of a lovely old town and its replacement with gimcrack concrete tower blocks would not involve any overall loss of beauty. No doubt, looked at in the right way, even the concrete blocks could be seen as having *some* beauty, but surely not enough to justify their replacing the old town. Still, am I saying that what we think of as ugliness is just a lesser degree of beauty? Do the tower blocks only seem ugly in *comparison* with the lost old town? Aren't the wretched things just eyesores, even if, say, a talented photographer could bring out a sort of grim visual fascination in them? There is an obvious comparison to be made here with the medievals' thesis that everything is good (to some degree). This has sometimes been considered callous, as though it was approving (even if in varying degrees) of suffering, cruelty, etc.—'It's all good.' But the medieval thesis was that all *beings* are good, which is not at all to say that everything that they do or undergo is good. It may not be immediately obvious how this helps with the parallel aesthetic problem, though: our objection isn't to anything the tower blocks are doing; it is to their being—at any rate, to the way they show up to us. However, we should remember the medievals' claim that evil is a *privation* of goodness, which means that it is not just a lesser degree of it, but a lack of something *that should be there*. (It is an inescapably teleological notion.) The towers have some positive aesthetic qualities, but they lack ones which should be there—grace, humanity, redeeming irregularities. Their stark geometry may have

some real aesthetic power taken by itself, and a photo taken from the right angle, in the right light, etc. can make that grim, unresponsive solidity show up in a visually striking way. This does not balance out the fact that they are horribly lacking in those aesthetic qualities that are precisely appropriate for human dwellings, and so we can't help experiencing them in terms of the qualities that they should have but lack. To assert that everything has some positive aesthetic merit is consistent with its having not only quantitatively outweighing demerits, but demerits that are qualitatively more relevant or significant than the merits it may have.

III

Not all artworks (or works of human contrivance or manufacture, generally) are of equal aesthetic merit. But if aesthetic merit has to do with making present, how are we to handle the fact that images and objects of all sorts which seem to have rather little aesthetic merit can apparently make present in the charged sense with which I am concerned? Peoples' snapshots of their loved ones may not count at all as art photography, but they still make those loved ones present to them. Blocks of uncarved stone, as Freedberg notes, have served as powerful religious images,[26] and kitschy plastic statues of the saints have done so too. Many icons are very beautiful, but others are cheap and garish. Bad pictures of cats or mountain scenery may apparently make them present to those who view them. What are we to make of this? I raised this problem in Chapter Three and started to address it (albeit a bit indirectly) at the end of Chapter Six, section II, but more needs to be said.

I have argued that making present is not something which happens simply by the painting (or statue or photo or whatever) exercising a magical power over anyone who happens to glance at it. One needs to attend to it in the right way. And, as I have also argued, all painting is partial, that is, it discloses things, not absolutely, but as they appear to the sensibility of a particular artist (era, tradition, etc.). Hence there is an element of something akin to intersubjectivity involved in art appreciation; even canonically great works may 'resonate' (to use Maritain's useful word) more or less with different spectators, even equally aesthetically sensitive ones. Owing to the particular interaction between my sensibility and that expressed in the work, I may or may not be able to properly appreciate it, even when I do make the effort of attention. This is not subjectivism. Nevertheless, making present involves an interaction between the work and the spectator; it doesn't just happen passively to the subject.

[26] By this I simply mean that they make present, even though they lack any literally representational features. See Freedberg 1989: 66–74.

One might, following up on these lines of thought, just say that kitsch (etc.)[27] *does* make present, but only to people with bad taste. Works of artistic merit are the ones that make present to those with good taste. An account along these lines might seem elitist in a way that would make some people uncomfortable, but it is not clear that this would by itself be an argument against it being true.[28] There is, however, the worry that it might be viciously circular. Who, one might ask, are the people with good taste? And it seems the answer would have to be those who appreciate good art rather than kitsch. (How else would you decide who had good taste? By doing fMRI scans?[29]) And if one asked who the people with bad taste were, one would again have to answer: those who actually do love kitsch. But now it seems we're just dealing analytically with definitions. Can we explain *why* good art appeals to some, and kitsch to others? Well, we might say that the former have refined sensibilities. But what do we mean by this? Presumably that these are sensibilities that enable their possessors to recognize and appreciate what actually is good art. But what makes art good? On my account, that it makes present. But the whole problem was that so (apparently) does kitsch. And if all we can say to distinguish them is that good art makes present to those who appreciate good art, then we are clearly in a none too virtuous circle.

We might then try looking not at the audience but at the subject matter. So we might argue that kitsch does make present—but what it makes present is shallow, non-valuable. But good art and kitsch are not distinguished in any clear way by their subject matter, and I certainly wouldn't want to say that the cute children depicted in a sickly sentimental painting are *not* actually beings of value. So, trying yet another tack, we might—and now I think more plausibly—say that the problem with kitsch is not with *what* it makes present, but with *how* it makes it present—that is, in a shallow or distorting way. This is where the argument from Chapter Six becomes relevant. I claimed there that both sentimental and cheaply cynical paintings are bad because they falsify, whereas good art is truthful. But if good art makes present in a truthful way, does this mean that, by contrast, bad art makes present in a false or distorted way, or does it mean that it only gives the illusion of making present? It might seem that I am committed to the latter, since I have argued that the truthfulness of (good) art consists in its ability to make

[27] I will mostly talk in what follows about kitsch as the antithesis to good art, although one might distinguish other categories of relevantly bad or non-art. Really, I am using 'kitsch' as a shorthand for 'bad/non-art that seems to make present'. This is a usage which is related to, but not identical to, some others in the critical literature; see, e.g., Greenberg's (1988a) influential essay 'Avant-Garde and Kitsch'.

[28] One should note, incidentally, that aesthetic elitism (to take that simply as the idea that some people have better taste than others) does not map straightforwardly onto socio-economic or even educational elitism. Popular artworks (and craft works) are often of very high aesthetic quality, while intellectuals may (and sometimes do) admire all sorts of rubbish, so long as it is fashionable in the contemporary art world or validated by some currently cool theory.

[29] Of course, scanning the brains of recognized connoisseurs and comparing the results with scans of the brains of paid-up bourgeois philistines might produce some interesting results, but the point is that one would need some prior criterion to distinguish the classes of people to be scanned.

present; for if this is right, then it seems that the idea of a non-truthful making-present cannot even make sense. But what would an illusion of making-present be? One might indeed argue that paintings that just copy surface appearances in a dull mechanical way, rather than evoking their essences, do initially seem to make present, but really only give us the illusion of doing so. They don't really disclose things, though their creator's facility in copying may make us at first think that they do. To distinguish what is truly disclosive from what is only apparently so is not always easy; there may often be less to a work than initially meets the eye, and (as is also the case when there is more) to discover this may take detailed and careful attentiveness.

But although a good deal of bad art may be dealt with in this way, I don't want to claim that it is only good art that can make present. The notion of making present itself is obviously a vague and broad one, and the making present that good paintings or other artworks do need not be the only kind that there is. People make themselves present (or refuse their presence) to others (the cases of literal intersubjectivity from which I started in Chapter Three). Natural objects—uncarved stones or whatever—that are set up as altars or other religious objects may powerfully evoke the divine, and so may natural objects *in situ*—groves of trees, mountains, caves, etc. (They may give and receive *Darsan*.) And artistically mediocre artefacts—plaster saints, bad paintings, blurred snapshots—may also become powerfully disclosive, present-making through their particular histories, the associations that have come to cling around them. If the kitschy statue or sentimental holy picture has become a focus for worship over the years, that doesn't mean that it becomes beautiful, but it becomes *significant* for that community of worshippers. But one would need to know that history—more than that, one would need to *participate* in it—to find the object truly disclosive. By contrast, a canonical great artwork may acquire a penumbra of special personal significance for one particular viewer, but in this case the personal associations are adding to a work that is powerful in itself, whereas in the case of the mediocre picture the personal associations are doing most or all of the work.[30] (A rather different sort of case where a not-great painting acquires significance is when one comes to know that it was, for instance, painted by Churchill or—a different kind of significance—by Hitler. (The blandly mediocre picture becomes something sinister.) But the point here is that one needs to know the relevant history.)

As well as bad paintings that only give the illusion of making present and others that do in a way make present, but only through their histories and personal or communal associations, I think there are other non-great paintings

[30] Some associations may be irrelevant, purely accidental; others may help to bring out the revelatory power of the work itself. A mother who has cared for a sick or injured adult child or been with one who died may find Michelangelo's *Pietà* more intensely powerful than a spectator without that experience. (This example is based on an actual case I know of.) Some songs may touch us even more because of the memories they bring back, but others may touch us only because of those associations.

which may really in themselves (and not just through their contingent histories and associations) express and disclose something, but which do so in a falsifying way. So, as I argued in Chapter Six, violent art that doesn't emphasize the horror of that violence falsifies ethically and thus in the end aesthetically even when it has real aesthetic merit. One could say the same of portraits of the Great Leader: some of them at least may make him present and may do so with a real power, but they falsify by portraying him as admirable rather than brutal. (It might be said they *do* portray his brutality; their aim is precisely to intimidate. But they *gloat* over his brutal power—thus, they falsify in the same kind of way that violent pornography does.) Corrupt political art (as with other kinds of corrupt art) can have a real artistic intensity—there is something real it is conveying, and it may do so with frightening force. But there is also a serious falsification. We can say this too about sentimental art. For instance, one might say that the charm of a cat (which is real) can be genuinely conveyed by a sentimental picture of it. But if that is the case, how can we say that the picture isn't truthful? The problem is its one-sidedness. A good cat picture would indeed show the charm of the cat, but also that it is a predator. Hence the purely sentimental picture falsifies, despite the element of truth it contains. Similarly, a sentimental religious picture may show God (through Christ or Krishna, etc.) as loving and approachable, but it fails to convey the numinous majesty of the divine and thus reduces God to a Santa Claus figure.

But whether or not something is great art is of course not necessarily an all-or-nothing matter. (Murdoch, as we have noted, has worried persistently about whether art necessarily falsifies or at least whether only the greatest art can escape falsifying to some degree.) So there is a continuum, not a neat distinction. It is not plausible to say that *either* a painting makes present *or* it only gives the illusion of so doing. (I think there are cases which are pretty clearly one or the other, but there is also a large grey area.) Nor is it plausible to say that if it does make present, it must *either* do it in a (wholly) truthful fashion *or* be condemned as simply falsifying. Great art may be truthful enough to deserve our admiration, although it suffers from some degree of, say, sentimental falsification. (Murillo is sentimental, but he is still a great painter, though not one of the greatest.) And it may be that even a seriously distorted vision does bring out so powerfully some aspects of the real that we have to admit it as great art, however false it may be, if it were taken as giving the whole story. There is something horribly real about Francis Bacon's reduction of human beings to lumps of screaming meat, appallingly false though it is as a total vision of humanity. This might seem to problematize my claim, in Chapter Six, that a work that evokes and makes manifest brutality without showing its horror cannot be a great work of art, however powerful it may be. I don't think it requires me to retract the claim, though. The real greatness of Bacon's work, for instance, depends upon the contrast between his nightmarish visions and a humane ideal which remains

implicitly present in his work—despite, it may be, his own intentions—and which enables us to experience what he depicts as *degradation*, rather than simply accepting it with a cynical shrug as the human condition per se.

IV

I want to conclude this chapter—and the book—with a brief consideration of the relationship between 'religious' and 'secular' painting. I use scare quotes because, of course, I have argued that all painting is in a significant sense, religious. But if this is the case, what is the relation between painting in general and painting that is, we might say, explicitly religious? Or, to make the question a bit more precise:for those who believe in an ultimate reality from which the world of nature receives its sacred character, but which transcends nature, what is the relation between art (painting) that seeks to evoke or make present that transcendent reality and art that aims only to make present the sacred depths immanent in nature? I will focus the discussion by returning specifically to the Orthodox icon and the sense in which it can be thought of as paradigmatic for painting, and I will take my bearings from the work of Paul Evdokimov, an emigré Russian philosopher and theologian, whom I cited in Chapter Four on the theology of the icon. Evdokimov is concerned with art, especially painting, in general and has some interesting discussion of the relation of painting generally to the icon. His overall philosophy of painting fits very nicely with the account I have developed so far; he argues that art in general seeks to evoke the deep, underlying essences or meanings of things: 'Every art worthy of the name never seeks simply to copy what is real but aspires to reveal its meaning, to unravel its secret message, to seize its *logos*.'[31] In other words, to 'make the invisible visible'. On this definition of art the icon *is* an artwork and, indeed, a paradigm for art generally: 'As a symbol, the icon goes way beyond art, but it also explains art.'[32] But in what sense does the icon do both these things?

For Evdokimov non-iconic art expresses the 'earthly *Sophia*',[33] that is, the ideal, structural, formal elements *in* the world as they make themselves manifest in and through matter. But beyond that is the heavenly *Sophia* of which the earthly one is only an 'ambiguous mirror'.[34] What icons express is not just the earthly *Sophia*: as visual, material works, they *do* of course express that, but they express it in such a way as to show the heavenly *Sophia* shining through it. How should we

[31] Evdokimov 1990: 204. [32] Evdokimov 1990: 89.
[33] Evdokimov 1990: 90.
[34] Evdokimov 1990: 90. I should say that, although I find his terminology helpful and will make use of it, I will use 'the earthly *Sophia*' perhaps more broadly than Evdokimov does, to refer to the deep, essential aspects of nature that painting discloses according to my account—these may be less ideal or formal than what Evdokimov has in mind.

understand this distinction between the icon and the 'mere' artwork? Someone who doesn't believe in any transcendent reality beyond nature (any 'heavenly *Sophia*') will not, of course, suppose that icons really manifest the transcendent (since there is nothing transcendent to manifest); rather (despite the intentions of their creators), what they really disclose are aspects of the human figure, or of humanity;, or of colour, line, and shape. They are 'sacred' or 'religious' only in the sense that all of art is.[35] What, though, are the options for a theist or other believer in the transcendent (the heavenly *Sophia*)? One sort of theist could take the old iconoclast line and reject any attempt to create an art that would directly evoke the transcendent. Art as such is secular; it has a legitimate role to play in disclosing the earthly *Sophia*, but the heavenly one is beyond not only depiction, but even evocation in art; and an art that attempts to do this is idolatrous.[36] Another— opposite but equally radical—option would be to say that the only really truthful art is iconography, that only the icon really shows the earthly *Sophia* as it is, which is to say, in its radical dependence on the heavenly. Secular art, which attempts simply to depict the earthly *Sophia*, is, at least implicitly and perhaps unintention- ally, atheistic and materialistic.[37]

Another—more conciliatory—option for a theist would be a division of labour view, holding that secular art should stick to presenting the earthly *Sophia* and icons to expressing the heavenly one. Someone who takes this view would, of course, differ from someone who does not believe in the transcendent at all but would still, like the latter, see icons offering only a structural parallel to secular art works. The icon aims to make its figures present in a way which presents their underlying essences to the viewer, and so does secular art. The difference is that what icons aim to make present is divine, not just worldly essences. So secular art is in a sense less ambitious than the icon, but it is still trying to do the same *kind of* thing that the icon does. This might seem to be taking us back to what I originally characterized in Chapter Four as the 'weak' thesis' (that non-religious painting has only a structural parallel with religious painting), but, given what I have said about the religious or sacred character of all painting, it would really be a version of what I called in Section I above the 'least strong' thesis, according to which the disclosure of the 'earthly *Sophia*' is itself religiously significant. But although, for a theist of the kind I am considering, the sacred character of the earthly *Sophia* is itself derived from God, one needn't know that to properly appreciate the earthly *Sophia* or to disclose it in art.

[35] Just to be clear, I am not thinking here of the position of a disenchanted naturalist, but of some- one who maintains a purely immanent version of re-enchantment.

[36] This seems to have been Karl Barth's view. See Barth 1957: 666 and 1962: 868. Perhaps more endearingly than consistently, he makes one exception: the music of Mozart manages, for him, to be a genuine disclosure of the divine nature; see Barth 1986.

[37] This seems to be the position taken by Florensky in his remarkable book *Iconostasis* (1996, esp. 98–114).

There is, however, another option, according to which even secular art expresses something of the heavenly, as well as the earthly, *Sophia*, even if this was not consciously intended. (Such a view would turn the tables on the anti-transcendent view I mentioned above, according to which even icons have, in fact, only a purely immanent significance, despite what was believed about them.) The 'division of labour' approach might seem to go naturally with a theology which accepts the autonomy of the natural world and its separation from what has now come to be regarded as the 'supernatural'. But such a theology would not be acceptable to Evdokimov, for whom the natural world can only be fully understood or appreciated if it is seen as participating in and expressing the heavenly *Sophia*. This is not a peculiarity of Evdokimov's approach (or even specifically of Eastern Orthodoxy). For Aquinas (and for the scholastics generally) it is God to whom all the transcendentals apply primarily and most fully. God *is* absolute Being, Unity, Goodness, and Beauty; everything else participates in them analogously and to some lesser degree. For this ultimately Platonic theism, everything that is participates in God and can only be what it is through this participation. God is not simply a distant creator, an efficient cause which we may or may not have good reason to posit but which leaves our understanding of the world itself unaffected. As Alasdair MacIntyre puts it:

> To be a theist is to understand every particular as, by reason of its finitude and its contingency, pointing towards God. It is to believe that, if we try to understand particulars independently of their relationship to God, we are bound to misunderstand them. It is to hold that all explanation and understanding that does not refer us to God, both as first cause and as final end is incomplete.[38]

This does not, of course, mean that God should be brought in to explain, for example, particular scientific phenomena. (An 'incomplete' explanation can be perfectly good as far as it goes and entirely adequate for some particular purpose.) But if art is, as Evdokimov affirms, concerned with making manifest the essential natures of things, and if it is part of the *essence* of anything that it is created and sustained by God and directed to God, then it follows that art understands things (even if only implicitly) in their relation to God. Evdokimov concludes that an art which loses its reference to the 'heavenly *Sophia*' will also tend to lose even the earthly *Sophia* and decline into a merely 'aesthetic' celebration of the artist's subjectivity:

> Every purely aesthetic work of art is a triptych whose panels open to show the artist, the work itself and the person who looks at the work. The artist executes his work; he plays on the keyboard of his genius, thus bringing out an emotion

[38] MacIntyre 2010: 23.

of admiration in the soul of the spectator. The whole is enclosed in a triangle of aesthetic immanentism ... In the presence of an icon, we sense a fourth principle, fourth in relation to the previously mentioned triangle; we sense the appearance of the transcendent whose presence is attested to by the icon. The artist fades away behind Holy Tradition; the art object gives way to a theophany.[39]

Evdokimov sets up here a rather stark contrast between the icon and a 'purely aesthetic work of art', but his basic position still seems to me to leave room for an art that is neither iconic nor merely 'aesthetic', but which is genuinely disclosive of the earthly *Sophia*. Such an art, in terms of Evdokimov's image above, would add to the 'triptych' of painting, artist, and viewer the necessary fourth element: the subject matter made present in its essential nature. This might seem to return us to the division of labour view: secular art just adds a different kind of 'fourth principle' to the one that icons add (earthly, rather than heavenly). But this would be misleading. If it is true that the earthly *Sophia* is what it is only because it derives from and mirrors the heavenly *Sophia*, then an art work that truly expresses the former will necessarily express something of the latter as well, whether or not its creator was conscious of or consciously intending that. So, on this view, an art that wants to make the earthly *Sophia* present will—*in its own way* and whether intentionally or not—have to do what icons do, that is, evoke the divine beauty through worldly beauty. The difference between such art and iconography becomes one of emphasis: the icon uses the earthly *Sophia* in order to evoke the heavenly, whereas secular art sets out simply to evoke the earthly *Sophia*, but, in order to do so, it unavoidably (even if sometimes unintentionally) expresses something of the heavenly also. But this means that art can only do something *analogous* to the icon (make things present in their essential natures) if it does in a sense do what the icon does (make the divine present).[40]

There would also remain the possibility of genuine sacred art which explicitly aims to evoke the divine through the material, without necessarily doing so in the way that traditional Orthodox icons do. Evdokimov distinguishes 'sacred art' from mere 'religious art'.[41] I have been using these terms much more loosely and more or less interchangeably, but I will in this context use 'sacred art' (in quotation marks) to refer to explicitly (and authentically) religious painting. Given my claims about the sacred or religious meaning of *all* painting, the distinction between 'secular' and 'sacred' art will inevitably be somewhat blurred, though. The very distinctive, traditionally established style of the Orthodox icon does clearly set it apart from other painting. But with other forms of 'sacred art', the

[39] Evdokimov 1990: 179–80.
[40] This argument, of course, takes theism as a premise—or perhaps, more generally, the thesis that there is a heavenly *Sophia* and that the earthly *Sophia*, the order immanent in the material world, is ultimately intelligible only by reference to the heavenly one.
[41] See Evdokimov 1990: 169–70.

distinction may be less clear. Obviously the notional subject matter by itself doesn't make a painting sacred; Claude Lorrain's *Landscape with the Wedding of Isaac and Rebekah* is a very beautiful painting, but if it has a religious significance, it is because of its evocation of natural beauty and light, not because it supposedly represents a biblical episode. I think that some biblical paintings by, among others, Giotto, Rembrandt, and Rouault are 'sacred art' in a quasi-iconic sense. But what distinguishes them from many other paintings with a biblical (or otherwise religious) subject matter, but which (like the Claude) are really just landscapes, figurative paintings, or historical or genre scenes? It's not just the artistic excellence of the former, since many of the latter are also artistically excellent. And one may well think that some paintings are 'sacred art' even though their subject matter isn't particularly religious or where they don't have a representational subject matter at all (I have already mentioned above the explicitly 'sacred' import of Mondrian, Kandinsky and—more ambiguously—Rothko.) However, given the claim that even secular painting which aims to evoke only the earthly *Sophia* inevitably ends up evoking something of the heavenly *Sophia* too, one should expect the difference between sacred and secular art to be less than clear-cut and more a matter of emphasis.

Of course, there is much more to say about all these topics. But to say it would be the task for another book.[42] In concluding this one I have been concerned only to set out some of the options for thinking about 'religious' painting, given the 'strong' thesis. To briefly summarize and recap: for someone who accepts the 'least strong' thesis, while rejecting any belief in a transcendent heavenly *Sophia*, what painting does—even supposedly 'sacred art', even icons—is to evoke or disclose the earthly *Sophia*. This is itself still a meaningful, value-laden order, one that rightly inspires reverence and awe—and so a sacred order, and so painting still has a broadly 'religious' significance. For some believers in the transcendent too, the disclosure of the earthly *Sophia* is all that art can do, and painting that claims to manifest or evoke the heavenly *Sophia* is an idolatrous delusion. For others, icons (or other forms of explicitly 'sacred' art) can evoke the heavenly *Sophia*, while secular art deals with the earthly. But for a less dualistic form of theism (or more generally belief in the transcendent), all painting is religious, not only because it discloses the deep things of the sacred order of nature, but because, in so doing, it unavoidably shows them in their relation to the heavenly *Sophia*. It is perhaps obvious that my sympathies lie with this latter position, but I am not claiming to have argued for it here, and to explicate it in any adequate way would, as I said, take another book. My concern here has simply been to distinguish the various possibilities for thinking about painting—and in what sense the icon can be regarded as exemplary or paradigmatic—given the 'strong' thesis.

[42] For those interested in further explorations of some of these themes, I would strongly recommend a recent work, written in collaboration by a philosopher and a painter: Taliaferro and Evans 2021.

Bibliography

Allison, H., *Kant's Transcendental Idealism* (rev. edn, New Haven, CT: Yale University Press, 2004).

Alter, T. and Nagasawa, Y., eds., *Consciousness in the Physical World: Perspectives on Russellian Monism* (Oxford: Oxford University Press, 2015).

Anscombe, E., 'Modern Moral Philosophy', *Philosophy*, 33/124 (1958), 1–19.

Armstrong, D., *A Materialist Theory of the Mind* (London: Routledge, 1968).

Atkins, P., 'The Limitless Power of Science', in J. Cornwell, ed., *Nature's Imagination* (Oxford: Oxford University Press, 1995), 122–32.

Augustine, *Confessions*, tr. H. Chadwick (Oxford: Oxford University Press, 1998).

Barth, K., *Church Dogmatics*, ii.1: *The Doctrine of God, Part 1*, ed. and tr. G. W. Bromiley and T. E. Torrance (Edinburgh: T. & T. Clark, 1957).

Barth, K., *Church Dogmatics*, iv.3.2: *The Doctrine of Reconciliation, Part 31*, tr. C. Pott (Edinburgh: T. & T. Clark, 1962).

Barth, K., *Wolfgang Amadeus Mozart* (Grand Rapids, MI: William B. Eerdmans, 1986).

Beiser, F., *Diotima's Children: German Aesthetic Rationalism from Leibniz to Lessing* (Oxford: Oxford University Press, 2009).

Bell, C., *Art* (London: Chatto and Windus, 1914).

Bell, J., *What is Painting?* (rev. edn, London: Thames and Hudson, 2017).

Belting, H., *Likeness and Presence: A History of the Image before the Era of Art*, tr. E. Jephcott (Chicago: University of Chicago Press, 1994).

Benjamin, W., 'The Work of Art in the Age of Its Technological Reproducibility', in *Selected Writings*, iii: *1935–8*, ed., H. Eliand and M. Jennings, tr. E. Jephcott, H. Eliand, et al. (Cambridge, MA, and London: Belknap Press of Harvard University Press, 2002), 101–133.

Benson, J., *Environmental Ethics* (London: Routledge, 2000).

Berkeley, G., *Three Dialogues between Hylas and Philonous*, ed. J. Dancy (Oxford: Oxford University Press, 1998).

Berleant, A., 'The Aesthetics of Art and Nature', in S. Kemal and I Gaskell, eds., *Landscape, Natural Beauty and the Arts* (Cambridge: Cambridge University Press, 1993), 228–43.

Bilgrami, A., *Secularism, Identity, and Enchantment* (Cambridge, MA: Harvard University Press, 2014).

Bowman, M., 'Indiscernibly Bad: The Problem of Bad Painting/Good Art', *Oxford Art Journal*, 41/3 (2018), 321–39.

Bowness, A., ed., *Some Statements by Barbara Hepworth* (St Ives: Barbara Hepworth Museum, 1977).

Brady, E., *Aesthetics of the Natural Environment* (Tuscaloosa, AL: University of Alabama Press/ Edinburgh: Edinburgh University Press, 2003).

Brandom, R., *Reason in Philosophy* (Cambridge, MA: Harvard University Press, 2009).

Bredlau, S., 'Phantom Limbs and Phantom Worlds: Being Responsive to the Present', in K. Semonovitch and N. DeRoo, eds., *Merleau-Ponty at the Limits of Art, Religion and Perception* (London and New York: Continuum, 2010), 79–93.

Buber, M., *I and Thou*, tr. R. G. Smith (Edinburgh: T. & T. Clark, 1958).

Budd, M., *Values of Art* (London: Penguin, 1996).

Bugbee, H., *The Inward Morning: A Philosophical Exploration in Journal Form* (Athens, GA: University of Georgia Press, 1999).

Buntrup, G. and Jaskolla, L., eds., *Panpsychism: Contemporary Perspectives* (Oxford: Oxford University Press, 2016).

Burgin, V., 'The Absence of Presence', *Studio International*, **191** (1976a), https://theoria.art-zoo.com/the-absence-of-presence-victor-burgin/, accessed 29 January 2022.

Burgin, V., 'From "Socialist Formalism"', *Studio International*, **191**/980 (1976b), https://theoria.art-zoo.com/from-socialist-formalism-victor-burgin/, accessed 7 February 2022.

Bush, S. and Hsio-yen Shih, eds., *Early Chinese Texts on Painting* (Hong Kong: Hong Kong University Press, 2012).

Callicott, J. B., *Beyond the Land Ethic: More Essays in Environmental Philosophy* (Albany, NY: State University of New York Press, 1999).

Callicott, J. B., 'Intrinsic Value in Nature', in *Beyond the Land Ethic: More Essays in Environmental Philosophy* (Albany, NY: State University of New York Press, 1999), 239–63.

Calvin, J., *Institutes of the Christian Religion*, ed. A. Lane and H. Osborne, tr. H. Beveridge (abridged edn, London: Hodder and Stoughton, 1986).

Carlson, A., *Aesthetics and the Environment: The Appreciation of Nature, Art and Architecture* (London: Routledge, 2002).

Carlson, A., *Nature and Landscape: An Introduction to Environmental Aesthetics* (New York: Columbia University Press, 2009).

Carlson, A. and Lintott, S., eds., *Nature, Aesthetics and Environmentalism: From Beauty to Duty* (New York: Columbia University Press, 2008).

Carroll, N., *Philosophy of Art a Contemporary Introduction* (London and New York: Routledge, 1999).

Carroll, N., 'On Being Moved by Nature: Between Religion and Natural History', in A. Carlson and S. Lintott, eds., *Nature, Aesthetics and Environmentalism: From Beauty to Duty* (New York: Columbia University Press, 2008), 244–65.

Chen, W., *Chinese Environmental Aesthetics*, ed. G. Cipriani, tr. Feng Su (London: Routledge, 2015).

Clark, T. J., *The Painting of Modern Life: Paris in the Art of Manet and His Followers* (rev. edn, Princeton, NJ: Princeton University Press, 1999).

Coleridge, S. T., *Biographia Literaria*, ed. G. Watson (J.M. Dent, London, 1956).

Coleridge, S. T., *The Friend*, i, ed. B. R. Brooke (London: Routledge and Kegan Paul/ Princeton, NJ: Princeton University Press, 1969).

Coomaraswamy, A., 'A Figure of Speech or a Figure of Thought?', in B. Keeble, ed., *Every Man an Artist: Readings in the Traditional Philosophy of Art* (Bloomington, IN: World Wisdom, 2005), 27–55.

Cooper, D., *A Philosophy of Gardens* (Oxford: Oxford University Press, 2006).

Cooper, D., *Convergence with Nature: A Daoist Perspective* (Totness: Green Books, 2012).

Copan, P. and Taliaferro, C., eds., *The Naturalness of Belief* (Lanham, MD: Lexington Books, Rowman and Littlefield, 2019).

Cormack, R., *Icons* (London: British Museum Press, 2007).

Corrington, R., *Nature and Spirit: An Essay in Ecstatic Naturalism* (New York: Fordham University Press, 1992).

Crowell, S., 'Phenomenology and Aesthetics: Or, Why Art Matters', in J. Perry, ed., *Art and Phenomenology* (London: Routledge, 2011), 31–53.

Crowther, P., *Phenomenology of the Visual Arts (even the Frame)* (Stanford, CA: Stanford University Press, 2009).

Crowther, P., *How Pictures Complete Us: The Beautiful, the Sublime, and the Divine* (Stanford, CA: Stanford University Press, 2016).

Dadosky, J., *The Eclipse and Recovery of Beauty* (Toronto: University of Toronto Press, 2014).

Danto, A. C., *The Transfiguration of the Commonplace* (Cambridge, MA: Harvard University Press, 1981).

Danto, A.C., 'Responses and Replies', in M. Rollins, ed., *Danto and His Critics* (Oxford: Blackwell, 1993), 193–216.

Davies, D., *Art as Performance* (Oxford: Blackwell, 2004).

Davis, D. H., 'The Art of Perception', in D. H. Davis and W. Hamrick, eds., *Merleau-Ponty and the Art of Perception* (Albany, NY: State University of New York Press, 2016), 3–52.

Davis, D. H. and Hamrick, W., eds., *Merleau-Ponty and the Art of Perception* (Albany, NY: State University of New York Press, 2016).

DeLay, S., 'Disclosing Worldhood or Expressing Life?', *Journal of Aesthetics and Phenomenology*, 4/2 (2017), 155–71.

Derrida, J., *Of Grammatology*, tr. G. C. Spivak (Baltimore, MD, and London: Johns Hopkins University Press, 1976).

Diffey, T. J., 'Natural Beauty without Metaphysics', in S. Kemal and I Gaskell, eds., *Landscape, Natural Beauty and the Arts* (Cambridge: Cambridge University Press, 1993), 43–64.

Doris, J., *Lack of Character: Personality and Moral Behavior* (Cambridge: Cambridge University Press, 2002).

Dreyfus, H., 'The Myth of the Pervasiveness of the Mental', in J. Schear, ed., *Mind, Reason and Being-in-the-World: The McDowell-Dreyfus Debate* (London: Routledge, 2013), 15–40.

Dreyfus, H. and Kelly, S., *All Things Shining: Reading the Western Classics to Find Meaning in a Secular Age* (New York: Free Press, 2011).

Dummett, M., *Thought and Reality* (Oxford: Oxford University Press, 2006).

Dupré, J., *The Disorder of Things: Metaphysical Foundations of the Disunity of Science* (Cambridge, MA: Harvard University Press, 1993).

Dustin, C. and Ziegler, J., *Practicing Mortality: Art, Philosophy and Contemplative Seeing* (New York and Basingstoke: Palgrave Macmillan, 2007).

Eck, D., *Darsan: Seeing the Divine Image in India* (3rd edn, New York: Columbia University Press, 1998).

Edgar, O., *Things Seen and Unseen: The Logic of Incarnation in Merleau-Ponty's Metaphysics of Flesh* (Eugene, OR: Cascade Books, 2016).

Edwards, J., 'The Beauty of the World', in *Basic Writings*, ed. O. E. Winslow (New York: Signet Classics, 1966a), 251–3.

Edwards, J., 'Personal Narrative', in *Basic Writings*, ed. O. E. Winslow (New York: Signet Classics, 1966b), 81–96.

Eliade, M., *The Sacred and the Profane: The Nature of Religion*, tr. W. Trask (New York: Harper and Row, 1961).

Eliot, T. S., *Collected Poems* (London: Faber, 2002).

Elkins, J., *Pictures and Tears: A History of People Who Have Cried in Front of Paintings* (New York and London: Routledge, 2001).

Evdokimov, P., *The Art of the Icon: A Theology of Beauty*, tr. S. Bigham (Redondo Beach, CA: Oakwood Publications, 1990).

Farrell, F., *How Theology Shaped Twentieth-Century Philosophy* (Cambridge: Cambridge University Press, 2019).

Flam, J., ed., *Matisse on Art* (Berkeley, CA: University of California Press, 1995).

Florensky, P., *Iconostasis*, tr. D. Sheehan and O. Andrejev (Crestwood NY: St. Vladimir's Seminary Press, 1996).

Foot, P., *Natural Goodness* (Oxford: Oxford University Press, 2001).

Frazier, J., 'Hinduism: Visual Art and Architecture', in F. B. Brown, ed., *The Oxford Handbook of Religion and the Arts* (Oxford: Oxford University Press, 2014), 350–57.

Freedberg, D., *The Power of Images: Studies in the History and Theory of Response* (Chicago: University of Chicago Press, 1989).

Friedenthal, R., ed., *Letters of the Great Artists* (New York: Random House, 1963).

Fuller, P., *Theoria: Art, and the Absence of Grace* (London: Chatto and Windus, 1988).

Furtak, R., *Knowing Emotions: Truthfulness and Recognition in Affective Experience* (Oxford: Oxford University Press, 2018).

Gadamer, H.-G., *Truth and Method*, tr. W. Glen-Doepel, rev. J. Weinsheimer and D. Marshall (2nd edn, London and New York: Continuum, 2004).

Gallagher, S. and Zahavi, D., *The Phenomenological Mind* (London: Routledge, 2012).

Gasquet, J., *Joachim Gasquet's Cézanne: A Memoir with Conversations* (London: Thames and Hudson, 1991).

Gaut, B., *Art, Emotion, and Ethics* (Oxford: Oxford University Press, 2007).

Gillespie, M., *Nihilism before Nietzsche* (Chicago: University of Chicago Press, 1995).

Gilson, É., *Painting and Reality* (New York: Pantheon, 1957).

Goldie, P., *The Emotions: A Philosophical Exploration* (Oxford: Oxford University Press, 2000).

Goldman, A. H., 'The Experiential Account of Aesthetic Value', *The Journal of Aesthetics and Art Criticism*, 64.3 (2006), 333–342.

Gombrich, E. H., *The Story of Art* (13th edn, London: Phaidon, 1978).

Goodman, N., *Languages of Art* (Indianapolis, IN: Hackett, 1976).

Graham, G., *The Re-enchantment of the World: Art versus Religion* (Oxford: Oxford University Press, 2008).

Greenberg, C., 'Avant-Garde and Kitsch', in J. O'Brian, ed., *The Collected Essays and Criticism of Clement Greenberg*, i: *Perceptions and Judgements, 1939–44* (Chicago: University of Chicago Press, 1988a), 5–22.

Greenberg, C., 'Towards a Newer Laocoon', in J. O'Brian, ed., *The Collected Essays and Criticism of Clement Greenberg*, i: *Perceptions and Judgements, 1939–44* (Chicago: University of Chicago Press, 1988b), 23–37.

Greenberg, C., 'Modernist Painting', in J. O'Brian, ed., *The Collected Essays and Criticism of Clement Greenberg*, iv: *Modernism With a Vengeance 1957–69* (Chicago: University of Chicago Press, 1995), 85–93.

Grenberg, J., *Kant's Defense of Common Moral Experience: A Phenomenological Account* (Cambridge: Cambridge University Press, 2013).

Harrison, R. P., *Gardens* (Chicago: University of Chicago Press, 2009).

Hedely, D., *The Iconic Imagination* (London: Continuum, 2016).

Hegel, G. W., *Introductory Lectures on Aesthetics*, ed. M. Inwood, tr. B. Bosanquet (London: Penguin, 1993).

Heidegger, M., *Being and Time*, tr. J. Macquarrie and E. Robinson (Oxford: Blackwell, 1962).

Heidegger, M., 'The Origin of the Work of Art', in *Poetry, Language, Thought*, tr. A. Hofstadter (New York: Harper and Row, 1971a), 17–87.

Heidegger, M., 'The Thing', in *Poetry, Language, Thought*, tr. A. Hofstadter (New York: Harper and Row, 1971b), 165–82.

Heidegger, M., 'On the Essence of Truth', in *Basic Writings*, ed. D. Krell (New York: HarperCollins, 2008), 111–138.

Henry, M., *Seeing the Invisible: On Kandinsky*, tr. S. Davidson (London: Continuum/ Bloomsbury, 2009).

Hepburn, R., 'Trivial and Serious in the Aesthetic Appreciation of Nature', in *The Reach of the Aesthetic: Collected Essays on the Aesthetics of Art and Nature* (Aldershot: Ashgate, 2001), 65–80.

Hepworth, B., *A Pictorial Autobiography* (Bath: Adams and Dart, 1970).

Hildebrand, D. von, *Aesthetics*, i, tr. B. McNeil (Steubenville OH: Dietrich von Hildebrand Legacy Project, 2016).

Hill, T. Jr, 'Finding Value in Nature', in D. Schmitz and D. Shahar, eds., *Environmental Ethics: What Really Matters, What Really Works* (3rd edn, Oxford: Oxford University Press, 2019), 108–112.

Hopkins, G. M. ed C. Phillips, *Selected Poetry* (Oxford University Press, Oxford, 1998).

Hume, D., 'Of the Standard of Taste', in *Selected Essays*, ed. S. Copley and A. Edgar (Oxford: Oxford University Press, 1996), 133–54.

Iseminger, G., *The Aesthetic Function of Art* (Ithaca, NY: Cornell University Press, 2004).

Ivanhoe, P., 'Zhuangzi on Skepticism, Skill, and the Ineffable *Dao*', *Journal of the American Academy of Religion*, 61/ 4 (1993), 639–54.

Ivanhoe, P. and Van Norden, B., eds., *Readings in Classical Chinese Philosophy* (2nd edn, Indianapolis, IN: Hackett, 2005).

Jackson, G. B., 'Skill and the Critique of Descartes in Gilbert Ryle and Maurice Merleau-Ponty', in K. Semonovitch and N. DeRoo, eds., *Merleau-Ponty at the Limits of Art, Religion and Perception* (London and New York: Continuum, 2010), 63–78.

John of Damascus, St, *Three Treatises on the Divine Images*, tr. A. Louth (Crestwood NY: St. Vladimir's Seminary Press, 2003).

Johnson, G., 'Introduction to Merleau-Ponty's Philosophy of Painting', in G. Johnson, ed., The Merleau-Ponty Aesthetics Reader (Evanston, IL: Northwestern University Press, 1996), 3–55.

Johnson, G., *The Retrieval of the Beautiful: Thinking Through Merleau-Ponty's Aesthetics* (Evanston, IL: Northwestern University Press, 2009).

Jullien, F., tr. J. M. Todd, *The Great Image Has No Form: Or, On the Nonobject through Painting* (Chicago: University of Chicago Press, 2009).

Kandinsky, W., *Concerning the Spiritual in Art*, tr. M. Sadler (New York: Dover Books, 1977).

Kearney, R., 'Merleau-Ponty and the Sacramentality of the Flesh', in K. Semonovitch and N. DeRoo, eds., *Merleau-Ponty at the Limits of Art, Religion and Perception* (London and New York: Continuum, 2010), 147–66.

Kivy, P., 'On the Unity of Form and Content', in *Philosophies of Arts: An Essay in Differences* (Cambridge: Cambridge University Press, 1997), 84–119.

Klee, P., *On Modern Art*, tr. P. Findlay (London: Faber and Faber, 1966).

Kohak, E., *The Embers and the Stars: A Philosophical Inquiry into the Moral Sense of Nature* (Chicago: University of Chicago Press, 1984).

Korsgaard, C., *The Sources of Normativity* (Cambridge: Cambridge University Press, 1996).

Lachman, C., 'Buddhism: Image as Icon, Image as Art', in F. B. Brown, ed., *The Oxford Handbook of Religion and the Arts* (Oxford: Oxford University Press, 2014), 367–78.

Lai, K., *An Introduction to Chinese Philosophy* (Cambridge: Cambridge University Press, 2008).

Lamarque, P., 'The Elusiveness of Poetic Meaning', *Ratio* 22 (2009), 398–420.

Lamarque, P., *Work and Object: Explorations in the Metaphysics of Art* (Oxford: Oxford University Press, 2010).

Landes, D., *Merleau-Ponty and the Paradoxes of Expression* (London and New York: Bloomsbury Academic, 2013).

Lane, B., *Ravished by Beauty: The Surprising Legacy of Reformed Spirituality* (Oxford: Oxford University Press, 2011).

Leddy, T., *The Extraordinary in the Ordinary: The Aesthetics of Everyday Life* (Peterborough, ON: Broadview Press, 2012).

Lerner, B., *Leaving the Atocha Station*, (Minneapolis, MN: Coffee House Press, 2011).

LeVasseur, T. and Peterson, A., eds., *Religion and Ecological Crisis: The 'Lynn White Thesis' at Fifty* (London: Routledge, 2017).

Lin Ci, *Chinese Painting* (Cambridge: Cambridge University Press, 2010).

Lipsey, R., *The Spiritual in Twentieth-Century Art* (New York: Dover Publications, 2004).

Liu, JeeLoo, *Neo-Confucianism: Metaphysics, Mind, and Morality* (Hoboken, NJ: Wiley-Blackwell, 2018).

Lopes, D. M., 'Painting', in B. Gaut and D. M. Lopes, eds., *The Routledge Companion to Aesthetics* (London: Routledge, 2001), 596–605.

Lossky, V., 'Tradition and Traditions', in L. Ouspensky and V. Lossky, eds., *The Meaning of Icons* (Crestwood NY: St. Vladimir's Seminary Press, 1999), 9–22.

Lyotard, J.-F., *The Postmodern Condition*, tr. G. Bennington and B. Massumi (Manchester: Manchester University Press, 1984).

Lyotard, J.-F., 'Excerpts from *Discours, Figure*', in G. Johnson, ed., The Merleau-Ponty Aesthetics Reader (Evanston, IL: Northwestern University Press, 1996a), 309–22.

Lyotard, J.-F., 'Philosophy and Painting in the Age of Their Experimentation', in G. Johnson, ed., *The Merleau-Ponty Aesthetics Reader* (Evanston, IL: Northwestern University Press, 1996b), 323–35.

McDowell, J., *Mind and World* (Cambridge, MA: Harvard University Press, 1996).

McDowell, J., 'Aesthetic Value, Objectivity, and the Fabric of the World', in *Mind, Value, and Reality* (Cambridge, MA: Harvard University Press, 1998a), 112–130.

McDowell, J., 'Values and Secondary Qualities', in *Mind, Value, and Reality* (Cambridge, MA: Harvard University Press, 1998b), 131–150.

McDowell, J., 'The Myth of the Mind as Detached', in J. Schear, ed., *Mind, Reason and Being-in-the-World: The McDowell–Dreyfus Debate* (London: Routledge, 2013), 41–58.

MacFarlane, R., *The Old Ways: A Journey on Foot* (London: Penguin, 2013).

McGrath, A., *The Reenchantment of Nature: The Denial of Religion and the Ecological Crisis* (New York: Doubleday, 2002).

MacIntyre, A., *After Virtue* (3rd edn, Notre Dame, IN: University of Notre Dame Press, 2007).

MacIntyre, A., 'On Being a Theistic Philosopher in a Secularized Culture', *Proceedings of the American Catholic Philosophical Association*, 84 (2010), 23–32.

Mai-mai Sze, *The Way of Chinese Painting* (New York: Vintage Books, Random House, 1959).

Marcel, G., *The Mystery of Being*, i, tr. G. S. Frazer (Lanham, MD: University Press of America, 1978).

Marion, J.-L., *God without Being*, tr. T. Carlson (Chicago: University of Chicago Press, 1991).

Marion, J.-L., *The Crossing of the Visible*, tr. J. Smith (Stanford, CA: Stanford University Press, 2004).

Maritain, J., *Creative Intuition in Art and Poetry* (New York: Meridian Books, 1955).

Maritain, J., *Existence and the Existent*, tr. L. Galantiere and G. Phelan (New York: Doubleday Image Books, 1956).

Marr, A., *The Making of Modern Britain* (London: Macmillan 2009).

Matherne, S., 'Merleau-Ponty on Style as the Key to Perceptual Presence and Constancy', *Journal of the History of Philosophy*, 55/4 (2017), 693–727.

Merleau-Ponty, M., *The Structure of Behaviour*, tr. A.L. Fisher (Boston, Beacon Press, 1967).

Merleau-Ponty, M., *The Visible and the Invisible*, ed. C. Lefort, tr. A. Lingis (Evanston, IL: Northwestern University Press, 1968a).

Merleau-Ponty, M., 'Working Notes', in *The Visible and the Invisible*, ed. C. Lefort, tr. A. Lingis (Evanston, IL: Northwestern University Press, 1968b), 165–275.

Merleau-Ponty, M., 'Cézanne's Doubt', in G. Johnson, ed., *The Merleau-Ponty Aesthetics Reader* (Evanston, IL: Northwestern University Press, 1996a), 59–75.

Merleau-Ponty, M., 'Eye and Mind', in G. Johnson, ed., *The Merleau-Ponty Aesthetics Reader* (Evanston, IL: Northwestern University Press, 1996b), 121–49.

Merleau-Ponty, M., 'Indirect Language and the Voices of Silence', in G. Johnson, ed., *The Merleau-Ponty Aesthetics Reader* (Evanston, IL: Northwestern University Press, 1996c), 76–120.

Merleau-Ponty, M., *The World of Perception*, tr. O. Davis (London and New York: Routledge, 2009).

Merleau-Ponty, M., *Phenomenology of Perception*, tr. D. Landes (London: Routledge, 2013).

Midgley, M., *Science as Salvation: A Modern Myth and Its Meaning* (Abingdon and New York: Routledge, 1992).

Montero, B., 'A Dancer Reflects', in J. Schear, ed., *Mind, Reason and Being-in-the-World: The McDowell–Dreyfus Debate* (London: Routledge, 2013), 303–19.

Moore, G. E., *Principia Ethica* (Cambridge: Cambridge University Press, 1962; 1st edn, 1903).

Murdoch, I., *Metaphysics as a Guide to Morals* (London: Penguin, 1993).

Murdoch, I., 'Art Is the Imitation of Nature', in *Existentialists and Mystics: Writings on Philosophy and Literature*, ed. P. Conradi (London: Chatto and Windus, 1997a), 243–57.

Murdoch, I., 'The Fire and the Sun: Why Plato Banished the Artists', in *Existentialists and Mystics: Writings on Philosophy and Literature*, ed. P. Conradi (London: Chatto and Windus, 1997b), 386–463.

Murdoch, I., 'The Idea of Perfection', in *Existentialists and Mystics* in *Existentialists and Mystics: Writings on Philosophy and Literature*, ed. P. Conradi (London: Chatto and Windus, 1997c), 299–336.

Murdoch, I., 'On "God" and "Good"', in *Existentialists and Mystics: Writings on Philosophy and Literature*, ed. P. Conradi (London: Chatto and Windus, 1997d), 337–62.

Murdoch, I., 'The Sovereignty of Good over Other Concepts', in *Existentialists and Mystics: Writings on Philosophy and Literature*, ed. P. Conradi (London: Chatto and Windus, 1997e), 363–85.

Murdoch, I., 'The Sublime and the Good', in *Existentialists and Mystics: Writings on Philosophy and Literature*, ed. P. Conradi (London: Chatto and Windus, 1997f), 205–220.

Nagel, T., *Mind and Cosmos* (Oxford: Oxford University Press, 2012).

Niemoczynski, L. and Nguyen, T., eds., *A Philosophy of Sacred Nature: Prospects for Ecstatic Naturalism* (Lanham, MD: Lexington Books, 2015).

Nietzsche, F., *The Genealogy of Morals*, tr. D. Smith (Oxford: Oxford University Press, 1996).

Nietzsche, F., *The Will to Power*, tr. W. Kaufmann and R. J. Hollingdale (New York: Vintage Books, 1968).

Nietzsche, F., 'Morality as Anti-Nature', in *Twilight of the Idols*, tr. R. J. Hollingdale (Harmondsworth: Penguin, 1968a), 42–6.

Nietzsche, F., *Twilight of the Idols*, tr. R. J. Hollingdale (Harmondsworth: Penguin, 1968b).

Nijhuis, M., 'Echoes of Brushstrokes', in D. H. Davis and W. Hamrick, eds., *Merleau-Ponty and the Art of Perception* (Albany, NY: State University of New York Press, 2016), 85–96.

Nussbaum, M., *Love's Knowledge* (Oxford: Oxford University Press, 1992).

Nussbaum, M., *Upheavals of Thought: The Intelligence of Emotions* (Cambridge: Cambridge University Press, 2003).

O'Leary, J., 'Meleau-Ponty and Modern Sacrificial Poetics', in K. Semonovitch and N. DeRoo, eds., *Merleau-Ponty at the Limits of Art, Religion and Perception* (London and New York: Continuum, 2010), 167–84.

O'Neil, J., 'The Varieties of Intrinsic Value', in A. Light and H. Rolston III, eds., *Environmental Ethics: An Anthology* (Oxford: Blackwell, 2003), 131–42.

Ouspensky, L. and Lossky, V., *The Meaning of Icons* (Crestwood NY: St. Vladimir's Seminary Press, 1999).

Parmelin, H., ed., *Picasso Says…*, tr. C. Trollope (London: Allen and Unwin, 1969).

Pfau, T., *Minding the Modern* (Notre Dame, IN: University of Notre Dame Press, 2013).

Pippin, R., *After the Beautiful: Hegel and the Philosophy of Pictorial Modernism* (Chicago: University of Chicago Press, 2014).

Plantinga, A., *Warranted Christian Belief* (Oxford: Oxford University Press, 2000).

Plato, *The Republic*, tr. C. D. C. Reeve (Indianapolis, IN: Hackett, 2004).

Plotinus, *Enneads*, tr. S. McKenna (London: Penguin, 1991).

Polcari, S., *Abstract Expressionism and the Modern Experience* (Cambridge: Cambridge University Press, 1991).

Pontynen, A., *For the Love of Beauty: Art, History and the Moral Foundations of Aesthetic Judgement* (Abingdon and New York: Routledge, 2017).

Rawls, J., 'Kantian Constructivism in Moral Theory', *The Journal of Philosophy*, 77/9 (1980), 515–72.

Read, H., ed., *Unit One* (London: Cassell, 1934).

Rilke, R. M., *Ahead of all Parting: The Selected Poetry and Prose of Rainer Maria Rilke*, tr. S. Mitchell (New York: Random House, 1995).

Rolston, H., III, 'Aesthetics of Nature and the Sacred', in B. R. Taylor, ed., *The Encyclopedia of Religion and Nature*, i (London and New York: Thoemmes Continuum, 2005), 18–21.

Rudd, A., *Expressing the World: Skepticism, Wittgenstein, and Heidegger* (Chicago: Open Court, 2003).

Rudd, A., *Self, Value, and Narrative: A Kierkegaardian Approach* (Oxford: Oxford University Press, 2012).

Russell, B., *The Problems of Philosophy* (Oxford: Oxford University Press, 1997).

Russell, B., 'Knowledge by Acquaintance and Knowledge by Description', in *Mysticism and Logic* (Nottingham: Spokesman Books, 2008), 197–218.

Saito, Y., *Everyday Aesthetics* (Oxford: Oxford University Press, 2010).

Sallis, J., *Klee's Mirror* (Albany, NY: State University of New York Press, 2015).

Sayre-McCord, G., 'The Many Moral Realisms', in G. Sayre-McCord, ed., *Essays on Moral Realism* (Ithaca, NY: Cornell University Press, 1988), 1–25.

Scarry, E., *On Beauty and Being Just* (Princeton, NJ: Princeton University Press, 1999).

Schapiro, M., *Theory and Philosophy of Art: Style, Artist, and Society* (New York: George Braziller, 1994).

Scharma, S., *The Embarrassment of Riches: An Interpretation of Dutch Culture in the Golden Age* (London: Fontana Press, 1991).

Schear, J., ed., *Mind, Reason and Being-in-the-World: The McDowell–Dreyfus Debate* (London: Routledge, 2013).

Schelling, F. W. J., *Philosophical Investigations into the Essence of Human Freedom*, tr. J. Love and J. Schmidt (Albany, NY: State University of New York Press, 2006).

Schopenhauer, A., *The World as Will and Representation*, Vol 1, tr. E. J. Payne (New York: Dover Publications, 1969).

Semonovitch, K. and DeRoo, N., eds., *Merleau-Ponty at the Limits of Art, Religion and Perception* (London and New York: Continuum, 2010).

Shepherd, N., *The Living Mountain* (Edinburgh: Cannongate Books, 2011).

Sheppard, A., *Aesthetics: An Introduction to the Philosophy of Art* (Oxford: Oxford University Press, 1987).

Simmonds, W. J., 'Artists at Work: Pat Steir', *Interview Magazine* (2016), https://www.academia.edu/39724200/Interview_with_Pat_Steir, accessed 29 January 2022.

Smith, C. J., ed., *After Modernity? Secularity, Globalization, and the Reenchantment of the World* (Waco, TX: Baylor University Press, 2008).

Sokolowski, R., *Introduction to Phenomenology* (Cambridge: Cambridge University Press, 2000).

Spaemann, R., 'Bourgeois Ethics and Non-Teleological Ontology', in D. C. Schindler and J. Hefferman Schindler, eds., *The Robert Spaemann Reader* (Oxford: Oxford University Press, 2015a).

Spaemann, R., 'Education as an Introduction to Reality', in D. C. Schindler and J. Hefferman Schindler, eds., *The Robert Spaemann Reader* (Oxford: Oxford University Press, 2015b), 111–20.

Spaemann, R., 'Individual Actions', in D. C. Schindler and J. Hefferman Schindler, eds., *The Robert Spaemann Reader* (Oxford: Oxford University Press, 2015c), 139–53.

Spaemann, R., 'Nature', in D. C. Schindler and J. Hefferman Schindler, eds., *The Robert Spaemann Reader* (Oxford: Oxford University Press, 2015d), 22–36.

Spinoza, B., *Ethics*, tr. S. Shirley (Indianapolis, IN: Hackett, 1992).

Steiner, G., *Real Presences* (London: Faber and Faber, 1989).

Steiner, G., *Grammars of Creation* (New Haven, CT, and London: Yale University Press, 2001).

Strawson, G., 'Realistic Monism', in *Real Materialism and Other Essays* (Oxford: Oxford University Press, 2008), 53–74.

Strawson, P. F., *Individuals: An Essay in Descriptive Metaphysics* (London: Methuen, 1959).

Street, S., 'Coming to Terms with Contingency: Humean Constructivism about Practical Reason', in J. Lenman and Y. Shemmer, eds., *Constructivism in Practical Philosophy* (Oxford: Oxford University Press, 2012), 40–59.

Sullivan, M., *Symbols of Eternity: The Art of Landscape Painting in China* (Stanford, CA: Stanford University Press, 1979).

Sylvester, D., ' "One Continuous Accident Mounting on Top of Another": An Edited Extract from Interviews with Francis Bacon by David Sylvester in 1963, 1966 and 1979', *The Guardian*, 13 September 2007, https://www.theguardian.com/theguardian/2007/sep/13/greatinterviews, accessed 29 January 2022.

Taliaferro, C. and Evans, J., *Is God Invisible? An Essay on Religion and Aesthetics* (Cambridge: Cambridge University Press, 2021).

Taylor, C., *Sources of the Self* (Cambridge: Cambridge University Press, 1989).

Taylor, C., *A Secular Age* (Cambridge, MA: Belknap Press of Harvard University Press, 2007).

Taylor, C., 'Disenchantment-Reenchantment', in *Dilemmas and Connections* (Cambridge, MA: Belknap Press of Harvard University Press, 2011), 287–302.

Theodore the Studite, St, *On the Holy Icons*, tr. C. Roth (Crestwood, NY: St. Vladimir's Seminary Press, 1981).

Thoreau, H., 'Autumnal Tints', in *Natural History Essays*, ed. R. Sattelmeyer (Salt Lake City, UT: Gibbs Smith, 1980), 137–177.

Tiwald, J. and Van Norden, B., eds., *Readings in Later Chinese Philosophy* (Indianapolis, IN: Hackett, 2014).

Traherne, T., *Centuries of Meditation* (Adansonia Press, 2018).

Trapani, G., *Poetry, Beauty and Contemplation: The Complete Aesthetics of Jacques Maritain* (Washington DC: Catholic University of America Press, 2011).

Van Norden, B., *Introduction to Classical Chinese Philosophy* (Indianapolis, IN: Hackett, 2011).

Vanderstappen, H., *The Landscape Paintings of China: Musings of a Journeyman* (Gainesville, FL: University Press of Florida, 2014).

Vasari, G., *Lives of the Artists*, tr. J and P Bondanella (abridged edn, Oxford: Oxford University Press, 1991).

Viladesau, R., *Theological Aesthetics* (Oxford: Oxford University Press, 1999).

Wainwright, A., *Twelve Favourite Mountains* (London: Frances Lincoln, 2007).

Walton, K., 'Categories of Art', *The Philosophical Review*, 79/3 (1970), 334–67.

Ward, K., *God: A Guide for the Perplexed* (Oxford: Oneworld Publishers, 2002).

Watson, G., *A Philosophy of Emptiness* (London: Reaktion Books, 2014).

Weil, S., *Waiting on God*, tr. E. Crauford (New York: Harper and Row, 1973).

White, L., 'The Historical Roots of Our Ecological Crisis', *Science*, 155/ 3767 (1967), 1203–1207.

Wilde, O., 'The Decay of Lying', in S. Feagin and P. Maynard, eds., *Aesthetics* (Oxford: Oxford University Press, 1998), 40–45.

Williams, B., *Ethics and the Limits of Philosophy* (Cambridge, MA: Harvard University Press, 1985).

Wiskus, J., 'Cohesion and Expression: Merleau-Ponty on Cezanne', in D. Davis and W. Hamrick, eds., *Merleau-Ponty and the Art of Perception* (Albany, NY: State University of New York Press, 2016), 67–84.

Wittgenstein, L., *Philosophical Investigations*, tr. G. E. M. Anscombe (Oxford, Blackwell, 2nd edition, 1958).

Wittgenstein, L., *Tractatus Logico-Philosophicus*, tr D. F. Pears and B. F. McGuiness (London, Routledge and Kegan Paul, 1961).

Wittgenstein L., 'Lectures on Aesthetics', in *Lectures and Conversations on Aesthetics, Psychology and Religious Belief*, ed. C. Barrett (Oxford: Blackwell, 1967), 1–40.

Wittgenstein L., *Culture and Value*, tr. P. Winch (Oxford: Blackwell, 1980).

Wordsworth, W., ed. R. S. Thomas, *A Choice of Wordsworth's Verse* (London, Faber, 1971).

Yazykova, I., *Hidden and Triumphant: The Underground Struggle to Save Russian Iconography* (Brewster, MA: Paraclete Press, 2010).

Young, J., *Heidegger's Later Philosophy* (Cambridge: Cambridge University Press, 2002).

Young, J., *Nietzsche's Philosophy of Religion* (Cambridge: Cambridge University Press, 2006).

Zagzebski, L., *Philosophy of Religion: A Historical Introduction* (Oxford: Blackwell, 2007).

Zahavi, D., 'Mindedness, Mindlessness and First-Person Authority', in J. Schear, ed., *Mind, Reason and Being-in-the-World: The McDowell–Dreyfus Debate* (London: Routledge, 2013), 320–43.

Zhu Xi, 'Categorised Conversations', in J. Tiwald and B. Van Norden, eds., *Readings in Later Chinese Philosophy* (Indianapolis, IN: Hackett, 2014), 168–184.

Ziff, P., 'Anything Viewed', in S. Feagin and P. Maynard, eds., *Aesthetics* (Oxford: Oxford University Press, 1998), 23–30.

Index

For the benefit of digital users, indexed terms that span two pages (e.g., 52–53) may, on occasion, appear on only one of those pages.